"*Allston, a man of genius, and the best painter yet produced by America.*"

SAMUEL TAYLOR COLERIDGE
Table Talk and Omniana

"*Washington Allston the painter (who wrote* Monaldi*) is a fine specimen of a glorious old genius.*"

CHARLES DICKENS
Letter to John Forester (February 28, 1842)

"*Not only the greatest painter America has yet produced, but one of the greatest painters of the age. An admirable designer, a rich and harmonious colourist, and a true poet in his art.*"

ANNA JAMESON
Companion to the Most Celebrated Private Galleries of Art in London

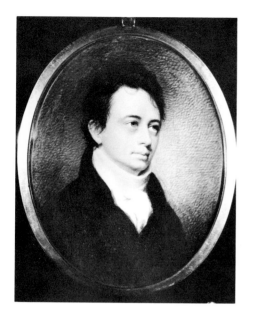
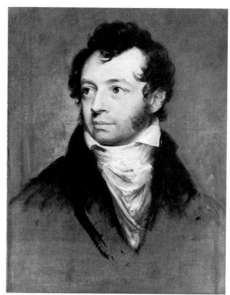
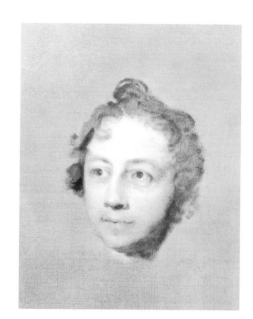
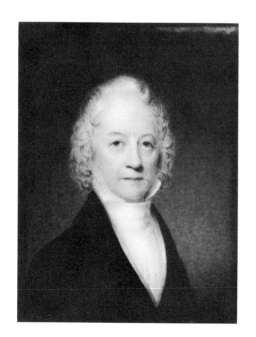
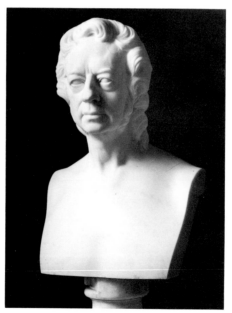
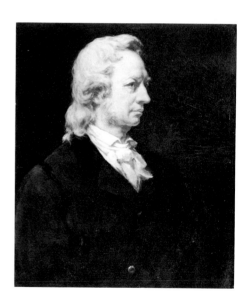

"*A Man of Genius*"
The Art of Washington Allston
(1779-1843)

By William H. Gerdts & Theodore E. Stebbins, Jr.

Published by the
Museum of Fine Arts
Boston

Copyright © 1979 by the
Museum of Fine Arts,
Boston, Massachusetts

Library of Congress Catalog Card no. 79-56222

ISBN 0-87846-145-0 (paper)
ISBN 0-87846-146-9 (cloth)

Typeset by
Dumar Typesetting, Inc., Dayton, Ohio

Printed by The Leether Press,
Yarmouth, Maine

Designed by Carl Zahn

Dates of the Exhibition:

Museum of Fine Arts, Boston
December 12, 1979-February 3, 1980

Pennsylvania Academy of the Fine Arts
February 28-April 27, 1980

Cover or jacket illustrations:
15. *Self-Portrait* (detail)
37. *The Sisters*

Frontispiece:
Portraits of Allston in the exhibition
(from upper left to lower right):

101. By Edward Malbone (ca. 1800-1801)
102. By Charles Robert Leslie (ca. 1816)
103. By Gilbert Stuart (1828)
104. By Shobal Vail Clevenger (ca. 1839)
105. By Richard Morell Staigg (ca. 1840)
106. By Joseph Ames (ca. 1840)

Foreword

THIS EXHIBITION celebrates the two hundredth anniversary of the birth of Washington Allston on November 5, 1779, and it provides the first opportunity in over thirty years to see the best of Allston's works gathered together. It enables us, moreover, to reevaluate the work of an artist who was considered preeminent in his day. Coleridge thought him a "genius"; the critic Henry Tuckerman wrote that he came closest of all Americans to the ideal of an old master; and a reviewer of 1850 commented, "As a painter he is acknowledged by all to stand at the head of American artists." The sweetness and sensitivity of Allston's nature and the nobility of his work were generally acknowledged. His successful paintings were praised for their coloring, their originality, and their expressive powers. And even his failure to finish *Belshazzar's Feast* did nothing to diminish his reputation, for, as C. E. Lester wrote of this canvas in 1846, "a few more weeks of the master's magic pencil would have given the world a creation that our countrymen three hundred years hence would speak of as the Italians now speak of the Last Judgement of Michelangelo."

Allston's reputation waned as the nineteenth century ended. His sophisticated style, his emulation of Venetian glazing, his mastery of academic draftsmanship, and his ambitious exploration of traditional biblical and literary motifs made him seem anachronistic to early twentieth-century critics. He was seen both as a failed artist and, worse, as one outside the native American mainstream. The essays in this catalogue suggest otherwise: they analyze Allston's work within an international context and suggest that the artist in fact gained great artistic and critical success. He is seen now as a sensitive portraitist, the first major American landscape painter, perhaps this country's most important history painter, and the most versatile draftsman of his time. The role he played was crucial to the growth of American art, and in Boston, especially, his influence was enormous.

It is appropriate that our institutions should share in presenting this extensive exhibition and catalogue of Allston's work; the Pennsylvania Academy became the first American museum to acquire a major painting by the artist with the purchase of *The Dead Man Restored* in 1816, and the first gift to the Museum of Fine Arts, at the time of its founding in 1870, was Allston's *Elijah in the Desert*. Allston enjoyed considerable patronage in Boston, where he lived for many years. It was the Boston Athenaeum and its members that supported the painter after his return from England in 1818 until his death in 1843. He was honored by major exhibitions in Boston: at Harding's Gallery in 1839 and at the Museum of Fine Arts in 1881. In 1947 an exhibition of his works was held at the Detroit Institute of Arts and the Boston Museum; that project was organized by E. P. Richardson, whose monograph of 1948 remains indispensable to Allston scholars.

The present exhibition was organized by Frank H. Goodyear, Jr., Curator, Penn-

sylvania Academy of the Fine Arts who first conceived of the idea, William H. Gerdts, Professor of Art History, at the City University of New York, and Theodore E. Stebbins, Jr., Curator of American Paintings at the Museum of Fine Arts. Dr. Stebbins has overseen all aspects of the exhibition, aided by Laura C. Luckey, Galina Gorokhoff, Mary Levin, and Patricia Loiko of the Paintings Department.

We are particularly grateful to Professor Gerdts for his groundbreaking essay, which forms the main part of this catalogue. In addition, we express our thanks to Carl Zahn for his design and production of the catalogue and Margaret Jupe who has skillfully and painstakingly edited it; to Linda Thomas, Registrar, and Lynn Herrmann, Assistant Registrar; and to Tom Wong and Judith Downes of the Design Department. Elizabeth Jones, Brigitte Smith, and Jean Woodward have cleaned the Allston paintings in the museum's collection for this occasion. At the Pennsylvania Academy, we acknowledge especially the work of Janice Stanland and Melinda McGough, Registrars, Kathleen Foster, Assistant Curator, Virginia Naudé and Elizabeth Romanella.

Much research for the catalogue was done at a graduate seminar in the spring of 1978, sponsored jointly by the City University of New York and Boston University. On behalf of Dr. Gerdts and Dr. Stebbins, who gave the seminar together, we express our thanks to the students who participated and especially to Barbara Harris, Chad Mandeles, Elizabeth Prelinger, and Diana Strazdes, who have continued to study Allston's works and who have made significant contributions to this exhibition.

This project has been kindly aided by a planning grant from the H. J. Heinz II Family and Charitable Trust and conservation grants from the Ramlose Foundation and the Wyeth Endowment for American Art. We also acknowledge with gratitude the generous support of the exhibition and our ambitious catalogue from the National Endowment for the Arts, a Federal agency.

Finally, we express our heartfelt appreciation to the owners, public and private, of Allston's works, who have agreed to our every request. We extend special thanks to the National Trust, England, and to Lord Egremont for allowing us to show two important paintings from Petworth House that have never before been seen in the United States, and to our colleagues at the Fogg Art Museum, who have with great kindness lent us thirty-three works, the majority from the Washington Allston Trust at Harvard University.

JAN FONTEIN, *Director*
Museum of Fine Arts

RICHARD J. BOYLE, *Director*
Pennsylvania Academy of the Fine Arts

Contents

Lenders
to the Exhibition

Addison Gallery of American Art,
Phillips Andover Academy

Amherst College, Mead Art Museum

The Baltimore Museum of Art

Eleanor A. Bliss

The Brooklyn Museum

Carolina Art Association,
Gibbes Art Gallery

The Cleveland Museum of Art

Columbia Museum of Art and Science

Corcoran Gallery of Art

The Detroit Institute of Arts

Lord Egremont, Petworth House

The Fine Arts Museums of
San Francisco

Fogg Art Museum,
Harvard University

Hirschl & Adler Galleries

IBM Corporation

Library of the Boston Athenaeum

The Lowe Art Museum,
University of Miami

Massachusetts Historical Society

The Metropolitan Museum of Art

Milwaukee Art Center

Montclair Art Museum

Mugar Memorial Library,
Boston University

Museum of Fine Arts, Boston

National Academy of Design

National Portrait Gallery, London

National Trust for Places of Historic
Interest or Natural Beauty, England

Pennsylvania Academy of the Fine Arts

Henry Channing Rivers

Shelburne Museum

Sisterhood of St. Mary

Society for the Preservation of
New England Antiquities

Toledo Museum of Art

Vassar College Art Museum

Wadsworth Atheneum

Walters Art Gallery

Estate of Mrs. Joseph Wearn

Elizabeth von Wentzel

Worcester Art Museum

Yale University Art Gallery

Anonymous (1)

Private Collections (4)

The Paintings of Washington Allston

By WILLIAM H. GERDTS

AT THE COLUMBIAN EXPOSITION in Chicago in 1893, American art was viewed as at last having come into its own and having achieved at least parity with the best that Europe had to offer. "Modern" achievements in American art were seen as having begun to manifest themselves in 1876, the date of the Philadelphia Centennial, the great precursor of the Chicago fair. But an infancy of American art was at least recognized, and to acknowledge that, one room of the Art Gallery in Chicago was given over to a "Retrospective Exhibit of American Painting" and included works by Benjamin West, Gilbert Stuart, the Peales, and others. The retrospective exhibition received little critical attention, and, when it did, it was appreciated more as a historical summary than as an artistic achievement, except in the case of works by a few artists such as William Morris Hunt, Jervis McEntee, and, significantly, J. Foxcroft (not Thomas) Cole. William Coffin, in the *Nation*, selected Washington Allston specifically as a painter whose showing proved "how little there was in his painting to justify the reputation ascribed to him by his biographers,"[1] certainly here referring to the biography by Jared Flagg, published only the year before and still the most important volume on the artist.[2]

Certainly, the encomiums showered upon Allston by writers and critics, by his friends and his patrons, at home and abroad during his lifetime exceeded the praise bestowed upon any other American painter before the Civil War, and it is natural that a reaction would set in, which it began to do, not long after his death in 1843. When, with historical perspective, America was presented with the opportunity of assessing Allston's artistic worth in the exhibition held at the Museum of Fine Arts in Boston in 1881, even so perceptive a critic as Mariana Van Rensselaer was at a loss to understand his earlier critical esteem,[3] and after that display, one of a series held at the new museum relating to major artists who had worked in Boston, Allston's fame was rapidly forgotten. Of course, matters were not helped by the problem of misattribution, for at Chicago Coffin particularly seized upon *Paul and Silas in Prison*, a rather fascinating work now recognized to be by another hand, but even this is indicative of the decline of Allston's significance in critical esteem. His authentic works had become indistinguishable from those falsely attributed; moreover, the selection committee had not deemed it necessary to borrow his once universally acclaimed masterworks to represent him.

Until the reassessment of Allston's art at the Detroit Institute of Arts exhibition of 1947 and Edgar P. Richardson's major volume on Allston of the following year, Allston's reputation remained in a kind of limbo, the painter recognized as significant in unfathomable and seemingly untenable ways. Rare were the figures such as Charles Demuth, who, two decades before the Detroit exhibition, was greatly impressed by Allston's paintings in Boston and wished to write something of him.

Demuth recognized a kindred spirit in Allston and felt he shared the alienation of the artist from society that he recognized in Allston's expatriate success compared with his isolation at home. He particularly admired the enigmatic *Self-Portrait* (no. 15) owned by the Boston Museum.[4] Demuth was perceptive; the two painters, despite the century-long separation, were not unalike.

This essay is concerned specifically with Allston's pictorial art, with the paintings upon which he primarily established that reputation so dearly won, then lost and now revalued. The attempt here is to describe it and evaluate it in terms of the standards of the period, to seek out the sources of Allston's paintings, their meanings for his contemporaries, and the influences exerted by his art upon other artists at home and abroad. But Allston was much more than a painter; a true "universal man," he designed sculpture and architecture, he wrote artistic theory, essays, poetry, and a novel. These can only be touched upon here, as can also his relationship with European romantic philosophy and literature, although these considerations must necessarily contain many of the keys to our understanding of Allston's art and its contemporary impact.

Allston was the most complete representative of the romantic age in American painting. Without discarding either the belief in formal values of artistic construct or moral certitudes as underlying the purpose of human existence, Allston chose to rely upon memory and upon imagination as the basis for his art, not centering his inspiration upon the continuum of artistic tradition as embodied in the dominant neoclassicism of his youth, but drawing upon his faith in individual genius, which he recognized as an emanation of the divine. This individuality may, of course, have offered little solace and comfort in his later days of artistic isolation in Cambridgeport, but it allies him firmly with the romantic movement of his time and with the dreamers and fantasists of future artistic generations, with artists such as Albert Pinkham Ryder and Demuth. Like those painters, or like Demuth's contemporary, the American writer James Branch Cabell, Allston might have said, "I have served that dream which I elected to be serving. It may be that no man is royal, and that no god is divine, and that our mothers and our wives have not any part in holiness. Oh, yes, it very well may be that I have lost honor and applause, and that I take destruction, through following after a dream which has in it no truth. Yet my dream was noble; and its nobility contents me."[5] Allston's dream, too, was noble; and it is hoped its nobility contented him. The wealth and the beauty of that dream are the essence of this exhibition. Let us here honor and applaud.

Washington Allston was born on November 5, 1779, in South Carolina.[6] His family was an eminent one that had settled along the Waccamaw River in South Carolina. His father, William A. Allston, was a landholder of note and a colorful figure during the American Revolution, serving under General Marion; he was referred to locally as "Gentleman Billy." Another William Allston of the family was distinguished as "King Billy"; to avoid confusion he changed the spelling of his name to "Alston," which, however, seems only to have led to a different confusion, since the name of Washington Allston's family was not infrequently written with one "l." Joseph, the son of this second William Allston, or Alston, married Theodosia Burr, a connection that may have strengthened Allston's later friendship with John Vanderlyn, the protégé of Aaron Burr, Theodosia's father.

The land holdings of Allston's father were extensive, consisting of the manor property where Brookgreen Gardens now stand and three other tracts of land beyond, including one by the South Carolina seacoast. In 1775, two years after the death of his first wife, Anne Simons (who bore him three children, Elizabeth, Benjamin, and another son who died in infancy), William Allston married Rachel Moore. The Moore family had emigrated from England in the late seventeenth century, settling on the Waccamaw River. Rachel's grandfather, John Moore, had married Elizabeth Vanderhorst, of a Dutch family, one of whose ancestors was Nikolaus Van der Horst, a pupil and associate of Peter Paul Rubens. Whether Washington Allston ever became conscious of this distant artistic tradition is not recorded. The Moores and Vanderhorsts remained on close terms, and a cousin of Rachel Moore, Elias Vanderhorst, was later appointed American consul in Bristol, England, and was able to befriend the young artist when he was abroad.

William and Rachel Allston had five children, two of whom, a daughter and a son, John, died in infancy. Mary, sometimes called "Polly," was the oldest of the surviving children, born in May 1778. She was to marry Benjamin Young and, after his death, her cousin William Algernon Alston. Washington was the middle child, born the following year, and then followed his younger brother, William Moore Allston, born in 1781. William, like Washington, studied in Newport, Rhode Island, under Robert Rogers and later, after attending Princeton College, married Ann Rogers, his tutor's daughter. He died a year after Washington, in 1884. Ann bore him five children, one of whom was named Washington, after his uncle. Allston spent his early years in South Carolina, and while those years were formative they were also very few, for he left in 1787 at the age of eight. Certainly, he had an extremely pleasant childhood, growing up on a well-to-do Southern plantation and exposed to gracious living. It is intriguing but difficult to attempt to estimate accurately the influence of this heritage and childhood upon him. He seems always to have paid deference and acknowledgment to his Southern origins, and in turn, he received the support and patronage of South Carolinians, which might otherwise have escaped him, from families such as the Draytons and the Balls. Allston's gentility, his consummate sense of honor, and his reflective nature seem to relate to the stereotype of the Southern gentleman as opposed, for instance, to that of the shrewd New Englander—a mantle Allston never assumed during the long years of his residence there.

Allston remembered much later his association with the blacks on the family plantation, his enjoyment in their superstitions and sense of mystery, his delight in being frightened. His love of astonishment suggests an intuitive sublime, which bloomed in artistic maturity into his great pictures of mystery, magic, and vision, the most celebrated of his career. It has been suggested, too, that the time spent on the Carolina shore, while visiting the family landholdings there, inspired his interest in the moods and majesty of the sea and thus set the stage for several of his finest paintings.

Indeed, Allston invites speculation on the lines of personal associationism more than any other American painter of his time, for an artist who relied so much upon conscious memory might naturally incorporate subliminal awareness of both past experience and family and cultural heritage into his art, particularly when it is an art of such great variety and little concreteness. The spectator is not troubled by

such considerations when reviewing the portraits, for instance, of his predecessor John Singleton Copley or his good friend and contemporary Gilbert Stuart. We may speculate whether Copley and Stuart have caught the accurate likenesses not only of their individual sitters but also of the societies they represented, and we may question also whether the artists considered casting their subjects into an ideal role or mold. We may also be aware of relationships, formal or informal, between the sitters and the painters, but we seldom see the need to interpret the images as reflective of the history and personality of the artist to the degree suggested by Allston's work. Even the art of his more imaginative friend Vanderlyn does not require this, for we may sum up the rationale for his *Ariadne* in the neoclassic aesthetic of David and Girodet and recognize the heritage of *Marius* more in the tradition and philosophy of David's *Brutus* than in Vanderlyn's own history; if anything, *Marius* may reflect rather the history of Aaron Burr. But, much later, is Allston's *Jason* (fig. 17) a subconscious statement of the fruitful quest of the artist to reap the harvest of European artistic study and heritage? Is his *Moonlit Landscape (Moonlight)* (no. 54), with its shadowy figures of family and mounted traveler against a distant Italianate background, a reflection of Allston's recent return to his native home and companionship? Or do we, indeed, read too much into these works of romance and imagination, or, in turn, does their ultimate achievement lie in this very intangibility offered consciously by the artist where *his* imaginative artistry invites our own to enter his world of revery or of dark mystery?

Allston's artistic interest blossomed early. His father died in 1781, the year that his brother William was born, and four years later, in December 1785, his mother married Dr. Henry Collins Flagg of Newport. The family continued to live in South Carolina, where, on April 28-29, 1791, George Washington visited them, an event remembered years later, although young Washington Allston was no longer there to pay homage. About the time of the marriage, he was sent to Charleston to Mrs. Colcott's school, where he studied and began to draw. As a youth he also created landscapes and buildings out of sticks and fashioned figures out of fern stems and the like. While such practices of childhood may seem typical for a future artist, they suggest not only the forms and possible bases for inspiration of his earliest surviving works and, indeed, the landscape theme that dominates this phase of his art, but also the methods of such contemporary artists as Thomas Gainsborough in England, whose manikin figures and pebble, moss, and fern studies for landscapes suggest a similar microcosmic basis of artistic vision.

The Allston family had strong ties with Newport in Rhode Island, for Allston's stepfather had left there to serve in South Carolina during the Revolution, and his mother's younger brother, John Elias Moore, lived there. On a visit to South Carolina Moore agreed to conduct the young Washington back to Newport in the spring of 1787 for serious study prior to matriculation at Harvard College. Indeed, there were close cultural and family ties between Charleston and Newport; like a good many other young Carolinians, Allston entered the school of Robert Rogers, who had graduated from Brown University and, after the Revolution, opened a classical school, becoming one of the most famous schoolmasters of his period. It was a logical step in Allston's education, but his exposure to the classics and to a wide range of literature at so early an age may have been a crucial element in his

development; the strength of Allston's later portrait of Rogers (fig. 10) may bear witness to that.

During his years in Newport, Allston began to develop his artistic interests in a somewhat calculated if informal manner. He made drawings after prints, painted in India ink, and began to use watercolors. His first oil was a depiction of the *Eruption of Vesuvius* (now destroyed or lost), a copy of an old painting, and one might speculate that the original and Allston's copy might have resembled the many views of the subject by Pierre Jacques Volaire, a specialist in depictions of Vesuvius from the mid 1750s on. Other works done in Newport (and no longer extant) include his watercolor of the *Siege of Toulon by Napoleon,* in which William Ellery Channing recalled that all the assailants were viewed from the rear, and which manifested an interest in contemporary military affairs (an interest that was not sustained), and a portrait of a *Santo Domingo Black Boy,* wearing a liberty cap, a refugee from a revolt on the Caribbean island. The contemporaneity of the subject seems foreign to our understanding of the later Allston; his sympathy with the black, however, was long lasting, from his early association in Charleston to the concern with the welfare of the slaves that he and his siblings inherited in late 1839, after the death of their mother.

Another acquaintance Allston made at this time that was significant to his later artistic career was that of Samuel King. King was both an instrument maker and painter of portraits and miniatures. Allston received some instruction from him, which was limited in duration and may have been limited also in professional scope, but it could not have helped being useful, since it would have been his earliest artistic training. King was a professional artist, albeit a very provincial one. He is still a shadowy figure in American art, better remembered as a teacher than an artist, but he seems to represent a provincial manifestation of the solid realism and attempts at strong characterization found in the art of John Singleton Copley.[7] This may have been the first time that Allston came into contact with the Copley tradition, but it was not, in any event, an encounter that had serious impact upon his work. Perhaps equally significant to the instruction he received from King was the formation of a close but unfortunately short-lived friendship with Edward Greene Malbone. Allston and Malbone began their friendship just before the latter left Newport to begin his professional career in Providence, Rhode Island, in September 1794. Presumably, then, they met that spring or early summer. Malbone may also have been a pupil of King's; some confusion arises here since Allston later wrote to William Dunlap that they had attended different schools, but this may refer rather to their formal than to their professional training.[8] It has erroneously been said that King was the instructor of Gilbert Stuart, but he probably offered the earliest artistic lessons to Charles Bird King and, possibly, late in his life, to Anne Hall.

In Newport also Allston came to know the Channing family. He became friendly with William Ellery Channing the younger, the future great Unitarian preacher, who preceded him to Harvard, entering the college in 1795. More significant to Allston's personal life, he formed a friendship with William Ellery's sister, Ann Channing, which began a long courtship that led to their marriage in 1809.

In 1796 Allston left Newport and matriculated at Harvard College, graduating four years later in the spring of 1800. His years there were happy ones, boisterous

and convivial. Many of the friendships he made at Harvard remained constant for the rest of his life and significant, potentially at least, for his career. These included an abiding friendship with Edmund Dana, his future brother-in-law, and with Leonard Jarvis, whose important congressional position was significant in the repeated importuning of Allston to paint pictures for the rotunda of the Capitol in the 1830s. At Harvard Allston continued the classical education begun at Rogers's school and became certainly the best-educated American artist of his time. This was reflected not only in the works he created in these early years and his classical pictures done later in life but also in his ability to meet on a cosmopolitan rather than a provincial basis with the major artists and writers of Europe. In that sense Allston achieved a cultural parity with his contemporaries abroad that even Benjamin West was not able to reach.

We know that Allston's favorite works of literature were German plays of horror and imagination, and one of his lost compositions was a scene from Schiller's *The Robbers*.[9] Another was a scene from the tragedy of *Barbarossa*, a play by John Brown produced in London in 1754, in which David Garrick performed; it may be significant in view of Allston's later concern with ghosts and visions that two of his earliest literary works—pictures of the Visigothic king Roderigo and of Frederick I Barbarossa—refer to historical figures who engendered belief in their mythic return. Robert Southey, whom Allston later met as a friend of Samuel Taylor Coleridge, was another favorite author; Southey's tale of *Roderick, The Last of the Goths*, published in 1814, when he and Allston first became acquainted, would presumably have been a source of interest to the artist. Allston painted a scene from Mrs. Radcliffe's *Mysteries of Udolpho*, and one wonders if he might not also have known her novel *The Italian*, of 1797, at this time; he later painted a major work based upon it. A more idyllic source for an early picture was James Thomson's nature poem *The Seasons*, which first appeared between 1726 and 1730. Allston's *Damon and Musidora* is probably the most famous example of pictorial imagery derived from that poem; the painting depicts the episode in which Musidora, a poetic counterpart to the biblical Susannah, is surprised while bathing by her lover, Damon, a subject that also served the brushes of English artists such as Thomas Gainsborough and later William Etty, and Americans such as Thomas Sully and Asher B. Durand.

A work by Allston done either just before he left Newport or early during his Harvard years was *Portrait of Rubens*, a drawing reported as a copy by him when he was about sixteen or seventeen. Henry Reed, a professor at the University of Pennsylvania and a great Wordsworth scholar, wrote to Richard Henry Dana about this work after Allston's death; Reed learned of it from Thomas Sully, who had received a letter from the owner, Robert W. Gibbes of Columbia, South Carolina. The work is included in an undated catalogue of Gibbes's collection, published sometime before the Civil War. Gibbes amassed one of the finest collections of American and foreign art of his time in the South; he was also a patron and biographer of the tragically short-lived James De Veaux, of Charleston, who attempted to study with Allston in 1829. Gibbes's collection also included a large group of engravings assembled by Charles Fraser, the Charleston miniaturist and good friend of both Allston and Gibbes. Gibbes also owned two portraits of Allston, a copy by George

Peter Alexander Healy after Chester Harding's portrait and a cast of Shobal Clevenger's bust of Allston. A copy of *Outlines and Sketches*, the posthumously published volume (1850) of Allston's drawings (see below "The Drawings of Washington Allston") was also owned by Gibbes. The Gibbes collection was thus an eloquent testimonial to the high regard in which the South Carolinians held their native son, long after his final departure from the South.[10] The *Portrait of Rubens* is also indicative of Allston's aesthetic breadth and curiosity, even in his youth, and suggests his future interest in Rubens's paintings, which culminated in the copy he made after Rubens in the Louvre in 1804. Allston's *Portrait of Rubens* is probably no longer extant, however, since Gibbes's collection was destroyed in the firing of Columbia by General Sherman's forces in 1865. Allston's enthusiasm for Rubens has been overshadowed by his devotion to Michelangelo, Titian, Raphael, and to some extent Rembrandt, but Rubens was a significant influence also. Allston wrote two poems that testify to his admiration for that master.

At the end of the eighteenth century, contemporary painting in Boston was in a somewhat curious slump. Copley had long since departed, and Stuart did not settle there until 1805; even Christian Gullager, the Danish emigré, left the city the year after Allston entered Harvard. Probably the most significant figure in Boston at the time of Allston's four years at Harvard was John Johnston, a minor but engaging portraitist whose work basically reflects first the art of Copley and later that of Stuart. There seems to exist no suggestion of any meeting or relationship between the young Allston and Johnston, although Allston later in his career occupied a studio formerly tenanted by Johnston. Of early artists of the Boston tradition, most significant was John Smibert, who had resided at Scollay Square, near Brattle and Cornhill Streets. Smibert had been dead more than forty years when Allston arrived in Boston, but his studio remained substantially intact. Copies of works by the old masters that Smibert had painted early in the eighteenth century when visiting Italy remained in the studio, which was the most important teaching ground for young artists in America during that century. Successively Copley, Charles Willson Peale, John Trumbull, and a good many lesser artists drew inspiration from it. Of all the paintings there, the most admired and most often copied was Smibert's copy of Anthony Van Dyck's *Portrait of Cardinal Bentivoglio*, the original of which hangs in the Pitti Palace in Florence. Trumbull's copy of the painting is now owned by Harvard University; Allston's is lost, but he acknowledged his debt to Smibert's copy, which then seemed to him "perfection."

Although the eighteenth-century painting tradition in America consisted primarily of portraits, in large oil and in miniature, Allston's concern with this theme was limited throughout his career. Almost all of his portraits are either juvenilia or later works done of family and friends. He was, in fact, the first American painter *not* dependent upon portraiture for his livelihood. Having remet his good friend Malbone, who had settled in June 1796 in Boston and was practicing successfully as a miniature painter, Allston undertook a miniature of his classmate John Harris (no. 1). It is a remarkably competent work for a first effort, and the tense introspection and delicacy of visage are Allston's own. While it suggests none of the sophistication and flair of Malbone's work of the period, such as *Portrait of John Langdon Sullivan* of 1797, it belies the story that Allston was shown the miniature later

in his career and, recognizing no promise in the quality of the picture, suggested that its painter should not pursue an artistic career. On the other hand, Allston must have sensed that the picture lacked the "happy talent at portraiture" he so praised in Malbone's miniatures, which combined convincing likeness with elevated character in men and beauty in women. There are about half a dozen other miniatures that have been reported by or attributed to Allston but the Harris picture is the only documented one assuredly by him.

Allston's painting done during his Harvard years—the "juvenilia" of his artistic production—is of greater interest than has usually been perceived or at least granted to it. First of all, there is more of it both recorded and even extant than one might expect. Secondly, while the quality of these early works of 1796-1800 varies greatly and is never outstanding and naturally never mature, the variety of Allston's investigations and experimentations is quite amazing. Thirdly, much of it, inevitably, is of interest in prefiguring the art of the later Allston. But last and perhaps most significant, some of the most interesting surviving works were unique in form and theme to the America of Allston's time and remained so for at least a generation. The question then arises as to whether Allston's vision, even at such an early age, was unique—and given his future artistic development, this is not improbable—or whether the juvenilia of contemporary artists (were it extant or discovered) would contain similar variety and richness and thus offer testimony to a cultural heritage that today we little suspect.

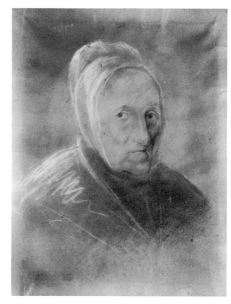

Fig. 1. *Mrs. Timothy Waterhouse,* 1796-97
Pastel, 20 x 16 in. (50.8 x 40.6 cm.)
Richardson 5
Private Collection (Photo courtesy of Longfellow National Historical Site, Cambridge, Massachusetts)

Not unexpectedly, Allston produced several portraits during his college years, in addition to the Harris miniature. Several of these depicted members of the family of Dr. Benjamin Waterhouse, the professor of medicine in whose home Allston roomed and boarded during his first two years at college. One, now lost, was a portrait of Waterhouse's son, Andrew Oliver Waterhouse, which, according to Moses Sweetser, was reputed by the family to be Allston's first essay in oil painting. This is one of a number of pictures competing for the title of the artist's initial oil; indeed, there may exist or have existed several contenders as "first oil portrait," "first landscape," "first original composition," and so forth, the previously mentioned *Vesuvius* having been a copy.

Allston at this time also produced several pastel portraits, a medium he quickly abandoned although his handling of chalk and charcoal later in his career proved consummate in some of his finest drawings. That of the doctor's mother, Mrs. Timothy Waterhouse (fig. 1), is an impressive delineation of old age, drawn with surprising assurance. It would seem logical that it was done in Allston's first years at college, when he lived with the family, but in fact it seems surer than that of Allston's good friend and college classmate Edmund Trowbridge Dana, brother of Allston's future biographer and of his second wife, Martha Dana. Only in his use of the pastel medium does Allston's art seem to bear any relationship to the heritage of Copley, but in fact Copley's great pastels of the 1760s rather mark the apogee of eighteenth-century pastel painting in this country. Copley's interest in the medium was not unique, as the contemporary work of Benjamin Blyth indicates, and perhaps more immediate inspiration for Allston's style and use of the medium stems from the pastels of John Johnston. Until Johnston is better studied and documented, it is useless to speculate upon the influence his work might have had upon

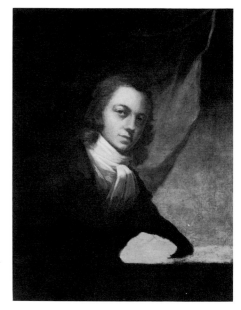

Fig. 2. *Self-Portrait,* 1796-1800
Oil on canvas, 33¼ x 26 in. (84.5 x 66 cm.)
Richardson 7
Fogg Art Museum, Harvard University, Washington Allston Trust

the young Allston, but the very unglamorous, direct likenesses of these youthful works by Allston and the somewhat uncomfortable expression of Edmund Dana have parallels in Johnston's work.[11] It has also been suggested that these early pictures are related to the rather stiff, uncompromising provincial portrait style of Allston's Newport teacher, Samuel King.

Of much greater interest is the unfinished *Self-Portrait* (fig. 2), painted in his college years and now in tragically sad condition. Its incompleteness cannot be explained, although it is a harbinger of the artist's future practice; still, portraiture never became of great interest to Allston, and one suspects that the picture was a practice piece for him that failed to hold his interest once the basic problems were revealed and many of them conquered. Even in the portrait's present condition, one can discern an artist who is quite sure of his pictorial intent if not completely at ease with the methods of achieving it. The left hand is unfinished, but this is almost surely the artist's right hand, transcribed from a mirror image; the directness of the gaze is also undoubtedly mirrored, as Allston sought to record himself. There is a suavity and elegance to his simple, relaxed pose and casual tilt of the body, which is silhouetted against a traditional red drapery. The modeling of the face and figure is simple but convincing. Most interesting is the suggestion of sensitivity in his self-imagery, for although the ease of pose conveys a worldliness, the serious expression of the mouth, the shadowy far side of the face, and the deep-set, rather haunting eyes define a poetic, introspective nature. The *Self-Portrait* is a slightly more youthful version of the quintessential artistic likeness of Allston painted by Malbone (no. 101), about 1801. Although the *Self-Portrait* is not precisely dated, the image would seem to predate that by Malbone by only a few years and, given its competence, would probably have been painted toward the end of Allston's college years, about 1799.

Of particular interest is the series of early landscapes by Allston that have survived. Three of these seem to have been painted in the last months of 1798, when Allston was in his junior year at Harvard, and are annotated with the months of November and December of that year. They may be among those that he later exhibited at the Royal Academy in London in 1802 and that appeared in his one-man show at Harding's Gallery in Boston in 1839 and at the Boston Athenaeum in 1845 and 1850; it is difficult to unravel precisely which of his early landscapes were those later shown as "among his earliest productions . . . painted while in college."

The *Landscape* of December 1798 (fig. 3) is the simplest of these. It is painted on a piece of shirt linen taken from Allston's own clothes, and on the back is an oil caricature of the president of Harvard, Joseph Willard (fig. 4). The portrait is a quickly brushed sketch; the landscape is carefully painted and organized, a rather shadowy scene of three figures, two in a cart and one on horseback, on a rustic road with a broad view opening up in the distance leading to a low mountain summit with buildings atop.

One cannot speak of Allston's relationship with an American landscape tradition, whether related to or divergent from one, since such a tradition did not exist in the eighteenth century. Only a few landscapes by such professional colonial artists as John Smibert and William Williams are known to exist, and scarcely any more from the early years of the new Republic at the end of the century. Richardson care-

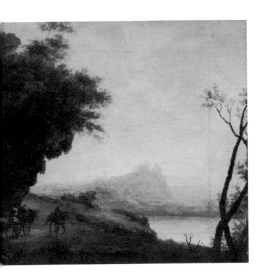

Fig. 3. *Landscape,* 1798
Oil on canvas, 11½ x 13¼ in. (29.2 x 33.6 cm.)
Richardson 11 (recto)
Boston Athenaeum, Gift of William H. Sumner

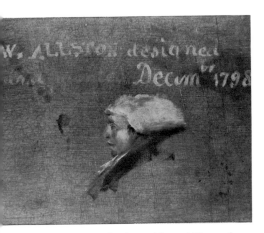

Fig. 4. *Joseph Willard, President of Harvard College,* 1798
Oil on canvas, 11½ x 13¼ in. (29.2 x 33.6 cm.)
Richardson 11 (verso)
Boston Athenaeum

fully distinguishes between the factual, topographical landscapes painted by Ralph Earl on commission in the 1790s and the early works of Allston that are conscious artificial constructions. In these early works Allston is emphatically *not* a realist. His aim, even this early in his artistic career, was to create a mood, and thus a work like this *Landscape* of 1798, for all its immaturity, relates to such later masterworks by Allston as his 1819 *Moonlit Landscape* (no. 54). But Allston had more in mind in painting this little scene: he was obviously attempting to ally his art with that of the past, paraphrasing (and simplifying) the forms and formulae of the respected old masters of the seventeenth century, Claude Lorrain and Gaspar Dughet particularly. The enframing but contrasting *repoussoir* trees at left and right (dense at the left, fragile at the right) surround a path that leads in a zigzag fashion toward the background, and as the road bends to the left, the eye is carried back in the other direction along the slope of the mountain and up to its more or less centralized peak. The light is an overall glowing haze; it is the light not of day but of the imagination and of tradition. Ultimately derived from that of the Roman Campagna as interpreted by Claude, it has filtered through that artist's imagination and over a century and a half into the dreams of the budding young artist, a romantic classicist, romantic in his evocation of mood, classical in his respect for a past tradition and the creation of a timeless world. The origin of Allston's concept here cannot be deduced with certainty, but it lies most probably in a combination of engravings after old master paintings and paintings in Boston collections, some ascribed to venerable artists of the past. Such attributions were, for the most part, almost certainly spurious, but for the technical lessons they could teach young Americans, they were as valuable as authentic originals would have been.

More surprising is Allston's painting of similar size done the previous month, in November 1798, *Landscape with Rustic Festival* (no. 2). The Claudian spatial disposition, leading the eye carefully back into space, is even more complete and convincing, but of particular interest is the genre activity of a fiddler and dancers in front of a rustic cottage. The scene bespeaks far more a Dutch than a Claudian inspiration and was echoed later in Allston's writings in his admiration for the naturalism of the painting of Adrian van Ostade. Again the scene speaks totally of tradition and is completely divorced from contemporaneous art in America. The figures are simplified and sticklike, but their gawkiness is not unlike that of other works of Allston's at this time and remains a mannerism of his style throughout.

In the Boston Athenaeum *Landscape* (fig. 3) one may discern a provincial parallel to the classical art of Richard Wilson and the rustic scenes of Thomas Gainsborough, in England, although Allston's familiarity with that tradition is conjectural at best. Certainly, he could not have known the revival of interest in the depiction of rustic activity that surfaced in the watercolors of the Scottish painter David Allan, such as the 1795 *Penny Wedding* and *Highland Wedding*, which are almost exactly contemporary with Allston's *Landscape with Rustic Festival*. The Scottish paintings instead display a parallel interest in a revival of the Dutch baroque tradition, a revival that found its full flowering a decade later in the paintings of David Wilkie and that, in turn, had enormous influence upon the art of both sides of the Atlantic, including that of Washington Allston.

Late in his life Allston spoke of his youthful "bandittimania" while in college,

which lasted until he went abroad. What Allston referred to here was his preoccupation with scenes of dark drama and mystery derived from his admiration for Salvator Rosa, the protoromantic Italian artist of the seventeenth century, and Rosa's many pictures of bandits and gypsies. Whether Allston was at all familiar with the paintings and drawings of the English artist John Hamilton Mortimer, a disciple of Rosa and friend of Benjamin West, we do not know, but Allston had the opportunity of knowing Mortimer's work through the many engravings after his studies of banditti. The admiration of Rosa, however, was first hand. Paintings ascribed to Rosa were relatively plentiful early in the mass importation of old masters into America, and, in fact, Allston's preserved student theme of 1799, "Procrastination is the Thief of Time," is concerned with a youthful shepherd-cum-artist, who makes his way to Rome and falls under the spell of the old masters—Raphael, Michelangelo, Correggio, and Claude Lorrain, but especially Salvator Rosa.[12] Indeed, Allston's hero felt that "the Soul of this master was in unison with his own; he felt a strange pleasure in brooding over his dark rocks and gloomy wildness and shuddered at, yet could not but admire the noble ferocity of his banditti."

Allston's *Landscape with Banditti* (fig. 5) of November 1798 is the earliest surviving testimony to that "mania," a dark brooding scene of horsemen traveling down a road and across a bridge in a wild, Rosaesque landscape of swaying and broken trees, with appropriate mist and clouds obscuring the distance. Whether soldiers or bandits is not defined; Allston is more concerned with setting a mood and evoking the past than telling a story. The exact nature of the scene is a little clearer in an obviously related wash drawing (no. 72) in the Gibbes Art Gallery in Charleston, where the figures appear to be in vaguely medieval costume and a medieval fortress can be seen overhead in the distance. The drawing is undated but annotated as painted when in college. The oil might possibly be the one shown in London in 1802, described by Allston to William Dunlap as a landscape with horsemen, "which I had painted in college."

In his landscapes of this period Allston's art already harks back to the seventeenth century, to Claude, Gaspar, Rosa, and the Dutch. They are landscapes of memory, tradition, and imagination. Allston was certainly conversant by this time with the academic hierarchy of thematic values wherein landscape *compositions* were superior to landscape *transcriptions*. Ralph Earl's landscapes were examples of the latter; Allston aspired to greater heights. While today we consider all works of art as endowed with a "composition," to previous ages the term had a more specific and literal meaning. Allston's landscapes were *composed*, that is, put together with elements derived from various sources, some perhaps ultimately based upon naturalistic observation, but modified and regrouped so as to create a work of art out of mental inspiration.

A Rocky Coast with Banditti (fig. 6) is dated in 1800; though still a youthful work, it appears far surer and more proficient. Forms are simplified and clarified, and a giant rocky projection dominates the landscape instead of the haze and murkiness of the earlier pictures. Nature appears vast and somewhat ominous; Allston has organized his forms around a series of diagonal thrusts, with the distant mountain repeated in the sail in the lower left of the bandits' boat and in the gesturing arm of the central robed bandit. The contrasting of the tiny figures with the large

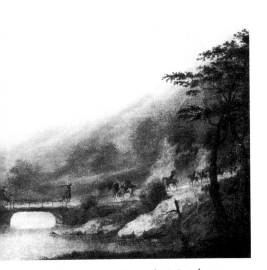

Fig. 5. *Landscape with Banditti (Landscape with a Bridge and a File of Horsemen)* 1798
Oil on canvas, 12 x 13½ in. (30.5 x 34.3 cm.)
Richardson 11a
Greenville County Museum of Art, South Carolina

Fig. 6. *A Rocky Coast with Banditti*, 1800
Oil on canvas, 13¾ x 19 in. (35 x 48.3 cm.)
Richardson 28
Museum of Early Southern Decorative Arts, Winston-Salem, North Carolina

natural forms is a stock romantic device that later dominated the art of Allston's future friend John Martin. Allston has seized upon a moment in time when shadows begin to lengthen, the hush of evening before the mystery of night. The work bears similarities to some of Mortimer's etchings and to Rosa's *Bandits on a Rocky Coast,* now in the Metropolitan Museum, New York.

A Rocky Coast with Banditti may have been painted in Allston's last semester at Harvard, on his visit to Newport after graduation, or in Charleston. It is tempting to see this work as the painting shown at the Royal Academy in 1802. That dating would seem to be appropriate also for the *Landscape* at the Fruitlands Museum, at Harvard, Massachusetts (fig. 7), which is the most complete expression of Allston's debt to Rosa. The landscape here is rockier and more irregular than that in *Rocky Coast,* with the broken shapes of the coulisse rock formation at the left and the distant mountains reflected in the varied cloud shapes, as night begins to descend. The group of gesturing figures in the foreground is similar to that in the previous picture, and the robed and pointing figure, as in the preceding work, is an early forebear of Allston's great image of the prophet Daniel in his future *Belshazzar's Feast* (see fig. 45). The figures seem more classical than bandit, however, and Henry Wadsworth Longfellow Dana has suggested that this is a scene from Virgil's *Aeneid,* representing *Aeneas and Achates Ashore.* Dana's theory is an ingenious one, attempting to relate a series of early works by Allston as derived from the Virgil story, but their disparate dates and divergent sizes would seem to make the suggestion untenable. Again, the composition bears a general resemblance to a work by Rosa such as *Landscape with Apollo and the Cumaean Sybil* in the Wallace Collection, London, and even more to the Rosaesque painting by Jacob De Heusch, recently on the Amsterdam market, so similar to the early work by Allston as to suggest his familiarity with a variant of or an engraving after the Dutch picture.[13]

Allston wrote to Dunlap that while at college his leisure hours were devoted equally to the composition of figures and landscapes; this remained true throughout his career. His earliest surviving works of art are the three watercolors of *The Buck's Progress,* painted on November 10, 1796 (see "The Drawings of Washington Allston," figs. 69-71, below). While they are certainly autobiographical reflections, they also betray both stylistic mannerisms personal to Allston and a further indication of his knowledge of past art. The three are subtitled *The Introduction of a Country Lad to a Club of Town Bucks, A Beau in his Dressing Room,* and *A Midnight Fray with Watchmen.* They may well reflect Allston's immediate recollection of himself as something of a country bumpkin when introduced to the quasi sophistication of an elegantly garbed drinking set of Harvard students, and the viewing glasses two of them hold probably reflect his apprehension of their critical attitudes. The "progress" into foppery at stage two, complete with housemen, barbers, and hairdressers, may well be Allston's humorous self-evaluation at what he saw as his own transformation, and the fray with watchmen may reflect an unrecorded but very real incident in his early student life at Harvard. Allston was, in fact, referred to by his classmates as "the Count," and Leonard Jarvis recalled in a letter to Dana that Allston was "dressed in more fashionable style than the rest of us."

The origin of the *Buck* series lies, of course, in William Hogarth's famous series *The Rake's Progress,* painted in 1735, engravings after which were universally

Fig. 7. *Landscape (Aeneas and Achates Come Ashore)* ca. 1800
Oil on canvas, 15½ x 26 in. (39.4 x 66 cm.)
Richardson 17
Fruitlands Museum, Harvard, Massachusetts

known. Indeed, two of Allston's watercolors refer rather specifically to Hogarth's *Youth* and *Morning Levee,* and his third is a conflation of Hogarth's *Tavern Scene* and *Arrest for Debt.* Allston's work may well draw upon the humorous spirit of other English caricaturists too, such as Thomas Rowlandson; both the watercolor medium and the traditional handling of it, in the manner of tinted drawing, suggest such a relationship, although the youthful Allston has none of the fluidity of colored wash or the liveliness of Rowlandson's drawing. Allston emphasizes geometric elements in these works such as the outlines of furniture, architectural details, floorboards, and the like to ensure a structural framework within which his rather zany figures operate. Although their disparity of scale is disconcerting, their malformations and grotesque visages reinforce the satire of his imagery, however unintentional.

Allston's youthful bravado and wit appear here and in numerous caricature drawings that survive from his college years. Somewhat less convincing is his oil painting of *The Tippler* (fig. 8) of 1799, a pathetic but disagreeable image of a solitary drinker. But Allston's most fascinating work painted during his college years is probably the last, dated on the verso (which is filled with caricatures) "April 1800," which was just two months before his graduation. This is *Tragic Figure in Chains* (no. 3), a grotesque and misshapen but powerful image of an old man, half-clad in rags and holding a chain that unites his wrists; his madness is revealed by the wildly unfocused but piercing gaze, open mouth, and awkwardly tilted head, topped by long, matted hair.

Starkly isolated in a bare and indeterminate ambience, the image is an extraordinary example of the sublime, an emotional, unreasoning being. The emphasis upon madness, with exaggerated expression and gesture, suggests a relationship to the horrific images of Henry Fuseli, the Swiss-born British artist, whose work Allston was soon to admire in engravings in Charleston and then at first hand in London. There is, however, no indication that Allston was familiar with Fuseli's art during his college years; nor did he need to be acquainted with it to produce such an image. A number of literary sources have been suggested for the work. A drawing by Allston connected with the figure can be found on the flyleaf of his own copy of Charles Churchill's *Poetical Works* (1763); the book is inscribed "Harvard College, 1799," the year before Allston did the painting. Ann Smith has suggested a connection between the painting and the Gothic writings of Mrs. Radcliffe, which served Allston for several pictures. And it has been noted that the image is similar to that described in the lines "Cruelty came next grasping with savage smile a widowed dove," in Robert Southey's epic poem *Joan of Arc,* published in 1796. Southey was admired by Allston at Harvard and became a good friend in England years later. Here again, too, is evidence of Allston's admiration for Hogarth, for the final print in the much admired series *The Rake's Progress* is *Scene in a Madhouse,* where the rake is shown in Bedlam, having gone mad. His clothes are in shreds and cover only the midbody, and he is being chained hand and foot to prevent him from another suicide attempt (a bandage attesting to his first try). Allston follows this iconography carefully. Thus, it is likely that Allston's painting was made in Cambridge, where he surely had access to Hogarth's engravings.

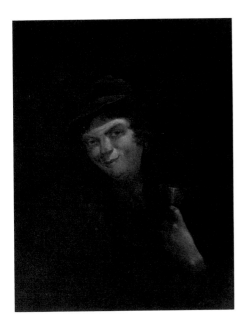

Fig. 8. *The Tippler,* 1799
Oil on canvas, 16 x 12¼ in. (40.7 x 31.2 cm.)
Richardson 16
Amherst College, Amherst, Massachusetts

Pictorially, however, there existed a source much more immediate for Allston, and one that we know he admired and emulated. Allston told Dunlap that in the coloring of figures in his early works, the pictures by Robert Edge Pine in the Columbian Museum in Boston were his first masters. Now, Pine is remembered today, if at all, as a rather indifferent portraitist during his last years in Philadelphia and as the painter of the incomplete *Congress Voting Independence*. Many years earlier, however, Pine had been one of the leading painters in England and a rival of the young Joshua Reynolds. When Pine arrived in Philadelphia in 1784, he brought with him a distinguished group of his subject pictures, which that year formed the basis of one of the earliest public art exhibitions in America. After Pine's death in 1788, his widow sold the paintings, and many of them were acquired by Daniel Bowen, who included them in his museum display shown variously in Philadelphia, New York City, and Boston. In 1795 he opened the Columbian Museum in Boston, which is where Allston saw Pine's work.

One of the paintings that Pine had exhibited in 1784 was entitled *Madness*, certainly an appropriate title for Allston's picture, which in its intense emotional response is not dissimilar to the few surviving examples of Pine's more imaginative and historical works. Allston's painting is, in fact, a variant of Pine's *Madness*, now known from the engraving after it (fig. 9), taking into consideration that the earlier and more sophisticated work has somewhat more of the grace and even voluptuousness of the eighteenth century. We can be quite sure that Bowen acquired that specific picture by Pine, for although many works of art were lost in a disastrous fire in his museum in 1807, some did survive. These ultimately were incorporated into the Boston Museum (unrelated to the present institution), which was founded in 1841. Included in the display was Pine's *Mad Woman in Chains*, almost surely the same picture as his *Madness* and very possibly the model for Allston's *Tragic Figure in Chains*, or *Man in Chains*, as it is alternatively entitled. Allston's small work is a reflection of the beginning of the investigation of pathological states of mind; it bears a curious kinship to the contemporaneous paintings of Fuseli and Goya and finds a later reflection in the painting *Murder*, or *The Murderer*, of 1813, one of the earliest works by Allston's pupil Charles Robert Leslie.

The records of Harvard College in the last years of the eighteenth century are filled with reports of Allston's punishment for tardiness at prayer, absence at prayer, absence at recitation, and absence from college, as well as admonishment for neglecting collegiate duties. He himself recognized his laziness and tendency to procrastinate, and his extracurricular activities in art and as secretary, vice-president, and poet of the Hasty Pudding Club must have further interfered with his scholastic pursuits. Nevertheless, Allston's various talents did not go unnoticed by the college administration, and following the death of George Washington in December 1799, Allston was called upon to deliver an elegiac *Poem on the Death of Washington*. Further recognition of his abilities was awarded when he was chosen to read the "Poem in English" at his commencement exercises on July 16, 1800, choosing as his subject "Energy of Character."

After graduation, Allston remained only a few weeks in Cambridge. He was by then determined to pursue an artistic career, and this inevitably meant study abroad; in 1800, certainly, for young American art students, it meant study in Lon-

Fig. 9. JAMES McARDELL, British, 1728-1765, after ROBERT EDGE PINE
Madness
Engraving
Courtauld Institute of Arts, London

don. Allston retraced his youthful steps on the way, however, returning for a visit to Newport and then to his family in Charleston, before departing for England.

He remained in Newport for almost half a year, leaving for Charleston in December. Undoubtedly he renewed his friendship with the Channing family and must have paid court to Ann Channing, although the arrangements and explanations for the protracted further engagement of nine years remain (perhaps mercifully) undocumented. A number of paintings are recorded as having been done by Allston in Newport, including a possible portrait of his former instructor in painting, Samuel King. The only known surviving work of this short Newport period, however, is the portrait of his old schoolmaster, Robert Rogers (fig. 10).

The Rogers portrait is a rather amazing performance. There is nothing unusual in its composition, a rather straightforward, three-quarter view of the man, with no props, accessories, or background elements. But Allston presents Rogers as a man of exceptional vigor, seemingly capable of action through great emotional and psychological intensity. The work is, of course, markedly more mature than Allston's early efforts at portraiture; its vigor did not appear again and was replaced by the reflective harmony of his later portraits. It is also totally divorced from both the calm objectivity of Copley's work and the fluid likenesses of Gilbert Stuart, who had not yet returned to the New England scene. The stylistic origins of the Rogers portrait seem both obscure and complex. It does not appear similar to the portraits of the admired Robert Edge Pine. The psychological concern and the glowing emanation of the head suggest some kinship with the works of Christian Gullager, although Gullager's consistent emphasis upon direct eye contact between subject and viewer in his portraits is quite different from Rogers's intense but averted glance, and in any case, Allston would probably not have known Gullager personally. In its solid plasticity and rather dark and swarthy tones, the picture suggests to some degree the work of John Trumbull, who had established himself as both a history and portrait painter when he returned to this country in 1789; such works as Trumbull's 1793 *Portrait of George Washington* and his *Portrait of Lemuel Hopkins* share stylistic similarities with the portrait of Rogers. Allston's other recorded but now lost work done in Newport was a portrait of his friend Dr. Armand Aboynan. Unfinished when the doctor took temporary leave, Allston altered the picture into a depiction of a squinting fiddler, to the mortification but ultimate enjoyment of the doctor on his return.

Allston's return to South Carolina at the end of 1800 was prompted in part by the illness of his stepfather, Dr. Flagg, who died early in 1801. Throughout his life Allston maintained a deep affection for his family—his mother, his brother and sister, and his half-brother and sister, and there are countless testimonials to this, in letter and in deed; but that affection was manifested at a distance. Records of visits to his mother and siblings are extremely infrequent, and this was to be his last recorded visit to South Carolina. Travel was, of course, extremely difficult in America in the early nineteenth century, but ship voyages were relatively fast though still hazardous, and his next known visit to his mother occurred when the aged lady herself journeyed as far as New Haven. Rather, for all his youthful enthusiasm and worldly charm, Allston had already developed a reticent nature, which manifested itself in hesitation, long deliberations, and, ultimately, an inability to bring many a project to completion.

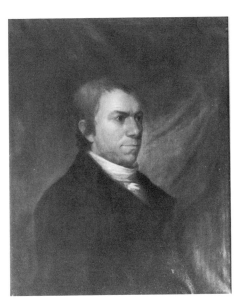

Fig. 10. *Robert Rogers*, 1800
Oil on canvas, 31½ x 25 in. (80 x 63.5 cm.)
Richardson 19
Redwood Library and Athenaeum, Newport, Rhode Island

One of Allston's companions during the previous summer months in Newport had been his colleague and close friend the miniaturist Malbone. Malbone had continued his somewhat itinerant life during the autumn, but sometime in late January or early February 1801, he rejoined Allston in Charleston. It was at this time that Allston and Malbone met the young law student Charles Fraser. Not only did the friendship provide close companionship then and a continuing relationship interrupted, in part, only by Malbone's tragic early death in 1807, but it also was decisive in turning Fraser away from his legal studies and toward art, where he developed into one of the finest miniature painters of the early nineteenth century and Charleston's best-known resident painter of the period. The little-documented Jeremiah Paul seems to have joined this coterie of artists, for he is known to have painted a portrait of Allston (fig. 11), which, as Fraser later wrote to Richard Dana, was painted in 1800.

If the painting *Robbers Fighting with Each Other for the Spoils over a Murdered Traveler* (fig. 12), at present unlocated but known from a photograph in the Dana Collection, is the picture recorded by Dunlap as painted in Charleston in 1801, then Allston had developed tremendously in his ability to render figural compositions since his work of several years earlier. The picture appears rather fluidly, in parts sketchily, handled with an arbitrary drama of light and dark, but a great deal of vigor and activity, and a sense of violent abandon consonant with the subject. The forms are rendered roundly and solidly, in a manner that suggests some acquaintance with actual examples of Flemish seventeenth-century art and, more specifically, with the style of the Dutch artist Philip Wouvermans. Such an influence—through prints and perhaps through works after or attributed to Wouvermans—is not impossible, for Wouvermans was a much respected and, in England at least, much collected "old master."[14] But it was evidently a momentary influence on Allston's art, though not unrelated to his Rosaesque "bandittimania."

Allston relinquished that "bandittimania" soon after arriving in Europe; his other works done in the winter and spring of 1800-01 presage his greatest achievements. Consisting of two heads, one of *Peter When He Heard the Cock Crow* and the other of *Judas Iscariot*, and a *Satan at the Gates of Hell Guarded by Sin and Death*, they would presumably define both Allston's greatest artistic concerns of the time and his ambitions, and their disappearance is especially regrettable. The subjects of Peter and Judas were ones to which Allston returned later, at a more mature stage of his career, but the most ambitious was probably *Satan at the Gates of Hell*, which, according to his brother, William, was first sketched on the bare floor of his room and then made into a finished sketch on paper. Charles Fraser later told Richard Henry Dana that Allston destroyed his painting of Satan after taking it to England in 1801.

During the eighteenth century, treatment of Miltonic subject matter by artists such as Joseph Wright of Derby had developed from book engravings to major historical canvases. William Hogarth had made his one notable excursion into Miltonic depictions in his 1764 oil of *Satan, Sin and Death*, but that horrific interpretation was soon replaced by artists such as James Barry and Henry Fuseli with a more equivocal representation of Satan as noble and heroic, a romantic figure of individual motivation against the authoritarian power of a deity, however just. Such an

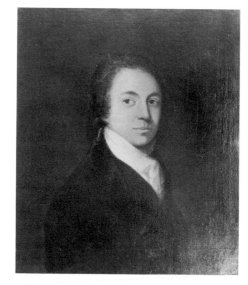

Fig. 11. JEREMIAH PAUL, American, d. 1820
Washington Allston, ca. 1800
Oil on canvas
Mrs. Burnet R. Maybank (Photo Frick Art
Reference Library)

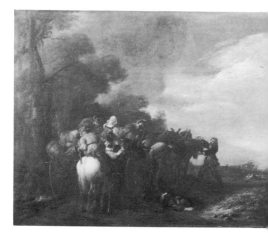

Fig. 12. *Robbers Fighting with Each Other for the Spoils over a Murdered Traveler*, 1801
Oil on canvas. Richardson 25
Location unknown (Photo courtesy of Longfellow National Historical Site, Cambridge, Massachusetts

ennobling pictorialization can be seen in the near-contemporaneous *Satan Summoning His Legions,* the greatest of the early historical paintings by Sir Thomas Lawrence, and it affected particularly the art of Fuseli, who became the major interpreter of Milton in Allston's time. This interest in Miltonic subjects culminated in the opening of the Milton Gallery, in London in 1799.[15] The gallery was not a success, however, and after the exhibition of the following year, many of the pictures were sold to sympathetic English patrons. But engravings after Fuseli's works, including Miltonic subjects, had long since begun to be produced, and Allston is known to have studied Fuseli prints at the Charleston Library. Some of these are known to have been engravings from Fuseli's contributions to John Boydell's Shakespeare Gallery in London; again they form the background for Allston's later career: his study with and admiration for Fuseli and his own participation in the creation of Shakespearean pictorial iconography.

It was during his visit home that Allston confirmed to his family that he had decided to enter the artistic profession; toward that end he sold his patrimonial estate at Waccamaw in 1801 to Robert Withers, one of the executors, and entrusted the proceeds to a London banker, unfortunately drawing on capital rather than trying to live on the interest. He had already announced his ambitions to his mother in a letter from Newport written in August 1800: "It is so long since I have mentioned anything about my painting that I suppose you have concluded I had given it up. But my thoughts are far enough from that, I assure you. I am more attached to it than ever; and am determined, if resolution and perseverance will effect it, to be the first painter, at least, from America."

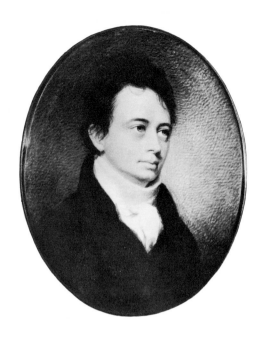

101
EDWARD MALBONE, American, 1977-1807
Washington Allston, ca. 1800-1801
Watercolor on ivory, 3⅛ x 3¾ in. (7.9 x
9.5 cm.)
Museum of Fine Arts, Boston

IN MAY 1801, a month after the death of his stepfather, Dr. Flagg, Allston and
Malbone departed for London from Charleston. They arrived a month later, tak-
ing rooms in Upper Titchfield Street, off Fitzroy Square. The experience of the great
metropolis of the English-speaking world must have been a revelation to the young
provincial art student; he immersed himself in the study of the old masters and the
works of contemporary painters in England. He gained an early introduction to the
American-born Benjamin West, then president of the Royal Academy and the lead-
ing historical painter in England of his time. West, more than any other painter in
England, had established in practice the academically accepted theory of the supe-
riority of historical painting over all other genres. He had received recognition
from George III and been made historical painter to the king, even surviving the
difficult years of the American Revolution. But about the time that Allston arrived,
West's position of supremacy was being seriously challenged. Rivalry with Copley
had surfaced aggressively in Robert Anthony Bromley's *A Philosophical and Crit-
ical History of the Fine Arts* (1793-1795), in which West's superiority in history
painting was lauded at Copley's expense; while Copley was not a popular Royal
Academician, his resentment was shared by other artists, including Fuseli, who was
always something of a skeptic concerning West's preeminence. West had been able
for many years to live comfortably on an annuity provided by the monarchy while
working on an enormous decoration project of paintings for the Chapel of Re-
vealed Religion at Windsor Castle. But beginning about the year that Allston ar-
rived in England, the interest of George III in the project began to wane markedly,
as did his support for West, who, the king felt, was displaying increasing sympathy
toward the French enemy. This suspicion was aggravated by West's trip to Paris in
1802 during the brief Peace of Amiens, and the monarch appears to have supported
the clique that deposed West as academy president in 1805, although James
Wyatt's incompetence in the position led to West's reinstatement a year later. Nev-
ertheless his financial support from the crown came to an end in 1810.[16]

Despite the increasing precariousness of his professional position, West welcomed the young Americans, Allston and Malbone, as he had countless others before them for over thirty-five years, including such artists as Matthew Pratt, Charles Willson Peale, and Gilbert Stuart. At the time, Allston was a handsome yet sensitive and perhaps somewhat reticent young man, as depicted in the miniature that Malbone had painted of him (no. 101). (In late August of 1801 the miniature was shown to West as proof of Malbone's talents.) The romanticized likeness both displays Malbone's ability to reveal the "elevated character" of a man and suggests the poetic dreamer within Allston. Indeed, it is, in a sense, tacit indication of the basis of the close friendship between the two young artists.

Shortly after arriving in London, Allston drew from a cast the head of *The Gladiator,* which, on October 3, 1801, earned him permission to draw as a probationer at the Royal Academy. Two more drawings secured him the ticket of a registered student, and he was fully admitted to the Academy schools, recommended by West, on October 23, 1801. Allston also visited Fuseli, who was then the professor of painting at the Academy, and there admired the visionary nature of Fuseli's art, as revealed in his Miltonic engravings. A few of the remaining pictures from the Milton Gallery were still hanging on Fuseli's studio walls, while the floor was covered with the rest of the canvases. When told that Allston had journeyed to London in hope of becoming a historical painter, Fuseli commented, "then you have come a great way to starve, sir." Allston continued to hold Fuseli's imaginative powers in great respect but was repelled by his eccentricity and profanity, a reaction shared a few years later by the young Benjamin Haydon, Allston's future friend and colleague.

Malbone did not attempt to enter the Academy schools and, given the impressive achievements he had made in miniature painting, one can but applaud his perceptivity and confidence. In any case, his interests lay only in portraiture; he greatly admired the pictures of Sir Thomas Lawrence, who had already begun to be recognized as the heir to Reynolds and Gainsborough. Allston himself had little or no interest in the professional practice of portraiture. He too admired Lawrence's skill and felt that he and William Beechey were the finest portrait painters working in England, but even in this area he believed that Gilbert Stuart was superior to them both. He had great respect for both the art and the philosophical discourses of Sir Joshua Reynolds, but among living artists he admired most Benjamin West (an opinion he later acknowledged to have been a youthful delusion) and especially his pictures from Revelation, that is, those painted for the Windsor Chapel. The one he appreciated most, West's sketch of *Death on the Pale Horse,* was probably the version that was exhibited in the Paris Salon the following year and that ultimately served as one of several studies for West's most ambitious single work, completed in 1817. It is not surprising that in the latter year Allston in turn began *his* greatest picture, *Belshazzar's Feast* (see fig. 45).

Second only to West, Allston admired Fuseli's art, his *Hamlet* and his *Satan with Sin and Death,* which he considered the only great Miltonic painting, and which subject he had himself recently depicted. He admired the *Arthur* and the *Hamlet* of James Northcote, the disciple and heir of Reynolds, and John Opie's imaginative compositions. Indeed, Opie's career and critical esteem bear some similarities to Allston's, for Allston may in a sense have assumed Opie's mantle when he returned to England in 1811, a few years after Opie's early death.

The fullest indication of Allston's life in England at this time can be gathered from the journals of John Blake White.[17] White was a fellow South Carolinian, who had left Charleston for London a year before Allston and Malbone, settling into Fitzroy Square where Allston later resided. Through John Trumbull, White was given an introduction to Benjamin West, with whom he studied for three years. In 1801 White met Allston and Malbone through Charles Fraser. Together with Allston's future brother-in-law, Edmund Trowbridge Dana, Arthur Maynard Walter, and a number of other young men, they formed what they named the "Midnight Crew," with much socializing and much theater. Other Boston friends and Harvard classmates joined them later, such as Sidney Willard and Allston's later traveling companion, Benjamin Welles. This fraternity, however, was not born merely of social compatibility. One may speculate that an incipient romanticism already nurtured by Allston, Dana, and Walter while at Harvard, where they shared enthusiasm for the poetry of Southey and the Gothic novels of Ann Radcliffe, was further stimulated by theories of romantic idealism stemming from British circles. Returning to Boston in 1804, Dana and Walter gave vent to their antiempiricist and antirationalist beliefs in the *Monthly Anthology,* to which they contributed. Walter died before Allston returned to Boston in 1808, but Edmund Dana remained a lifelong friend, and their shared beliefs in the transcendent powers of the imagination are manifest in Allston's art. White also documented a number of journeys that the young men took around England. On some of these journeys the identities of Allston's companions are not certain. However, in November 1802, Allston was one of White's companions on a trip to Bath and Bristol; and in April 1803 they were together at Windsor. There they examined and studied the great tapestry cartoons by Raphael, the greatest artistic monuments of the Italian Renaissance in England, works of primary importance in the evolution of British history painting and significant for a number of the major paintings of West, Allston, and other masters.

White's journal leaves no doubt as to Allston's presence in Bristol, yet the visit is curious. Allston's uncle, Elias Vanderhorst, lived in that city, and Allston's surviving correspondence with the Vanderhorst family contains apologies for his inability to visit them and accept their hospitality. Perhaps his mother's letters to her cousin present an acceptable explanation: she informs Vanderhorst of her son's arrival in England and apologizes for his diffidence particularly in the company of attractive young women.[18] Allston did not meet his uncle and cousins until his second stay in England, when he painted a portrait, now unfortunately lost, of one of the young women.

Allston's training at the Royal Academy and the sympathetic supervision of Benjamin West were certainly crucial to Allston's artistic development, and it is a pity that this, too, has been neither studied nor documented. His labors would have consisted primarily of drawing from plaster casts and then from the live model. Where he would have gained his first introduction to Venetian color is not known, although he could study the works of Titian and Veronese in Benjamin West's gallery and other private collections, and the adaptation of Venetian techniques by the admired Sir Joshua Reynolds. Certainly, Fuseli would have inculcated him with the basic tenets of neoclassicism—respect for antiquity, belief in the perfection of form and the superiority of drawing over color, and avoidance of the accidents and

vagaries of nature—but, as we have seen, Fuseli's own imaginative vision attracted him, and, ultimately, he certainly patterned his physiognomic expressivity after the art of that master. He knew Edmund Burke's theories on beauty and the sublime and in his later work chose to combine elements of beauty with the mystery, drama, and surprise resulting from the terror of sublimity.

In 1802 Allston exhibited three works at the Royal Academy annual exhibition, no small achievement for the newly arrived American.[19] One was the *Landscape, Banditti on Horseback*, which may be the painting now in Greenville, South Carolina (fig. 5). A second, *A Sea Coast with Banditti*, was painted in London; it is now lost, although it is tempting to identify it as the picture now in Winston-Salem, which is, however, dated the year previous to his arrival. A third, recently painted, was *A French Soldier Telling a Story*. This is also missing, but it is recorded as having been purchased by John Wilson, an expatriate from South Carolina, who had founded the European Museum in 1789; Wilson then commissioned from Allston a companion picture, *The Poet's Ordinary*. These were both reported to be comic pictures, in the general style of Hogarth, and thus we might envisage them relating to his early series of *The Buck's Progress*, and his two surviving comic works of a decade later, 1811. *The Poor Author and the Rich Bookseller* (no. 24) and *A Scene in an Eating House* (no. 30). The European Museum seems to have engaged in the buying and selling of paintings as well as maintaining a public gallery, for the Allstons are not listed in the European Museum catalogue of 1813, although they appear in the earliest located one, of 1804.

Allston's most ambitious work of his first London years was a religious picture, *And Christ Looked at Peter* (now unlocated), painted during his first year abroad. He wrote about it in a letter of August 1801 to Fraser in Charleston and described it as containing twenty figures, about two feet in height, distributed in two groups, one of Christ between soldiers and priests, the other of Peter surrounded by his accusers. Spectators reacted in gesture and expression in a manner that suggests a foretaste of West's great *Christ Rejected* of 1811 or Allston's own *Dead Man Restored* (no. 25) of 1811-1814. West had interpreted the latter subject in 1778.

One other subject that Allston undertook in London was *Caius Marius in the Dungeon*, mentioned not in the surviving documentation on Allston but rather in the biographical manuscript (undated, but ca. 1848-1853) on John Vanderlyn written by Robert Gosman. The subject of the Roman leader held prisoner at Minturnae, whose commanding presence forces a soldier ordered to slay him to drop his weapon, was a well-known theme in neoclassic times, famous above all in the 1786 painting by the French artist Jean-Germain Drouais. Even earlier, however, about 1764, Fuseli had drawn the subject. Not many years ago, an unsigned version of the subject appeared in England; once attributed to Benjamin West, the work temptingly suggests Allston's authorship, for it would be consistent with his art at this time, although there are no known figure compositions by him from his London years. The picture has the neoclassic composition that one would expect of a West follower, but the horrified reaction of the would-be murderer and the studied but exaggerated expressions and gestures suggest above all the influence of Fuseli. Certainly, the subject of intellectual vigor and moral force triumphing through will over menace and evil would have appealed to Allston, as it presumably did to his

later pupil Samuel F. B. Morse, who painted the subject, also in London, in 1812. Morse too has been suggested as the author of the disputed picture, but he himself refers to his painting as a "small picture," whereas the unsigned work is of some size. And, of course, it seems logical that Allston would urge his pupil and follower to try his hand at the same subject as he, the master, had undertaken at the same stage in his career.

The most convincing attribution to Allston of a work of these early years in London is the portrait of Matthias Spalding (no. 4), painted in 1801, thus shortly after his arrival.[20] Spalding was a colleague of Benjamin Waterhouse, professor of medicine at Harvard, and thus probably knew Allston during his college years. In any event, we may presume that he made contact with Allston through the Harvard professor. While portraiture was not Allston's principal concern nor that of his instructors, the Spalding likeness is sure evidence of Allston's growing artistic maturity. It is a starkly simple work, a rigidly frontal half-length figure, standing, with a traditional drapery hanging behind. The likeness is almost iconic as Spalding stares straight out, both at and beyond the viewer. The outline is simple, the forms are large, and a monumentality is achieved here that presages other portrait masterworks by him such as the 1805 *Self-Portrait* (no. 15) and the 1814 *Dr. John King of Clifton* (no. 33). Allston, like Malbone, has aspired to more than a transcription of an outward likeness; but rather than aim at "elevation of character," he here achieves a sense of inner mind and presence.

A *Man of the Theatre* has also come to light (private collection, South Carolina) and has been assigned a date of about 1803; whether it depicts an actor or a character from literature has not been determined. An intriguing entry appears in the catalogue of an exhibition held in Troy, New York, in 1878: a portrait by Allston of John Kemble after Sir Thomas Lawrence.[21] If the work (unlocated today) were, indeed, by Allston, it would presumably date from his first English period; when he returned to London in 1811, he was too much the master and too disinclined toward portraiture to copy a picture by Lawrence. But in 1801-1803, during his learning and formative years, at a time when Lawrence's art was admired by Malbone and others, it might have seemed natural for Allston to make a copy, perhaps even on commission from an admirer of either Lawrence's painting or Kemble's histrionics. Allston, too, was a lover of the theater and later a friend of such performers as John Howard Payne. The theater offered the artist the opportunity to study the visual presentation of gestures and poses of emotionally communicative significance, and Kemble was a master of his profession. Indeed, one is tempted to deduce that Allston copied Lawrence's portrait of Kemble either as Coriolanus (1798) or as Hamlet (1801), probably the former, given the combination in that role of Shakespearian inspiration with neoclassic motivation of sacrifice and loyalty to state and family.

In 1803 Allston exhibited a landscape at the Royal Academy exhibition. The nature of the painting is totally unknown, although one might be tempted to identify the work with the *Romantic Landscape* now in the Concord Free Public Library (no. 5). At least, this painting would seem to represent the stage at which Allston's artistic development had arrived. While the dark, slightly muddy tonality and the general wildness, together with the still-favored banditti or soldiers in the group

left of center, suggest a continuation of Allston's practices of his American years, the relatively fluid spatial progression in a classical manner, leading the eye in a winding fashion back toward the distant mountain, suggests the artist's experience with works of the seventeenth century. The central figure of a peasant woman, also, though stock staffage, is quite gracefully conceived and echoes in a small way the curvilinear movement back into space. The atmosphere and particularly the lake or river at the left have a clarity that again suggest first-hand experience with professional landscapes, if not actual training in this type of painting. On the other hand, although the picture presages his early landscapes painted on the Continent, Allston is not yet working with the color clarity and light transparency seen in those works, which derived from his experience with the traditions of the Venetian Renaissance.

It was in 1803 that Allston met in London his fellow countryman and painter John Vanderlyn, who had worked with Gilbert Stuart and then studied in Paris under François-André Vincent, a follower of David. Vanderlyn had developed into the leading American proponent and practitioner of Davidian neoclassicism. Although Allston's artistic development abjured contemporary French influence and led him in directions opposite to those of Vanderlyn, the two artists quickly developed a close friendship that remained strong throughout their lives, and after Allston's death, Vanderlyn wrote a tribute to his late friend.[22]

As mentioned earlier, Vanderlyn's career was under the patronage of Aaron Burr, whose daughter, Theodosia, was married to a kinsman of Allston's, and this connection may have spurred the friendship of the two young painters. Allston would also have been impressed with Vanderlyn's apprenticeship to Stuart, whose work he so admired even in the face of the rich portrait tradition he found in England.

In addition to his intention to have engravings made in Europe of two views he had painted of Niagara Falls, Vanderlyn was there by commission of the nascent American Academy of the Fine Arts to procure casts of antique sculpture. This necessitated Vanderlyn's return to Paris, and late in October 1803, the two men left London and traveled via the Low Countries. It was not an easy journey. Bad winds made the crossing from Gravesend (Kent) to nearby Holland almost interminable, and Allston's fatigue caused the travelers to remain in Rotterdam for a prolonged time. They went from there to Antwerp, where Allston became ill and was confined to his sickchamber for four or five days. We have no record of what they saw of Dutch and Flemish art, although, certainly, we may assume interest in and study of the Rubens paintings in Antwerp, a supposition that would seem to be verified in Allston's subsequent interest in that artist's work in Paris. On the other hand, neither painter revealed in his work of this period much affinity with the northern baroque, which was abhorrent to the traditions of Vanderlyn's neoclassicism and suspect to Allston's concerns with high art and High Renaissance traditions.

The distinction between the aesthetic interests of the two artists was apparent in Paris, where they arrived on November 20, 1803. Vanderlyn rejoined his contemporary neoclassicists and painted a number of portraits and his well-known *Murder of Jane McCrea*. This work was accepted and exhibited in the Salon of 1804, as well it might be, for it was then the purest translation of neoclassic principles into an American historical theme. Allston, on the other hand, in common with British

artistic attitudes in general, had no interest in the opaque tones, the local coloring, and the hard outlines and sculptural forms of contemporary French painting. His goal in Paris was rather the study of the old masters in the Louvre and the Luxembourg.

Among the masterworks of the past that Allston much admired was Ludovico Carracci's *Interment of the Virgin* and, more specifically, the works of the great painters of the Venetian Renaissance, Titian's *St. Peter Martyr* (since destroyed) and Veronese's vast *Marriage at Cana* (fig. 41), which he copied much later, during his second visit to Paris in 1817. It would seem likely that Allston was directed toward the Venetian masters by the theories of Sir Joshua Reynolds and, even more likely, by his mentor Benjamin West, who advised his associates to study the coloring of Titian in order to achieve sublimity and majesty. The experience of the Venetian painters in the Louvre reinforced Allston's already heightened concern with the sensation of color achieved through glazing, which had been awakened in him by the paintings of Reynolds, and which was so opposite to the hard opacity of French neoclassicism. Veronese's work particularly offered Allston forms of pleasure that filled his imagination, and that artist's subsuming of the biblical story beneath the aura of pageantry had a great emotional impact on the young American. With a viewpoint rather similar to Whistler's, Allston likened the imaginative appeal of such a work to the realm of music, where story was unimportant.

Allston later described to the author Henry Greenough, brother of his friend and disciple Horatio Greenough the sculptor, his observation and analysis of the Venetian method of color painting: "You must have observed the difference in lustre between silks woven from different colored threads and those dyed with a compound hue. A purple silk woven of two sets of threads, one blue and the other red, cannot be matched by any plain silk dyed purple. The first has a luminous appearance like the human complexion. This luminousness is the grand characteristic of flesh. It is what Titian calls the 'luce di dentro' or internal light. When I first heard that expression of Titian's it opened to me a world of light."[23]

Allston applied these observations to his own technique and to the interpretations of old masters that he copied.

Allston's interest, however, was not confined to Venetian painting and his 1804 *Cupid Playing with the Helmet of Mars* survives (no. 6), a copy of a detail in Rubens's *Henry IV Receiving the Portrait of Marie de' Medici,* then in the Luxembourg. Allston's copy is a faithful transcription of the original, and one can easily deduce the motivation for the copy, for his concern is totally with the reproduction of transparent flesh tones and the multiplicity of colors in the glowing skin. Indeed, Allston has very competently captured the rippling surfaces of the original where color and light, not structure, are of primary concern. This copy was the source of the well-known anecdote of a group of young French painters who had seen Allston at work and condescendingly expressed to Vanderlyn their pity over Allston's incompetence, having seen only his dead coloring before the glazing process began. Far more significant to Allston was the high commendation of an Italian cardinal passing through the gallery who complimented him on his understanding of the true techniques of the old masters, a compliment that must only have strengthened Allston's determination to continue to paint in a mode at variance with contempo-

7
Rising of a Thunderstorm at Sea, 1804
Oil on canvas, 38½ x 51 in. (97.8 x 129.5 cm.)
Richardson 33
Museum of Fine Arts, Boston, Everett Fund

rary French practices. One must not overlook, however, Allston's choice of subject for his copy. He may have chosen this section of that particular Rubens because it was manageable in size and perhaps particularly available to a copyist on a sight line. Yet, it is in keeping with Allston's psychology and his morality, for while he went to Rubens for that artist's mastery of the painting of flesh, Allston chose an image of innocence rather than voluptuousness, Cupid rather than a naiad or the Graces. But more, it is an image of philosophic love conquering war as Rubens—and Allston—contrast the steely gleam of the helmet of Mars with the soft, glowing, and enveloping form of Cupid over it. Although Europe was in strife, America was at peace, and the young artist was finding his satisfaction and learning his metier among the monuments of pictorial achievement celebrating cultural progress and orderly reign.

Allston joined his friend and colleague Vanderlyn in exhibiting in the 1804 Salon with a *Paysage—Site Sauvage* (listed as No. 511), the two friends thus becoming the earliest artists of the new republic to exhibit in Paris. Whether Allston's work was painted in London or in Paris is not known; it may have been a work similar to the Concord landscape (no. 5). Contemporary French reaction to his exhibit is not known, although it may be presumed that the picture was badly shown, since a letter from Vanderlyn to Allston ten years later likens Allston's 1804 showing with those of their friend George Wallis, three of whose works had recently been hung "in bad and indifferent lights." Vanderlyn's letter is intriguing also in its reference to the "two pictures" Allston sent to the exhibition. Since Wallis had had one of his paintings rejected, it is probable that Allston had sent two, only one of which was accepted.

Vanderlyn had thought Wallis's rejected work was his best, and so may it have been in Allston's case. It is tempting to speculate whether that picture might have been Allston's *Rising of a Thunderstorm at Sea* (no. 7), the one original painting done in Paris in 1804 that survives and the first true masterwork by Allston. Certainly, it seems inconceivable that Allston would not have submitted the picture to the Salon if it had been completed in time. Allston has here created a romantic landscape of great drama, one hitherto inconceivable by an American artist and, incidentally, unlike any work in the French pictorial tradition, either past or contemporary. Although Allston's previous efforts at landscape may be said to have paved the way for this magnum opus in their nontranscriptive, dramatic concerns, he has traded in the picturesque staffage and formula-based configurations for a display of the powerful drama of nature's force and majesty. Richardson has suggested the influence of Claude Joseph Vernet, whose painting Allston admired, but the story-telling incidents, the interjection of pathos and sentiment, and attractive but ameliorating rococo configurations characteristic of the French artist are excised by Allston here. Instead, the viewer is offered a stark and dramatic presentation of the naked sea. There is no safe toehold on terra firma as the spectator is plunged along with the small pilot boat directly into the seething ocean, with the larger sailing vessel minute on the horizon. That vessel, easily riding the horizontal bifurcation of the painting, shares the calm of the thrusting right half of the sky; it is the nearer, more fragile boat that the sea threatens to engulf as it surges precariously on a diagonal, while the handful of sailors attempt to pull in the billowing

sails. They gesticulate wildly, mere color dots against the dark monochrome drama.

The picture is almost exactly divided into two horizontal strips, one of sea and one of sky. Allston parallels the shape and substance of the seething foam with the billowing clouds, and the sharp-pointed forward sail of the pilot boat is repeated in large by the chevron shape of blue sky piercing the surrounding dark, threatening clouds. The clouds seem to be engulfing the glowing sky as the waves engage the boat, and the dramatic energy of the sideways V of the sky seems almost to anticipate the favorite compositional device of the Italian futurists of over a hundred years later.

It is likely that the painting may trace its origins in part to Allston's personal experience, perhaps his recollections of his long passage across the Atlantic, and certainly to the recent arduous voyage from England to Holland, which would have been fresh in his mind. If such an interpretation is correct, then we might speculate further that the picture was the result of efforts early in his ten-month Parisian stay and thus more possibly a work offered to (and rejected by) the Salon. In any case, its recent English antecedents are obvious, for Allston is here working directly in the manner of Joseph Mallord William Turner. In 1801, the year that Allston arrived in England, Turner had exhibited at the Royal Academy his *Dutch Boats in a Gale (The Bridgewater Seapiece)* (collection of His Grace, The Duke of Sutherland), in which he had discarded the more rococo and Wright-of-Derby-inspired manner of his *Fishermen at Sea* (exhibited at the Royal Academy in 1796; Tate Gallery) for one more directly inspired by the Dutch traditions of Willem van der Velde and northern baroque art. His *Ships Bearing up for Anchorage (The Egremont Seapiece)* (exhibited at the Royal Academy in 1802; Petworth House) was painted in the same manner; in both this and the painting of 1801, a sailing ship sits on the horizon parallel to the picture plane, as in Allston's *Thunderstorm at Sea.*[24] In *The Egremont Seapiece* and in his *Fishermen on a Lee Shore,* also shown in 1802, Turner introduced the chevron division of clouds and luminous clarity, which are major features of Allston's work, and these elements were developed to their fullest the next year in his great *Calais Pier* (fig. 13), which again Allston must have seen, and which would have been commended to him by his mentors, West and Fuseli. Turner's painting, as perhaps Allston's also, was autobiographical, reflecting his journey to France. By comparison with Turner, Allston has drastically reduced the narrative incident and raised the horizon (in a manner distinct from the Dutch baroque), thus further abstracting the power of nature and the drama of frail and helpless man against the cosmic elements. Here Allston's aesthetic foretells that of his later friend John Martin, whose art also owed a basic debt to Turner. However, Allston's composition, for all its romantic drama, maintains a sense of order, balance, and symmetry, and a clarity of form that acknowledges a classical heritage; he never sought or achieved a release from that classicism which Turner developed a few years later in such works as *The Wreck of a Transport Ship* (1810; Gulbenkian Foundation, Lisbon).

Italy, not Paris, was the goal of both Allston and Vanderlyn, but the latter found the French capital a more congenial artistic milieu and remained there until 1805, while Allston left, probably in August or September, with his Harvard classmate Benjamin Welles. Sidney Willard, the young Bostonian and friend of Allston and

Fig. 13. JOSEPH MALLORD WILLIAM TURNER,
British, 1775-1851
Calais Pier, 1803
Oil on canvas
National Gallery, London

11
Diana and Her Nymphs in the Chase, 1805
Oil on canvas, 65⅝ x 97⅝ in. (166.7 x 248 cm.)
Richardson 37
Fogg Art Museum, Harvard University, Gift of Mrs. Edward W. Moore

12
Italian Landscape, ca. 1805
Oil on canvas, 39 x 51 in. (99.1 x 129.5 cm.)
Richardson 38
Addison Gallery of American Art, Phillips Academy, Andover, Massachusetts

Welles, was also in Paris in August 1804; in his *Memories of Youth and Manhood* he mentions going to dine at Beauvillier's Hotel with "A . . . and W . . .," almost certainly a reference to his two Harvard friends, then about to leave for the south of Europe. They traveled via Switzerland, where Allston made sketches of the Alps, following the pattern of Turner's journey two years earlier. His subsequent progress is confusing. Flagg recounts that Allston visited Venice and Florence in addition to Siena, where he stayed to learn Italian, while Richardson discounts Venice entirely and suggests a Florentine stay sometime during 1807. Yet, it seems logical enough that Allston would make the effort to visit Venice and view the paintings of his favorite school of old masters; and Florence would be almost unavoidable in any progress to Siena and Rome. On the other hand, since he arrived in Rome in November 1804, the entire journey could not have taken him more than two or three months, so that his sojourns in the various Italian centers must have been quite brief, seemingly too brief to settle into thoroughly learning a foreign language.

Allston was the first artist of the young Republic to visit Italy and to paint there. He soon formed a lasting friendship with Washington Irving, who had just arrived in Rome from Sicily and Naples.[25] Together the two young Americans explored Rome and her artistic treasures. It was at this time that Allston's great esteem for the work of Michelangelo was formed; he was drawn to the Italian master's *terribilita* and sense of the colossal, not of this earth, admiring most his sculpture of *Moses* (fig. 14). Titian was appreciated above all for his color, and Raphael for his grace, his intellect and his sanctity. But it was Michelangelo that dominated Allston's vision, and years later, in 1860, Richard C. McCormick recalled: "It was Allston, I think, who said [with reference to Michelangelo], 'there is something in his works that so lifts one above our present world, or, at least, which so raises one above ordinary emotions that I never quit the Sistine chapel without feeling it impossible to believe any charge to his discredit.' "[26] Under Allston's sway, Irving momentarily considered renouncing the pen for the brush and ever after acknowledged his fondness for Allston.

Rome was a city of foreigners during the years that Allston was there, attracting numerous artists, writers, scholars, and political refugees from all over Europe. John Vanderlyn rejoined Allston in November 1805; since Vanderlyn had left the previous August for a stay in Switzerland and then a journey through Italy, we may assume some similarity in the routes taken by the two Americans a year apart.[27] Vanderlyn went first to Milan, then to Parma to study the Correggios, and from there to Florence, Siena, Viterbo, and Rome, probably taking much the same time for his trip as Allston had previously. Possibly Allston had a shorter stay in Switzerland and was able to manage a visit to Venice between Milan and Parma.

On or before the last day of December 1805, Samuel Taylor Coleridge arrived in Rome, and he and Allston quickly formed a firm friendship that lasted the rest of their lives. Coleridge and Allston took trips into the Roman Campagna and for three weeks in March 1806 were at Olevano. But Coleridge heeded a warning that his life might be endangered by the coming of Napoleon's troops and speedily left for Florence and Leghorn on May 18, 1806, thus bringing to a close the first chapter of their friendship. Unfortunately, in fear of French pursuit, Coleridge threw overboard his manuscript material after departing from Leghorn, and thus valu-

Fig. 14. MICHELANGELO BUONAROTTI, Italian, 1475-1564
Moses, 1533
Marble
Basilica of San Pietro in Vincoli (Photo Alinari)

able records of their friendship were irretrievably lost. His notebooks, however, record his impressions of Allston and include a description of the artist's *Diana and Her Nymphs in the Chase* (no. 11), which Coleridge intended as the basis for a poem, and also a moving tribute to the artist, which explains the depths of their lifelong friendship: "To Allston—After the formation of a new acquaintance found by some weeks or months unintermitted—Communion worthy of all our esteem, affection & perhaps admiration, an intervening Absence—whether we meet again or only write—raises it into friendship, and encourages the modesty of our nature, impelling us to assume the language and express all the feelings, of an established attachment."[28]

For companionship, the two Americans, Allston and Vanderlyn, met a number of countrymen, young Nicholas Biddle on the way to the Orient, Colonel George Gibbs of Rhode Island, William Carter of Virginia, and Richard and George Sullivan of Boston. However, they felt the lack of other American artists. "We regret," Vanderlyn wrote, "we have not a few more fellow countrymen here as companions in pursuit of similar studies. Here are upwards of 50 young artists from different parts of Germany & almost as many from France besides Spaniards, Russians, etc." And he continued: "Rome is certainly the first place in the world for an artist to pursue his studies. We both regret that there are not a couple more fellow countrymen pursuing the fine arts—as is the case with artists here from other nations who are numerous and less liable to feel the want of society."[29]

Allston and Vanderlyn seem to have had little contact with contemporary Italian artists, although they were certainly aware of them, as indicated by references in correspondence between Coleridge and Allston to Pietro Benvenuti, head of the Florentine Academy. Likewise, Vanderlyn seems to have sought the approbation of Vincenzo Camuccini, head of the Accademia di San Luca and the Roman equivalent of David, for his *Marius on the Ruins of Carthage*, begun in 1806 (in part inspired by Allston's earlier and now lost *Marius at Minturnae*) and completed in 1807.

Through Vanderlyn, Allston came to meet a number of the French artists working in Rome. These included Guillaume Descamps, a former fellow pupil in the studio of Vincent, who became *peintre ordinaire* to Joachim Murat, King of Naples; Paulin-Jean-Baptiste Guérin, another Vincent student, and Joseph Odevaere, a Belgian follower of David who spent eight years in Rome after winning the Prix de Rome in 1804 and then became court painter to William I of the Netherlands. The best known of the Frenchmen was François Granet, the good friend of Ingres; no meeting or relationship with Ingres himself is recorded, although Vanderlyn later indicated that they were aware of his presence in Rome. Among the landscapists, to whom Allston would presumably have been more attracted than Vanderlyn, correspondence mentions Pierre Chauvin, who settled in Rome in 1804 and was the subject of a pencil drawing by Ingres. They also found a friend in the Spanish sculptor José Alvarez de Pereira y Cubero. Allston, however, was much more closely identified with the German art colony in Rome.[30]

The large German colony of artists centered around the personality and home, the Villa Malta, of Wilhelm von Humboldt, the Prussian consul in Rome, who was a major patron of the arts. The popular meeting place for the German artists, and

15
Self-Portrait, 1805
Oil on canvas, 31½ x 26½ in. (80 x 67.3 cm.)
Richardson 39
Museum of Fine Arts, Boston, Bequest of Miss Alice Hooper

19
Francis Dana Channing, 1808-09
Oil on canvas, 30½ x 27½ in. (77.5 x 69.9 cm.)
Richardson 51
Private Collection

for Allston, was the Caffè Greco, "the resort of the northern barbarians for so many decades," where each nationality had its own table, the Germans being in the greatest number, as indicated in Vanderlyn's letter quoted above. A major figure among the northern artists in Rome was the sculptor Bertel Thorvaldsen of Denmark, whose relationship with the German art colony extended to patronage of their paintings and drawings. Baron Karl Friedrich Rumohr knew Allston during 1804-1806 and in 1840 recalled to Athanasius Raczynski his impressions of Allston's color and Rembrandtesque light.

In the previous decade, at the end of the eighteenth century, the guiding spirit for the German classicists in Rome had been Asmus Jakob Carstens. Although Carstens died in 1798, his influence continued to a great degree, and he was identified among German artists with the revival of interest in monumental figure painting and with the attempt to unite the classical revival with forms drawn from Michelangelo. Among Carsten's followers in Rome was Gottlieb Schick. Schick's *Sacrifice of Noah* was exhibited in the Pantheon for two weeks in 1805, early during Allston's Roman years, and was one of the major events in the art world that year. The powerful forms therein are derived from Michelangelo, but the influence of Carstens is also present, while the landscape background is said to have been painted by Joseph Anton Koch, the leading German landscapist in Rome at the time. The entire painting, in fact, is based upon Koch's 1830 *Sacrifice of Noah* (Städelsches Kunstinstitut, Frankfurt am Main), for which Schick, in turn, had painted the figures. Koch had been close to Carstens and made engravings after Carstens's series of designs on the story of Jason and the Argonauts, and his landscapes have a clarity of form that elicited the admiration of such artists as Camuccini. Koch was also a friend of Fuseli's, and Allston might well have known of Koch before his arrival in Rome.

Into this Germanic environment came Washington Allston. One biographer reported that "he and Vanderlyn cast their lot with an association of youths from Germany, Sweden and Denmark who assembled frequently to draw from the live model." Here in Rome, Allston not only studied anatomy but also learned to model in clay. Years later, Coleridge described to Sir George Beaumont the admiration of Antonio Canova for Allston's ability in sculptural modeling. The many fine early figure drawings by Allston of the nude model, drawn with a sense of precise, sculptural form and something of Carsten's lassitude, most probably date from this association.

It was the German group of artists, in fact, who referred to Allston as "the American Titian," because of his knowledge of the techniques of the Venetians. Horatio Greenough wrote that the Germans owed to Allston their first ideas of the means as well as the end of the modern techniques, and German respect for Allston's art can be traced throughout the century. German artists came to Allston to learn from him the art of glazing rather than the prevalent opaque technique. This is true both of Gottlieb Schick and of George August Wallis, a Scottish painter who lived in Rome and who had become thoroughly Germanicized. (His daughter married Gottlieb Schick in 1806.)[31]

In Rome Allston was very generous and free with technical information, although, unfortunately, this also included his advice on the use of asphalt, which

damaged both his work and that of some of the artists who followed his advice. Wallis particularly sought out Allston's technical procedure, and when he produced a landscape in which the glazing technique was misunderstood, Allston brushed in the clouds in the sky to ensure Wallis's comprehension. Later, when Coleridge commented upon the work, Wallis made no acknowledgment of Allston's contribution, claiming to have known the technique all along.

Schick was the other German artist who is documented as having been influenced, technically at least, by Allston. According to his biographers, he had given up a painterly colorism practiced in his youth for a hard, glassy tonality but reverted to color under Allston's influence. Allston also taught Schick how to prepare his ground and underpainting. Schick had been particularly impressed by *Diana in the Chase* (no. 11), Allston's most ambitious landscape of the period, and it is possible, too, that Schick's growing interest in landscape painting before his early death in 1813 was partially influenced by Allston. Their relationship was personal also; Allston was godfather to Schick's second son, and it is significant in terms of the cultural interplay in Rome that the boy's godmother was the wife of Wilhelm von Humboldt.

In Rome Allston continued his exploration and development of the landscape theme. Almost certainly, his *Landscape with a Lake* (no. 8), is the earliest of his Italian paintings since it is dated 1804; although it was exhibited at the Boston Athenaeum in 1832 as painted in Paris, the reminiscences of the Alps in the mountain configurations almost certainly suggest it was done after he left France. It would thus have been painted in Italy, probably in Rome, at the very end of 1804. The *Landscape with a Lake* is an important picture, too often ignored because of the magnum opus that succeeded it. In place of the picturesque derivations from the Rosa tradition or the seething natural forces of the *Thunderstorm at Sea* (no. 7), the picture evinces a clarity of form and spatial recession, a geometric structure and a balanced monumentality of the impressive trees and mountain formations very different from any of Allston's earliest work. The picture is a truly classical landscape, not in subject but in formal aesthetic—in its simplicity, symmetry, and formal harmony. It also further develops Allston's utilization of a Venetian glazing technique of transparent colors that absorb and reflect light, first explored in the *Thunderstorm,* earlier that year.

The *Landscape with a Lake* is an impressive painting, measuring 38 by 51 in., but it pales in dimension by comparison with his great *Diana and Her Nymphs in the Chase* (no. 11) of the following year, which is 66 by 98 in. The matter of size is not merely one of comparative scale and ambition but of assurance in the presentation of scale, which convincingly reflects the monumentality of the conception and the forms contained therein. Of all of Allston's paintings, *Diana* was the work that so impressed his contemporaries, not only his German colleagues but others as well, such as Samuel Taylor Coleridge.

The work was also extensively reviewed in one of the most significant Italian publications of the period, and the review deserves notice here. In Volume I of Giuseppe Guattani's *Memorie enciclopediche romane sulle belle arti, antichità, etc.,* of 1806, in an article entitled "Paesaggio," the writer describes *Diana* as a work of genius by an artist named Allston from the Carolinas in the New World, just lately

22
The Valentine, 1809-1811
Canvas, 25½ x 22 in. (64.8 x 55.9 cm.)
Richardson 63
Private Collection

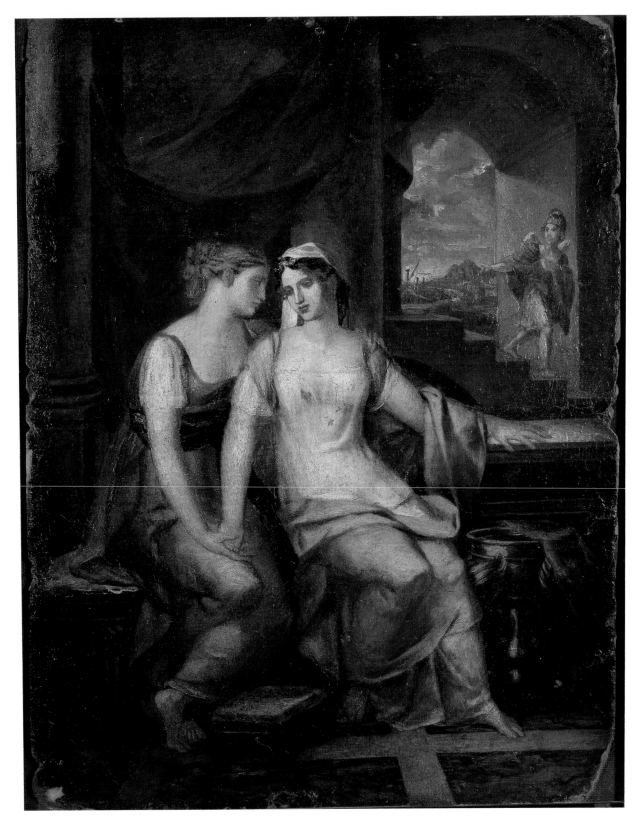

26
Dido and Anna, 1813-1815
Oil on millboard, 24 x 18⅛ in. (61 x 46 cm.)
Richardson 45
The Lowe Art Museum, University of Miami, Florida

exhibited in a Roman studio to a crowd of connoisseurs and amateurs. He went on to emphasize the stylistic novelty in its execution and proceeded to a minute description of the picture and the effects Allston achieved. The author praised the majestic trees, the spacious lake, and the Alpine mountains, and admired the introduction of Diana and her companions in order that the landscape not remain mute and deserted. He likened the picture to a beautiful Caravaggio or a strong Guercino but concluded that it was most like the manner of Claude, though recognizing the coloration in the manner of the Venetians. He also mentioned that some critics wished to rank the picture as a historical work so that it might be displayed in the Pantheon. Allston was acknowledged also for his ability in sculptural modeling and for his talents as a poet.

Diana in the Chase is based upon Swiss scenery, and there exist for it studies such as a drawing of Mount Pilat (see no. 76), a peak rising above Lake Lucerne, but Allston has transformed the geographic features into a more generalized visual experience. In the oil, instead of emphasizing the irregular contours and the ranges of concentric arcs of clouds, cliffs, and hills found in the drawing, the artist has concentrated upon tectonic, structural elements. *Diana* is ostensibly a classical scene, but its classicism lies actually in its sense of harmony, completeness, and self-containment. The figures themselves give the scene a quality of timelessness, in which nature itself creates a monumental vision as the landscape elements in the foreground are pulled back to reveal the heroic mountain looming up. *Diana* also displays Allston's mastery of the Venetian technical procedures in its transparencies of tone, rich use of oil, and glistening color.

Perhaps the most perceptive and moving description of Allston's *Diana* was written, not surprisingly, by Benjamin Rowland, Jr., in 1955. Rowland characterized the picture thus: "It seeks to induce a mood of tranquility and meditation in the spectator. The artist paints what he sees and feels, not what he thinks and reasons, about nature. The picture has an air of magic solitude, together with a wonderful feeling of luminosity and aerial harmony. It has an indescribable effect of being bathed in a luminous haze, from which the mountain emerges as a tower of crystalline purity. No wonder that the author of *Kubla Khan* should have been spellbound by this painting."[32]

In such a work as the *Diana,* Allston had moved strongly in the direction of Joseph Anton Koch, although no actual evidence of their meeting can be found. Koch was extremely close to the von Humboldts and to Schick, and he was also an influence upon George Wallis. One possible example, at least, of direct relationship and derivation can be found in Koch's *Heroic Landscape with Rainbow* of 1805 (fig. 15), exhibited at the Caffè Greco that year, the first of three versions of one of the artist's greatest conceptions, and the first of his "heroic landscapes." It represents the complete, totally ordered scene, including all the elements of nature in stratified zones, leading up to the towering, distant peaks, and encompassing man and his dwellings. Here is the complete, inhabited classical city, clearly defined in a band of light, with a rainbow unifying the composition and conferring a heavenly blessing upon the whole. The mountain forms used by Koch in his landscapes were based, as were Allston's, upon Swiss scenery, and Koch had profited from several years spent in Switzerland during the previous decade.

Fig. 15. JOSEPH ANTON KOCH, German, 1768-1839
Heroic Landscape with Rainbow, 1805
Oil on canvas
Staatliche Kunsthalle, Karlsruhe

Allston's *Italian Landscape* (no. 12) in the Addison Gallery, Andover, was also painted in 1805. It represents a change in his landscape conception, where figures and man's habitations become more than accessories, and the setting changes from an ordered wilderness to the inhabited, total landscape, still dominated by the great mountain in the distance. It would appear that Allston, working in a parallel direction with Koch, was influenced by the latter's conception of the heroic landscape and conceptually veered in a more similar direction. Direct relationships between the two pictures may also be found in certain forms in the landscape, such as the shape of the distant mountain, buildings in the cities, and the placement of some of the figures. Like Koch too, Allston has introduced the human cyclical range: the child within the family unit, the isolated youth in departure (who was a feature in the two previous landscapes also), the mature mother image, and the contemplative old man. Though lacking Koch's unifying rainbow as well as the more mature artist's sophisticated handling of recession in banded light and dark planes, the *Italian Landscape* represents the concept of balance in natural and human harmony, a classicism in landscape in Winckelmann's terms.

Both Koch and Allston, of course, acknowledge in these paintings a debt to Poussin, the great classical landscapist of the past, and particularly to Poussin's landscapes of about 1648/9 such as his two Phocion paintings, the *Funeral of Phocion* (collection of the Earl of Plymouth) and the *Discovery of the Ashes of Phocion* (collection of Lord Derby), which Allston might have known in England, or his *Diogenes* (Louvre) and *Polyphemus* (Hermitage) landscapes, about which Koch wrote. Of Koch's landscapes Keith Andrews has written that they "combine a Poussinesque grandeur with his own direct experience of the Alpine world," and that "majestic interpretations of mountainous regions represent the heroic climax of classical landscape art"; these comments are applicable also to Allston's classical landscapes.

Both artists might have been influenced in addition by the universality of the landscape conceptions of Alexander von Humboldt, who was in Rome in 1805 visiting his brother, Wilhelm, the Prussian consul, and meeting the latter's artist friends. Alexander had been traveling in the New World, where he had explored the tropics and then met American artists such as Charles Willson Peale in Philadelphia. When Alexander von Humboldt later wrote that "the grander style of heroic landscape painting is the combined result of a profound appreciation of nature, and of this inward process of the mind," he was expressing ideas that certainly mirrored Allston's artistic conceptions.

The extent of Allston's landscape production during his four years in Rome is not easily determined. An undated *Italian Landscape* (no. 13) in the Baltimore Museum is most probably a work from this period, although its provenance suggests that it may be the picture owned by Isaac Davis and dated 1810 when shown in Harding's Studio in the Allston exhibition of 1839. Richardson, in turn, suggests that the work exhibited might have been an 1810 *Landscape of American Scenery*, but the 1810 date in the 1839 exhibition might well be erroneous. The architectural details in the Baltimore picture suggest his Italian period landscapes, as do the marked shalelike surface of the rocks (strikingly similar to those in the *Landscape with a Lake*) and the generalized geometry of the composition. Perhaps even more pertinent is that the combination of classical forms and format with an intimate, genre-ized scene

in this painting resembles that in a Roman landscape of 1813 by Johann Christian Reinhart, now in the Georg Schäfer collection in Obbach. Reinhart was a German painter working in the circle of Koch and the tradition of the "heroic landscape." Allston's landscapes were closer to that tradition when he worked in Rome and were correspondingly removed from it when both Italy and the classical tradition were only a memory.

Likewise, there is the intriguing example of the Shelburne Museum's *Morning in Italy* (no. 14), which Richardson suggests, was Allston's painting exhibited in 1817 in London at the British Institution and should be dated that year. But there is no evidence that Allston's exhibited picture was painted in that year, and, indeed, it could have been one of his pictures long in storage in Italy that had finally been shipped to England. While the landscape forms are softer and the distant architecture is more subdued in the composition, the transparent glazes overlaying specific local color areas suggest the beginning of Allston's dependency upon Venetian technical derivation, in a manner similar to his other Roman landscapes. *Morning in Italy* was later in the collection of Dr. John King, the Bristol surgeon who saved Allston's life in 1813, and whose portrait Allston painted. This ownership is documented in a letter to Allston from the Bristol critic, amateur painter, and intellectual, the Reverend John Eagles, written on May 24, 1842. Eagles sketched a landscape by Allston then in John King's collection and sent a note: "Mr. Eagles, thinking Mr. Alston [sic] would like to see a sketch, however slight, of his beautiful little landscape has begged the favor of Mr. Savage to convey it to Mr. Alston & at the same time the expression of his admiration of Mr. Alston's genius in painting and poetry. We have a lively remembrance of the pleasure of Mr. A's society when in Bristol many years ago."

This letter and sketch, now in the Longfellow National Historic Site in Cambridge, is identified as "A sketch from a painting by Mr. Alston belonging to Mr. King of Clifton by the Revd. John Eagles." It may be presumed that King acquired the picture in the middle years of the second decade of the century, certainly before Allston departed from England for the last time, in 1818, but the picture may have been done much earlier.

The dating of this painting is complicated also by its relationship to a study of a landscape (fig. 16) now on the New York art market. This large preparatory work in oil and chalk on canvas is an underpainting that was never developed to completion but that in the general landscape configuration and even in the form of the dominant tree in the foreground relates to the Shelburne picture. The study has been dated 1801-1803, but the architectural features and the general architectonic nature of the composition certainly suggest a later date. The work would most likely date from Allston's Italian period; that it remained unfinished is inexplicable but hardly unique for Allston. The Shelburne picture may be a variant of it in a smaller size or may even precede the unfinished picture, which could represent a conception on a more monumental scale that Allston was diverted from carrying to completion.

The other painting by Allston that particularly impressed the German artistic contingent was his *Self-Portrait* (no. 15), also of 1805. It is one of the artist's finest works, visually and structurally, and still reveals the glowing transparency of suc-

Fig. 16. *Landscape Study*, ca. 1805
Oil and chalk, 20½ x 35¼ in. (52 x 89.5 cm.)
(sight)
Hirschl and Adler Galleries, Inc., New York

< **25**
The Dead Man Restored to Life by Touching the Bones of the Prophet Elisha, 1811-1814
Oil on canvas, 156 x 120 in. (396.2 x 304.8 cm.)
Richardson 67
Pennsylvania Academy of the Fine Arts, Philadelphia
(shown in Philadelphia only)

cessive layers of colored glazes that so astounded his contemporaries. Allston's visual self-image and presentation conform closely to Washington Irving's description of him at the time: "light and graceful of form, with large blue eyes, black silken hair, waving and curling around a pale, expressive countenance, a man of intellect and refinement. His conversation was copious, animated and highly graphic, warmed by a genial sensibility and benevolence and enlivened at times by a chaste and gentle humor."

Allston, moreover, here assumes the role of a cultivated, sophisticated cosmopolitan. Perhaps surprising, however, is the picture's indebtedness to earlier Venetian art *only* in technical terms. The expansiveness of Titian's imagery and of Venetian portraiture in general is missing here, and, in fact, if one were to specify similarities to an earlier style or school of portraiture, sixteenth-century mannerism would probably come first to mind. Although Allston presents himself with a suggestion of movement and a faint glimmer of a smile, the expression is basically enigmatic and the figure quite columnar. Mannerism is suggested also in the dark, monochromatic palette and particularly in the austere and compressed architectural setting, which is oppressive in the way it cuts off the spectator's view, although it pushes the subject forward and constructs a compositional unity, with the distant half-arch at the left continued in the outline of Allston's silhouette, and its shadowy interior repeated in the figure's slightly mysterious shadow at the right.

Allston here created one of the master portraits of his period and one completely removed from American tradition either of Copleyesque realism or of the painterly, idealistic elegance that Gilbert Stuart had introduced from his years in Great Britain. No other American artist had assimilated the experience of European art to such a degree as to create a modern work in the spirit of the masters, not even Allston's mentor West, whose relationship to the past was more one of outward forms than inner conception. Nor is the seeming inconsistency of combining Venetian techniques with mannerist construction unusual for Allston. The legacy of the past was his in entirety, and the contribution the modern artist could make lay precisely in his ability to fuse the best and most appropriate of the riches of the past with a contemporary and individual sensibility.

Allston's other portrait painted in Rome, that of Coleridge (no. 16), begun the following year, is unfortunately incomplete, left in that state upon the Englishman's hasty departure ahead of Napoleon. The picture is sufficiently similar to Allston's *Self-Portrait* in tonality, setting (though not completely realized), and expression, and even in the placement of the figure within a canvas of almost equal dimensions, that they may be thought of perhaps as pendants, a commemoration of a newly formed but already intense personal relationship. Allston himself recalled the depth of that relationship when he said: "To no other man do I owe so much intellectually as to Mr. Coleridge, with whom I became acquainted in Rome, and who has honored me with his friendship for more than five and twenty years. He used to call Rome 'the silent city,' but I could never think of it as such while with him, for meet him when and where I would, the fountain of his mind was never dry, but, like the far-reaching aqueducts that once supplied this mistress of the world, its living stream seemed specially to flow for every classic ruin over which we wandered; and when I recall some of our walks under the pines of the Villa Borghese, I am almost

tempted to dream that I have once listened to Plato in the groves of the Academy."[33]

While we may today regard Allston as primarily a landscape painter during this first period abroad, he was obviously completely cognizant of the ultimate worth and esteem of historical painting and ambitious to assume a position in its ranks. Moreover, in Rome he lived in the font of the classical and, in some sense, the neoclassic world; he was never to be closer to such inspiration than during these years, for it was an inspiration that all but evaporated after his departure from Italy in 1808.

A particularly intriguing pair of "historical" canvases, religious pictures, are *David Playing before Saul* (no. 9) and *Moses and the Serpent* (no. 10). These were both sufficiently unrecorded during Allston's lifetime to lend some doubt as to the authenticity of their attribution, and their twentieth-century provenance, including ownership in the New York Ehrich Gallery and in the Thomas B. Clarke collection, does not increase confidence. Nevertheless, they were acknowledged as by Allston in Sweetser's listing and were shown in the 1881 memorial exhibition in Boston.

The pictures are certainly unusual for Allston on many counts. First of all, the works are *esquisses,* small, preliminary oil studies of complete compositions, formulated as guides for larger and more finished works, which in this case do not seem to have been done, and which were perhaps abandoned after this initial step. Usually, Allston seems rather to have worked directly upon the larger canvas, first creating an *ébauche* (an underdrawing in oil and other media) and utilizing often carefully finished drawings as aids to the final realization. Secondly, no other religious works are known from this period in his career. His later emphasis upon this thematic area involved instances of mystery and the supernatural not comparable here, although the magic of Moses's turning a staff into a serpent to gain the attention of the pharaoh and the leadership of Israel may be seen, possibly, as a distant harbinger of Allston's great *Belshazzar* (fig. 45). Technically also, the *alla prima* technique is certainly inconsistent with Allston's deepening investigations of Venetian technical procedures, as is the almost rococo colorism and mixing of tones, the fluid painterly technique and the heavy-bodied figures. Lastly, the enclosed compositions, that of the *David* particularly, suggest similarities to French neoclassicism, particularly to the compositions of that most austere of neoclassic masters, Pierre Narcisse Guérin.

Yet, it may be that we demand today too great a consistency on the part of the still-developing young American artist, eager to explore all the facets of earlier and contemporary European art. He would undoubtedly have looked at contemporary French painting and would perhaps not have been averse to considering a compositional form of that nature. Religious subjects were certainly abundant in Rome and constituted a growing part of the repertoire of the great masters working in London and Paris, among them Benjamin West. And the technical mode of the *esquisse* was a regular aspect of the academic practice of such contemporary neoclassicists as Vincenzo Camuccini, whose work must have been known to Allston and was perhaps admired by him, and was at just this period in the early nineteenth century developing in France as a formal required practice.[34]

David and *Moses* are usually dated "1804/5-1808," the years of Allston's Roman residence, but Sweetser in the earliest reference to them specifically designates them

as painted in 1805; and while Sweetser's information is certainly not to be relied upon consistently, a date just after his arrival in Rome would seem most logical and consistent with Allston's development, when he was viewing and assimilating all the various artistic currents available to him. In any case, he appears to have rejected the expansion of these works into major historical statements and instead, perhaps under the influence of his friend and companion Vanderlyn, turned to a classical theme, *Jason Returning to Demand his Father's Kingdom,* a work conceived and begun in 1807. This was almost exactly the time that Vanderlyn began his classical magnum opus, *Marius on the Ruins of Carthage. Jason* exists as a relatively complete and quite large monochrome oil study on paper (no. 17) and as the very incomplete painting in color, enormous in scale, 20 feet long (fig. 17). *Jason,* in fact, remained Allston's largest conception, and its gargantuan proportions may well have been inspired by the very famous, ambitious work just then being completed by Rome's most celebrated painter, Camuccini, the *Death of Caesar.*[35]

Allston's conception is a stark, simplified composition, geometrically ordered, centering around a heroic statue. The arrangement is fairly symmetrical and quite static, except for the rearing horse, and offers a limited spatial complex. It is significant that the theme of Jason was the basis for a major series of designs made by Asmus Carstens, which were engraved by the latter's friend and colleague Koch in Rome in 1799. Indeed, a number of similarities can be found between the *Jason* of Allston and the best-known of Carstens's series, *Jason at Iolcos.* These extend to the general compositional arrangement, severely geometric, the almost archaic nature of the architectural forms, and the centralized Renaissance box space. The brooding, intense figures in Allston's picture can also be paralleled in other works of Carstens.

The *Jason* colored oil is also of great interest in its revelation of Allston's methodology. Whole areas are blank, blocked out only in the overall, predetermined design. Others are "dead-colored," flat areas of coloration upon which successive glazes were still to be added, while the group at the left are closer to completion. It was Allston's usual practice to leave his dead coloring to dry, often for months. In such a state it became unrelievedly hard. He would then apply the softening, luminous glaze of transparent color, but when, as here, he abandoned the work, only the harshness of the dead coloring remains. Interestingly, perhaps surprisingly, the principal figure of Jason himself is not yet realized, so that in its present state, it is Jason's uncle, Pelias, who has usurped the hero's position, who dominates the scene. It has been suggested that the choice of subject was determined not only by the general emphasis in Paris and Rome on sources classical, and more specifically on the precursion of Carstens's interest in Jason, but also in autobiographical sublimation; that is, Allston-Jason has arrived at his sources and heritage, in Europe and in Rome, reclaiming a birthright enabling him to transcend American provinciality.

It would probably be specious to carry such speculation too far, but even in its unfinished state, Allston's *Jason* encompasses a grandeur of conception not realizable by any of his contemporaries—not even by his colleague Vanderlyn. But Allston's classical period existed when he was close both to the classical source and to a group of artists of classical inspiration. It is not surprising therefore that after he departed from Italy, leaving most of his paintings and his old master acquisitions

Fig. 17. *Jason Returning to Demand His Father's Kingdom,* 1807-08
Oil on canvas, 168 x 240 in. (426.7 x 609.6 cm.)
Richardson 41
The Lowe Art Museum, University of Miami, Florida, Gift of the Allston Trust

boxed up and in storage, he moved away from the neoclassic world. When Allston reclaimed the *Jason* some seven years later, he was devoting his attention to a series of great religious canvases, and he disdained this painting to the extent that he not only refused to continue work on it but also gave it over to Brown, his London colorman, recognizing it as belonging to a mode no longer pertinent to his own artistic vision. In 1844, the year after Allston's death, Brown offered the painting to the administrators of the Allston estate, who had the picture sent over from England. Leslie told Richard Henry Dana at the time that while some admired the *Jason,* others found it too imitative of Raphael and Poussin.

The ambitious nature of Allston's never-completed *Jason* has tended to obscure consideration of his other figure and history pieces painted during his years in Italy. One of the most beautiful of these is the *Casket Scene from "The Merchant of Venice"* (no. 18). Given Allston's nature, it is perhaps not surprising that he would choose the dénouement of Bassanio's suit for Portia's hand, a climactic success in the course of courtship and love, rather than the melodramatic demi-plot of Shylock and the pound of flesh. Allston's figures are his rather typical mannered ones, thin, somewhat wooden, with set expressions and often in profile, but they glow with the lustrous glazing of their rich Renaissance costumes, within a darkly luminous interior. The confrontation of the genders is attractively realized with Bassanio silhouetted against the sky and perceived through an open arch, reaching behind him to the leaden casket, while Portia, reserved but bemused, leans back in a chair surrounded by attendants, a path of light separating them. It is surely coincidental that the episode of the caskets in Shakespeare's play derived from the popular Latin tales of the late Middle Ages compiled as the *Gesta romanorum;* in fact, these were first printed not in Rome but in Utrecht.

The *Casket Scene* may document a visit that Allston made to Florence, for John E. Allston, the picture's later owner, who bequeathed the painting to the Boston Athenaeum, reported that it was painted there in 1807; Sweetser dates it much earlier, in 1802. The earlier date might seem logical, for, in that case, Allston would have painted the Shakespearean subject while still in England, but the later date is more likely in view of the Venetian technique; and, in fact, Allston identified that manner when he exhibited the picture in Bristol in 1814: "in the manner of Paul Veronese." Furthermore, the choice of the subject may well derive not only from Allston's love of the theater, but also from the encouragement of his new friendship with Coleridge, one of the leading Shakespearean scholars of the time. This may also explain in part the existence of a second Shakespearean subject painted by Allston in the Roman years, *Falstaff Enlisting His Ragged Regiment* (fig. 18), derived from *Henry IV, Part II,* a comic piece and one of a small group of such works that the artist composed periodically during his earlier professional years. Indeed, *Falstaff* may represent a conscious contrast with the more romantic subject of the *Casket Scene.*

In keeping with the nature of the subject, Allston's *Falstaff* is strongly caricatured. Falstaff himself is properly corpulent, as opposed to the emaciated figure of Justice Simple. It has been pointed out that the basis of Allston's conception was an engraving by William Hogarth of the same subject, although Allston typically played down the low-life character of the participants in the scene, as well as the

Fig. 18. *Falstaff Enlisting His Ragged Regiment,* 1803-1808
Oil on canvas, 25¼ x 32½ in. (64.1 x 82.5 cm.)
Richardson 49
Wadsworth Atheneum, Hartford, Connecticut, Gift of the Allston Trust

detail of Falstaff accepting a bribe.[36] Allston thus lessens the impact of farce and cupidity and suggests a greater sense of malevolence, which is heightened by the somber, dark interior in which the figures appear quite small. The setting, in fact, suggests a derivation from Dutch seventeenth-century lower-class genre, into which a Shakespearean literary subject has been placed, and this source is reinforced by the double interior, with a distant back chamber at the right lighted by several arched windows.

This picture is almost surely the "little Falstaff" that Allston mentioned to Vanderlyn in 1808 as one of only two pictures he was taking with him back to America when he left Italy. Charles Robert Leslie mentioned later to Richard Henry Dana a *Falstaff Playing the Part of the King* as painted during this period; but this work contained figures the size of life, which Leslie acknowledged was unusual for comic pieces, recognizing the traditional appropriateness of monumentality only for historical painting and for portraits. Allston returned to Shakespearean subjects periodically throughout his career; he owned an eight-volume set of Shakespeare's plays published in 1799, which may have been his source for these and other paintings. In July 1860 *Falstaff Enlisting His Ragged Regiment* was reported to have been sold in Charleston for $2,000, according to the *Cosmopolitan Art Journal*.

Allston also appears to have painted two pictures of the subject of *Cupid and Psyche,* both unlocated. One of these was a small work that Dana saw in Boston and that Allston took with him to England, where it was seen by Wordsworth and Coleridge, the latter comparing its coloring to Titian's. This may have been the inspiration in turn for the second treatment of the subject, the first work he completed during his second English period. The most problematic of the pictures assigned to these years is Allston's beautiful but uncompleted *Dido and Anna* (no. 26), but, as will be shown, this was probably painted later, about 1812-1818.

The number of paintings that Allston painted during his stay in Italy is quite small, and the number located today even smaller. It is difficult to account for his time and activity and even to document his specific whereabouts, particularly after the departure of Irving and Coleridge. It would probably be correct to assume that he had developed even this early the reflective and contemplative nature that gave much time to conceptual considerations, perhaps far more than to the actual mechanical procedure of paint to canvas. Of course, there might have been much more traveling within Italy than we are aware of today, and much looking at the masterworks of past and contemporary Roman art.

Allston and John Vanderlyn occasionally made excursions into the Roman Campagna and were also involved together in studying and acquiring works by or attributed to the old masters. Sometime around the beginning of January 1807, Allston purchased a supposed Veronese for a little over $100; Vanderlyn at the time bemoaned his financial inability to purchase similarly, but he too eventually acquired a "Veronese." The picture was left with Allston and remained in storage in Italy until Allston arranged for their acquisitions to be shipped to him in England almost a decade later. Allston's "Veronese," the authenticity of which he himself, with West's advice, came to doubt in 1815, represented Hercules, Cupid, and two female attendants. Although its location is unknown today, the artist must have retained the work, for in 1838 his nephew, George Flagg, wrote to Asher B. Durand that

Allston was anxious for the return of the picture, which he had lent to the New York painter George Oakley to copy.[37] Allston also owned numerous prints by old master and contemporary British and American artists and a cast of a classical bust of *Thalia*, which Leslie told Dana was marked by sweetness of expression.

Vanderlyn remained Allston's close companion until he left Rome for Paris in 1807, following the completion of his canvas of *Marius on the Ruins of Carthage*, which met with great approval in Rome, and which won him a medal at the Paris Salon of 1808. Allston did not remain in Rome much longer; in March 1808 he left for Leghorn and from there sailed for America on April 24. He left all but two of his own paintings, including the uncompleted *Jason* and the acquisitions he and Vanderlyn had made, with the counting house of Filippo & Antonio Filichi; it was about six years before he saw these works again.[38] The French army had entered Rome on February 2, and Allston greatly feared that America would soon be involved in the Napoleonic wars. This, more than his decision to return to his (long-waiting!) fiancée, Ann Channing, seems to have been the primary cause of his return home, and, in fact, he seems to have left Rome quite precipitately. Allston appears to have returned directly to America; perhaps he was homesick, particularly after Vanderlyn's departure, and the war would have made a visit to England extremely hazardous at the time. Several writers, Flagg among them, have suggested that Allston made a stopover in England, arriving in America only in 1809, but there seems to be no evidence for this.

102
CHARLES ROBERT LESLIE, American
(active in England), 1794-1859
Washington Allston, ca. 1816
Oil on canvas, 25½ x 17½ in. (64.8 x
44.5 cm.)
National Academy of Design, New York

ON HIS RETURN TO AMERICA, Allston set himself up as a professional painter in Boston. The building on Court Street where Allston established his studio was an artistically historic one.[39] It had been the old Williams house where John Smibert had been established for many years after marrying Mary Williams, and although the house passed through many owners after the death of Smibert's oldest son, William, the paintings that Smibert left there continued to attract visiting art students such as Charles Willson Peale, while other painters had boarded there, such as John Mason Furness, Allston's old teacher Samuel King, and, more recently, John Johnston, who had been the finest resident artist in Boston until Gilbert Stuart settled there in 1805.

Allston's involvement with the relatively small Boston art world in 1808 and subsequent years is not documented. Perhaps the cosmopolitan nature of his training and the lifestyle of his recent years kept him aloof, although he became at this time a good friend and close colleague of Stuart's; it was a friendship that even deepened when he finally returned again to America in 1818, after his second period abroad. It is interesting, though, that these years in Boston, from 1808 to 1811, saw Allston's greatest production of portraits, a reflection of the continuing thematic artistic preference in America.

The portrait of *Francis Dana Channing* (no. 19), Allston's brother-in-law, is probably one of the earliest of this group, made when Channing was a strikingly handsome young man in his early thirties (he died in 1810). The emphasis upon the strong classical profile and the intense but slightly glazed, unfocused eye is somewhat akin to the treatment of several figures in Allston's Roman canvases, such as those in his *Jason* or Bassanio in the *Casket Scene*. The profile view accentuates a linear and rather flattening spatial effect and also disengages the subject from the viewer's ambience. Most of Allston's other known portraits of this period establish

Fig. 19. *The Artist's Mother, Rachel Moore Allston Flagg,* 1809
Oil on canvas, 30⅛ x 25⅛ in. (76.5 x 63.8 cm.)
Richardson 55
Private Collection

Fig. 20. *Lucy Ellery Channing,* 1811
Oil on canvas, 26½ x 21¾ in. (67.3 x 55.2 cm.)
Richardson 66
The Fine Arts Museums of San Francisco, Collection of Mr. and Mrs. John D. Rockefeller 3rd

a visual link between subject and spectator, and it is not unlikely that this most classical of his portraits was the first painted after his return from Italy.

Allston's own favorite among his portraits was that of his mother (fig. 19), a judgment that the viewer today probably would not share. His preference suggests the mood of euphoria he later recalled, when, immediately following his marriage to Ann Channing on June 19, 1809, he visited his mother after an interval of eight years. Allston painted the picture while in New Haven, where she was staying with her son, Allston's half-brother, Henry C. Flagg, a student at Yale University. The portrait is an intense but rather prosaic picture, simple and monumental but rather unsympathetic. Its glowing luminosity, with the rather fussily detailed features and bonnet emerging from the dark, shadowy ambience, makes the work somewhat more interesting for its technique than for its interpretation.

The most striking of Allston's portraits of this period is a small picture, almost a cabinet portrait, of his wife (no. 21) reading by lamplight. The date of this work is not known, and it would probably be wrong to assume that it was painted as a marriage portrait. Such traditional and official motivations would not seem characteristic of Allston. Rather, one should acknowledge the contemplative nature of the interpretation of the subject and project that characteristic to the artist's motivations. It might be well to assume that Allston had studied Ann Channing as she read in the evening and that he chose such an interpretation not only because it was typical of her but also because it was the mode with which he wished best to identify—like unto like. That is, Allston both honors and sympathizes with Ann Channing in her deep concentration, in her literary pursuits, and in a solitary and withdrawn role.

The best-known of this group of portraits is, of course, that of the famous clergyman William Ellery Channing (no. 20), Allston's old friend and the brother of Ann and Francis Channing. In the engraving reproduced in a life of Channing,[40] the portrait is referred to as painted in 1811. It is the most gently eloquent of this group of portraits and one of Allston's finest. Channing seems to emerge through the soft, luminous glazes almost as a mystical apparition, a spiritual being, benign but enigmatic, evincing something of the reserve that earlier marked Allston's Roman *Self-Portrait.* It must be acknowledged, however, that this Channing portrait is unfinished, and, in fact, Allston's last letter was written on July 4, 1843, to Channing's widow, who had been pressing him to complete this painting of thirty-two years earlier![41] Even then, however, Allston delayed, offering as his excuse the pressures exerted on him to complete his great *Belshazzar's Feast,* which had to take precedence. He offered her the touching lament: "It is not with me now as in former days—when the original was painted—when I was young and in health, and with nothing extrinsic to overshadow my Art."

The last of the surviving group of Allston's Boston portraits, also painted in 1811, is that of Lucy Ellery Channing, his mother-in-law (fig. 20). The picture has the strength of his mother's portrait, but it is a more sympathetic likeness, as the elderly woman emerges from a golden aura not unlike that of her son's portrait, soft dark shadows falling across her bosom as she appears within a darkened ambience. The slight anxiety in her expression may reflect her concern for the imminent departure of her daughter with Allston, about to settle in England. Allston may have painted other members of the Channing family as well, and possibly portraits

of Edmund Dana and Henry Flagg, at this time, but the known series here enumerated offers a fascinating variety of interpretations: the glowing likeness of William Channing and that of Channing's mother; the contemplative interpretation of Allston's wife; and the more classical but idealized portrayal of Francis Channing, with eyes averted, absorbed in timeless thought and inner vision. They are extremely romantic portraits. Allston's motivation for all of them is similar: a combination of interpretive and technical problems to be solved and an expression of familial warmth and affection for his own and adopted family. He remained the only significant American painter not primarily occupied with the lucrative production of formal portraiture, which at this time was the chief occupation not only of Stuart but also of Vanderlyn in Paris.

Although Allston painted several landscapes in Boston, in a studio on Devonshire Street, where they were seen by his old schoolmate Leonard Jarvis, his interest in this theme seems to have abated after the inspiration of the Alps and Italy. Two of the Boston works, both listed as having been done in 1810 when they were later shown in his 1839 exhibition at Harding's Gallery in Boston, were at that time owned by Edmund Dwight and Isaac Davis, both of whom also acquired other landscapes by Allston. Both appear to have been Alpine scenes, although Dwight's was also described as an Italian landscape; Dwight's picture had been previously owned by Francis Winthrop of New Haven, who had purchased it about 1810 on the advice of Mr. Sullivan (probably William Sullivan, who had acquired one of Allston's *Falstaff* pictures). Dissatisfied, Winthrop sold the landscape in 1816. Jarvis mentioned a *Landscape of American Scenery,* intriguing in its suggestion of a concern with a native subject yet unlikely in the overall context of Allston's more introspective and memory-inspired imagery. He also mentioned a *Sunrise,* in the humorous context of Allston's own disinclination ever to actually see the sun rise. This may, in fact, be the one located landscape of this period, Allston's *Coast Scene on the Mediterranean* (no. 23), in which spectacular light effects of either sunrise or sunset dominate the picture; furthermore, since Jarvis specifically refers to the first work as American, a foreign locale for the other is probable; and Sweetser refers to this picture as a "sunrise." What Allston presents here is an idyllic vision of the Italy he was never again to see. With a strong source of light centered in the distance upon the horizon, the rays emanating forward in all directions, and the ships, foreground horse-drawn cart, and shadows arranged symmetrically on balanced diagonals, Allston has drawn on the Claudian tradition. The picture is, of course, extremely Turneresque, but the Turners it most resembles were either those that had not yet been painted or—even more similar—near-contemporaneous ones such as *Sun Rising through the Vapors* (National Gallery, London; exhibited 1807), which Allston could not have seen, although such resemblance adds weight to the suggestion that Allston might have stopped in London in 1808 on his way back to America.

Of course, the picture is *not* Turner. The Venetian colorism in the sky, the strong silhouettes of the ships, the emphasis upon the staffage of picturesque fisherfolk defined in strong neoclassic linearism and several in profile—all this bespeaks Allston's recent Italian experience. Also of interest is that he has substituted Claudian light for Poussinesque solidity, to the extent that, as Barbara Novak has percep-

tively recognized, the picture is an example of proto-luminism in its combination of enveloping light and foreground ultraclarity,[42] and one might add also a prototype of the extravagant sunrise and sunset-cloud treatments that Frederic Church developed in the 1850s. Furthermore, the picture is about the earliest known American example of exotic Italianate genre (the presentation of the Italian peasantry in their native milieu) which became a staple of American artistic interest in the work of such midcentury expatriates as John Gadsby Chapman and George Loring Brown (the latter an artist directly encouraged by Allston) as well as Samuel F. B. Morse and even Thomas Cole, a generation after Allston painted his luminous masterwork.

Only three figure pieces are recorded from these years in Boston, two of which are located today. *The Poor Author and the Rich Bookseller* (no. 24) of 1811 is one of Allston's rare excursions into comic genre. It therefore follows in the line of the earlier *Falstaff*; in fact, the rich bookseller bears a marked similarity to the Falstaff figure. Compositionally, also, Allston repeats a suggestion of deep space in presenting a second, distant room with its separate light source, although here it is a centered space, and the emaciated poor author is silhouetted against a bright, arched opening not unlike Bassanio in Allston's earlier *Casket Scene*.

Allston's style here appears uniquely his own. He emphasizes a startlingly severe geometry, with emphatic foreshortening and recession of doors and shutters and sharp angles of walls, ceiling, and floor in a manner almost recalling the Flemish primitives. His figure style, also strongly linear and very exaggerated, is Hogarth-like in its caricature, but bears no relationship to that artist's voluptuous handling of form or paint, and, in fact, derives from his own early figure style in the watercolors of *The Buck's Progress* (see figs. 69-71 below) of his Harvard years.

The point of Allston's satire is obvious but nevertheless extremely effective. The resolutely disinterested, complacent, and well-fed bookseller contrasts with the anxious and harried author who is being swept out of the office along with the other sweepings by the office minion, a young boy who sets the pyramidal balance of the figures and contrasts in his youth with the author and bookseller, a third player in the range of humanity here offered. He appears again in more sympathetic guise as Baruch, the scribe in Allston's later *Jeremiah* (no. 57), and in other canvases. Although the picture suggests a literary source, and its satirical edge parallels the literary flavor of the writing of Allston's good friend Washington Irving (and prophesies the comedy and satire of that later illustrator of Irving's writing, the New York painter John Quidor), there is no actual literary source known. Rather, Allston offers here his version of the age-old plight of the creative artist, whose original inventions are at the mercy of the indifferent commercial agents and indifferent public. Picture dealers per se did not yet exist in early nineteenth-century Boston, but societal reception could be hostile then to the imaginative artist. Ironically, perhaps, the picture's earliest owner was that most significant of all of Boston's early patrons of the arts, Thomas Handasyd Perkins.

Allston's *Catherine and Petruchio*, of 1809, is unlocated and in all probability resembles the *Casket Scene* of a few years earlier. Another in the succession of Shakespearean canvases that Allston undertook through the 1830s, it was owned by Walter Channing, while a study for it was owned by Allston's brother, William.

His other figure painting, *The Valentine* (no. 22), is a very different matter. The picture was inspired by Allston's portrait of his wife and although both are undated, one may presume *The Valentine* to have been done in 1809 or later; Sweetser states alternatively that the inspiration was a Mrs. Russell, sister of Ann Channing Allston. In fact, Allston might have combined several images, a specific moment or stance of Mrs. Russell and his own imagery of his wife, for, given Allston's developed methodology, *The Valentine* would be based upon memory and reflection.

The picture was engraved by James Longacre for *The Common-Place Book of Romantic Tales* of 1831 and was extravagantly admired by Sweetser, Ware, and James Jackson Jarves; it is, in fact, one of Allston's simplest and most touching works. Jarves appears to have admired it more unreservedly than any other work by Allston, praising the sitter's easy, unconscious absorption in her occupation.[43] Although Allston was certainly inspired by the portrait of his wife, he has transformed the fascination with intense candlelight into a general glowing illumination, which renders the letter (the "Valentine") his subject is reading gently translucent. The lady's costume is similar to that worn by Mrs. Allston, but it is more generally rendered and is given the suggestion of a period flavor, though a period undefined.

In other words, Allston has created a generalized image of charm, tenderness, and reverie, and while this may strike the viewer today as commonplace, it was an unusual, even novel form in its time. It is a figure painting, one without story or anecdote, one that communicates a mood and an impression, in this case, not dramatic but poetic. The hierarchy of thematic values had no name for this type of subject; it might later have been referred to as a "fancy piece." But figure painting did not really enter into the categoric consciousness of American art until the late nineteenth century, when Allston's heirs, significantly dominated by Boston artists, included such painters as William Morris Hunt, George Fuller, and William Babcock. Allston himself developed this form into that series of female images of revery which occupied much of his attention and won the admiration of his champions during the 1820s and 1830s. *The Valentine* inaugurated the series and, in turn, inspired a poem by the well-known author Lydia Maria Child.[44] The subjects are often women reading letters and books, and the understatement of their interest and concentration establishes the mood communicated to the admiring viewer. They are a very different breed from the later nineteenth-century ladies of leisure reading books and letters—often, again, painted by Boston artists such as Edmund Tarbell and his associates—who reflect a class and a position in contemporary society. Allston's emphasis is upon the general, not the particular, and it reflects not the contemporary world but, on the one hand, a timeless mood and, on the other, the loveliness of the Venetian tradition seen in Titian's female imagery, again, Allston's link with the tradition of the Old World and the old masters.

To that tradition Allston returned at the age of thirty-one. He never again revisited Italy, but he spent the seven years from 1811 to 1818 living in England, primarily in London. He returned there, not as a fledgling art student but this time as a mature and sophisticated professional artist, who, in fact, must have chafed at the limitations and provincialisms of Boston, and who sought the open cultural vistas and far wider patronage of England. And his judgment was correct. These years constituted Allston's period of greatest success, in the creation of many of his major

historical paintings, in his patronage by some of England's leading connoisseurs, and in the opportunity for self-expression and for development of a cosmopolitan and erudite personality, which far transcended his roots in South Carolina. The experience of these years increased and confirmed his feeling of allegiance to Britain, which he later expressed to his friend and colleague William Collins, in a letter written in 1819 after his final return home: "If it should be my lot never to revisit England I still hope to preserve my claim as one of the British School, but occasionally sending pictures to London for exhibition—a claim I should be most unwilling to forego; my first studies and the greater part of my professional life passed in England among English artists."[45] Allston's declaration was more than an expression of his affection for the art and culture of Britain and a recognition of his personal achievements there; it was an affirmation of his position in the larger context of Western art.

Boston had already begun to take notice of Allston as an exceptional being, a superior creative spirit. Anticipating Allston's return to Britain, Anna Cabot Lowell wrote to her friend Mrs. Anne Grant of Leggan, Scotland, in 1810: "There is one species of genius . . . for which our country, considering its youth, holds a high rank among the nations. I mean Painting; it has for a long time been distinguished for giving birth to painters, who having in this country no masters, and no models but the great sublime of nature, are self-taught. . . . We have also a young man who bids fair to surpass them all; his genius is wonderful; he is a poet as well as a painter, but the pencil is his first and cherished love. Of course the other talent is less cultivated. He has visited England, France and Italy to improve himself. He returned to fulfill an engagement of the heart, but as we have few or no purchasers for such pictures as his he will soon go to England, where I hope the sunshine of patronage may await his labors. Few young men deserve it more. His manners are polished; his mind improved and elevated, his morals pure."[46]

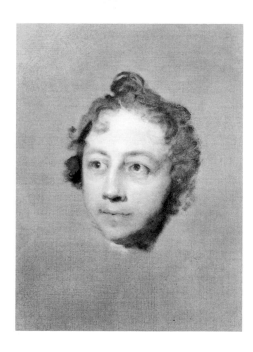

103
GILBERT STUART, American, 1755-1828
Washington Allston, 1828
Oil on canvas, 24 x 21½ in. (61 x 54.6 cm.)
The Metropolitan Museum of Art, Alfred
N. Punnett Fund, 1928

ON JULY 13, 1811, Allston departed from America, leaving from New York, on the ship *Lydia*. He was accompanied by his wife, Ann, and the young Samuel F. B. Morse, who was destined to become his most famous pupil. Ever-admiring of his teacher and mentor, Morse followed in Allston's footsteps in the pursuit of artistic glory through the painting of history. Allston appears to have met Morse in late spring of 1810, just before the younger man graduated from Yale. Recognizing the merits of Morse's early history painting *The Landing of the Pilgrims*, Allston encouraged the fledgling artist and successfully persuaded his reluctant parents to allow him to pursue the profession and journey with him and his wife to study in England.

The matter of Allston's direct influence upon Morse is a complex one. He not only taught Morse the skills of the profession but also guided him through the British art world and some aspects of the course of British society. He remained his firm friend and attempted to gain him major commissions in later years, and he acted as his counselor when these fell through. Allston was certainly the principal influence, benevolently but perhaps wrongly (in retrospect), upon Morse's conviction to develop his talents toward historical painting. More specifically, however, two of Morse's finest and most intimate portraits seem to have been directly inspired by Allston's work. His early *Self-Portrait*, in its sharp, classical profile outline, seems to take its inspiration from Allston's portrait of *Francis Channing* (no. 19), although Morse has introduced a dramatic chiaroscuro and a vigorous brushwork unknown to Allston. More dramatic and yet obvious in derivation is Morse's portrait of his mother (fig. 21), which is based upon Allston's portrait of *Ann Channing Allston* (no. 21). They are both candlelight portraits of women exceedingly close to and beloved by their respective artists, an interpretation almost unknown in American art. And Morse would not only have known the portrait of Mrs. Allston but would also have been close to, almost intimate with, the subject as well as the artist.

Fig. 21. SAMUEL F. B. MORSE, American, 1791-1872
By Candlelight (Mrs. Jedidiah Morse), 1820
Oil on canvas
Yale University Art Gallery, Gift of Richard C. Morse

Allston's party reached Liverpool in less than a month but left quickly because of the antagonistic political situation between America and England, with a ten-day permit from the mayor of Liverpool. They reached London in a week, perhaps traveling in slow stages because of Mrs. Allston's poor health. It would be interesting to know what Allston and Morse saw on the journey.

The Allstons settled into 49 London Street, and Morse into 4 Buckingham Place nearby, both in the vicinity of Fitzroy Square, the residence of many artists in London at that period. In December the Allstons and Morse were joined by another American, the English-born, Philadelphia-raised young art student Charles Robert Leslie, who likewise acknowledged his debt to Allston as one of his mentors. Allston directed young Leslie's attention specifically to Venetian color and painting. Morse and Leslie quickly became firm friends and took rooms together, again in the vicinity of Fitzroy Square, on Great Titchfield Street. Allston and Morse joined Leslie in a love of the theater and in turn became friends of the famous actor, John Howard Payne.

In England Allston resumed his close friendship with Samuel Coleridge, a friendship that became crucial during these years to both men, spiritually and philosophically. Through Coleridge, Allston was enabled to establish friendships with such literary worthies as William Wordsworth and Robert Southey, both of whom acknowledged Allston's genius in their poetry. Coleridge also introduced Allston to Sir George Beaumont, one of the great collectors and patrons of the arts at the time and a founder and director of the British Institution, where Allston had earlier first exhibited his painting publicly. They had met by April of 1812, and Beaumont visited Allston's studio in August of that year. Beaumont was one of the arbiters of taste of his period and, in line with the purposes and concepts of the British Institution, a strong upholder of academic standards, increasingly critical of artists such as Turner, who departed from traditional norms. His collection contained works by Claude, Poussin, and Rembrandt, although his most famous work was probably Rubens's *Château de Steen*. He was also a patron of contemporary British artists, possessing Benjamin West's early *Pylades and Orestes* and a more recent work of note, David Wilkie's *Blind Fiddler*. He also became a significant patron of Allston.

Allston's own belief in the academic tradition recognizing the supremacy of history painting and his wish to ally his art with the traditions of the old masters were thus reinforced by his contact with patrons such as Beaumont and with Coleridge, who led Allston further in the direction of Christian art and incidentally away from the classical tradition. But the most important single influence upon Allston was his old teacher, Benjamin West. Now well into his seventies, West was still a major figure and force in the British art world, still president of the Royal Academy, having weathered numerous attacks within that august institution and severe professional and economic blows without. The most serious of these was the discontinuation of his ambitious scheme originally commissioned by George III for the decoration of the Horn Chapel at Windsor Castle occasioned by a combination of factors. One was the increasing theatricality and occasional morbidity of West's conceptions for a religious pictorial scheme meant to be soothing and revelatory. Another was the increasing royal fear of the taint of democracy and the suspicion that West's American background harbored such seeds, a suspicion reinforced by West's trip

to Paris during the brief Peace of Amiens in 1802. Lastly, the king's increasing mental instability, leading ultimately to the Regency, brought about first a breakdown of the king's personal reliance upon West and finally a withdrawal of his support for West, which had included a comfortable annuity for some three decades.

West, then, had to seek out other means of support and more active ways of regaining a position of artistic prominence after the relative complacency of his years of royal favor. One such successful attempt was his great *Death of Nelson* of 1806, a late equivalent to his famous *Death of Wolfe* of 1770 and a picture visited by 30,000 persons in the artist's studio in one month. He later reaped substantial profits from the sale of engravings. But a follow-up attempt to secure the important commission for a Nelson monument in St. Paul's was unsuccessful. Instead, West's master stroke was the creation of a series of monumental paintings of popular religious imagery, born of his Windsor Chapel project but now conceived on an individually larger scale and for the general public. The first of his great moral dramas, *Christ Teacheth to be Humble,* was not strictly speaking a public offering for it was shown in 1810 at the Royal Academy and purchased by a private collector from Bristol, Harte Davies, for an extraordinarily large sum. But West recognized the significance of this form of popular pictorial sermon, conceived on the scale of life, which brought him greater remuneration than he had ever received outside of royal patronage. The results were his *Christ Healing the Sick in the Temple* (fig. 22), *Christ Rejected,* and *Death on the Pale Horse.*

Fig. 22. BENJAMIN WEST, American, 1728-1820
Christ Healing the Sick in the Temple, ca. 1816
Oil on canvas
Pennsylvania Hospital, Philadelphia

The history of these paintings is beyond the scope or purpose of this essay; it suffices to say here that their success in the exploitation of human emotion, supported by historical references to the work of the old masters, Rembrandt, Poussin, and, above all, Raphael, was a major influence upon the artistic focus of British painting in the second decade of the nineteenth century. The tremendous complexity of the paintings received lengthy interpretations in the critical press, and detailed explanatory booklets accompanied the exhibition on both sides of the Atlantic. The best-known emulation of West's great success can be found in the religious imagery of Benjamin Haydon, but a host of now little-known British artists, such as William Hilton and even Edward Bird (today remembered, if at all, for his Wilkie-inspired genre), were regarded in their own day as younger masters in the revival of historical art in Britain and in the creation of a great, national religious art in keeping with the attempted revitalization of the English Church. Allston was not infrequently coupled with artists such as Hilton in English critical reviews; he and Haydon formed a friendship that led Allston to offer to James McMurtrie the opinion that Haydon ranked among the very first of living artists, while Haydon wrote highly of Allston in the *Annals of the Fine Arts* in 1818 and 1819.

Not surprisingly, American artists of similar inspiration were not exempt from this influence of West. John Trumbull's *Our Saviour with Little Children* of 1812 is directly inspired by West's *Christ Presenting a Little Child,* which in turn must closely reflect West's now-lost *Christ Teacheth to be Humble;* and William Dunlap toured this country in the 1820s with a series of great religious paintings in direct emulation of West, one of which, *Christ Rejected,* is a near-verbatim copy of West's 1814 work. Rembrandt Peale's *Court of Death* of 1820 was the most successful home-grown variant of West's moralizing pictorial sermons taken "on tour." But

the most significant and, in England, the most successful follower and emulator of West was Allston.[47]

Shortly after arriving in London, Allston renewed his relationship with his old teacher and mentor, a relationship that gained additional strength with the introduction of a new aspirant, Morse, into the world of Anglo-American history painting. It was a significant and propitious moment for the renewal of their acquaintance; at that meeting West jubilantly informed Allston of the great success of his *Christ Healing* at the British Institution, which fetched a price of £ 9,000. Allston was no longer a novice, but his friendship with West remained complex; besides respecting his old teacher's professional prominence and warmth of personality, Allston continued to show West the paintings on which he was working and tremendously valued West's opinions and criticisms. He also felt the need to improve his figural draftsmanship and returned to the Royal Academy life classes to draw from the nude.

The first work Allston began after settling in London was his *Dead Man Restored to Life by Touching the Bones of the Prophet Elisha* (no. 25), arguably his greatest and most significant completed painting. This was the work that, more than any other single picture, established Allston's position of prominence on both sides of the Atlantic; it won him the admiration, adulation, and patronage of English critics and collectors, and, partly as a result of that success, was sought after and acquired for a public collection in America. The theme that Allston chose for his magnum opus was a rare one in the history of art; Andor Pigler, in his monumental *Barockthemen*, lists only six previous treatments of the subject. Of these, only the painting by Jean-Joseph Taillasson, now in the Musée des Beaux-Arts, Bordeaux, is a major work, conceived in a very baroque, Rosa-like manner, and certainly unfamiliar to Allston. Coincidentally, or perhaps inspired by Allston's plans, the little-known W. Findlater exhibited along with Allston a depiction of this theme at the British Institution in 1814.

A great deal is known about the *Dead Man,* but, regrettably, some of the pieces in its formation are still missing. For one, there existed a small study for the picture that might be instructive for our understanding of the picture's ultimate development; the study, in fact, was seen by Sir George Beaumont and on the strength of its quality and conception led to Beaumont's commission for Allston's great *Angel Releasing St. Peter from Prison* (no. 28). Even more intriguing is the record of small sculptures that Allston created in preparation for the principal figure in the painting of the *Dead Man:* a sculpture of the total figure and one of the head only, done in clay. The latter belonged afterwards to the Philadelphia portraitist John Neagle.[48] Many years later, in 1838, the young sculptor Henry Dexter, who lived near Allston in Cambridgeport, called upon the master. In the course of his visit, Allston showed him several sculptures he had created for use in his historical canvases, two small figures and a colossal foot.[49] One of the figures may have been a study for *The Dead Man Restored.* Given the basic sculptural origins of pictorial conceptions in neoclassicism, such a procedure is not surprising. Moreover, Allston may have derived the pose of his figure from the most famous and much discussed classical sculpture of the moment, the *Ilissos* figure from the Parthenon pediment, among the marbles that Lord Elgin had only recently brought to London from

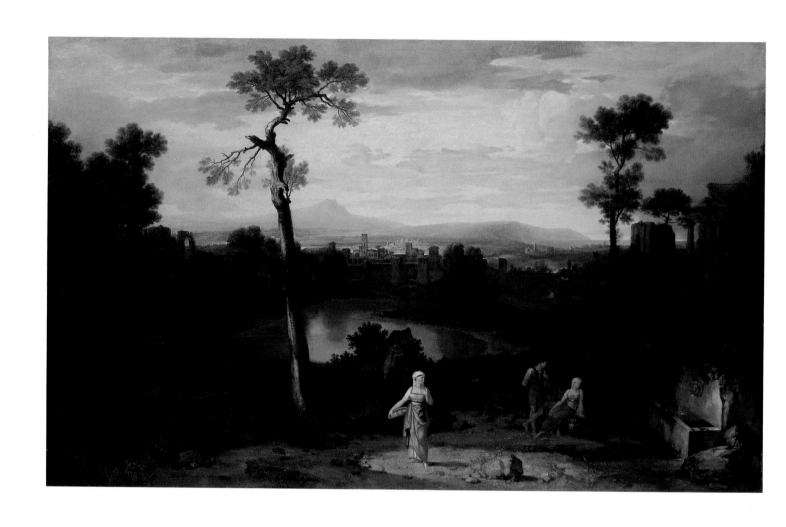

31
Italian Landscape, 1814
Oil on canvas, 44 x 72 in. (111.8 x 182.9 cm.)
Richardson 85
The Toledo Museum of Art, Gift of Florence Scott Libbey

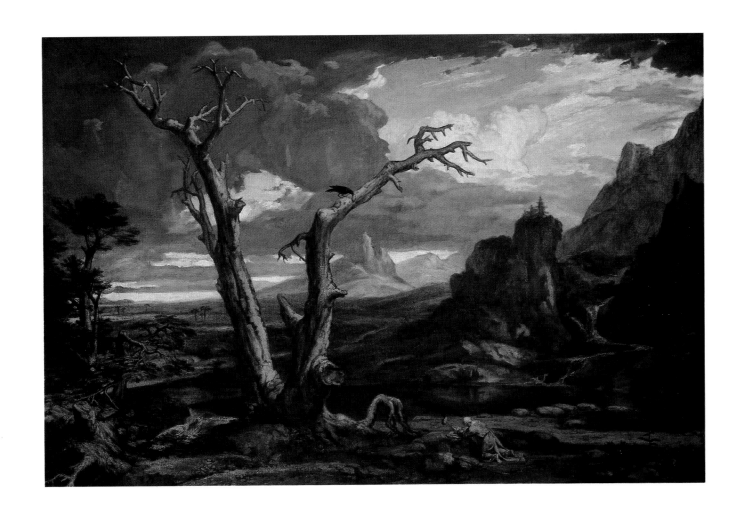

49
Elijah in the Desert, 1817-18
Oil on canvas, 48¾ x 72½ in. (123.8 x 184.2 cm.)
Richardson 107
Museum of Fine Arts, Boston, Gift of Mrs. Samuel Hooper and Miss Alice Hooper

Greece. In so doing, Allston would have allied himself with those artists and connoisseurs who believed in the genuineness of the attribution to fifth-century Greece; among these were West and especially Benjamin Haydon, who reported on Allston's drawing from the marbles. Although Allston's sculptures have long since disappeared, the concept and approach were imitated at the time by his pupil, Samuel Morse, who created a small figure of the *Dying Hercules* in clay, in preparation for his heroic painting of this subject, both inspired by casts of the *Farnese Hercules* and the *Laocoön*. Both were critically rewarded, also, the painting well received at the Royal Academy in 1813, and the sculpture winning a medal the same year at the Society of Arts. Interestingly, a reflection of this methodology can be seen in the sculptures prepared much later in the century by Thomas Eakins for his 1877 painting of *William Rush Carving the Nymph of the Schuylkill*, a work honoring Allston's famous contemporary, who, in turn, was one of the few artist-founders of the Pennsylvania Academy of the Fine Arts, which acquired Allston's *Dead Man Restored* in 1816.

The Elgin marbles were by no means the only formal inspiration for Allston's great painting. Indeed, for the principal figure, Allston also had recourse to those common denominators of so much early nineteenth-century history painting, Raphael's Stanze in the Vatican and his tapestry cartoons. The latter Allston would have seen at Windsor Castle when he was a student in England; at this time they had been returned to Hampton Court. In view of their inspiration for much British history painting exhibited at the British Institution during this decade, the Prince Regent began allowing individual cartoons to be lent to the Institution beginning in 1816. Allston's figure of the dead man resembles particularly Raphael's figure of Heliodorus in the Vatican fresco and Ananias in the tapestry cartoon of the *Death of Ananias* (fig. 23).

Fig. 23. RAPHAEL SANTI, Italian, 1483-1520
Death of Ananias, ca. 1517
Oil on paper mounted on canvas
Victoria and Albert Museum, London

Derived ultimately from the later Raphael and Michelangelo also is Allston's emphasis upon the intense expression of varying emotions, so that each figure is literally "read" for the state of his reaction to and involvement in the principal scene. But this vocabulary has filtered through a series of recognized states from the Renaissance masters, the most significant being their codification by Charles Le Brun, director of the French Academy under Louis XIV, in his *Expression des passions*. Le Brun offered specifications for the reproduction of the different emotional states in gesture and facial expression, which, in turn, were accepted and adopted by English aestheticians and writers such as Jonathan Richardson in his *Essay on the Theory of Painting* of 1715 and William Hogarth in *The Analysis of Beauty* of 1753. Perhaps of significance for Allston, a new edition of Le Brun with twenty copperplate engravings appeared in London in 1813. The emphasis upon this vocabulary of the passions was an important element in the effectiveness of West's religious painting, beginning as early as his *Saul and the Witch of Endor* (fig. 24) of 1777, and it became increasingly significant in his great Revelation series for Windsor Castle and the popular "machines" of the 1810s, Allston's immediate source of inspiration for the *Dead Man Restored*. Perhaps one can relate the intensity of Allston's facial expressions and gestures also to his experience with the contemporary theater in England. Edmund Kean made his theatrical debut in a variety of Shakespearean roles in 1814, bringing a much acclaimed emotional emphasis to

Fig. 24. BENJAMIN WEST, American, 1728-1820
Saul and the Witch of Endor, 1777
Oil on canvas
Wadsworth Atheneum, Hartford, Connecticut

his performances. Already a good friend of John Howard Payne, the American-born actor in London, Allston attended Kean's first theatrical season.

There was yet one other major source of inspiration for Allston's picture, one more specific and perhaps more immediately famous. This was the great *Raising of Lazarus* by Sebastiano del Piombo (fig. 25), then in the collection of John Julius Angerstein, whose collection formed the basis of the National Gallery in 1824. The *Lazarus* was registered as the first acquisition of that gallery. Indeed, the relationship of Allston's work to the *Lazarus* is quite complex. Given Allston's intense admiration for Michelangelo, who had, for him, greater genius and imagination than even Raphael, and his concern for and dependence upon Venetian coloristic methods, the Renaissance master most renowned for the combination of Michelangelesque form and Titianesque color might certainly serve as the ultimate model of inspiration. The *Lazarus,* in fact, was said by Vasari to have been painted by Sebastiano in 1517-1519 with the assistance of Michelangelo himself; it was done in competition with Raphael's *Transfiguration,* the most admired masterwork of all the Renaissance in Allston's time (as well as before and after!). Thus, the *Lazarus* was the Michelangelesque challenge to the primacy of Raphael.

Allston's painting, then, like a number of his other major religious works of the decade, may be seen as a combination of homage to the masters of the past whom he most admired and an application for his own elevation into the modern equivalent of their rank. With the continued recognition of the supremacy of history painting, now receiving new impetus with the activities of the British Institution (which was devoted especially to its furtherance), and the private patronage of such painting by Beaumont, the Earl of Egremont, and others, and the visible proof of its popularity in the work of West, Allston here found a congenial, even ideal working ground for the expression of his historical ambitions.

The picture is, of course, not only an emulation of the past but also an expression of Allston's artistic and philosophic purposes. Allston's most ambitious, often most successful religious works are concerned with miracle, mystery, and revelation, surely in the wake of West's concerns in the Chapel of Revealed Religion. In such subjects, Allston could demonstrate the power of the sublime—the effects of startling drama with forces proceeding from the Deity—as it at once affects human consciousness in great variety and reveals eternal truths.

Long explanatory passages accompanied the picture on its several exhibitions on both sides of the Atlantic, affirming the meaning of the sensate reactions to the witnessed miracle of the dead man reviving during his interment.[50] Allston has portrayed a rough, shadowy ambience of a cave where the miracle takes place. Two slaves, at the head and feet of the principal figure, express astonishment, fear, and doubt, while above, an armored soldier fearfully rushes away, instead of displaying the usual military firmness. Next to him, a figure holds the soldier's arm, expressing curiosity rather than fright. In the upper left, two men listen to the explanation of a priest, while a young boy attends, too young to understand the miracle. Balancing them on the right are two young men conversing. Centered in this upper range are the fainting wife of the "deceased" and her daughter, the latter now joyful but solicitous of her mother.

Allston later stated that he regretted the introduction of this last group. He rec-

Fig. 25. SEBASTIANO DEL PIOMBO, Italian, 1485-1547
The Raising of Lazarus, 1517-1519
Oil on canvas
National Gallery, London

32
Samuel Taylor Coleridge, 1814
Oil on canvas, 44 x 33½ in. (111.8 x 85.1 cm.)
Richardson 81
National Portrait Gallery, London

48
Samuel Williams, ca. 1817
Oil on canvas, 56 x 44 in. (142.2 x 111.8 cm.)
Richardson 110
The Cleveland Museum of Art, Purchase, Mr. and Mrs. William H. Marlatt Fund

ognized these two figures as dramatic, the rest of the scene as epic. For pictorial theory of the time, this was more than a matter of semantics. As spelled out in Robert Bromley's *A Philosophical and Critical History of the Fine Arts,* of 1793-1795 (which any student of West's would have ample reason to know, given Bromley's championship of West as the greatest history painter of the age), epic painting reached for eternal truths, while dramatic history painting was more concerned with the immediate situation and its effects.

We may note, then, that Allston's opus, unlike its possible Raphaelesque origins, is concerned with life, or rebirth, not with death; with uplift and inspiration, not with destruction. In this it is also emulatory of the *Lazarus* of Sebastiano; indeed, Allston's miraculous subject can be seen as an Old Testament counterpart to that most famous of Christian resurrections. Allston's aim, in fact, was more difficult and more ambitious than Sebastiano's for his purpose was to portray the miracle itself, the sense of divine revivification, while the Renaissance masterwork illustrates Christ as agent of resurrection.

Allston embodies the force of resurrection in no human or divine figure but rather in light. As his subject is a divine miracle, so his agent of the miraculous is the glowing light that irrationally but supernaturally radiates from the foreground figure of the once dead man, now unwrapping not only his winding sheet but also the source of illumination—animation—beginning to fill up the darkened cave, so that the glow of natural light in the outside world in the upper right pales against the spiritual light at the bottom of an otherwise dark cavern. Thus, also, the rationale for Allston's choice of a vertical format, so that the glowing illumination can radiate upwards in opposition to the course of natural light, a format that also offers a parallel to the inspirational example of Sebastiano. The format also created problems of a different kind for Allston, for the spatial piling up of successive layers of figures who are "read" more vertically than recessionally was one cause of confusion and criticism when the work was exhibited.

The painting was not a commissioned work but was conceived by Allston in the manner of West's *Christ Healing the Sick* (fig. 22) and *Christ Rejected.* West, in fact, visited Allston's studio during the course of the creation of the work and recognized it as a continuation of the forms and ideals of the Renaissance.[51] He also predicted that it would be admired as such and was not mistaken, for the picture was shown to much critical acclaim. Allston originally had in mind a private exhibition of his picture (as West was to arrange for his own *Christ Rejected* in 1814) and had gone so far as to rent a Pall Mall gallery, but Sir George Beaumont persuaded Allston to show his work at the British Institution, certainly a more sensible consideration for a still little-known painter, and one who was a national of a country with whom the British were at war! Since Beaumont was one of the most influential figures of the Institution, Allston could be assured of a positive reception and an excellent hanging position—although one of the advantages of the creation of enormous, "Salon-size" paintings for public exhibition was their enviable hanging requirements, if accepted; unlike a bust portrait or a small landscape, a painting thirteen feet high could not be hidden or "skied"!

Allston had hoped to exhibit the picture in 1813, but it was not completed in time for exhibition that year. He felt he had put his finishing touches upon the work on

January 1, 1814, and it was shown at the British Institution in that year. (Richardson's statement that it was exhibited in 1813 is incorrect; furthermore, since Allston worked on the painting extensively in 1814, it should be dated 1811-1814, as we shall see.) The work was well received, and was awarded the major prize of 200 guineas, as among the finest history paintings of that exhibition and in conformation with the stated purposes of the Institution. The press was equally responsive. The critic for the *Examiner* wrote on February 13: "The dead Man restored to Life by touching the Bones of Elisha, W. Allston, is a work which comes at once before us with the double and delighted surprise of high excellence from a novel hand, such a hand as would justify its being placed at the side of some of the best Masters of History, and which makes us deeply regret that the brother natives of two such countries as Great Britain and the American Republic, should be engaged in any other war than that of social and intellectual rivalry, the only rational hostility of sentient beings. . . . Mr. Allston's mind's eye is evidently nourished by invigorating, close, and intelligent study of the lively graces of the old masters and the antique. For the rich, ocular, and intellectual treat he has afforded us, we offer him, as a small proof of our thankfulness and esteem, the testimony of our humble approbation."

William Hazlitt, in *The Morning Chronicle* of February 5, was more reserved in his judgment, although he too felt that Allston "deserves great praise both for the choice and originality of the subject, the judicious arrangement of the general composition, and the correct drawing and very great knowledge of the human figure throughout." Hazlitt recognized some affinity with the work of Raphael but felt that the faces "in the school of Le Brun's heads" were too much theoretical diagrams of the passions, rather than natural or profound. He summed up his criticism by stating: "we think Mr. Allston's picture demonstrates great talents, great professional acquirements, and even genius; but we suspect that he has paid too exclusive an attention to the instrumental and theoretical parts of his art. The object of art is not merely to display knowledge, but to give pleasure."

News of the success of Allston's picture soon spread. Coleridge reported that the Marquis of Stafford wished to buy the work and that Stafford, Beaumont, and the collector William Howell Carr wanted to acquire it for the British Institution, but they were persuaded against it, partly out of growing anti-American sentiment and partly out of Benjamin West's envious bad-mouthing. Instead, the Institution paid 566 guineas for William Hilton's *Mary Anointing the Feet of Jesus*. In a letter to J. J. Morgan of June 16, 1814, Coleridge deplored Beaumont's fickleness and accused West of duplicity, having already warned Allston of the "excessive meanness of Patrons, of the malignant Envy & Brutality of the Race of Painters!"[52] Coleridge's account, however, must be considered suspect, for his letters at the time, particularly in regard to Allston, were extremely paranoid. Vanderlyn wrote to Allston in November of 1814 that George Wallis, who had been in England and was now his neighbor in Paris, spoke of the painting with highest praise. More important, on the cessation of hostilities, James McMurtrie of Philadelphia appeared in London about September of 1815 and, after enthusiastically viewing *The Dead Man Restored*, persuaded the Pennsylvania Academy the following year to purchase the picture for $3,500 in three installments, certainly the highest price there-

36
Rebecca at the Well, 1816
Oil on canvas, 29¾ x 35½ in. (75.6 x 90.2 cm.)
Richardson 92
Fogg Art Museum, Harvard University, The Washington Allston Trust

37
The Sisters, ca. 1816-1817
Oil on canvas, 49½ x 38¾ in.
(125.7 x 98.4 cm.)
Richardson 109
Fogg Art Museum, Harvard University, Gift of Mrs. Edward W. Moore

tofore given for a work by a painter of the new Republic. (Allston may well have been in dire need at the time; Coleridge reported that his property was lost in a London bankruptcy in 1814.) The negotiations were carried on with the assistance of Thomas Sully and McMurtrie, who became a close friend and an occasional agent for Allston. Part of the huge sum was raised by subscriptions of $20 each, but the larger part was secured through a loan in which the Pennsylvania Academy building was mortgaged for security in 1817. Allston's tremendous satisfaction with this patronage was to some extent offset by the tardiness of the payments to him. Even after his return to America in October 1818, he had not been fully paid, and the following month he wrote to McMurtrie, asking for the balance due him to be sent to Boston. However, his satisfaction with the honor of its purchase remained sufficient so that he relinquished any interest payments.

The acquisition of *The Dead Man* was significant for a number of reasons. The Academy thus established a pattern of acquisition, primarily of American works, and it became both a repository and a study collection. The purchase also indicated the prevailing preference for grand-manner historical paintings, to which testimonial was given in a special exhibition held in the year the picture was acquired. The exhibition also included a large group of paintings by Charles Robert Leslie, among which was *Murder of Rutland by Lord Clifford*, of 1815, his most significant known work in the historical manner advocated and taught by his teachers, Allston and West. For Allston, the purchase not only offered a sizable financial reward but also established his reputation in his native land, and it must certainly have been a factor in his decision to abandon his successful career in England and return home.

The Dead Man Restored was not, of course, the only painting on which Allston worked during the years 1811-1814. Leslie, in a letter written after Allston's death, recalled a *Cupid and Psyche* the size of life, painted in the manner of Titian and much admired by William Wordsworth, who found the style of coloring unlike that of any other artist.[53] This work is lost, as is another classical subject, his *Diana,* which was seen by West who commented that it looked like a bit of Titian, particularly in the flesh tones. West saw the painting when it was exhibited at the British Institution along with *The Dead Man*. From a review in the *Examiner* of March 6, we know a good deal about the *Diana,* which was praised at the expense of the depiction of a similar subject by Samuel Woodforde, *Musidora Bathing.* "How unlucky is it for him," the critic observed, "that his picture is hung in contrast with Mr. Allston's *Diana Bathing,* which without any striking beauty of shape or attitude, has such an air of reality, is so forcibly yet so delicately marked and has so bright and so tender a hue over all her limbs, that in these respects, Guido himself has done nothing in his exquisite little silvery pieces to surpass it. The landscape is delicately conceived and touched."

Not long after Allston began *The Dead Man Restored,* he received the important commission from Sir George Beaumont that culminated in *The Angel Releasing St. Peter from Prison* (no. 28), but this work was not completed until 1816. Meanwhile, in 1813, he had commenced a New Testament subject, *Christ Healing the Sick* (no. 29). This was Allston's most direct emulation of the great works on which West was engaged during this decade and, in fact, deals with exactly the same subject as his teacher's successful picture of 1811.

Allston became dissatisfied with his treatment of the theme and abandoned the work, which is known today in a large sepia study and an uncompleted oil version; the latter is of particular interest in revealing Allston's technical methodology, many areas of the painting being dead-colored, before the application of softening, luminous glazes. But even in its incomplete state, the work is an impressive rendering of the traditional theme. Allston's dissatisfaction stemmed from two interrelated factors. He was unhappy with the figure of Christ and concluded that he should never attempt to render this subject; indeed, he never again ventured to do so. Allston came to believe that neither the conception of the Creator nor the image of Christ could be rendered satisfactorily, since their power was impossible to comprehend, they would necessitate a pictorial brightness beyond human artistry. Thus, it is an ironic conclusion that Allston's figure of Christ remains in dead coloring—lacking the luminous glazes that could not achieve the requisite celestial splendor.

Allston's original goal was to depict the actual miracle of healing. This is important, for he acknowledged that West had successfully rendered the narrative story, showing Christ in the act of healing and successfully depicting the sick man wanting this healing. Allston's aim was different and, of course, a basically impossible one. But the miraculous could at least be approached in subjects of mystery such as *The Dead Man Restored;* the challenge in this New Testament subject was beyond him, perhaps since the figure of Christ was itself one of potential miraculous embodiment and yet one traditional if not hackneyed in the history of painting. Allston concluded that he had only succeeded in his studies in expressing the factor of illness and disease, although he felt that the rendering of the blind boy was effective. This, presumably, is the small figure in the extreme right of the oil study and the most significant change from the first sepia sketch.

Allston had chosen certainly a very traditional approach to the rendering of the biblical story. Though obviously acknowledging a debt to West, who was actually working on his large rendering of the subject when Allston visited him in 1811, Allston has depended as much or more on the painting of Raphael. In the centralized imagery, the symmetry, and the double figural placement, curving at the sides to ease the transition between the two levels, Allston's picture is strikingly similar to Raphael's *Death of Ananias* (fig. 23), while Christ's gesture toward the lame man mirrors that in Raphael's work. The figure of Christ himself is almost a mirror image of that in *Christ's Charge to St. Peter.* These are in the series of cartoons by Raphael that were, in 1813, hanging at Hampton Court Palace; it is of significance, therefore, that the Allstons, with Leslie and Morse, made a visit to the palace early that year.

Had Allston been satisfied with his studies for *Christ Healing the Sick,* he would have enlarged it to monumental proportions, and he estimated that its execution would have consumed between eighteen months and two years. It is perhaps unfortunate that he did not follow this plan, for the painting might well have developed into one of the major religious works of his career and a major contribution to British painting. Allston's self-doubts were only partly reasonable, for the embodiment of the miraculous, when successful in such works as the *Dead Man Restored* and *The Angel Liberating St. Peter,* was achieved through and within his adept handling of colored light and luminosity, which could not even be hinted at in his studies as

41
Uriel in the Sun, 1817
Oil on canvas, 97⅝ x 78 in. (248 x 198.1 cm.)
Richardson 106
Mugar Memorial Library, Boston University

47
Isaac of York, 1817
Oil on canvas, 30 x 25 in. (76.2 x 63.5 cm.)
Richardson 94
Hirschl & Adler Galleries, New York

we know them today. A distant reflection, though not entirely fortuitous, of what such an achievement might constitute can be seen in the large *Christ's Entry into Jerusalem* of 1814, by Benjamin Haydon. Haydon was an English colleague and friend of Allston's of the same generation, similarly inspired by West's popular religious series and even more dedicated to the thematic and formal ideals of the old masters than Allston. In a letter of 1831 Haydon mentioned that Allston and Beaumont had visited his studio to see the progress of his painting. Allston's delight with Haydon's picture is recorded in correspondence.[54] Allston may well have been interested in and enthusiastic about Haydon's picture, for it may have embodied qualities that he himself had sought, unsuccessfully.

Allston appears, for the most part, to have remained in London during this time, making only an occasional journey to other parts of England, such as the short visit to Hampton Court. Morse, meanwhile, had ventured farther afield. On the voyage to Britain, in 1811, he and Allston had made the acquaintance of a Captain Visscher (or Visger) and his wife, who had in turn given them introductions to Harmon Visger of Bristol, a wealthy merchant, father of seven children, and something of a patron of the arts. Visger was related to the Van Rensselaer family of New York. Morse appears to have spent the early months of 1813 in Bristol, but he returned to London in late April because of Allston's indisposition and reported to his parents on May 30 that, owing to illness, Allston was unable to finish and therefore to exhibit his *Dead Man Restored* that year.[55]

In the summer of 1813 Allston visited Bristol himself, but the initial reason for this had to do with his health rather than with family ties or with his art. During the several years in which he was actively engaged upon *The Dead Man,* Allston's ambition to create a vast work of considerable impact upon both the public and the critics had caused him to severely neglect his health. Allston's wife and his friends Morse, Leslie, and Coleridge became deeply solicitous of him, and Allston finally accepted the invitation of his uncle Elias Vanderhorst to vacation in Bristol. The Allstons, Leslie, and Morse set out on the journey, but Allston became so ill by the time they reached Salt Hill, near Windsor, that Morse hurried back to inform Coleridge. The latter immediately brought his friend the eminent doctor G. L. Tuthill to care for Allston. After several days, Allston was well enough to proceed slowly to Bristol, visiting Oxford, Blenheim, and Bath along the way.

When Allston finally arrived, he settled into the lovely suburb of Clifton, recommended to him by Vanderhorst. The exact nature of his further treatment is somewhat confused, for according to Allston's biographers, he was immediately put under the care of the noted surgeon of Bristol, Dr. John King, to whom Coleridge had procured for Allston an introduction from Robert Southey. Yet, the introductory letter from Southey is dated September 17, 1813, by which time Allston had already returned to London. It would appear, then, that he gradually recuperated enough in Clifton to return to London to continue work on *The Dead Man Restored,* which Southey admired greatly when Coleridge brought him to Allston's London studio in September. Southey remarked, also, that Allston looked like a ghost but was recovering. In all likelihood, King began treating Allston in late September of 1813. Coleridge wrote from Bristol, on October 24, that King had performed several operations on Allston for stricture or thickening of the colon,

likening Allston's infirmity to that of Thomas Wedgewood, but mentioning also that Allston was better and out of pain. The patient-physician relationship in Clifton was made difficult by the antipathy of Allston's uncle toward the medical profession. Several stories exist of the discrepancy between the rich, lavish meals sent in to Allston by Vanderhorst and the thin, meager gruel prescribed by King, and of the Allstons' manipulation of the various visits by Vanderhorst and King so that their paths would not cross.

Allston seems to have been able to work at this time, however, for Coleridge mentioned that the artist had sold several paintings to Harmon Visger for £160. Allston also appears to have completed his book of poetry, *The Sylphs of the Seasons,* which he had begun in America and now published. By late November Allston had moved from 5 Richmond Place in Clifton to 18 Pritchard Street at Portland Square in Bristol, where Visger himself resided.

Morse was also in Bristol in October for professional reasons. He stayed for five months during the winter of 1813-14, returning to London sometime in March and planning a return engagement in May. He also stayed near the home of Harmon Visger and painted a portrait there of James Russell of that city. His activity in Bristol, in fact, seems to have consisted wholly of portraiture. Allston kept in communication with Morse, sending New Year's greetings to him in a letter soliciting advice from Visger, through Morse, as to the price that should be placed upon a landscape—whether 500 or 600 guineas. A little later, in January 1814, Allston wrote further about the painting which apparently was to be raffled off; he advised Morse against subscribing to the lottery, since his winning the picture was naturally problematic and might lead to a charge of collusion.

Allston, meanwhile, was busy in London. Leslie reported to Morse that a number of Allston's close friends had returned to the capital, including Wallis, the friend from Allston's Roman years, and James Lonsdale, a portrait painter and pupil of George Romney. Allston was also preparing his pictures to be exhibited in London, the *Dead Man* and *Diana* for the British Institution and his *Landscape, Italian Scenery,* for the Royal Academy.

By the summer of 1814 Allston had returned to Bristol, this time for artistic endeavor. He was busy arranging a one-man exhibition of his work there, encouraged by his local friendships and the fame resulting from his success at the British Institution. In early June Allston called upon Coleridge in Bristol, and a month later on July 5, he wrote to Morse that he had taken Merchant Tailors' Hall there. Allston is known to have painted in Bristol *The Agony of Judas,* "the finest head he had ever painted," in his own words; but he later destroyed it, feeling that he might gain a reputation by recording so dreadful a reality as that scene. Another major activity, however, was his retouching of *The Dead Man Restored* (no. 25). He told Morse that he had repainted the greater part of the draperies of all the principal figures except the dead man, with powerful, positive colors and had strengthened the shadows. Coleridge wrote on July 7 that he had visited Merchant Tailors' Hall and found only the great picture there, which Allston had improved greatly; the other paintings were at the artist's lodgings until later in the week. Allston was also engaged by Harmon Visger to paint a large transparency of a gigantic figure in the attitude of terror, shrinking from an imp sitting on his shoulder—a figure that, if

standing, would have been eight or nine feet high. It was a work obviously in the manner of the admired Fuseli.

The Allston exhibition, consisting of eight paintings, opened on July 25. Although not a large exhibition, it represented something of a landmark. It was one of the earliest one-man shows held in England of the work of a living artist, although it had been preceded by, among others, Joseph Wright's 1785 show in London of twenty-five pictures and Francis Towne's large watercolor exhibition of 1805. Richard Westall, who had won a large premium at the British Institution in 1813, exhibited several hundred of his works, in his own gallery in Fitzroy Square in London, in the same year as Allston's Bristol exhibition. Allston may also have been inspired to hold his show by the memorial exhibition at the British Institution in 1813 of the work of Sir Joshua Reynolds. What was especially unusual was Allston's exhibiting in a provincial center, which was constantly lamenting its own lack of artistic and cultural patronage, despite the presence in and around the area of significant writers such as Coleridge, Southey, and Hannah More, and intellectuals and patrons such as John Eagles, John King, and Richard Cumberland.[56] Of course, Allston must have been encouraged to undertake this venture by his relatives and friends, and by prospective patrons in Bristol, and the contact he had made with Dr. King the previous year was certainly fortunate. This was also one of the earliest one-man shows of a living American artist, followed many years later by the much larger Allston exhibition held in Boston at Harding's Gallery in 1839.

Allston's exhibition in Bristol was open from twelve to seven each day except Sunday and was accompanied by a small catalogue. Allston announced that all the paintings were for sale and that prospective purchasers could apply to him at a Mr. Humphrey's on Paul Street, Portland Square. The major feature of the show was, of course, *The Dead Man Restored,* and this was naturally singled out by the local press, although all the works shown were much admired. In the *Bristol Gazette,* for instance, on August 4, appeared the following comment: "We congratulate the Public, and the Amateurs of the Art, on this very exquisite and delightful treat. The collection consists of eight pictures executed by this gentleman. On which pictures to begin our admiration when all are in their various ways so admirable, it is difficult to determine."

Allston, in fact, appears to have consciously attempted to display the scope of his talent, a course that Coleridge had earlier advised against in Allston's London debut. One picture that received even greater critical attention than *The Dead Man Restored* was his *Scene in an Eating House* (no. 30), about which the *Gazette* commented at length: "This is a comic picture. An attempt to unite the humour of the Dutch school, with the colour of the Venetian The waiter, a boy, is represented as having had the double misfortune, of at the same time breaking a tureen of soup and of spilling its scalding contents on the legs of a German fiddler." The *Gazette* then went on to point out one of the humorous issues of the picture, the contrast between the reactions of the onlookers according to their nationality: the insincerity of the Frenchman, the indifference of the Dutchman, and the immoderate laughter of the Englishman. In addition to the exaggerated emotional reaction in the picture is the contrast between a drunken simpleton and a shrewish lady tavern keeper. The work was another of the rare excursions by Allston into the area of

comic genre, and although we have noted its precursors in *The Buck's Progress* watercolors (figs. 69-71 below), the *Falstaff* pictures, and the *Poor Author and the Rich Bookseller*, Allston may have received additional inspiration here from the growing contemporary vogue for scenes of everyday low-life. Such inspiration ultimately derives from David Wilkie, for the Scottish artist was enjoying great fame at the time, and from patronage of such collectors as Beaumont. Allston may also have been equally inspired here by the example of Bristol's own Edward Bird. A friend of Coleridge's, Bird was known to Allston, and there appear to have been exchanges between the two artists during these years. Local supporters of the arts in Bristol were then encouraging Bird as an English rival to the Scottish Wilkie, and Bird was enjoying a strong measure of success in London. He was also Bristol's first artist of national importance, and his popularity with both Bristol and London connoisseurs may have led to Allston's painting the *Scene in an Eating House* in 1813 and exhibiting it in Bird's native town the following year. Later, Allston's great *Belshazzar's Feast*, begun in London in 1817, bore a compositional and expressive debt to Bird's diploma picture of 1815, *Proclaiming Joash King* (fig. 26). In turn, Allston's exhibition of 1814 set the stage for the memorial exhibition in Bristol in 1820 of Bird's paintings, the second art exhibition of significance in that city. Allston, by that time, had returned to America, but he noted with sadness the death of his English colleague, although there is no indication that they were more than casually acquainted.

Fig. 26. EDWARD BIRD, 1772-1819
Proclaiming Joash King, 1815
Oil on panel
Royal Academy of Arts, London

The *Scene in an Eating House* is not painted in a manner particularly similar to Bird's; it is too exaggerated for that, and Allston has used tones and glazes that bear witness to his very individual dependence upon his study of Titian and the Venetian old masters. The *Gazette*, in fact, went on to say: "It is in the most vivid tone of the Venetian school, and so it differs from every piece of the Flemish kind which we recollect to have ever seen here the artist has given a gem-like lustre to a Flemish subject." This is, in fact, one of the most striking aspects of Allston's art, his willingness to invest one traditional form of art with the technique and even the reverence traditionally accorded to another. By interpreting low-life themes with "high art" methods, Allston endows the pictures with a new respect, curiously similar to the monumentalizing of plebeian subject matter that Gustave Courbet undertook decades later. Allston is also here amalgamating his studies and knowledge of the past, combining Low Country baroque and Italian Renaissance traditions. It may be this painting to which Sir Thomas Lawrence's biographer, D. E. Williams, referred in 1831 as characterized by "broad humor in the style of Hogarth,"[57] for it is the only mature comic piece Allston composed in England; it seems far less likely that Williams would have known either of Allston's early works of about 1802, *A French Soldier Telling a Story* or *The Poet's Ordinary*, although he may have been familiar with one or both of Allston's illustrations for Washington Irving's *Knickerbocker's History*.

A number of classical subjects were also shown in the Bristol exhibition. These included a *Hebe*, now unlocated, described in the press as the size of a whole-length portrait and commended for its color, grace, and beauty of form. There was also the *Diana*, which had been shown at the British Institution; this may have been the painting that figured in the correspondence between Harmon Visger and Morse

early in 1814. Visger therein greatly commended the *Diana* but felt that he could not hang it, and he wrote that he would rather purchase a landscape or a comic piece. Also in the Bristol show was a *Landscape Depicting Diana and Her Nymphs in the Chase,* the early painting done in Rome in 1805, which Allston had to rework somewhat after the storage of the paintings at Leghorn for six years. The picture was later retouched by another hand in Boston, and according to Flagg, Allston claimed, "It is not my picture now," when he saw it in the collection of his patron Isaac Davis of that city. Another of the paintings shown was *The Rising of a Thunderstorm at Sea* (no. 7), which had been painted in Paris. Presumably, then, this work had also been stored in Italy since Allston's departure of 1808, although conflicting reports indicate that it had been sold to a Boston collector. In any case, by their presence in the Bristol exhibition, they offer proof that these early paintings, along with both Allston's and Vanderlyn's old master acquisitions, had arrived in England by the summer of 1814. Indeed, the addition of these works to the limited group Allston had painted by that time may have been the inspiration and rationale for the Bristol exhibition. Allston wrote to Vanderlyn the following year, on August 17, 1815, that the pictures from Leghorn, including Vanderlyn's "Veronese," had recently arrived, but given Allston's tendency toward procrastination, the immediacy here suggested should not be taken too literally.

Another seascape in the show, *Rain at Sea,* now unlocated, was described by the *Gazette* as "more quiet," and with "this wet and heavy atmosphere exceedingly well expressed." The artist also exhibited *Casket Scene from the Merchant of Venice,* which had been painted in Italy. And, about a month after the opening of the exhibition, Allston added three more pictures: a large landscape of *Italian Scenery* (no. 31) and "two portraits of gentlemen residing in or near Bristol." The *Italian Scenery* (or *Italian Landscape)* had just been exhibited at the Royal Academy, which must account for its late arrival. At that time, the London *Examiner* compared it in its imaginative, poetic qualities with Turner's *Dido and Aeneas,* while noting that Allston had well studied the great Italian painters and the Poussins. This landscape, one of Allston's most beautiful, appears to be a transition from the heroic forms of his *Diana in the Chase* and his late landscapes done in America. The forms in the picture, and its composition, are still classical, and the spatial recession is deep, but the heroic mountains have disappeared, and the landscape is endowed with a mood of poetry and reverie.

One of the "two portraits" was almost certainly that of his surgeon, Dr. John King (no. 33), and the other, his second depiction of Coleridge (no. 32), of 1814. King is portrayed as a three-quarter, seated figure; he is shown rather low in the painting, his face in benign relaxation, looking out beyond the artist and the spectator. A classical reference is suggested in the column or pilaster behind him, and even more in the unfocused gaze out into the unknown—that is, beyond everyday concerns. Allston's portrait of King is one of his finest, one of the most poised of his likenesses, with a sense of timeless grandeur.

Perhaps the most unusual aspect of the picture is that Allston has not portrayed King as a doctor at all, despite his recent—and successful!—association with King in that regard. It is possible, of course, that Allston preferred not to recall the pain and unpleasantness of that aspect of the association, but even so, there seems to be

implied here a calculated choice of art over science, perhaps desired by both artist and subject. King is depicted in his role of patron and art collector, and especially as amateur, for he holds a small book and a watercolor brush rather than, for instance, a scalpel, in his hand. King was not merely a leader in the intellectual community in Bristol; he had also been a professional artist himself in London before coming to Bristol in 1799. He was a friend of both Coleridge and Southey and was married to Emmeline Edgeworth, sister of the famous novelist Maria Edgeworth. It is this aspect of King's personality and interests that Allston has chosen to depict.

King was also a close associate and occasional patron of the local artists, and Allston's friendship with him suggests another point of contact with other painters of the Bristol school. Edward Bird, for instance painted a portrait of King (fig. 27), an immediate, lively likeness in strong contrast to Allston's timeless one; and the miniaturist Nathan Branwhite was another local artist who painted the doctor's portrait. Even more intriguing is the pastel of King by either James or Ellen Sharples. The Sharpleses had spent much time in America, and James died there, whence Ellen and several of her children returned to England and settled in Bristol. Although there is no concrete evidence of Allston's association with the Sharpleses during his stays in Bristol in 1813 and 1814, it is quite probable, for one of the family, presumably Ellen, drew in addition to the pastel of King the likeness of Allston's uncle, Elias Vanderhorst.

As mentioned, the other portrait added to the exhibition at Merchant Tailors' Hall seems almost surely to have been that of Coleridge (no. 32). It was painted for Coleridge's friend Josiah Wade, of Bristol, and was much later acquired by the National Portrait Gallery in London; a copy or replica of it hangs in Jesus College, Cambridge. Although Allston emphasized that he was painting Coleridge in repose, the portrayal, like that of King, is an extremely dignified one, with Coleridge also shown in intellectual isolation and with gaze averted, and placed in a Gothic setting. The dark ambience seems appropriate, as Coleridge appears to radiate light from within, while the tall lancet windows and shadowy sculptural forms in niches add a note of religious reverence; it has not been determined whether Allston drew upon a specific architectural setting or concocted an appropriate one from his prior experience and his imagination. For this work, as for *The Dead Man Restored,* Allston may have relied upon a now lost sculpture, as Coleridge reported to Beaumont in a letter of December 1811 that he had had "a mask taken, from which, or rather with which, Allston means to model a bust of me." This is more likely, however, a momentary confusion on Coleridge's part, for in 1811 George Dawe, who, like Allston, was a painter rather than a sculptor, did take a life mask of Coleridge from which he fashioned a bust that was exhibited at the Royal Academy in 1812. Wordsworth said of Allston's picture that it was the only likeness of Coleridge that ever gave him any pleasure—the finest done of the poet; and Coleridge's family, also, spoke of the painting as the best likeness of him. (It is probably this portrait that Edward Everett attempted to acquire in 1847 through George P. Putnam.) Allston, too, thought the portraits of King and Coleridge among the finest he had ever painted.

These works might also have been added after the original opening of the exhibition because they were painted in late July and August. The King portrait was a gift to the surgeon in appreciation of the medical attention he had bestowed upon the

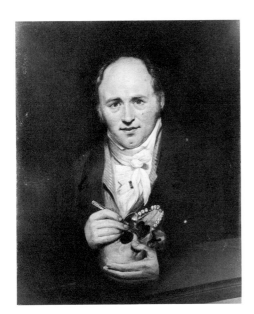

Fig. 27. EDWARD BIRD, 1772-1819
Dr. John King
Oil on canvas
City of Bristol Museum and Art Gallery

artist. A still missing portrait is that of Mrs. King. One might speculate that King, receiving his own portrait as a gift, then commissioned the artist to paint his wife as a pendant; her portrait, then, created later than that of her husband, would not have been ready for the exhibition and was thus not included.

The period around 1814 constitutes Allston's second and final significant excursion into portraiture. Sweetser states that Allston also painted a portrait of Robert Southey at this time, but no other record of such a work is known, and no possible example has yet come to light. Allston did paint at this time, again after the exhibition had opened, a portrait of his cousin, Elizabeth Taylor, daughter of his uncle, Elias Vanderhorst, and wife of J. Duncombe Taylor of Bristol. The picture is referred to in a letter Allston wrote to Mrs. Taylor on October 22, 1814; two years later, Elias Vanderhorst bequeathed the picture to her. Either this or the portrait of Mrs. King is probably one recalled by Dana as particularly elaborate in costume and jewelry.[58]

It is noteworthy, of course, that again Allston's interest in portraiture was a concern for the depiction of friends and relatives close to him, the recognition of their intimacy, and the exploration of their psyches, rather than the traditional commissioned portrait. Another portrait painted or at least begun this year, 1814, was of Benjamin West (no. 34), although it was not painted in Bristol. It was commenced after Allston had finished his small picture of *Diana*. The head alone was painted at the time; the body and background were not added until over two decades later, in America. No recognition is given here to West of his role as president of the Royal Academy or as a major historical painter. Rather, Allston depicts West in very beautiful old age. A luminous likeness from which an inner radiance shines out, almost obviating the suggestion of growing feebleness and infirmity, it is a just homage to Allston's revered master and friend. Many years later, George Inness praised it as "so real next to Stuart's pink fancy of Washington and what a piece of bosh, by contrast is the 'Portrait of Benjamin West' . . . by Sir Thomas Lawrence."[59] Perhaps such praise is natural enough from an artist who, like Allston, was primarily concerned with the spirit rather than the flesh, and it is not surprising that Allston's later landscapes constitute the first American harbinger of Inness's late style.

The last recorded portrait by Allston is that of his London friend Samuel Williams (no. 48), who was also Allston's banker and financial agent while in England. The picture is traditionally dated 1817; certainly, it was done before Allston left England in 1818 and probably after the King portrait, of which it seems to be an elaboration.[60] Williams, like King, assumes immense benignity and dignity, and again, the averted gaze suggests intellectuality, timeless thought, and contemplative memory. Such suggestions are enhanced by the book he holds open in his hand and by the elaborate architectural setting of a monumental arch and a classical colonnade beyond which is a deep, distant mountainous landscape. This background offers a romantic aura of faraway time and place, uniting Williams with the ages, an evocation given further aesthetic credence by the rich Venetian colorism of its technical interpretation. Recent analysis has unhappily revealed extensive overpainting of abraded areas so that only the rich brown and plum coloration may reflect Allston's original palette. After his departure from England, Allston kept up with Samuel Williams through Charles Leslie, who reported to him in July 1826 that Williams was bearing up well under financial reverses.

Samuel Morse was also in Bristol in the summer of 1814; he spent six months there on Harmon Visger's promise of further patronage in portraits, but none of these appear to have been forthcoming. Morse did paint four landscapes, two of which he sold to a collector named Breed from Liverpool, the other two remaining unsold. Morse's correspondence exhibited increased bitterness at the lack of patronage in Bristol, and he commented to his parents that Allston's exhibition was also not a success. He attributed this to the British concern with the war with America, the implication being, of course, that Allston's and Morse's American background interfered with public approval. The *Bristol Mercury,* for instance, on August 29, spoke out hotly in anti-American terms and elsewhere noted that Allston's exhibition was competing with a display of Mme Tussaud's waxworks at the Assembly Rooms.

Coleridge was in Bristol all this time. Increasing signs of paranoia can be found in his references to Allston even in the spring of 1814 in London, complaining that Allston had not been to see him, and the situation became worse when they were both in Bristol. Coleridge wrote on July 7 to John Morgan: "The same game in Bristol as in London—A. can visit *me*; but his own House and Feelings belong as exclusive Property to his 'Countrymen,' as he called one of the Beasts last night." He continued to admonish Allston by insisting "the World is your Country, and England with all its faults your *home*." Coleridge considered Mrs. Allston the cause of his banishment from the Allston household.

Nevertheless, Coleridge attempted to promote the success of Allston's exhibition in a three-part article that appeared in Felix Farley's *Bristol Journal,* between August 13 and August 27.[61] The justification for writing this essay on the fine arts is quite strange, for Coleridge in his letters suggests that it was undertaken to defend Allston from attacks from various directions, aimed particularly at his *Dead Man Restored*. Coleridge attributed these attacks to English anti-Americanism and the enviousness of Benjamin West during the British Institution exhibition, although West had, in fact, praised the picture. Likewise, Coleridge seemed to find the center of the attack in the writing of Tom Taylor of the *Sun,* and he condemned the calumny and detraction against Allston there; but the *Sun,* though not particularly favorable toward Allston, had only spoken of his premium as "due to attempt [rather] than to the merit of his picture." In any case, the articles, though ostensibly in support of Allston's exhibition, really constitute an exposition of Coleridge's aesthetic philosophy and offer only passing references to the artist, the show, or the individual paintings, although Coleridge did observe that "the great picture, with his Hebe, landscape and sea-piece, would of themselves suffice to elucidate fundamental doctrines of color, ideal form, and grouping."

Bristol patronage was not greatly forthcoming. Allston acknowledged his uncle's interest in acquiring three of the pictures, in a letter to Vanderhorst's daughter, Mrs. Taylor, of October 22, 1814, now in the Bristol City Archives. These were the *Italian Landscape,* the comic piece—the *Scene in an Eating House,* and one of the sea paintings, for which Vanderhorst offered 200 guineas; Allston felt that he had put too much time into the comic piece and offered to substitute for it the *Casket Scene*. This appears not to have been satisfactory to Vanderhorst, however, for he did, indeed, acquire his original choices, the seascape being the smaller *Rain at Sea*.

Mrs. Taylor later inherited the Allston paintings, and her daughter in turn exhibited the *Scene in an Eating House* and the *Italian Landscape* in 1858, at a Royal West of England exhibition in Bristol.

Allston remained in Bristol at least through October 1814. Morse wrote that Allston expected to return in mid-October, but Leslie in London reported his continued absence in late November. There is no evidence that after his return to London he ever again went back to Bristol. In February of the following year, the Taylors invited him to visit them, along with his friend Samuel Williams, but Allston respectfully declined, pleading the need to continue his painting. Yet, Allston was remembered by the citizenry of Bristol. Some of his works, of course, remained in Bristol collections. Years later, in 1838, the *Bristol Mirror* recalled and praised his art. Allston was remembered by the connoisseurs and intelligentsia of Bristol also. It has been suggested that the young Francis Danby, who had settled in Bristol in 1813, might conceivably have met Allston and almost certainly would have visited the Allston exhibition, then a unique event during Danby's Bristol residence. In turn, some of Danby's later large exhibition pictures seem to bear similarity to and suggest influence of Allston's oeuvre.

It is probable that Allston's first work painted on his return was *A Mother Watching Her Sleeping Child* (fig. 28), a beautiful painting unfortunately now in a distressingly deteriorated condition. Since the picture was not included in the Bristol exhibition, we may again conclude that it had not been painted by then, and his later months in Bristol were presumably occupied primarily with portraiture. The figure of the mother is large and powerful, though poetically conceived; she may, in fact, owe a debt in her breadth of conception and contrapposto to Michelangelo. Allston had originally designated the picture *Madonna and Child* but concluded that a Madonna should be youthful and that his figure was more of a matron. Perhaps, too, he wished to imbue the picture with more purely human sentiment in deference to his beloved wife. The picture was sent to James McMurtrie in 1816 as a token of his gratitude for McMurtrie's part in the acquisition by the Pennsylvania Academy of *The Dead Man Restored* that year. Allston returned to the theme of the *Mother and Child* in a more monumental composition in 1829; the work is now lost, having been sold by the Boston Athenaeum to the English collector John Watkins Brett in 1837. However, it was engraved by Seth Cheney for the *Token* that year, and an unfinished study for it is also known (Lowe Galleries).

The Allstons, on their return to London, had taken a house on Tinney Street, but soon after they had furnished it and moved into these quarters, Mrs. Allston fell ill and died shortly thereafter, on February 2, 1815. The funeral was attended by Allston's pupils, and the young actor-playwright from America, John Howard Payne; Allston's grief was such that he could not bear the strain. He entered into a deep depression and was unable to paint, but the support of his friends, especially of Coleridge, helped him through what was probably the greatest trial of his life. The loss of Ann Channing Allston was the basis of the story by Allston's close friend Washington Irving entitled "Recollections of a Student," according to the author John Neal in his novel *Randolph*, of 1823. A second though less severe loss for Allston occurred with Morse's departure in August 1815. With his funds exhausted and with the ratification of the treaty of peace with Britain in February, Morse re-

Fig. 28. *A Mother Watching Her Sleeping Child*, 1814
Oil on millboard, 23½ x 18 in. (59.7 x 45.8 cm.)
Richardson 80
Private Collection

turned home, although his respect and admiration for his friend and former teacher remained constant until Allston's death. Allston left the ill-fated Tinney Street house after his wife's death and took lodgings on Fitzroy Square with Leslie and Morse. After Morse departed, Leslie continued to send him news and reassurance concerning Allston.

Understandably, Allston's production in 1815 was extremely limited. The only work that is known to have been conceived and completed that year was *Donna Mencia in the Robber's Cavern* (no. 35). The painting is derived from a romance by Alain Le Sage, written 1715-1735, which follows the career of Gil Blas and his Candide-like journey through life. The book is a lighthearted one, but Allston has chosen to illustrate an especially dramatic moment, in which the heroine, Donna Mencia, has just recovered from the shock of her husband's murder and finds herself, with Gil Blas, captive of the bandit Rolando. Soldiers of the bandit chief are at the left and back, and the cook, an old crone, kneels beside her.

In one sense, Allston here reverts to his days of "bandittimania," though now on a monumental scale, the conception darkly dramatic and in the spirit of Caravaggio or, given the aesthetic preferences of Allston and his times, Rembrandt. The facial expressions are intense, even exaggerated, in the physiognomic traditions of Charles Le Brun and Fuseli, a predilection already displayed in *The Dead Man Restored*. The depiction of the hero, Gil Blas, separated from the rest of the scene and interpreted more as a musing, poetic observer, may be Allston's interpretation of himself, the man of thought rather than of action.

The subject would seem an unusual one for Allston. Perhaps he was inspired in part by the well-known depiction of exactly the same moment in the novel made by John Opie in his last subject picture (see fig. 29). Opie, who died young in 1807, had been hailed as one of the leading young painters of historical subjects when Allston was first in England. Allston may have viewed himself as somewhat in Opie's succession, beginning to establish a reputation in the following decade along similar lines and even reflecting similar influences; Opie's manner was seen as especially deriving from Rembrandt. Allston might, in fact, have known the replica of Opie's painting that was early owned in the United States by Paul Beck; it was exhibited at the Pennsylvania Academy in 1816 but must have been here earlier since it was copied by Thomas Sully in 1812. In any case, we know that Allston admired Opie's work in 1801, next after that of West and Fuseli.

Allston's *Donna Mencia* was finished in time for exhibition at the Royal Academy in 1815 and was shown the following year at the British Institution. In exhibiting this painting and then also his *Morning in Italy* (no. 14) this way, Allston was following a not infrequent practice of British artists to attempt to utilize the publicity gained previously at the Academy to compete for the prizes offered by the British Institution. At the Academy it must have been hung disadvantageously, according to the *Examiner* of May 14, but the critic still found it admirable in character and execution, contrasting the sympathy aroused by Donna Mencia and the pitying looks of Gil Blas with the licentious gazing and fierce, guilt-impressed physiognomies of the robbers. In February of the following year the same journal mentioned the work briefly but was equally commendatory in its remarks on the forceful character, brilliant color, and firm and finished execution of the painting. At the

Fig. 29. JOHN OPIE, British, 1761-1807
Gil Blas Securing the Cook in the Robbers' Cave
Oil on canvas
Pennsylvania Academy of the Fine Arts, Paul Beck Collection

Academy, George Ticknor, Allston's future friend and patron, greatly admired the picture as one of the two finest works shown, along with David Wilkie's *Distraining for Rent*.[62] *Donna Mencia* was acquired by Colonel William Drayton of Charleston, who had known Allston when the latter returned there after graduating from Harvard in 1800. (Drayton himself made a watercolor copy of Allston's oil.) For some time the painting was the principal work representing Allston in his native Charleston, exhibited there at the Academy of Fine Arts in 1823, along with the portrait of Allston by Jeremiah Paul (fig. 11).

Since the *Donna Mencia* was exhibited in 1815, Allston must have worked on it while he was deeply in mourning, and years later, when the painting was shown at Harding's Gallery in Boston in 1839, the artist told his nephew and pupil George Flagg that he was constantly in tears while working on it. By the end of 1815, however, Allston, encouraged by the solicitations of his friends, reemerged into London society. The diary of the American minister John Quincy Adams is filled with accounts of visits and dinners with Allston and Leslie during 1815 and 1816, and his admiration for Allston's *Beatrix* (sic), *Italian Landscape, Mother and Child,* and *Rebecca*. Much of the remainder of that year, 1815, however, must have been devoted to the completion of Allston's second great religious work, *The Angel Releasing St. Peter from Prison* (no. 28). This picture is usually given a date of 1812, but that was the year a work was commissioned by Sir George Beaumont. The specific subject was only proposed by Allston about the beginning of 1814 and approved by Beaumont in a letter to him of January 6 of that year. *St. Peter* was not completed until January 1816, and taking into consideration Allston's other preoccupations of the preceding years, much of the work was probably done during 1815. Whitley suggests that Allston had planned to show the picture privately at the Spring Gardens Gallery in Charing Cross and that he was persuaded by John Young, the keeper of the British Institution, to exhibit it there on the promise that he could work on it further in their galleries for three weeks; but given Beaumont's prominence in the directorship of the British Institution, it is doubtful that any other place of exhibition would have been conceivable.[63]

As early as 1802, Sir George had asked George Dance to draw up plans for rebuilding the house at Coleorton, the family's Leicestershire estate. Coleorton Hall was opened in 1808, and in 1812 Sir George rebuilt part of Coleorton Church; it was at this time that he commissioned Allston to paint his large altarpiece. Beaumont was initially led to Allston through Coleridge, but William Wordsworth's friendship and enthusiasm for Allston must have reinforced Beaumont's decision concerning his patronage. Beaumont, like John King, a practicing and exhibiting artist, had inspired Wordsworth's 1805 poem "Elegiac Stanzas Suggested by a Picture of Peele Castle, in a Storm, Painted by Sir George Beaumont," and in 1815 Wordsworth's *Miscellaneous Poems* appeared, dedicated to Sir George and illustrated by engravings after his paintings. In the year of Allston's commission, 1812, Beaumont erected the cenotaph to Sir Joshua Reynolds on the grounds of Coleorton, with an inscription composed by Wordsworth; the cenotaph itself is best recorded in the late painting of it by John Constable of 1836. It is significant here, too, that Beaumont should wish to honor Reynolds, for, as Benjamin Haydon acknowledged, Beaumont was a traditional collector following the precepts of Reynolds; as such, he would patronize Allston and criticize Turner.[64]

In his painting for Beaumont, Allston continued his investigation of the pictorialization of supernatural mystery and miracle; his goal was to present the idea of divine interposition and the power of truth to—literally—emancipate. For his conception Allston appears to have drawn upon a number of sources. His teacher, West, had essayed the same subject in a small picture of 1800, but the ultimate inspiration for both West and Allston would certainly have been Raphael's Vatican fresco. The figure of the angel is very Raphaelesque, in general grace and even in facial type, although it has also been suggested that the face of the angel is a recording or memory image (or both) of the recently deceased Mrs. Allston. If this is so, it would seem to have been truer of his original conception preserved in an oil study than of the completed work, Allston finally deciding upon a less feminine interpretation of the angelic figure.[65]

The concept of the light emanating from the figure of the angel—thus, as in *The Dead Man Restored,* divinity represented by glowing luminosity—may find its ultimate source in the work of Correggio, as well as in the Raphael frescoe. Classical sources may include the *Laocoön* for the head of the contorted St. Peter and the *Apollo Belvedere* for the pose and interpretation of the angel. The latter may seem an unlikely derivation for a Christian figure representing divine grace, but Allston stated in his *Lectures*[66] that angelic figures should be endowed with perfection of form. His reaction to the *Apollo* was a recognition of just that, an image of celestial splendor, which he interpreted as a "vision . . . of one who had just lighted on the earth, and with a step so ethereal that the next instant he would vault into the air." But while the perfect form of the angel, according to his *Lectures,* embodies Allston's concept of beauty, divine intrusion, which he categorizes as the essence of the sublime, is manifested in the light emanating from that form. For Allston, the highest state of being that an artist could represent was the angelic spirit, whose divinity is here manifest in its celestial brightness.

Again, however, Allston's increasing sympathy for the work of Rembrandt may also be of significance. Beaumont had commissioned the painting after viewing a study of *The Dead Man Restored,* but at the same time he appears to have suggested a preference for Rembrandt rather than Sebastiano del Piombo, the influence of both of whom he saw in Allston's conception, and Allston may here have tried to accommodate Beaumont's inclination.

Beaumont particularly praised the "downy softness" of the angelic wings with which Allston endowed his ethereal creature, but in private he complained to Wordsworth that the figure was too material, dressed in a garment that should have been more like a cloud than like flannel.[67] The criticism was substantiated when the work was exhibited at the British Institution in 1816, urgently requested for the show because of the paucity of entries. The *Examiner* of February 11 generally praised it and found the author a proper representation of the glorious energies of his native country; but the critic found that although "the action of the angel is elegant and dignified, . . . he is too intrusive, too substantial, for an object that is immaterial and spiritual." The critic concluded, however, that if "the subject is in some respects incorrectly expressed, it is interestingly energetic, and altogether far excels most of the historical pictures in our Exhibitions."

The Angel Releasing St. Peter from Prison (no. 28) is pictorially better docu-

mented than most of Allston's works, for, in addition to a small complete oil study (fig. 30) for the painting (which Allston turned over to Francis Winthrop of New Haven, probably about 1822 or later, to compensate the latter for the loss he sustained in selling Allston's *Alpine Landscape* of 1810 for $300 less than he had paid for it), there exist an early drawing of the subject (fig. 77), a finished *Study for the Head of St. Peter in Prison* (no. 27), a double-sided study for the head of the angel of monumental proportions, known as the *Ideal Head* (figs. 31, 32), and other drawings. Many years later, in 1857, the *Crayon* reported that Morse had sat for the *Head of St. Peter*. The most fascinating and quite beautiful preparatory sketch in oil is the *Study of Drapery for "The Angel Releasing St. Peter"* (fig. 33), a treatment solely of the drapery and pose. There seems to be no preparatory work for the gloomy dungeon that serves to enframe the miracle of liberation, with an arched second chamber behind, lit by a grill-covered oculus whose dim natural light contrasts with the supernatural glow of the angel. John Martin, whom Allston met in 1814, had been asked to provide a drawing for a circular staircase for the setting, but his dilatoriness caused Allston to complete the setting himself.

While Beaumont commissioned the work as an altarpiece for a Christian chapel, Allston must have welcomed the opportunity to create not only a depiction of miraculous intervention but also an ideological companion to his earlier success, corresponding Old and New Testament images of divine power and heavenly restoration. The choice of the subject was Allston's; Beaumont had suggested a Resurrection scene. It is significant that it is the only major New Testament scene that Allston brought to completion.

Allston's painting remained in the chapel for many years and was finally removed in the early 1850s to make way for a stained glass window. It remained rolled up until it was exhibited in the "Art Treasures of the United Kingdom" exhibition held in Manchester, England, in 1857, a landmark in displays of international art.[68] The appearance of the work there led Dr. Robert W. Hooper of Boston to acquire it in 1859. It was first exhibited at the Athenaeum in 1860 and entered the collection of the Museum of Fine Arts in 1921. However, for many intervening years the picture was deposited with the Institution for the Insane in Worcester, Massachusetts, and while the suggestion of moral uplift and even the proffered hope of spiritual rescue might be interpreted as pertinent, one of Allston's great canvases was effectively less accessible than it had been in rural England.

Despite the significance of the *St. Peter,* both as a major exhibit and altarpiece and as indicative of Beaumont's favor, the great collector only commissioned one other picture from Allston, a landscape acquired in 1816 on Coleridge's recommendation and now unlocated. Beaumont was a careful collector, not an accumulator, and much of the emphasis in his collection was upon the old masters. Allston's landscape may well have been an earlier picture, since there is relatively little indication of a concern with that theme during these years in Britain when he was primarily fired by the attainment of a position among the leading historical artists of his age. In fact, the only recorded landscape by Allston other than the *Italian Landscape* (no. 31) of 1814, which entered his uncle's collection in Bristol, was *Morning in Italy,* shown, as mentioned earlier, at the Royal Academy in 1816 and at the British Institution the following year. It is tempting to speculate that this is the pic-

Fig. 30. *Study for "The Angel Releasing St. Peter,"* ca. 1813-1815
Oil on canvas, 29 x 25⅛ in. (73.8 x 63.8 cm.)
Richardson 71
The Virginia Steele Scott Foundation, Pasadena, California

Fig. 31. *Ideal Head (Head of the Angel),* ca. 1813-1815
Oil on millboard, 29¾ x 25½ in. (75.6 x 64.8 cm.). Richardson 183
Museum of Art, Rhode Island School of Design, Providence

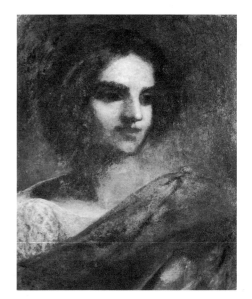

Fig. 32. *Study of Head with two inscriptions:*
"W. Allston pinxt.," ca. 1813-1815
Oil on millboard, 29¾ x 25½ in. (75.6 x 64.8
cm.). Richardson 183 (verso)
Museum of Art, Rhode Island School of Design,
Providence

Fig. 33. *Study of Drapery for "The Angel
Releasing St. Peter,"* 1813-1815
Oil on millboard, 36¼ x 26¼ in. (92.1 x 66.8
cm.). Richardson 31 (verso)
The Metropolitan Museum of Art, New York

ture acquired by Beaumont, particularly since an Italian reminiscence would have appealed to Coleridge and to his sentiments in regard to his first acquaintance with Allston; but, presumably, in its second showing at the British Institution, Beaumont's ownership would have been acknowledged. In any case, the exhibited picture, which Edgar Richardson has suggested might be the landscape now in the collection at Shelburne, was enthusiastically received by the critic of the *Examiner,* who wrote about it on June 16, 1816, although his description is unfortunately too generalized to permit specific identification: "Whether this be an actual scene in Italy or a composition from different scenes it is honourable to Mr. Allston's abilities; for if it is the first, it is well selected, if the second it is well arranged; and in either case, it is well executed. It is a landscape in which art elegantly mixes with and sets off Nature and tower and temple and the pensiveness of ruins are seen, just as morning breaks and the king of day is sending his harbinger-light to chase away the night. The colours are well mingled into a dun and natural hue, which hovers over nearly the whole scene, giving it a soft solemnity, and to which the yellow-edged turrets, hills and clouds, oppose a delicate sprightliness, looking, in its meek lustre like a smile on a dejected face."

Allston's only located work dated in 1816 is *Rebecca at the Well* (no. 36), which was purchased by Myndert Van Schaick of New York. The work was later shown in the first exhibition of the National Academy of Design, in 1826, though without the designation of Van Schaick's ownership. In this picture, which Allston described to its owner as a pastoral, the figures that dominate the small scene are elegant and relaxed. The artist has successfully departed from the stiff manner of the *Casket Scene* (no. 18) (which in size and composition it somewhat resembles), while at the same time he eschews the emphatic drama of *The Dead Man.* The principal figures, Rebecca and Abraham's servant, appear in the foreground against a background of an idyllic and deep landscape in the manner of the 1814 *Italian Landscape;* the enframing architecture of the well at the left is balanced by the group of relaxing travelers in exotic costume and semi-undress at the right, accompanied by a pair of rather fantastic camels.

This is an Old Testament scene, of course, but Allston's conscious choice of subject should be noted. He has seen fit to depict not the intervention of the Lord in connection with Rebecca's barrenness or her favoring of Jacob over Esau but, rather, a scene wherein, after angelic intervention, Abraham's servant has arrived to choose a bride for Isaac, while the maid offers drink to him and his camels. In other words, Allston has coupled the theme of human goodness and generosity with implied angelic intervention.

It may be pertinent here to consider Allston's beautiful though uncompleted *Dido and Anna* (no. 26). Richardson places this picture during Allston's Roman years, 1805-1808, on the basis of both subject and style. Certainly Allston renounced grand classical themes during his second stay in England, but his *Cupid and Psyche, Diana, Hebe,* and a possible *Clytie* (the last mentioned by Sweetser) suggest that the abandonment of classical subject was not total. In style, the figures in *Dido and Anna* seem as close to those in his *Mother Watching Her Sleeping Child* as to those in *Jason* although the incomplete nature of both the *Jason* and the *Dido and Anna* makes such comparison hazardous. More to the point, however, is that

the *Study from Life* (fig. 35) by Allston appears to be preliminary for the figure of Anna. Now, Richardson and others date the *Study from Life* to Allston's early years because it relates to the *Dido and Anna;* but the *Study from Life* appears on a canvas that bears on the reverse the drapery and figure study for the angel (fig. 33) in *The Angel Releasing St. Peter from Prison.* Since the latter must date from about 1813-1815, one may presume that the *Study from Life* does also; it seems extremely unlikely that Allston would carry around with him for a decade an unfinished figural work; and, in any case, the *Study from Life* has a poetic softness and sentimental emanation that more comfortably relate to some of Allston's later works, such as *Contemplation,* than to his early pictures. Richard Henry Dana mentioned that the *Study from Life* was painted in London, but it is much more likely that he refers to Allston's second and longer stay there.

In the *Dido and Anna* an awkward, miniature figure of Aeneas creeps stealthily away, down steps in the middle distance, looking more like a house thief than a departing lover. But Allston's emphasis here is not upon the drama of the frenzied separation of Dido and Aeneas or even upon the horror of Dido's suicide, but upon her sentimental relationship to her servant. The picture, then, becomes an emblem of *Schwesterschaft,* a *Freundschaft* image found primarily in romantic painting in Germany, appearing in the work of Caspar Friedrich and others. Such works depict an overtly nonsexual expression of deep tenderness and love among members of the same gender.

Since the *Dido and Anna* is so undocumented, there is no explanation of the reasons for its abandonment. Perhaps Allston did not, in the end, find satisfaction in continuing to work with classical imagery. The painting, however, may offer a pictorial clue as to the appearance of the now lost *Hermia and Helena,* which was painted in England. Allston's attention to Shakespearean literature has been documented, and his subject here is drawn from *A Midsummer Night's Dream.* The work was shown at the Royal Academy in 1818 and may be seen as part of the basis for his election as an associate of that body. The picture was acquired by Harmon Visger, Allston's friend in Bristol; Visger hung it in his Portland Square drawing room in Bristol, where Leslie visited him, probably in midsummer, in 1819.[69] The reviews of the picture were mixed. The *Morning Herald* deplored the choice of subject matter, but the *Examiner,* ever faithful to Allston, praised its pleasant sedateness and its elegance. The partial description in this review allows us to identify the picture as similar to the *Dido and Anna,* as a "scene of seclusion, [in which] the connected position, studious and kindly looks of the young friends as they hold the same book to read from, give us a charming picture of friendship." By 1818 Allston had become more comfortable with Shakespeare than with Virgil.

Allston's best-known and perhaps ultimate interpretation of the *Freundschaft* image is *The Sisters* (no. 37), which would appear to date from about 1816 or 1817 and was certainly painted in England. An idyllic piece showing a pair of entwined young women, the painting is a partial statement of Allston's artistic credo and loyalties. The two figures display an easy affection and justify the title that Coleridge supplied for the work. But, at the same time, amidst the elegant appointments of the heavily draped interior and the rich and bejeweled accoutrements of the figures, the artist has carefully distinguished the two. One is blond, the other

Fig. 34. *Studies of Figures and Drapery for "The Angel Releasing St. Peter,"* ca. 1813-1815 Oil on millboard, 25 x 34 in. (63.5 x 86.4 cm.) Richardson 101 (verso) Fogg Art Museum, Harvard University, The Washington Allston Trust

Fig. 35. *Study from Life,* 1813-1815 Oil on millboard, 36¼ x 26¼ in. (92.1 x 66.8 cm.). Richardson 31 The Metropolitan Museum of Art, New York

brunette; the former tosses her head back and looks out at the spectator, the latter, head averted, appears to look at her companion.

The blond figure at the left is taken directly from a work by Titian, a supposed portrait of his daughter Lavinia, entitled *Girl Holding a Jewel Casket,* then in the collection of the Countess de Gray and formerly in the Orleans collection, which was the most celebrated group of old masters to have appeared in recent years in England. Allston's frank "borrowing" from Titian must be coupled with his establishing the dark figure as his own creation. In other words, Allston's indebtedness to the great Venetian master is here presented, not in rivalry or competition but in admiration. He presents his images, literally uniting Titian and himself, the old master and the modern master of the poetic figure. The "Titian figure" looks back at us as she appears in numerous similar works by this master, but it is also "backward-looking"; it *is* a figure from past art. Allston's own original young woman looks at her "sibling" as Allston looked upon Venetian art; the painting as a whole, and especially the distant sky, is painted in a notably Venetian manner.

An acknowledgment to a second artist may be implicit here, though a more private one, for Allston's master, Benjamin West had, in 1797, painted a *Bacchante* (fig. 36) inspired by the same so-called Titian, and Allston's imitation of his teacher's borrowing is in a way a form of flattery also. West's picture had been acquired by one of the great collectors of contemporary British painting, Sir John Leicester, whose patronage Allston may have sought but never gained; Leicester's patronage encompassed not only such older artists as West, Fuseli, and Northcote but also younger men with whom Allston was critically compared, such as William Hilton. *The Sisters* is the closest pictorial analogy in Allston's art to the Germanic iconography of *Schwesterschaft.* While he could not have known Johann Overbeck's great *Italia und Germania,* a painting not completed until 1828, in Italy, though begun in 1811, the German work evinces startling similarities to Allston's picture in the levels of affection and contrast. In both paintings the blond-brunette figures represent cultural and geographic comparisons between northern and southern cultures; in Allston they represent a comparison between Renaissance and modern periods and in Overbeck between Renaissance and Gothic. In both works also, affectionate artistic alliances are enshrined. Allston's is a tribute to the long dead Titian, Overbeck's to his close friend, the recently deceased Franz Pforr, whose *Shulamite and Maria* had been the source of his inspiration.

Allston's *Sisters* was neither exhibited nor sold in England, and he brought it back with him to America; he parted with it only in 1839, when it was purchased by a Boston portrait painter and colleague, Francis Alexander, for the quite substantial sum of $1,500. Another person who was also interested in it at the time was Samuel Ward, whose patronage of Allston was deflected by the commission he gave to Thomas Cole for *The Voyage of Life.* Ward, of the New York banking house of Prime, Ward & King, sent his two daughters, Julia (later Julia Howe) and Louisa (later married to the sculptor Thomas Crawford), to Boston in 1839 with their tutor, Joseph Cogswell, to see the Allston exhibition at Harding's Gallery, and the young ladies were so enthusiastic that Ward himself visited Allston's Cambridgeport studio and admired particularly *The Sisters* and his outline design for *Titania's Court* (fig. 63).[70]

Fig. 36. BENJAMIN WEST, American, 1728–1820
Bacchante, 1797
Oil on canvas
Mr. and Mrs. Philip I. Berman

In 1817 Allston became involved for the only time in his career in creating original designs for book illustrations, two comic pieces for *Knickerbocker's History of New York* by his good friend Washington Irving. The first of these is mentioned in a letter from Allston to Irving of April 15 and detailed in another of May 9, the subject being *Wouter von Twiller's Decision in the Case of Wandle Schoonhoven and Barent Bleeker* (fig. 37). Allston himself considered the figure of the constable the finest and as illustrative of the best part of Irving's humor. Irving replied on May 21, agreeing that the humor was "rich but chaste."[71]

By March 1818 Allston had finished the drawing for the second engraving, *A Schepen Doing Duty to a Burgomaster's Joke* (fig. 38), chosen in place of the original subject of a lawsuit; Allston was surprised to learn from Gulian Verplanck that this illustration gave offense to the New York Dutch community. Again, as in the design of the previous year, Allston emphasized a contrast in character between the figures that is expressed physiognomically—a contrast that recalls his earlier comic paintings, *Falstaff* (fig. 18), the *Poor Author* (no. 24), and especially the more recent *Scene in an Eating House* (no. 30) of 1813. Allston's illustration of the *Schepen* appeared as frontispiece, engraved by W. Finden, in the two-volume edition published by Moses Thomas in Philadelphia in 1819. *Wouter von Twiller* was planned for this edition also but seems finally to have appeared only in the John Murray edition of 1824, published in London and engraved by John Romney.[72] Allston wrote to Leslie in 1823 that he was disturbed by the reduction in size of the Romney engraving and the omission of the initials designating his association with the Royal Academy. The *Schepen* appeared again in 1860 engraved by Henry Bryan Hall, in the "Sunnyside Edition" published in New York by G. P. Putnam. The two illustrations, then, seem never to have been published together.

About this time, Allston became involved with the transatlantic commission of a statue of George Washington for the State of Massachusetts offered to his friend Sir Francis Chantrey, the great English sculptor, a commission in which Massachusetts was emulating the earlier orders for statues of Washington by Virginia and North Carolina from Jean-Antoine Houdon and Antonio Canova, respectively. Chantrey received his commission from the Washington Monument Association in Boston in February 1816. Allston and Benjamin West carried the negotiations to completion with the assistance of Allston's Anglo-American banker, friend, and patron Samuel Williams, although Allston later acknowledged to the Charleston sculptor John Cogdell, in 1833, that the work was not a success, since it had not been done from life.

In 1817 Allston attracted the attention of another of the great collectors, the third Earl of Egremont. Unlike Beaumont, Egremont was exclusively a patron of contemporary British painters and sculptors and is best known today for his support of Turner, whose work was criticized and spurned by Sir George. Egremont owned two, perhaps three, works by Allston; a *Repose in Egypt* is mentioned in an early catalogue of the collection at Petworth, Egremont's house in Sussex, but no further reference to it is known.

A small, very lovely picture, still in the Petworth collection, is Allston's *Contemplation* (no. 38). The picture marks a further step after his early *Valentine* toward the series of idyllic images of women, often shown in contemplative mood, which

Fig. 37. *Wouter von Twiller's Decision in the Case of Wandle Schoonhoven and Barent Bleeker,* 1817
Richardson 99
Illustration for Washington Irving, *Knickerbocker's History of New York*

Fig. 38. *A Schepen Doing Duty to a Burgomaster's Joke,* 1818
Richardson 108
Illustration for Washington Irving, *Knickerbocker's History of New York*

became a major feature of his later art. The woman is seated here in a wooded embankment, softly illuminated by what appears to be evening light, while she reads, or contemplates, a book that rests upon a rock. The overall grace of the figure and the series of wavelike curves of form and drapery suggest an inspiration from the figures in the East Pediment of the Parthenon, the Elgin marbles about which so much controversy was then raging, but the figure is not a direct paraphrase of any of them. The form of the small figure is really quite heroic, although this belies the sense of romantic melancholy that infuses the image and unites it with the soft, lovely landscape—the woman seems to be as absorbed into the wooded setting as she is in the book she reads. Here Allston has created a poetic rather than a dramatic image, one concerned not with story or anecdote but with mood. The picture seems to anticipate the first significant work of Francis Danby, *Disappointed Love* of 1821 (fig. 39), but even there, Danby's story is much more explicit, as is his botanical setting, while he substituted a Flaxman-like neoclassical abstraction of his figure for the more truly classical and even Michelangelesque source of Allston's. In some ways also, Allston's small picture seems to be a precursor to the figural pieces of his friend and quasi pupil Charles Leslie, who exhibited a now unlocated picture of the same title at the British Institution in 1820.

Fig. 39. FRANCIS DANBY, British, 1793-1861
Disappointed Love, 1821
Oil on canvas
Victoria and Albert Museum, London

Neither the date of Allston's *Contemplation* nor the date of Egremont's acquisition of the picture is known, but Allston's connection with the earl seems to have actively begun about 1817. It was in that year also that Allston at least began to paint his large *Jacob's Dream* (no. 39), which Egremont acquired. Egremont had wanted the picture for his house in London, but Allston found, on measuring the space, that his picture was too large. He feared the loss of Egremont's order, but his patron installed it instead in his country house. Allston became one of the numerous artists to enjoy Egremont's famed hospitality at Petworth; his visit of about August 1, 1818, was probably his last outing before his final departure from England. Dunlap quotes a letter, presumably to James McMurtrie, written in 1817, in which Allston expressed his intentions in the painting: "I am now engaged on 'Jacob's Dream', a subject I have long had in contemplation. It has been often painted before, but I have treated it in a very different way from any picture I have ever seen; for, instead of two or three angels I have introduced a vast multitude: and instead of a ladder, or narrow steps, I have endeavored to give the idea of unmeasurable flights of steps, with platform above platform, rising and extending into space immeasureable. Whether this conception will please the matter of fact critics I doubt; nay I am certain that men without imagination will call it stuff! But if I succeed at all, it will be with those whom it will be an honor to please."

Allston was mistaken. While Hazlitt found the setting too much like an architectural plate out of Vitruvius or Palladio when Egremont exhibited the picture at the Royal Academy in 1819, and Allston's faithful *Examiner* on May 24 that year admonished him for the lack of movement on the part of the angels, whom the Bible directs to ascend and descend the celestial ladder, the artist's preeminence in the depiction of biblical poetry was universally acknowledged. James Elmes, in his *Annals* for 1819, summed up the prevailing estimation of Allston as an artist whose "powers lie in the abstract poetical part of the art, and not in the expression of human passions." He wrote, "the grandest picture in the Exhibition . . . will give

it a character, hereafter to be remembered by, as one would say, 'The exhibition in which was Allston's Jacob's Dream' " Egremont sent the painting to the Academy rather than to the British Institution because of Allston's election to the former that year. Both the critics and Allston's patron, Lord Egremont, recognized the Raphael-esque inspiration in the painting; the relationship is perhaps not so much to the subject of the Vatican frescoes painted by Raphael's workshop as to the figural types and their grouping. The critic in the *New Monthly Magazine and Universal Repository* described the angels on the lowest step and the one who descends near the angel at Jacob's head as "Raffaellic, although perfectly original." He concluded, "there is a sublimity in Mr. Allston's conception of the subject, which places it among the foremost of the first class of sacred compositions in our time." The fame of the picture, and especially of the figures admired in this review, was renewed in 1850, when Allston's memory and abilities were recollected and extolled in the publication of *Outlines and Sketches by Washington Allston*. Allston's debt to his teacher West for the angelic figures should also not be discounted, particularly those that appear in *The Ascension* in 1781, painted for the Chapel of Revealed Religion.

Anna Jameson recalled the work in her memorial tribute to Allston, published the year after his death, and summed up its effects and derivations well. "The subject is very sublimely and originally treated," she wrote, "with a feeling wholly distinct from the shadowy mysticism of Rembrandt, and the graceful simplicity of Raphael. Instead of a ladder or steps, with a few angels, he embodied the idea of a glorious vision, in which countless myriads of the heavenly host are seen dissolving into light and distance, and immeasurable flights of steps rising, spreading above and beyond each other, vanish at last in infinitude."[73]

Dissolution and infinitude may seem strange aesthetic companions to a classical and geometric composition, balanced and symmetrical, but those qualities may also suggest the attraction for a patron who was also drawn to Turner. And, in fact, the hollowed-out, centralized composition, with the eye drawn into a never-ending distance by luminosity is a form that Turner exploited fully during his career and that drew him a host of imitators. The glowing central space surrounded by dark spandrels may recall such works by Turner as *Snow Storm; Hannibal and His Army Crossing the Alps* (fig. 40), exhibited in 1812, although the rococo cresting of light-filled areas harks back further to that master's *Fishermen at Sea* of 1796. Indeed, Leslie quoted Allston in a letter to his sister, after they had been to see the *Hannibal* at the Royal Academy, that it was "a wonderfully fine thing" and that "Turner was the greatest painter since the days of Claude."[74]

John Martin was a friend and associate of Allston's in England whose art descends in part from Turner. His relationship to Allston in the execution of their respective depictions of *Belshazzar's Feast* has been discussed elsewhere, but Allston's *Jacob's Dream* may also have served in the evolution of Martin's biblical extravaganzas. Allston, in turn, despite the illusionistic emphasis upon the almost infinite expanse of his celestial staircase, may have drawn upon the designs of his Fitzroy Square friend and neighbor John Flaxman, whose *Celestial Steps* from Dante's *Il Paradiso* of 1793 Allston would surely have known, since he owned Flaxman's linear designs after Dante and the Greek authors and strongly recommended them

Fig. 40. Joseph Mallord William Turner, British, 1775-1851
Snow Storm; Hannibal and His Army Crossing the Alps, exhibited 1812
Oil on canvas
The Tate Gallery, London

to young artists in their course of study. The architecture and the angelic figural relationship to it in Flaxman's design closely parallel Allston's treatment in *Jacob's Dream.*

Hazlitt, in his criticism of Allston's work, was comparing the modern picture to Rembrandt's treatment of the same theme. Rembrandt, indeed, was a growing concern for Allston, beginning with his *Angel and St. Peter* and becoming particularly strong in his last years in England. *Jacob's Dream,* in fact, was inspired by a picture then ascribed to Rembrandt but now recognized as painted by Aert de Gelder, in the Dulwich Gallery. In a curious juxtaposition somewhat paralleling his homage to Titian in *The Sisters,* Allston conceived of a treatment diametrically opposite to the homely simplicity of the Dutch painting, what might be termed homage by opposition. Such deference was underscored by Allston in his "Sonnet on Rembrandt: Occasioned by His Picture of Jacob's Dream."

Jacob's Dream, perhaps more than any other painting by Allston, kept his memory alive in Britain after his departure. It was exhibited again at the British Institution in a major loan exhibition of 1825. Much later, in October 1838, during an exhibition of old master paintings in Bristol, a writer in the *Bristol Mirror* commented: "Some of our readers may remember a picture by Alston [sic], an American artist, who resided some time in this city. There was some resemblance to Raffaele's composition, but it had more poetry." This allusion to *Jacob's Dream* was made in a comparison with a treatment of the same subject in a painting then said to be by Federigo Barocci.

Perhaps the greatest tribute to Allston's painting, however, is to be found in the poem by William Wordsworth *Composed upon an Evening of Extraordinary Splendour and Beauty,* written in 1817. One stanza reads as follows:

> And if there be whom broken ties
> Afflict or injuries assail,
> Yon hazy ridges to their eyes
> Present a glorious scale,
> Climbing suffused with sunny air,
> To stop—no record hath told where!
> And tempting Fancy to ascend,
> And with immortal Spirits blend!
> —Wings at my shoulders seem to play;
> But, rooted here, I stand and gaze
> On those bright steps that heavenward raise
> Their practicable way.

Allston received a copy of the poem with a note from the poet: "Transcribed by Mrs. Wordsworth in gratitude for the pleasure she received from the sight of Allston's pictures, in particular 'Jacob's Dream'," and a further addition: "the author knows not how far he was indebted to Mr. Allston for part of the third stanza." Wordsworth's 1829 poem *Humanity* also seems to recall Allston's painting. After Allston's return to America in 1818, and especially after his death in 1843, American writers were constantly lamenting that some of his major works resided so far away in Great Britain, and *Jacob's Dream* was one of these. This may in part ac-

count for the exhibition of a copy of Allston's picture at the Boston Athenaeum by G. L. Chandler in 1853.

In September 1817 Allston traveled with his friends and colleagues Charles Leslie and William Collins to Paris via Brighton and Dieppe. With the cessation of the Napoleonic wars, artists and connoisseurs were again free to travel on the Continent and renew the artistic interchange and experience with past and present masterworks from which Great Britain had been effectively cut off for so long. The collections of the Louvre in Paris were a natural magnet for British artists, enriched as they were with some of the works confiscated by Napoleon that the French had managed to retain. One might wonder, in fact, why Allston had not made the journey sooner. His friend of previous years, John Vanderlyn, had spent the years of the War of 1812 in Paris but, as mentioned, had returned to America in the fall of 1815.

Part of Allston's activity in Paris was devoted to copying in the Louvre, which he and his friends were regularly visiting by September 17, and it is significant that an extant copy by Allston (no. 40) is after a work of the Venetian school, Veronese's great *Marriage at Cana* (fig. 41). Allston has reduced it to little more than two feet wide, but it is an enchanting work, replete with some of the richest coloration in Allston's oeuvre. He wrote to Dunlap of the "gorgeous concert colors" he discovered in the painting; and his observations continued: "In some of them, *The Marriage at Cana*, for instance, there is not the slightest clue given by which the spectator can guess at the subject. They addressed themselves, not to the senses merely, as some have supposed, but rather through them to that region (if I may so speak) of the imagination which is supposed to be under the exclusive domination of music."

It is interesting that Allston's copy is extremely faithful to the original, with one small but significant difference. Although the principal figures in Veronese's painting are all but overwhelmed by the pageant of the event and by the even distribution of glowing colors and the activities of myriad figures, the presence of Christ is still given emphasis as the literally central figure in the composition; his pose is rigorously formal amidst so many relaxed and animated companions, and the combination of faint nimbus and internal glow of light focuses the viewer's attention. This is exactly what Allston *omits:* in this color- and light-filled composition, Christ is painted as the most opaque of figures, and he alone is deprived of features. Furthermore, Allston has lightly altered the pose of the figure by turning him toward the right so that he participates more in the general clamor around the table and is lost amidst the crowd.

Allston has thus taken Christ *out of* the *Marriage at Cana.* Given Allston's earlier decision never again to render the figure of Christ, after his failure with *Christ Healing the Sick* (no. 29) in 1813, this curious rendering in the copy after Veronese is understandable. But there is more here. If, as he wrote to Dunlap, it was after visiting the Louvre that he understood "why so many great colorists, especially Tintoret and Paul Veronese, gave so little heed to the ostensible *stories* of their compositions," then Allston has carried such a disregard even further. In the painting by Veronese, through the clues attached to the figure of Christ, one "*can* guess at the subject." In Allston's copy, one can *not* guess, so that, even more completely, such works, as Allston himself further wrote, "leave the subject to be made by the spectator, provided he possessed the imaginative faculty."

Fig. 41. PAOLO VERONESE, Italian, 1528 (?)-1588 (?)
The Marriage at Cana
Oil on canvas
Musée National du Louvre, Paris

The other extant "copy" by Allston presents very different and far more complex problems. This is his adaptation of Titian's *Adoration of the Magi* (fig. 42) in which Allston has reproduced the white horse from the original, reorganized a group of exotic Near Eastern figures, and added several at the left of the composition totally of his own invention. The picture became famous in the literature after Allston gave it to Coleridge. A German collector saw the picture in the poet's home probably in 1817, and was sure it was an original Venetian work, probably by Titian or Veronese; Coleridge referred him to Allston. Perhaps the Allston copy actually fooled more than one viewer at Coleridge's. The connoisseur has been variously identified as a well-known picture dealer, Montague, and as the dealer Laurent. Emerson heard the story in London in August 1883, from Coleridge, who reported that the startled Montague touched the picture and exclaimed, "By Heaven! this picture is not ten years old.[75] But, as Coleridge also spoke of him as the possessor of a collection of old Netherland masters, he was surely the German collector Karl Aders, who was especially close to Coleridge and whose works by Bouts, Gerard David, and Memling were admired by such connoisseurs as Beaumont. Coleridge bequeathed the picture to Anna Gilman, in whose house he had lived for many years.

Flagg suggests and Richardson states that Allston copied the *Adoration of the Magi* during his 1817 sojourn in Paris. But, although there are four versions of the painting accepted as by or attributed to Titian, none of them are in the Louvre. Therefore, it seems that it must have been painted at some other time in Allston's career. One version of the painting is in the Escorial, and another is in the Prado (Madrid), and it seems unlikely that Allston could have seen either of these. A third version of the picture was and is in Milan, through which Allston almost certainly passed in 1804, after visiting Switzerland and leaving by the St. Gothard pass. A fourth version, now in the Cleveland Museum and in the early nineteenth century in the Walsh Porter collection in England, would seem the most likely candidate. However, Allston copied the harness of Titian's white horse quite exactly and reproduced the girth around the belly of the horse that appears in the Spanish and Italian versions of Titian's painting, but *not* in the Walsh Porter picture in Cleveland. But a slight remaining trace of the girth suggests the possibility of a later abrasion. Thus, the problem at present appears insoluble. Given Allston's early interest in Titian, it is not unlikely that he visited Milan during his four years in Italy and that this adaptation by him was one of the pictures crated and stored at Leghorn until its delivery to him in 1814 in England. The stiff, thin, elongated figures of Allston's own invention at the left are actually closest in his oeuvre to the figures in the *Casket Scene* (no. 18), which may have been painted in Florence in 1807; at that time a visit to Milan would not have been impossible. On the other hand, in the general exoticism of the oriental costumes and in the introduction of the camels, the work resembles his 1816 *Rebecca at the Well* (no. 36). Of course, the animals in *Rebecca* might be derived from those in the *Adoration,* although camels are, in fact, absent from the Milanese version of the Titian painting.

There is also the possibility that Allston was engaged at this time in acting as a picture agent. Otis family tradition has it that about 1820, Harrison Gray Otis commissioned Allston to purchase some old masters in Paris.[76] Now, Allston was not in

Fig. 42. *Adoration of the Magi,* ca. 1804-1811, after Titian
Oil on canvas, 28¼ x 36¼ in. (71.8 x 92.1 cm.)
Richardson 104
Private Collection

Paris in 1820, and he did not return there after his visit of 1817. But he might have received such a commission in that year. Five pictures were purchased, two of them views of Tivoli and Terni, and three Dutch pictures, two by "Seybrechts" and one by Rembrandt of a *Music Lesson*. While such family tradition is often incorrect and, as in this case, at least inaccurate, and while it may be difficult to recast Allston, conventionally presented as an aristocrat, in an even faintly commercial role, there is an intriguing possibility in the choice of pictures involved. The purchase of Italian views would be natural enough, given his fond memories of his Roman years and his own involvement with Italian landscape scenes. "Seybrechts" is almost certainly Jan Siberechts, the most important Dutch artist of the seventeenth century to work extensively in England and thus one whose work would almost certainly be familiar to Allston. And while the *Music Lesson* is today recognized as by Willem de Poorter, its earlier attribution to Rembrandt would coalesce with Allston's increasing admiration for that artist during his English years, most noteworthy in his paintings of 1817, the same year as the supposed purchase of the old masters.

Allston, Collins, and Leslie stayed six weeks in France in the autumn of 1817. They displayed a critical interest in contemporary French painting, admiring especially the work of Pierre Narcisse Guérin, above all, his recently completed *Dido and Aeneas*. The only painter of note whom they met was François Gérard; there are no reports of their having seen his impressive *Entry of Henry IV into Paris,* which was shown in the Salon that year. Like so many Americans and Englishmen, they found the works of David "unnatural." Allston met Gulian Verplanck from New York, and together they admired the famous statue of Voltaire by Houdon. Verplanck and Allston had known each other earlier in London, and their friendship led to the unsuccessful attempt at employing Allston for one or more paintings for the Rotunda of the Capitol in the 1830s. They were joined in Paris by Gilbert Stuart Newton, the young artist nephew of Gilbert Stuart (born in Halifax, Nova Scotia), who had been traveling in Italy before coming to Paris. After Collins and Allston had departed, Leslie remained in the city for a while with Newton, before returning to London. Newton settled there for most of his short and troubled career, devoted to the painting of literary subjects in the manner of Leslie. Allston seems to have gone directly to Paris and back to London again without investigating other French cities or the countryside. However, one of William Collins's major works of the following year, *Departure of the Diligence from Rouen,* which was shown at the Royal Academy, probably documents a stage of their journey. It is interesting and perhaps significant that this painting was acquired by Allston's good friend and patron Sir George Beaumont.

Certainly, Allston's visit to Paris seems to have infused him with new creative energy, for on his return to London he engaged himself upon several major paintings. The first of these was *Uriel in the Sun* (no. 41), completed in six weeks at the end of 1817 and exhibited at the British Institution the following year. The picture, listed first in the catalogue, was one of Allston's greatest successes. The Marquis of Stafford, one of the important collectors of his day and a major patron of the British Institution along with Sir George Beaumont, purchased the work for 150 guineas, and the institution awarded Allston a prize of £150. Stafford's acquisition was par-

ticularly noteworthy, for his collection concentrated upon old master works, and the contemporary British representation was relatively sparse. Allston's *Uriel* joined such distinguished company as Poussin's series of the *Sacraments*. Anna Jameson remarked upon it in London in 1844 and again in 1846, when it was at Trentham, one of Stafford's country houses, where Richard Henry Dana also saw it. The picture remained at Trentham until 1908, when the house and contents were sold at auction; it was then acquired by Richard Henry Dana III, with funds that had accrued to the Allston Trust, and deposited in the Museum of Fine Arts in Boston.

Allston's painting shows a single figure, that of the archangel Uriel, who guarded the approaches to the heavens after Satan's fall, according to Milton in *Paradise Lost*, the "sharpest-sighted spirit of all in heaven." Allston ascribed his source to a poem, "Visit to the Sun—A Vision," which describes Uriel as "That once entranced th'immortal Milton saw."[77] *Uriel* is Allston's only major excursion into Milton iconography; but it may have been his success with this image that led him years later to recommend to his disciple Horatio Greenough the subject of *Abdiel*, Uriel's counterpart, the angel who withstood the blandishments of Satan in the latter's revolt. Allston's English friend and fellow history painter Benjamin Haydon later undertook the subject of *Uriel and Satan*.

Uriel in the Sun is one of the most complete statements of Allston's aesthetic purpose. It is an angelic vision of high moral purpose for it was Uriel who was the guard against a resurgence of Satanic revolt. The figure is over-life-size and appears as a colossal image of resolution, combining Raphaelesque beauty with Michelangelo's power and contrapposto and Venetian coloration. Allston's experimentation with color, fresh from his renewed contact with the Venetian masters, was at its most subtle and refined. The halo glare of heavenly light against which Uriel is silhouetted was produced by painting over a white ground successive glazes containing the primary colors, each allowed to dry separately. Allston himself wrote about it as follows: "I surrounded him and the rock of adamant on which he sat with the prismatic colors, in the order in which the ray of light is decomposed by the prism. I laid them on with the strongest colors; and then with transparent color, so intimately blended them as to reproduce the original ray; it was so bright it made your eyes twinkle as you looked at it."

The work is also a masterful treatment of intense foreshortening, so that the spectator must look up at the towering figure, framed, almost enflamed, against a background of pure light, the glow of the celestial heavens. Just as Allston carries the spectator's vision upward to the figure, so the figure himself, though so idly affixed to his adamantine perch, an image of stability, carries the viewer ever upward; one is carried along the sharp parallel axes of Uriel's leg and the staff he holds, which are countered by the sweep of his foreshortened torso and the turn of his head sharply to the right, a curving action repeated in the arc of colored light behind him. The largeness of Uriel's form matches well the grandeur of Allston's vision, which here suggests a relationship to the prominent master of the previous generation, James Barry. In Barry's *Elysium and Tartarus*, painted in the early 1780s, the final panel of his series *The Progress of Human Culture and Knowledge* in the great hall of the Royal Society of Arts, Tartarus, like Milton's Hell, is guarded

by a sublimely monumental angelic figure, in pose and conception not unlike All-ston's archangel.[78] The prominent, vigorously modeled foot of the archangel may have been based upon the colossal sculptured foot that Allston showed Henry Dexter many years later in America. Allston told Dexter he had used the sculpture in several major paintings; these most likely included *Uriel* and, three years later, *Jeremiah,* where a very similar, equally prominent foot appears. Whether this foot was used previously for *The Dead Man Restored* cannot be documented. Presumably it was one of the sculptures shown by Allston to John Quincy Adams in September 1816.

Uriel was extensively reviewed in 1818. James Elmes, in his *Annals of the Fine Arts,* offered the fullest encomiums, spoke of it as an honor to the British school, and cited its advantageous position in the British Institution exhibition not only to justify the show as the best London had seen for years but also to attack the rival Royal Academy for reserving preferential hanging exclusively for the work of elected academicians. Elmes also discussed the feelings of rivalry and envy toward Allston engendered by Stafford's purchase and the premium award, on the basis that the work depicts but a single figure. The *Examiner* of February 9 spoke of Allston's high aim, commenting that the work was "already engraved on our hearts." The *Times,* a week previously, commended it as one of the finest pieces in the show, and the *Morning Herald,* on the same date, February 2, recognized a severity of design that was described as belonging to the Roman school. The critic admired the conception of Allston's *Uriel* but deplored a weakness in his drawing of the figure that even Elmes recognized. In any event, *Uriel* did not enlist unanimous praise; John Keats could not bear the work, as he remarked in a letter to his brothers George and Thomas of February 21, 1818, after viewing the British Institution show, although he confused the authorship of the picture, believing it to have been painted by Leslie.[79]

If *Uriel* was painted quickly, Allston's progress on his large biblical landscape *Elijah in the Desert* (no. 49) was almost miraculous, for he completed his painting in three weeks in the winter of 1817-18, presumably immediately after finishing *Uriel.* Although both are religious statements, the *Elijah* is a very different concept, Allston's only known excursion into the historical and biblical landscape.[80] In his investigation of this mode, Allston was not exactly pioneering, nor did he have the need to seize upon this thematic category to enhance his standing within his profession, for he was already recognized as a historical painter, the most honored artistic position. As mentioned earlier, landscape had always traditionally assumed a lower place in the hierarchic ladder, below historical and poetic painting, to the extent that in 1810 the British Institution found it necessary to decide whether the inclusion of landscape backgrounds could be allowed in historical compositions submitted to them. That same year, however, Benjamin West's *Escape of Lot and His Family from the Destruction of Sodom and Gomorrah* was categorized as a "Historical Landscape." The combination of history with landscape thus tended to raise the level of critical appreciation of landscape painting. The year 1817 seems to have been crucial for the recognition of this thematic category. It was then that the King of France was reported to have founded "Historical Landscape" as a class of painting to be encouraged, an event that may not have gone unnoticed by All-

ston during his visit to Paris that year. That year also, Turner changed his own designation from "landscape" painter to "historical landscape" painter, perhaps in recognition of the appointment of his colleague and Allston's friend John Martin as "Historical Landscape Painter" to Prince Leopold and Princess Charlotte.

In the historical landscape, as Allston's *Elijah* demonstrates, the figures, or, as here, the single figure and the ravens, are subordinate to the landscape elements. But more significant, the landscape assumes the character and the mood of the historical subject matter. Thus, Allston endows the landscape with a degree of hardness and barrenness unknown in his other landscape paintings—all of them lovely and poetic scenes—but here justified to symbolize the drought of Elijah's prophecy against the false prophets of the reign of Jezebel and Ahab. The pitiful, bent figure of Elijah, almost lost in the vast, parched landscape, is echoed by the crawling roots of the barren tree, its two stark trunks gesticulating anthropomorphically in agony. They are silhouetted against a magnificent sky of rolling dark clouds, pierced by a chevron of blue sky and white clouds, a return with new, richer coloration to the sky of Allston's *Thunderstorm at Sea* (no. 7). The landscape itself is somewhat reminiscent of that in the *Sacrifice of Moses* by his German colleague in Rome, Joseph Anton Koch, over a decade earlier. The dominant tonality is a deep, resonant brown; even the still waters of the Cherith, the stream from which Elijah drank, reflects only this parched tone.

Elijah was exhibited at the British Institution in 1818 along with *Uriel* but does not seem to have elicited similar interest. It also remained unsold, and Allston returned with the picture to America. In Boston it hung in the house of Allston's good friend and patron Isaac Davis, where it was seen in 1827 by the Englishman Henry Labouchere (later Lord Taunton), who purchased it from Allston for $1,000. Labouchere returned with it to England and included it in one of the greatest collections of old and modern masters formed in the mid-nineteenth century. Labouchere may have tired of it quickly, however; James Fenimore Cooper wrote to him in 1833: "I will come all the way to Hamilton Place to see you, if you have Alston's [sic] *Elijah* yet in your possession . . . I take it for granted that you will be willing to sell, for I remember when I went to see the picture, five years since, it was in the garret."[81] *Elijah* was exhibited at the British Institution by Labouchere in 1849, and after his death it was shown at the Royal Academy in 1870. It was then purchased by Mrs. Samuel Hooper, who presented it to the newly formed Museum of Fine Arts, where it is first in that institution's list of acquisitions. Boston's Hooper family was responsible for the recovery of several of Allston's major works, left in England; Robert Hooper had brought over the *Angel Releasing St. Peter* (no. 28) in 1859.

Elijah embodied further technical experimentation on Allston's part: a unique and successful use of skimmed milk as a medium. He mixed the liquid with his dried colors to the consistency of oil paint and applied it to the canvas covered with an absorbent ground. The colors dried as quickly as he could paint. After varnishing the result, he touched the picture with transparent oil colors and glazed it. This allowed for its rapid execution. But, although he was extremely satisfied with the results and felt he had achieved a brilliance of tone and color that was unsurpassed, he never repeated the experiment.

Before Allston began work on the *Uriel* and *Elijah* paintings, he had already conceived of *Belshazzar's Feast* (fig. 45), the work that was to be his most ambitious effort, part Holy Grail and part albatross. The final judgment on this painting will never be resolved; some contemporaries viewed it ultimately not only as his greatest triumph, even in its unfinished state, but also as the greatest work painted by an American; others, in increasing numbers after Allston's death, viewed it as his most abysmal failure, standing for the failure of the nation in its quest for mature cultural expression.

In 1816 Allston wrote to his good friend James McMurtrie of Philadelphia that he wanted to paint some splendid subject from the Scriptures, uniting brilliant color with strong character and expression, such themes being the most known and the most interesting. The following year, on May 8, he presented his ideas more clearly and specifically to Washington Irving in his famous letter:

> One of these subjects (and the most important) is the large picture I talked of soon beginning; the Prophet Daniel interpreting the handwriting on the wall before Belshazzar. I have made a highly finished sketch of it, and wished much to have your remarks on it. . . . I think the composition the best I ever made. It contains a multitude of figures, and (if I may be allowed to say it) they are without confusion. Don't you think it a fine subject? I know not any that so happily unites the magnificent and the awful. A mighty sovereign surrounded by his whole court, intoxicated with his own *state*, in the midst of his revellings, palsied in a moment under the spell of a preternatural hand suddenly tracing his doom on the wall before him; his powerless limbs like a wounded spider's kept from vanishing by the terrified suspense that animates it during the interpretation of his mysterious sentence. His less guilty, but scarcely less agitated, queen, the panic-struck courtiers and concubines, the magicians, the holy vessels of the temple (shining, as it were, in triumph through the gloom), and the calm, solemn contrast of the prophet, standing like an animated pillar in the midst, breathing forth the oracular destruction of the Empire! The picture will be twelve feet high by seventeen feet long. Should I succeed in it to my wishes, I know not what may be its fate; but I leave the future to Providence. Perhaps I may send it to America."[82]

So Allston wrote with high hopes for his great canvas; and it is prophetic that the work, indeed, went to America. One might speculate that Allston considered offering his painting for consideration among the great history paintings in the rotunda of the Capitol, although it was hardly compatible with the revolutionary subjects on which John Trumbull was working at exactly the same time. On January 27, three months before Allston wrote to Irving, Congress had resolved to employ Trumbull to fill four of the eight rotunda panels, and a month later Trumbull's contract for canvases twelve by eighteen feet had been signed. Years later, when Allston was approached to fill several of the rotunda panels, he suggested scriptural works, and the size he planned for his *Belshazzar* was almost identical to the proportions of the spaces in the Rotunda.

The subject of *Belshazzar's Feast* had attracted countless painters since the Renaissance. Baroque Italian artists such as Luca Giordano and Mattia Preti and such notable Spanish and Dutch artists as Ribera and Rembrandt undertook to in-

terpret this dramatic biblical theme, which continued to appeal to artists, composers, and authors right down to H. Rider Haggard. Strangely enough, though fraught with moral and dramatic implications, it seems to have had little interest for neoclassic artists in either France or England.

The most notable treatment of the Belshazzar theme in England before Allston began his work was Handel's great oratorio of 1745. The only important eighteenth-century pictorial treatment by an English artist was that by Allston's mentor, Benjamin West (see fig. 43), exhibited at the Royal Academy in 1776 and published in engraving by Valentine Greene in 1777. The West interpretation undoubtedly affected Allston's choice of the theme, and Oliver Larkin has suggested that Allston derived the spatial composition of his *Belshazzar* from West.

West appears to have been unique among painters in his choice of this theme and precocious as well. Hannah More published a "Belshazzar" in 1782 in her *Sacred Dramas,* and it may be pertinent that she was a friend and associate of Coleridge and Southey in Bristol, although no direct contact with Allston appears evident. It was not until the early nineteenth century, however, that a number of literary and artistic interpretations of the Belshazzar story appeared. The Reverend Thomas S. Hughes published a prize poem in 1818, a dramatic poem by Henry Hart Milman appeared in 1822, and Robert Lander's "Impious Feast" in 1828. The most important literary interpretation, however, was Lord Byron's "Vision of Belshazzar," a six-stanza poem paralleling the biblical story, published in *Hebrew Melodies* in 1815. In the same year Byron also wrote an alternative poem, "To Belshazzar," which was not published until 1831.

It is not unlikely that Allston was familiar with Byron's poem. There may, however, have been more to the fascination with the story of Belshazzar than just the attraction of powerful biblical drama. In England at the time, Belshazzar's fate was recalled as a warning to future Napoleons (Byron's poem appeared in the same year as Waterloo): dreams of world conquest and impious self-glorification could only result in heavenly retribution. By 1816-17, Allston had become part and parcel of English artistic society; it was only proper that his moral and aesthetic sentiments should be grounded there by that time also. Even years later, James Russell Lowell referred to Allston as "the greatest English painter of historical subjects."

English artistic interest in the subject of Belshazzar paralleled the literary. In his *Lectures,* delivered at the Royal Academy in 1807, John Opie referred to Rembrandt's painting of the subject as an outstanding example of sublime terror. Allston's admiration for Opie and the growing influence at this time of Rembrandt have already been noted. The most famous native English treatment of the theme in the nineteenth century was by Allston's good friend John Martin, the triumphant success of whose painting contrasts sadly with the history of Allston's effort.

An article in the *Athenaeum* of 1834 derisively quoted an apocryphal meeting described in an American magazine between the youthful Allston and the destitute Martin at the beginning of the century, with Allston aiding the Englishman's growth from rags to riches, and then a later meeting between the two during Allston's second stay in England. According to Martin himself, however, he was introduced to Allston in 1814 by their mutual friend Leslie, whom he met at Benjamin West's. Martin was visiting West to show his painting *Clytie.* Allston had

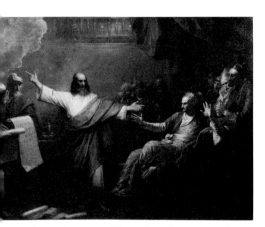

Fig. 43. BENJAMIN WEST, American, 1728-1820
Belshazzar's Feast, by 1776
Oil on canvas
Berkshire Museum, Pittsfield, Massachusetts

previously admired Martin's *Sadak in Search of the Waters of Oblivion,* and later the two discussed the subject of Belshazzar. Allston is said to have suggested to Martin the form and spatial character that the latter's picture was to take, based upon the poem by the Reverend Thomas Hughes; Martin, the story goes, then returned home and worked out the plan of his great picture, gaining Allston's approval. Martin's picture became his most famous: a fantastic essay in architectural perspective and panoramic vastness, with the cataclysmic biblical drama reflected in the architectural and natural surroundings.

Martin's *Belshazzar* (fig. 44), when exhibited at the British Institution, in 1821, was an enormous success. It was later moved to a private gallery in London and then shown in Edinburgh and elsewhere.[83] West's painting of the same subject was brought out and shown alongside Martin's at the British Institution. The latter's work was so popular that he prepared at least four versions of it as well as two mezzotints, while an unauthorized copy was presented as a diorama in 1833; this "nearly 2000 feet of canvas" was later shown in New York at Niblo's Garden. Prints after Martin's work were popular in America and were copied, although the fame of Allston's version of the subject must certainly account for the interest in Martin's picture. Allston himself followed the progress of Martin's *Belshazzar;* when he heard the news of its success in 1821, he was back in America, and he wrote to Leslie: "Tell Martin I would get up before sunrise and walk twenty miles to see his picture, which is saying a great deal for me, who have seen the sun rise about as often as Falstaff saw his knees."

Allston's description of his conception to Irving well characterizes his work,

Fig. 44. JOHN MARTIN, British, 1789-1854
Belshazzar's Feast, 1821
Oil on canvas
Mr. and Mrs. J. M. Tanenbaum

Fig. 45. *Belshazzar's Feast,* 1817-1843
Oil on canvas, 144⅛ x 192⅛ in. (366 x 488 cm.). Richardson 100
The Detroit Institute of Arts, Detroit, Michigan, Gift of Allston Trust

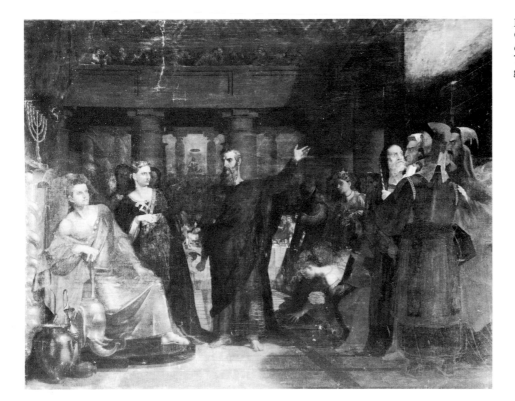

which is known today in two studies for the great, unfinished final painting (fig. 45). The earlier of the two studies is probably the sepia version (no. 42), but by May 1817 Allston had almost surely painted the "color study" (no. 43). The latter differs from the sepia study in only one significant passage, that in the lower left corner. In the sepia version a pair of serving boys join the general reaction of the dismayed audience as Daniel translates MENE, MENE, TEKEL, UPHARSIN: "God hath numbered thy kingdom and finished it. Thou art weighed in the balances, and art found wanting. Thy kingdom is divided, and given to the Medes and Persians." In the color study these figures have been found extraneous and have been replaced by the golden vessels seized by the Babylonians from the Temple of the Jews, to which Allston refers in his letter to Irving. This change must have been deemed an improvement by Allston, for it remained in his final statement. Otherwise, the emphasis in the two studies upon emphatic and strained gesture and expression is similar, and these qualities were refined in the final work.

At the time Allston was first working on *Belshazzar's Feast,* he painted a series of four studies of Polish Jews (nos. 44-47), whom he had observed in the streets of London. Interest in and appreciation of venerable exotic types are common enough in art, as witness the studies made by slightly later American painters such as Thomas Cole and Asher B. Durand during their several *Wanderjahre.* But Allston's choice of Polish Jews is significant, for it allies him especially with Rembrandt, both in subject and in interpretation. The four bust-length, life-size studies are similar to and are often related to *Belshazzar.* Although they constitute prototypes for the group of soothsayers at the right of the canvas, they are not models for any of them, nor would this have been Allston's reflective methodology. Rather, they provided the basic raw material for his development and rumination. In fact, it is significant that the closest parallel is between the *Polish Jew* (no. 44) in the Boston Museum's collection and the soothsayer at the far left in the *final* version of *Belshazzar,* a figure that was markedly changed from that in the initial two studies for the painting done at the same time as the series of Polish Jews.

Three of the four figures in the series are unfinished, but one of them is complete, with the inclusion of a hand with a ring, holding a staff. There seems to be no explanation for this difference, but Allston may have intended to finish all four and then have either decided against this or become diverted toward other projects. One of the other figures was renamed *Isaac of York* (no. 47) when it was exhibited at the Boston Athenaeum in 1833. Except for the religious applicability, the link with Scott's *Ivanhoe* is somewhat capricious (the book did not appear until three years after the picture was painted!); certainly it is the strongest, most sympathetic, and most "Rembrandtesque" of the paintings. All four were brought back to America and were shown in the 1839 exhibition of Allston's paintings at Chester Harding's gallery. By then they had all left Allston's hands; two were privately owned, and two had been acquired by the Boston Athenaeum. The *Isaac of York* designation for one of the latter would have distinguished it from its companion.

By 1818 Washington Allston was at the height of a successful career in England as a historical painter; in the *Annals of the Fine Arts* in 1816 he had been listed as one of the principal history painters in England. He had gained the patronage of three of the most significant patrons of the arts.[84] He was a friend of many of the

leading artists and literary figures of the day, among them his now close friend Collins, the Anglo-Americans Leslie and Newton, John Martin, Sir Thomas Lawrence, Benjamin Haydon, the brothers James and William Ward, the Norwich landscape painter James Stark, William Brockedon, the portrait painter James Lonsdale, the Irish landscape painter William Willes, and, of course, Benjamin West. All these figure in Allston's correspondence, particularly, after his return to Boston, in the letters that traveled back and forth across the Atlantic between him and Collins and Leslie. He had shown often and well at the two institutions exhibiting art in Great Britain and had been enthusiastically reviewed in the press. He was now at work on his grandest effort and had recently had an enjoyable and successful visit to the Continent, undertaken, undoubtedly in part, to further his artistic understanding and certainly with a view to even greater dramatic and artistic effect in his *Belshazzar*.

Yet, in August of 1818, Allston departed from England. Even though he had begun to make intimations of his plans the year before, it would appear that he left abruptly. A number of reasons have been adduced in explanation. Homesickness is one; but that would seem far less likely in 1818 than earlier, before his position became so firmly entrenched in the British social and artistic establishment. The promise of artistic success in America is another; but while the Pennsylvania Academy's acquisition of *The Dead Man Restored* was undoubtedly a significant event both professionally and monetarily, Allston had experienced disappointment in the tardiness of the payments due to him, and certainly the cultural climate of America was not comparable to that in England with regard to support for history painting.

Another reason given is the mishandling of his patrimony by his American agent; but it seems that would only encourage Allston to remain abroad, where he was achieving ever increasing success. And another is the tragic death of Allston's wife; yet Ann Channing Allston died early in February 1815. If her death did not bring about the artist's return to America shortly afterwards, it would surely not be a compelling motivation three and a half years later.

The strangest explanation was offered by Charles Leslie, and yet it may be the most persuasive and incisive. Leslie attributed Allston's departure to the constant soliciting by beggars of the ever generous artist. He even cited a case where Allston had given one female beggar some of his wife's fine clothes, only to see her subsequently importuning in her customary rags. And he stated that Allston even received distressing letters from some of the beggars whom he had aided. Such a motivation for leaving England may strike us today as trivial. Yet, there is something rather odd in this affair, not least, the suggestion of "literate beggars" in London in 1818! And this explanation is given further credence by two letters Allston wrote on shipboard, on August 23, to Leslie and to William Collins, then his closest friends in England. To Collins Allston wrote that he did not want his address in America given to anyone, and that he did not want to hear from anyone to whom he had not given his American address. He was more explicit to Leslie. He instructed him not to take any letters directed to his former lodging at Buckingham Place and that he had cautioned his landlady similarly. His letter to Leslie became increasingly anguished: "I know, my good fellow, you will excuse this," he wrote, "for you

know what I have already suffered. . . . There are letters of this unpleasant kind I have had from Bristol and other places. Tell Mr. Bridgen never to take out any letters to me from the Dead-Letter Box. If any should be there let them remain; for I don't want them."[85]

All Allston's friends and patrons advised him to remain in England. As early as 1813, Morse had written to his parents that in the opinion of the greatest connoisseurs in England, Allston was "destined to revive the art of painting in all its splendor, and that no age ever boasted of so great a genius." Sir George Beaumont wrote to him: "I am convinced you are quitting this country at a moment when the extent of your talents begins to be felt, and when the encouragement you are likely to receive will bring them to perfection." And Lord Egremont wrote in a similar vein: "I hear you are going to America. I am very sorry for it. Well, if you do not meet with the encouragement you deserve in your own country, we shall all be very glad to see you back again." And years later, Wordsworth, writing appreciatively of Allston, remembered his concern at Allston's severing his English ties. Washington Irving, distraught at Allston's imminent departure, came to London from Birmingham to meet him at Coleridge's; all attempted to persuade him from leaving. Allston waved farewell from the stagecoach. Pierre M. Irving, nephew of Washington Irving, quoted the great author: "He was the most delightful, the most loveable being I ever knew; a man I would like to have always at my side—to have gone through life with; his nature was so refined, so intellectual, so genial, so pure."

As early as 1814 Allston had been proposed as a candidate for membership in the Royal Academy; he did not compete successfully at that time, when his friend William Collins became an associate academician, but he was successfully voted in as an associate in 1818, although he had by then returned to America. Joseph Farington commented in his *Diary* that many of the members of the Academy were in favor of Allston and that he had the support of Henry Howard, then a major figure in British historical painting.[86] On receiving notification of his Academy membership, Allston acknowledged the honor with much pleasure and signed a number of the pictures he subsequently painted "W. Allston A.R.A." There were many, in fact, who believed that had Allston remained in London, he would have been chosen to succeed Benjamin West as president of the Royal Academy after the latter's death in 1820. Certainly, he would have had no rival for the leading position among the English history painters of the period. Benjamin Haydon was too difficult a man for the post and already had a tarnished reputation; John Martin was too eccentric and was combatively associated with the rival British Institution. Lawrence, who did in fact succeed West, was a portrait painter and thus an artist of lower rank. Allston's affection for England was openly acknowledged; he himself wrote, "next to my own, I love England, the land of my adoption." And in a letter to William Collins from Boston, in April 1819, he expressed the hope that he would preserve his "claims as one of the British School."[87]

That an American citizen would have been elected president of the Royal Academy is unlikely. But it is true that, in 1821, Allston was seriously considered for election to full academician to fill the place vacated by West's death. The historical painter Henry Thompson joined Collins in urging Allston's election, but Lawrence felt it would be ill-judged to elect an artist who might never return to England. All-

ston wrote to Dunlap that he felt the rule of the Royal Academy, barring eligibility to a nonresident of the United Kingdom, a narrow one. Nevertheless, Allston's name was on the ballot, and he placed third on the first ballot. He was eliminated on the second, the sculptor Edward Bailey winning the election, and William Daniell placing second. Daniell was elected the following year, but there was no further discussion of Allston's election. He may, of course, have run strongly in 1821 because of sentiment in regard to replacing West with an American who was one of his pupils, but one might wonder also if election to full academician might have proved a sufficiently strong inducement to Allston to return once more to England. Such an outcome would certainly have altered the course of his career significantly and might also have affected the state of British art.

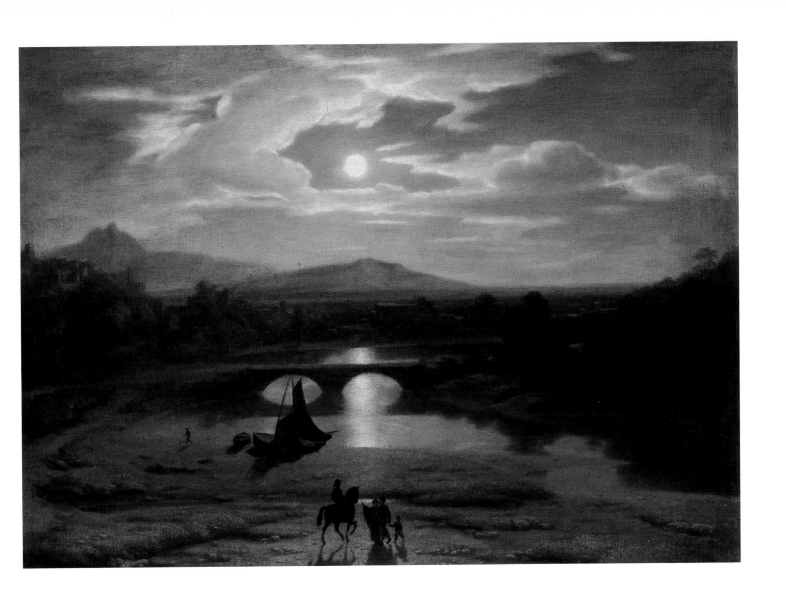

54
Moonlit Landscape (Moonlight), 1819
Oil on canvas, 24 x 35 in. (61 x 88.9 cm.)
Richardson 117
Museum of Fine Arts, Boston, Gift of William Sturgis Bigelow

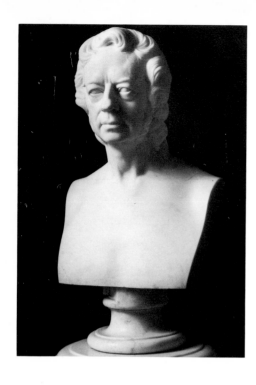

104
Shobal Vail Clevenger, American,
1812-1843
Washington Allston, ca. 1839
Marble, height 18 in. (45.7 cm.)
Library of the Boston Athenaeum

Allston traveled back to Boston accompanied by Thomas Handasyd Perkins on the ship *Galen*. He drew a spirited watercolor of the ship in a storm, which Perkins acquired; unhappily, the work is unlocated today and known only from a photograph in the Dana collection. Another drawing done on shipboard was *Polyphemus Immediately after His Eye Was Put Out, Groping about His Cavern for the Companions of Ulysses*, also unlocated. It was later acquired by a major patron of Allston's, Loammi Baldwin, of whom there exists an unfinished portrait by the artist (Fogg Art Museum). Allston's fame had preceded him to Boston, where his British successes were well known; he told Collins that Boston was impressed also with his election as an associate of the Royal Academy. In that context, "Boston" would have included not only Allston's friends and the resident artists and writers but also his future patrons in the community such as the Eliots, the Sears, the Appletons, the Lowells, the Ticknors, and perhaps Thomas Handasyd Perkins, Boston's foremost art patron of the period.

Allston brought with him to Boston the conceptions of a history painter and transplanted them to American soil. Boston itself had almost no tradition of high art. The leading painter there on his arrival was the aging Gilbert Stuart, with whom Allston soon became fast friends. Allston became an important and influential member of the committee that organized the Stuart Memorial Exhibition of 216 of the artist's portraits at the Boston Athenaeum in August 1828. John Neagle arrived from Philadelphia in 1825 with letters of introduction to Stuart and Allston and met the latter at Stuart's house. At the time, Neagle was painting Stuart's portrait, a work that Allston commended, while generously—and typically—offering Neagle sound artistic advice. Alvan Fisher, another Boston artist of many talents, was an able though uninspired portraitist and a developing landscape painter. The

most significant example of historical painting done in Boston before Allston's return was Henry Sargent's *Landing of the Pilgrim Fathers* of 1815, and it is a significant testimonial to Allston's sense of professional honor and his friendship with Sargent that he refused to consider this subject for the rotunda of the Capitol expressly because it had already been well executed by a fellow artist. Elsewhere, Trumbull was developing his Capitol commission, and Allston's earlier companions, Vanderlyn and Morse, were unsuccessfully attempting to develop American taste and perception toward history while they unhappily fell back upon portraiture to make a livelihood. That was not to be Allston's pattern; there are no known portraits by him completed during the last twenty-five years of his life in Boston and Cambridge.

While Allston suffered severe economic restrictions, and while later art historians have despaired over the lack of encouragement given to our greatest, most original talent of the period, he was actually one of the best patronized artists in America. Anna Jameson was very conscious of this in her memorial testimonial, published in the *Athenaeum* in 1844: "Certainly, if his genius languished in America, it was not for want of patronage so called—it was not for want of praise. The Americans, more particularly those of his own city, were proud of him and of his European reputation. Whenever a picture left his easel there were many to compete for it: they cited the high prices they had paid for his productions as matter of exultation; they triumphed in the astonishment and admiration of a stranger." Indeed, Allston's patrons of the 1820s and 1830s constitute something of a social register of Boston of the period, men who supported his every effort and offered him tremendous adulation and financial aid. The only exception to this was Francis B. Winthrop of New Haven, perhaps significantly *not* a Bostonian. Winthrop wrote to Allston, then in London, in 1817 that he had previously purchased, in 1810, a landscape on the advice of a Mr. Sullivan (probably William Sullivan who was a patron of Allston). Winthrop had paid $500 for the picture; not enjoying it, he sold it in 1816 and complained that it fetched only $200. Edmund Dwight was the later owner of this *Alpine Landscape* and may have been the purchaser in 1816, for Winthrop had lent it to the American Academy of Fine Arts exhibition of 1816 in New York, conspicuously marking the work "for sale." Allston offered to recompense Winthrop by sending him another painting in its stead, which he hoped to paint on returning to America in 1818. Immediate need to paint small pictures to sell prevented Allston both from recommencing *Belshazzar* and from satisfying Winthrop; the latter, however, continued to pressure Allston, who wrote to his irate patron that he had a work under way in November 1821 that he was pleased with. Either this did not reach a satisfactory conclusion or else Allston had to sell the work to make ends meet. In any case, he finally turned over to Winthrop the study for *The Angel Releasing St. Peter from Prison* (fig. 30), but this does not seem to have satisfied Winthrop either. Allston's early biographers roundly condemn Winthrop for his constant pressuring, judging it not only insensitivity but persecution as well; all the more reprehensible was his refusal to lend his picture to the 1839 exhibition of Allston's work at Harding's Gallery in Boston.

One cannot compare Allston to the prevailing hordes of portrait painters, of course, because portraitists almost always paint on commission. But Allston

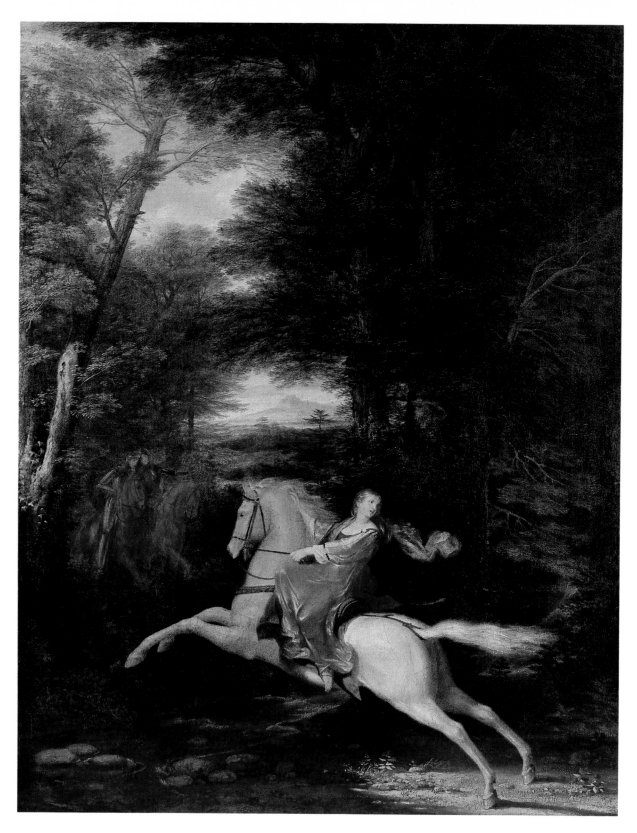

52
The Flight of Florimell, 1819
Oil on canvas, 36 x 28 in. (91.4 x 71.1 cm.)
Richardson 119
The Detroit Institute of Arts, City Purchase

53
Beatrice, ca. 1816-1819
Oil on canvas, 21¼ x 25¼ in. (76.8 x 64.1 cm.)
Richardson 120
Museum of Fine Arts, Boston, Anonymous gift

throughout his later career was constantly beleaguered by patrons and prospective patrons clamoring for works that he refused to produce or finish. It is significant that among the forty-seven pictures exhibited in his one-man show in 1839, only one was owned by the artist, and that a curio of his college days. The prices Allston received for his paintings done in America were certainly relatively low, particularly as compared to the rewards he garnered for his efforts in England, which several times included both prize and purchase monies. But two further factors are significant here. First, a number of the pictures painted in England either were acquired then or later by Americans or were brought back by Allston to Boston, where they then found purchasers. Secondly, only a very few of his finished later American pictures are anywhere comparable in size to the major creations of his English years, and many of the pictures are extremely small.

On his return to America, Allston's art continued in the imaginative variety that had increasingly characterized it during his English years. He painted landscapes, literary subjects, and idyllic figures, but he at first expended his major energy on a continuation of images of dramatic grandeur drawn from the Bible and particularly from the Old Testament. Three of these appeared in 1820-21; they were Allston's last completed biblical subjects, and they must have complemented and reinforced the efforts he was then making to complete his painting of *Belshazzar.*

Allston's *Saul and the Witch of Endor* (no. 60), painted for his Boston patron Thomas Handasyd Perkins in 1820, strongly contrasts with the comic piece of 1811, *The Poor Author and the Rich Bookseller* (no. 24), also in Perkins's extensive collection. Allston was surely familiar with the treatment of this theme by his teacher West in 1977 and one of the latter's first major excursions into the aesthetic of the sublime. The subject would have had great appeal for Allston, again one dealing with the supernatural, with prophetic determinism, and with retribution upon the vainglorious. In fact, the subject is a miniaturized *Belshazzar,* complete with the confrontation of king and prophet and the foretelling of destruction. But it is instructive to compare the versions of West and Allston. West's picture is completely beholden to the Burkean notion of sublimity. The ghost of the prophet Samuel is an eerie shrouded figure, almost more "real" than the grotesque witch of Endor or the shrinking figure of Saul almost absorbed into the ground. By contrast, Allston's painting is a much more rational one. His figures are symmetrically ranged in a front plane, while their limbs form a diamond-shape void within which emerges the spectral shade of Samuel. The gestures of the witch and Saul are frozen in counterpoint to each other, her pose of command and dignity balancing that of Saul's anxiety and fear. Saul's companions on the right hark back to the subsidiary figures in Allston's *Dead Man Restored* (no. 25), repeating in reverse the pose of the principal soldier in the earlier picture, both derived from the Borghese *Warrior* of antiquity; the witch herself is a powerful woman of heroic endowment, indebted to Michelangelo's sibyls. The work has been criticized for frozen lifelessness, but this, I think, indicates a misunderstanding of Allston's intentions and of his attempt to juxtapose his English manner with a new, more original and personal one. Here, as in his *Belshazzar* and in the *Jeremiah* of the same year, Allston was reaching that moment of miracle, the instant of dramatic denouement. The painting remained before the public in exhibition in Boston, reaching a particularly wide audience as

the basis for the engraving distributed by the New England Art Union in 1851.[88] Of all of Allston's later dramatic compositions, *Saul and the Witch of Endor* was probably the least well received critically. Oliver Wendell Holmes, in his review of Allston's 1839 retrospective exhibition, for instance, voiced the usual reaction to the painting in finding it too stereotyped, too dependent upon British models in the manner of Richard Westall and, chiefly, of Benjamin West. Yet the young George Fuller marveled at the painting, finding it the finest work exhibited at the Boston Athenaeum in 1843, which he visited shortly after Allston's death.[89]

The same year, 1820, Allston completed his *Jeremiah Dictating His Prophecy of the Destruction of Jerusalem to Baruch the Scribe* (no. 58), the most ambitious of the pictures he completed during his twenty-five years back in America, and one of those to which he proudly affixed the initials designating himself as an associate of the Royal Academy. The work had been begun the previous year in Cambridge, to which Allston had fled because of an epidemic in Boston. It was acquired by Mrs. Mary Channing Gibbs, mother-in-law of William Ellery Channing; Allston had known her son, George Gibbs, in Rome in 1807 when he had sat for a portrait by John Vanderlyn. Allston's *Jeremiah* shows a monumental figure, powerful and yet motionless, abstracted in thought, seated in vast prison chambers that are filled with a hushed solemnity. Lewis Gray, a servant in the Dana family, modeled for *Jeremiah*. The cavernous interior seems barely sufficient to contain the majesty of the principal figure, although the expansion of the spaces beyond, possibly influenced by Piranesi, suggest the extension in time and space of Jeremiah's prophetic vision. These darkened spaces are lit with passages of light that penetrate from the outside through the massive walls, but they pale in contrast to the golden illumination that emanates from the figure of Jeremiah himself. It bathes the forward chamber, a divine and benign light with an even glow, and encompasses the figure of Baruch, the young and very beautiful scribe, who shares and reflects its protection. Allston filled the void in the lower right with a superbly formed jar, partially covered with drapery, a still-life element so disproportionately admired that Allston voiced regret over its inclusion.

The figure of Jeremiah reflects more clearly than any other in Allston's oeuvre the inspiration of Michelangelo and brings to mind Washington Irving's comment: "I well recollect the admiration with which he contemplated the sublime statue of Moses by Michael Angelo" (see fig. 14). Allston makes effective contrast between the dominant, awe-inspiring prophet and the smooth, youthful Baruch, bent in rapt attention to him. Wisdom and innocence, age and youth, dominance and subservience are compared—as are Michelangelo and Raphael as sources of inspiration—and yet united in the implication of prophecy and divine light. Again, as in his earlier Old Testament pictures and in his abandoned *Christ Healing the Sick* of 1813 (no. 29), Allston has attempted to communicate the moment of miracle and prophecy, to capture divine intervention in the depth of tomb and dungeon. The closest similarity of all, of course, is the prophetic vision of Daniel in the great *Belshazzar's Feast*, to which Allston was about to devote his attention.

In turn, Allston's *Jeremiah* would seem to have inspired the heroic statue of *George Washington* (fig. 46) conceived by the painter's disciple Horatio Greenough in the subsequent decade. Greenough came under Allston's influence shortly after

Fig. 46. HORATIO GREENOUGH, American, 1805-1852
George Washington, 1832-1841
Marble
Smithsonian Institution, Washington, D. C.

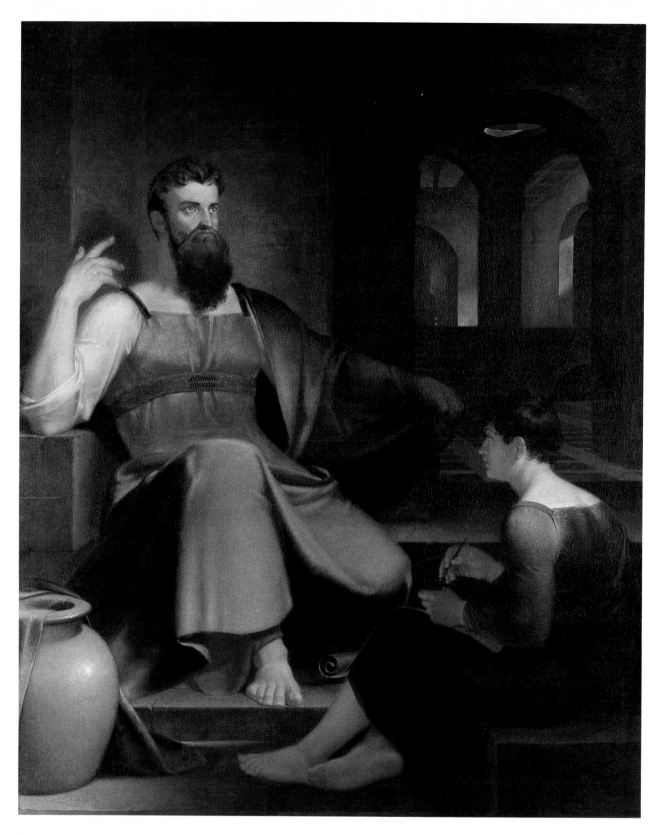

58
Jeremiah Dictating His Prophecy of the
Destruction of Jerusalem to Baruch the Scribe, 1820
Oil on canvas, 89⅜ x 74¾ in. (227 x 189.9 cm.)
Richardson 122
Yale University Art Gallery, Gift of S. F. B. Morse, B.A. 1810

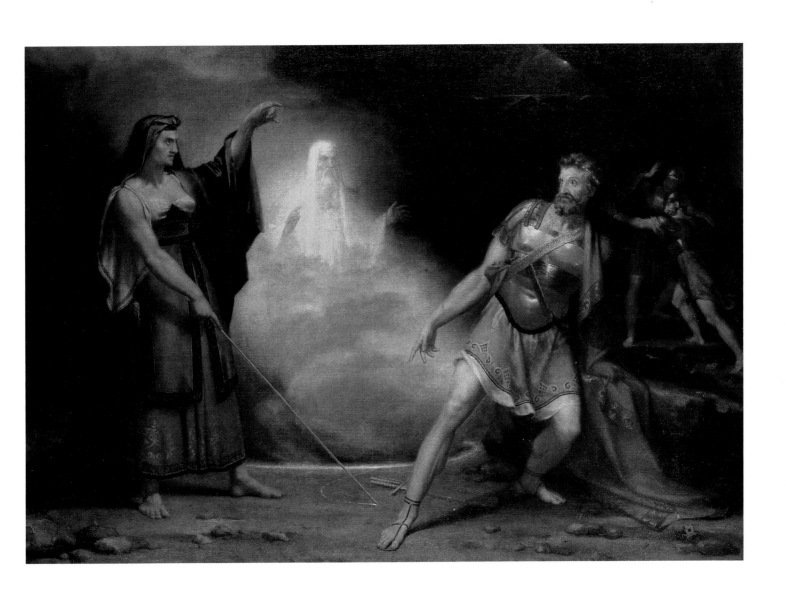

60
Saul and the Witch of Endor, ca. 1820
Oil on canvas, 34 x 47 in. (86.4 x
111.94 cm.)
Richardson 125
Amherst College, Mead Art Museum
Amherst, Massachusetts

the *Jeremiah* was completed and exhibited in Boston, when he was a junior at Harvard University in 1823-24 and living in the house of Allston's future brother-in-law and close friend, Edmund Dana. Allston often spent Saturday evenings at Dana's, and it was there that Greenough first met the painter. They were artistically associated several times during their careers, with the Bunker Hill Monument for Boston, the Gibbs family memorial outside of Newport, and the statue of Washington for the rotunda of the Capitol. For this last, Allston strongly recommended Greenough and later offered criticisms of his design. The monumental statue, as Greenough conceived it, is based, at least in part, upon the reconstruction of the Phidian *Zeus* for the Temple at Olympia, but it also strongly resembles Allston's figure of Jeremiah, not only in its solemn majesty but also in the pose—the outstretched arm, and one leg raised higher than the other—and in the treatment of the drapery around the legs and knees, a similarity perceptively noted by Ralph Waldo Emerson. It is significant, too, that Allston's major criticism of the sculpture concerned the discomfort suggested by the arm perpetually held high; in effect, he was suggesting that it be in a lower position, as, indeed, he had situated the more comfortable but still eloquent arm of his Jeremiah.[90]

Allston had been offered $1,000 by Mrs. Gibbs to paint the *Jeremiah* to adorn her Beacon Hill dining room, but she consented to its public exhibition at the Boylston Market House, beginning August 29, 1820, and running through November, to augment the artist's financial remuneration. It was shown again in Boylston Hall in 1822. At that time Boston still did not have regular public exhibitions; when these were established at the Boston Athenaeum in 1827, the picture was once again on public view, this time lent by the deceased Mrs. Gibbs's daughter, Sarah. At one time the new owner sent Allston an additional $1,000 after having been offered $2,000 for the picture by an English visitor. Miss Gibbs kept the picture in her houses in Boston and near Newport; after her death, Samuel F. B. Morse acquired it from her estate for the considerable sum of $7,000 and presented it to Yale University in 1866, as a tribute to his former teacher and friend. Two oil studies for the *Jeremiah* are also extant, a complete rendering of the entire composition (no. 57) and an oil study for the prophet's head (no. 56), more expressive, less idealized, and closer to its Michelangelesque source than the final rendering. A plaster model for the foot of the prophet, seen by the sculptor Henry Dexter in 1838, is now lost. Another, later involvement in sculpture for Allston was the design for the marble monument to Mary and George Gibbs, in St. Mary's Church in South Portsmouth, near Newport, Rhode Island, carved by Horatio Greenough about 1839-1842; Allston occasionally visited there as a guest of the Gibbs's daughter, Sarah, at the family mansion, "Oakland."[91] Allston also designed a monument for the Cheever-Shattuck families, carved in 1837 by Alpheus Cary for installation in Mt. Auburn Cemetery in Cambridge and described by Eleanor Shattuck to Dr. George Shattuck, Allston's physician, in a letter of April 4, 1837, now in the Massachusetts Historical Society.

Another major work by Allston of this period, conceived in a vein similar to that of *Jeremiah* was *Miriam the Prophetess* (fig. 47), commissioned by David Sears, whose wife was named Miriam. The picture was painted in 1821; it is perhaps closest in spirit to the artist's *Uriel,* in which a monumental figure is pushed up close to

Fig. 47. *Miriam the Prophetess,* 1821
Oil on canvas, 72 x 48 in. (183 x 122 cm.)
Richardson 127
William A. Farnsworth Library and Art
Museum, Rockland, Maine

the picture plane and is viewed by the spectator from below. Like Uriel and Jeremiah, Miriam glows with golden radiance in her Titianesque robes. This may be the artist's least successful biblical rendering, however; Allston has attempted to reinforce the sense of prophetic exultation by an expressive countenance, which is unconvincing, and by activating the figure. Miriam strides forward and to the left, one arm raised toward the heavens and drapery billowing wildly behind, but the circling motions of the body, arms, and drapery do not propel the figure successfully, and the swelling anatomy suggested beneath the garments seems grotesque. Allston was never completely successful in the rendering of violent motion; rather, he was able to use it as an effective counterpoint to a dominant, static, and commanding presence, as in *The Dead Man* and *Belshazzar*. The tiny figures of the Egyptians hosts catapulting into the Red Sea in the distance also appear distressingly out of scale. Yet, Oliver Wendell Holmes judged *Miriam* the finest of all of Allston's works, and George Ticknor found in the picture the wondrous creation of sound itself, hearing Miriam's singing and the music of her timbrel. Perhaps not coincidentally, William Wetmore Story's sculptural treatment of *Miriam Singing Her Song of Triumph* is close in form to Allston's painting, both artists choosing the same moment in biblical history. As a continuation in America of the grand historical style that Allston had practiced so successfully in England, *Jeremiah* and *Miriam* were highly regarded. *Jeremiah* was praised in the press on its first exhibition in 1820, and both paintings inspired poetic treatment; the poem relating to the former was by Sarah S. Jacobs, published in the *Rhode Island Book* of 1841, and, more impressive, the work relating to the latter was by James Russell Lowell.

In May 1820 Allston had written to Henry Pickering, the Salem poet, that he was completing work on a commissioned picture (almost certainly *Jeremiah*) and that in about six weeks he would begin again on *Belshazzar's Feast*. He had planned to resume work on the picture much earlier, immediately on his return to America. After returning to Boston, he had written to James McMurtrie that all the laborious part was over but that there remained about six or eight months' more work. By 1819 Allston had received a $5,000 commission from the Boston hospital for a large picture (a commission undoubtedly prompted by the Pennsylvania Hospital's acquisition of West's *Christ Healing the Sick* three years earlier). Both Charles Leslie and Thomas Sully believed that *Belshazzar* was destined there, but Allston himself wrote to Collins in June 1819 that for the hospital he might enlarge his sketch of *St. Stephen before the Council*, which he had made in England and brought back with him. In March 1819 Allston had written to Gulian Verplanck that he hoped to get back to *Belshazzar* by June; in October he told James McMurtrie that lack of funds had delayed him but that he hoped to proceed soon; he repeated this to Leslie in mid-November, saying that first he had to finish his smaller works on commission, after which he would be able to devote his time to *Belshazzar's Feast*.

Thus, the large canvas remained rolled up and untouched for two years after Allston's return to America. When he finally unrolled it in September 1820, there occurred an event that was to have a catastrophic effect on his effort to complete the great work. He invited Gilbert Stuart to inspect the picture and to criticize it. The choice of Stuart may at first seem peculiar, for Stuart, almost more than any

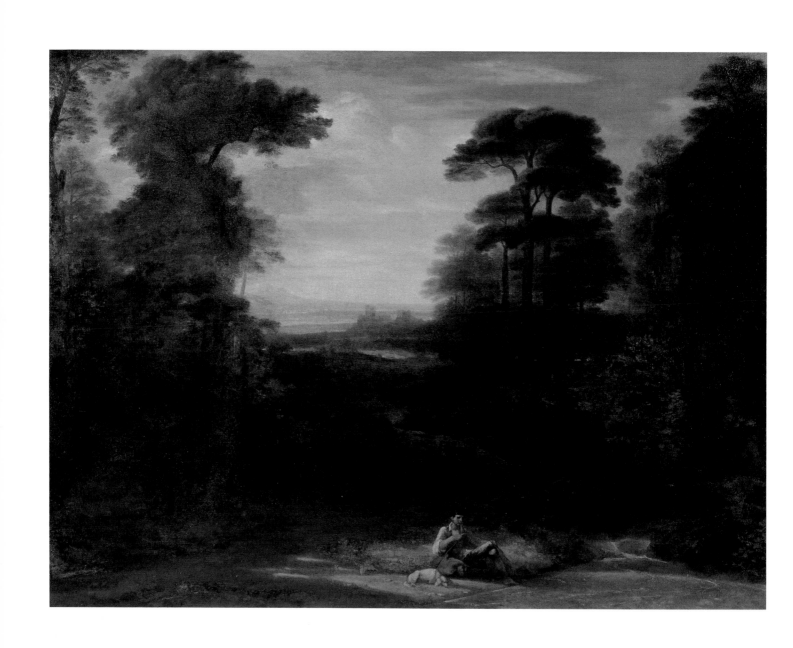

61
Landscape, Evening (Classical Landscape),
1821
Oil on canvas, 25½ x 34 in. (64.8 x 86.4 cm.)
Richardson 126
IBM Corporation, Armonk, New York

63
The Spanish Girl in Reverie, 1831
Oil on canvas, 30 x 25 in. (76.2 x 63.5 cm.)
Richardson 135
The Metropolitan Museum of Art, Gift of
Lyman G. Bloomingdale, 1901

painter of the period, was strictly a portraitist and content to be one; neither the full-length figure nor group portraiture had ever been his forte. Yet, one can understand Allston's invitation. In England, as earlier in Rome, he had had the benefit of constant communication and exchange with other artists. In Boston there was almost no one apart from Stuart, at least no peer, with whom he could discuss aesthetic problems. And he and Stuart had both achieved enormous success in London. Stuart was a fellow anglophile, and it is likely that Allston was now beginning to chafe at his cultural isolation, as had the older artist for so many years. Allston's admiration for Stuart received attestation in the obituary he wrote for the local newspaper in Boston on Stuart's death in 1828.[92] Dunlap quotes both Sully's and Neagle's account of Allston's praise of Stuart's *Portrait of George Gibbs II,* a work he deemed finer than any of the portraits of Rembrandt, Rubens, Van Dyck, Reynolds, or Titian.

Nevertheless, Stuart's well-meaning criticisms of *Belshazzar's Feast* dealt a crucial blow to Allston's progress. Stuart made some observations concerning the perspective of the painting, which, though minor, necessitated Allston's reworking the entire composition and rescaling the figures and the architectural background. Allston began to incorporate the necessary changes, and these were apparently made by May 1821, when he wrote to Leslie as follows:

> On seeing it at a greater distance in my present room, I found I had got my point of distance too near, and the point of sight too high. It was a sore task to change the perspective in so large a picture; but I had the courage to do it, and by lowering the latter and increasing the former I find the effect increased a hundredfold. I have spared no labor to get everything that came within the laws of perspective correct, even the very bannisters in the gallery are put by rule. Now it is over I do not regret the toil, for it has given me a deeper knowledge of perspective than I ever had before, for I could not do that and many other things in the picture, which are seen from below, without pretty hard fagging at the Jesuit [a work on perspective]. I have, besides, made several changes in the composition which are for the better, such as introducing two enormous flights of steps, beyond the table, leading up to an inner apartment. These steps are supposed to extend wholly across the hall, and the first landing place is crowded with figures, which being just discoverable in the dark, have a powerful effect on the imagination. I suppose them to be principally Jews, exulting in the overthrow of the idols and their own restoration, as prophesied by Jeremiah, Isaiah, and others, which I think their action sufficiently explains. The gallery, too, is also crowded, the figures there foreshortened as they would appear seen from below.

In late October 1821, Thomas Sully wrote that the picture was two-thirds finished, with Belshazzar completed, but not Daniel. Although Allston's letters of the following year to Leslie report him hard at work and at one point foreseeing only three months more effort, each new effort seems to have involved only more changes. In another letter, of February 1823, he wrote that he now hoped to finish by the end of May. Yet Chester Harding reported that he saw the picture before sailing for Europe in 1823 and that, except for the figure of Daniel, it was finished. Certainly, the American press kept a watchful eye on the progress of Allston's great

picture at this time, and it may have been either the reports of Allston's *Belshazzar* or the success of Martin's painting that inspired the young Thomas Cole, in remote Steubenville, Ohio, to essay a depiction of this subject in the winter of 1822-23. The date of the fourteen-figure, ninety-square-foot *Belshazzar* by the Connecticut painter Joseph Steward is not known. Steward died in 1822, and his work was mentioned in an advertisement two years later. Hugh Reinagle exhibited a *Belshazzar's Feast* at Peale's Museum in New York in 1830 and took it to New Orleans three years later. Many years after Allston's death, Thomas P. Rossiter included the subject in his multiepisodic *Jeremiah*. All of these may have been inspired by Allston's painting or the fanfare connected with it.

Recognition of Allston's struggle, equated with a view of American materialism and the nation's lack of recognition of her great creative figures, was implicit in the poem delivered by James G. Percival before the Connecticut Alpha of the Phi Beta Kappa Society, on September 13, 1825. It reads in part:

> . . . Wherefore else should He,
> Who, had he lived in Leo's brighter age,
> Might have commanded princes by the touch
> Of a magician's wand, for such it is
> That gives a living semblance to a sheet
> Of pictured canvass—wherefore should he waste
> His precious time in painting valentines,
> Or idle shepherds sitting on a bank
> Beside a glassy pool, and worst of all
> Bringing conceptions, only not divine,
> To the scant compass of a parlor piece—
> And this to furnish out his daily store,
> While he is toiling at the mighty task,
> To which he has devoted all his soul
> And all his riper years—which, when it comes
> To the broad light, shall vindicate his fame.[93]

The other momentous event that hindered Allston's work on the painting was a result of sheer good will. A group of twelve wealthy and interested art lovers, friends of Allston and most of them already his patrons, signed an indenture agreement whereby they subscribed a total sum of $10,000 to enable him to finish the painting without the constant harassment of pecuniary problems. The money was to be used for the purchase of the picture, but it was entrusted to a third party, a group of three other Boston citizens, so that Allston might draw upon the fund when in need. The exact date of the agreement is not known; it was redrawn on May 9, 1827, at which time Thomas Handasyd Perkins took over the shares previously held by Timothy Williams. Nathaniel Amory was the largest shareholder, having six shares at $500 each. Perkins, Samuel Eliot, and the only non-Bostonian, John Cogdell of Charleston, South Carolina, each held two shares. All the other shareholders held one share worth $500: Loammi Baldwin, David Sears, William S. Rogers, Benjamin Welles, James Perkins, Thomas H. Perkins, Jr., Samuel Appleton, and George Ticknor. By 1827 Allston had already drawn upon $5,000 of the

66
Evening Hymn, 1835
Oil on canvas, 25 x 23 in. (63.5 x 58.4 cm.)
Richardson 142
Montclair Art Museum, Montclair, New Jersey, Gift of Mr. and Mrs. H. St. John Webb, 1961

amount, and the second indenture was to enable him to have $1,500 more. Allston promised to insure the work and to finish it without delay, and he agreed that he would not publicly exhibit the picture without the permission of the subscribers, although he was allowed to show it to friends from time to time. The subscribers in turn agreed not to hinder Allston by visiting him unnecessarily to see the picture. Finally, it was agreed that the unpaid balance on the work would be forthcoming within ten days after notification of completion.

The subscription agreement may have been renewed in 1827 because of the subscribers' disappointment that the picture was not ready for the Boston Athenaeum exhibition in May of that year. The institution in 1827 of annual exhibitions at the Athenaeum was of tremendous importance to the artists of Boston and the region, and Allston was well represented by some of his earlier works. *Poetical Illustrations of the Athenaeum Gallery of Paintings,* a collection of poetry honoring the principal works in the show, appeared in 1827, with four poems devoted to Allston's paintings: "Saul and the Witch of Endor," "Rising of a Storm at Sea: Pilot Boat Going Off," "Landscape after Sunset," and "The Prophetess." So close to completion did *Belshazzar* appear in 1827 that John Doggett, the noted Boston framemaker, was called in to furnish a frame; at that time Doggett thought the picture was completed. Indeed, in order to assure the presence of the painting in the first annual exhibition at the Athenaeum in 1827, the trustees had offered Allston the use of their rooms to give him the space for its completion and to have it at hand. Allson appears to have accepted their generosity and may still have been using the facilities in 1828. It was hoped, too, that the picture would be available in 1828 for exhibition at the Pennsylvania Academy; when in the end *Belshazzar* did not arrive, William Dunlap's *Calvary* was shown in its place.

Ostensibly, one of Allston's problems was finding a studio large enough to continue with his masterwork. He had found his first attempt at correcting the perspective faulty when he was able to view the picture from a proper distance, and he undoubtedly feared a repetition of such errors. In the winter of 1828-29, his studio in John Prince's barn on Pearl Street was sold for a livery stable, and Allston had to remove his painting. At that time, Chester Harding offered Allston his own large studio, since he was moving to Washington; on his return he found that Allston had not even unrolled *Belshazzar*. And according to Harding, at one point Allston told one of his subscribers, Loammi Baldwin, "I have to-day blotted out my four years' work on 'Handwriting on the Wall.' "

Allston's attitude both to his general surroundings and to his great, unfinished work changed gradually. Around 1827, a different quality can be discerned in his letters and in his life pattern. He had had a severe illness, lasting four months in the winter of 1825-26, and following this he seems to have resigned himself to the role of provincial patriarch instead of international artist. For one thing, he seems almost to have dropped his English connections. Before 1827 his principal correspondent was Leslie; after that date, it was John Cogdell of Charleston, whom he had remet in 1825, after many years in Boston, and encouraged to become a sculptor. It is significant that when Leslie returned to America in 1833 to assume the position of instructor of drawing at West Point—an appointment he abandoned after a few months of longing for the cosmopolitan existence of London—he and Allston did

not renew their acquaintance. For another, the urge to complete *Belshazzar* seems to have lessened. Perhaps the distance in time from his bright years in England made their glow fade; then again, the death of Gilbert Stuart in 1828 may have suggested to Allston that he, too, would never be able to retrace his steps and regain the fame that had eluded him. And from oblique references in his letters, we know that he felt the oppression of his indebtedness to the twelve subscribers, however much these honorable gentlemen sought to alleviate any suggestion of pressure. On the one hand, despite the generous sums provided, he was almost always in debt; on the other hand, he constantly felt the weight of his obligations, which, in turn, prevented him from working successfuly. As he wrote to Cogdell in 1832, "I have never ceased to regret that I ever allowed myself to receive any advance on the picture."

The subscription agreement in regard to *Belshazzar* was only the most conspicuous of a number of financial rescue operations undertaken on Allston's behalf during his years in Boston and Cambridgeport. In 1835 his good friends William Ellery Channing, Warren Dutton, and Franklin Dexter raised a contribution in the form of both loans and outright gifts to pay off Allston's debts. The sum of $3,250 was raised from nine persons, and after Allston's debts were paid, there was a surplus of over $1,000, which was kept by Richard Henry Dana to advance to the artist when he was in need. Yet his indebtedness four years later, in 1839, was the basis for the important retrospective exhibition of ultimately forty-seven of his works at Harding's Gallery; forty-five were listed in the catalogue, and two, *The Spanish Girl in Reverie* (no. 63) and a comic piece, were added later. The show was of significance not only for Allston's fame but also as a milestone in the history of American art exhibitions, displaying as it did the full range of the work of an eminent *living* artist. It also engendered an important body of early Allston criticism.[94]

At this juncture it may be useful to summarize Allston's activity during the years following his final return to America; these twenty-five years may be subdivided into four periods. During the period of 1818-1821, when he was reestablishing himself in Boston and producing a good many paintings, his activity was comparable to that of his years in England, although he was now engaged upon smaller works. From 1821 to 1828 he was concentrating upon *Belshazzar*, and after *Miriam* there are no known pictures completed during these years. Allston wrote to Leslie in February 1823 that he had put aside several unfinished literary subjects, including *Macbeth and Banquo Meeting the Witches on the Heath* and *Minna and Brenda on the Seashore*, the latter derived from Walter Scott's new novel *The Pirate*, of 1822, and one of two works by Allston known to have been inspired by the writings of the great romantic Scotsman. It is idle to speculate on the appearance of this unfinished and presumably lost work, but the subject of two women, united by birth and by their love for two brothers, suggests a continuation of the theme already expressed by Allston in *The Sisters, Dido and Anna*, and *Hermia and Helena*. The *Macbeth and Banquo* may have been inspired in part by Leslie's description of John Martin's similar picture in a letter to Allston of March 3, 1820.

The third phase of Allston's later career lasted for a decade, from 1829 to 1839, when *Belshazzar* remained untouched and Allston returned to the production of small pictures and to the consideration of more ambitious, larger compositions, which he never carried to completion. It is probable that many of his fragmentary

works date from these years. Finally, in 1839, he returned to *Belshazzar* and continued to work on it until his death four years later; he appears again to have abandoned most other work in order to concentrate upon his magnum opus.

Even while Allston was continuing the production of biblical paintings during the first years after his return to Boston, he was exploring a new, more elegiac mood in his art. This poetic propensity, which grew and came to dominate his later work, had actually appeared earlier in his painting, in the last years in England, in such pictures as *The Sisters, Contemplation,* and even *Jacob's Dream.*

In May of 1821 Allston wrote to William Collins describing his first two and a half years back in America.[95] He admitted that for the first three months he had spent his time primarily renewing his earlier friendships but that he had been busy afterwards with figure and landscape compositions. It would appear that the listings Allston gave to Collins can be accepted as a chronology of these works, beginning with a representation from James Beattie's *The Minstrel* of 1771-1774. Painted in 1819, this picture, *Edwin*, was exhibited at the Pennsylvania Academy in 1826 and at one time was owned by one of the most significant of all American collectors, Robert Gilmor of Baltimore. Allston may have known the most famous representation of this subject, the work by the British artist Joseph Wright of Derby, which had been painted in 1777-78 and had been engraved. Allston's *Edwin* is unlocated today, but there is a possibility that it is, in fact, not unknown.

One of Allston's loveliest renderings of a single figure is the *Italian Shepherd Boy* (no. 50), now in the Detroit Institute of Arts; the picture is, indeed, dated 1819. The history of the painting is not unshakably secure, and although it descended in the Borland family, it could conceivably have been owned by Gilmor; it has no prior exhibition history, which makes it unique among Allston's pictures done in America. Richardson equates it with another picture mentioned by Allston in his letter to Collins of May 1821, but that reference is only to "a small figure." Allston's depiction of the young shepherd boy is, in fact, consistent with Beattie's conception of the birth of poetical genius as embodied in a single figure, an itinerant poet and musician—"a shepherd-swain, a man of low degree." And Allston's shepherd boy is a flautist, following the pictorial tradition set forth by Joseph Wright.

Allston's figure, set in a tranquil wooded landscape, harmonizes with his setting; it is a contemplative and poetic image that became dominant in Allston's later pictorial iconography. Yet, this shepherd boy has his roots in Allston's earlier work. The artist's *Contemplation* (no. 38) of several years earlier presents a female image in a like mood of reverie; while the young shepherd himself is based upon one of Allston's early figure drawings, presumably done in Rome. In other words, Allston has drawn upon his earlier study for pose and form but, having absorbed the image over the course of time, has breathed into the form a reflective spirit and a romantic aura drawn from his imagination.

Allston returned to the subject a second time in the *Italian Shepherd Boy* (no. 51), now in the Brooklyn Museum. The pose, similar though not identical to the first, is taken from another drawing in the earlier series of life studies. The model in the drawing, and therefore in the painting, was a younger boy; here Allston has depicted him on a larger scale and closer to the picture plane, while the landscape behind is wilder, rockier, and more mountainous. Rosaesque rather than classical. The light falls sharply on the boy from the front rather than filling the entire scene with a gentle luminosity, as in the Detroit version. This painting would seem less likely to be a representation of the Beattie *Minstrel* because of the boy's age, and it has always had its present designation since its exhibition at Harding's Gallery in 1839. Richardson assigns it to a date of 1821-1823, presumably because it is not mentioned in Allston's 1821 letter to Collins; and since it is of good size, it would probably not correspond to his "small figure," although he might have meant here a figure smaller than life-size. There seems no other reason for giving it a date two to four years later than the other version.

105
RICHARD MORELL STAIGG, American, 1817-1881
Washington Allston, ca. 1840
Watercolor on ivory, 3⅜ x 2⅝ in. (8.5 x 6.6 cm.) (sight)
Museum of Fine Arts, Boston

It has been pointed out that these works pictorialize the glorification of the shepherd, the pastoral life, and the oneness with nature of simple childhood that is found in Wordsworth's poetry. Writers such as Elizabeth Peabody spoke of the ineffable sweetness of the image of the shepherd boy, while Margaret Fuller recognized him as an embodiment of Allston's concept of beauty, his reverie of nature dimly anticipatory of the ecstasies of love. Allston is here following a tradition of pastoral imagery that had been explored by Thomas Gainsborough in his "fancy pictures," works upon which, according to Allston's English colleague the painter and critic William Hazlitt, "Gainsborough's fame chiefly rests." It is likely that Allston had seen the retrospective exhibition of Gainsborough's works held in London in 1814.

Allston's second literary subject after returning to America was *Flight of Florimell* (no. 52), also painted in 1819 and probably the artist's finest work derived from literature. It is a beautiful poetic rendering wherein the spirit of Edmund Spenser's allegorical romance of chivalry is successfully translated into pictorial imagery. Here, the new poetic mood that was to displace the bolder drama of his English years reflects the corresponding verse:

> All suddenly out of the thickest brush
> Upon a milk-white palfrey all alone
> A goodly lady did foreby them rush
> Whose face did seem as clear as christall stone
> And eke, thru fear, as white as whale's bone.
> Her garments all were wrought of beaten gold
> And all her steed with tinsel trappings shone
> Which fled so fast that nothing might him hold
> And scarce them leisure gave her passing to behold.
> Still, as she fled her eyes she backward threw
> As fearing evil that pursued her fast
> And her fair yellow locks behind her flew, . . .

Allston has here rendered faithfully the garments of beaten gold, the fair yellow locks, and the tinsel trappings of the milk white palfrey in a new resonance and luminosity drawn from his study of the Venetians; Florimell, in fact, is the most Titianesque of all Allston's images. The sense of mystery and the fear of the unknown are suggested in Florimell's backward glance as well as in the darkness of the murky landscape at the right. Yet Allston provides balm for Florimell's fears and the spectator's shared anguish in the figures of Prince Arthur and Sir Guyon approaching at the left, the latter's horse alarmed and drawing back, that of Arthur more sure of stance. Allston's command of animal anatomy and motion is surprisingly effective here, and Florimell's steed is quite masterfully depicted, classically conceived but romantically expressive. The landscape itself has a new softness and a feathery quality similar to the setting of the 1819 shepherd boy and quite distinct from the monumental forms and careful delineation of his earlier landscapes.

Florimell was Allston's first depiction drawn from Spenser, but the epic of the *Faerie Queene* had served British painters for the previous half century and notably Allston's teacher, West, whose *Una in the Woods* of 1772, and *Fidelia and Speranza,*

also of the 1770s, Allston may have known. The latter painting, in fact, is a progenitor of Allston's series of images of contrasting yet united paired females. Copley's *Red Cross Knight,* of 1793, was another well-known Spenserian depiction, but in any event, Allston must certainly have been familiar with the Spenser-derived subjects of Thomas Macklin's famous Poets' Gallery, for which Richard Cosway, Elias Martin, Opie, and Fuseli all painted. Both Opie's and Fuseli's works were engraved at the end of the century.

It is not surprising that Allston's literary derivations were the works he had read at Harvard, but he sought those images only after they had filtered through years of memory and recollection. Harvard College Archives record Allston's borrowing of Spenser's *Faerie Queene,* along with Tasso's *Jerusalem Delivered* and the works of Shakespeare and Milton. Yet his pictures of those early years drew rather upon Gothic tales. He began his depictions from Shakespeare only in Italy, Milton in 1817 in England, and Spenser and Tasso after returning to America. His image *A Roman Lady Reading* (fig. 51) of 1831 was derived from Tasso.

Florimell was acquired by Allston's patron Loammi Baldwin, who also owned his early *Diana* landscape and his study of *Polyphemus,* and who was one of the subscribers to the agreement in support of *Belshazzar.* Allston told Elizabeth Peabody that Spenser was an inexhaustible source of subject matter. Several undated and unfinished renderings of *Una* are known; one, showing her sleeping in a wood, may ultimately derive from West's early rendering of the subject. The other, in which Una is seated in a wood, is part of Allston's series of poetic images of "reverie," or "dreamerie," as Longfellow called it.

As already noted, an increasingly poetic mood infuses the majority of Allston's later pictures, both the figural paintings and the landscapes. The figure paintings are mostly of single images: a group of youthful shepherd boys, minstrels, and troubadours and, better known, a group of dreamy women. This second group consists of a series of half-length figures seen close up and smaller, full-length figures in romantic landscape settings, the unfinished *Una in a Wood* numbering among the latter.

The earliest of these images is the most beautiful of the half-length figures, that of Beatrice (no. 53) of 1819, taken from Dante. Allston wrote to Charles Leslie on November 15 that he had painted the picture; however, three years earlier, in September 1816, Leslie, in London, had written to Morse, now returned to the United States, that Allston had lately painted this subject. John Quincy Adams also, in his diary for September 24, 1816, commented that "his ideal Portrait of Dante's Beatrix [sic] is a beautiful face."[96] Whether the example now known is a variation on this earlier picture or a reworking of it has not been ascertained. The figure, which fills the canvas, suggests tremendous delicacy and sweet melancholy, a proper image of love and inspiration. The flesh tones are incredibly soft and transparent, in a manner distinct from either the *alla prima* facture of contemporary romantic painting or the hard surfaces of neoclassicism. The gentle, rounded incline of the head is supported by the repeated curves of the fillet of pearls in Beatrice's hair, the circling edge of her shoulders and of her garment, and the soft sweep of her arms; one hand at her bosom discreetly holds a cross.

Margaret Fuller, in reviewing the Allston exhibition of 1839 in the *Dial,* chose

the *Italian Shepherd Boy* and *Beatrice* to illustrate the finest and most original of Allston's qualities. "The Prophets and Sibyls are for the Michael Angelos," she wrote. "The Beautiful is Mr. Allston's dominion. There he rules as a Genius. . . . The excellence of these pictures is subjective and even feminine. They tell us the painter's ideal of character. A graceful repose, with a fitness for moderate action. A capacity of emotion, with a habit of reverie. Not one of these beings is in a state of *épanchement,* not one is, or perhaps could be, thrown off its equipoise. They are, even the softest, characterized by entire though unconscious self-possession."

The painting of *Beatrice* continues the poetic figural renderings begun by Allston with *The Valentine* (no. 22) almost a decade earlier but omits specific reference to the inspiration of that work, which was based upon his portrait of his wife, Ann. It is probably difficult to realize today how radical Allston's concepts were in the development of pure figure painting; for him, works were meant to communicate through the representation of a mood and an ideal rather than to illustrate a story. Allston has entitled *Beatrice* after Dante's great epic, but, as Margaret Fuller rightly discerned, "the painter merely having in mind how the great Dante loved a certain lady called Beatrice, embodied here his own ideal of a poet's love." For antecedents one must look again back to Titian and the Venetian Renaissance, but Allston has reinterpreted the image of female loveliness and cast it in very nineteenth-century romantic terms. This and the succeeding works stand as precursors of late nineteenth-century expressive figure paintings and more particularly of the images of reverie that populate late nineteenth-century American iconography and so dominate that paradigmatic volume of 1886, *The Book of American Figure Painters,* introduced by one of Allston's most perceptive later critics, Mariana Van Rensselaer. *Beatrice* was ecstatically extolled during the artist's lifetime: Elizabeth Peabody saw in it a "celestial ray," Margaret Fuller, "the synthesis of the best of every creature," and William Ware found it "perfection of painting." But later, less romantic writers such as James Jackson Jarves found her "weak and pale, a sentimental nothing."

In 1821 Allston turned his attention fully to *Belshazzar* and gave up for many years the painting of smaller figure and landscape compositions, but with the loss of his large studio at the end of the decade, he returned once again to a variety of themes. At the same time, there was a change in his personal life, for he decided finally to marry the cousin of his first wife, Martha Remington Dana, fifteen years after the death of Ann. Just as Allston's courtship of Ann Channing had been long, so too his engagement to Martha Dana lasted for ten years; Allston had written to Leslie of the engagement as far back as May 1821. The marriage took place on June 1, 1830, and the couple went to live in a house in the village of Cambridgeport, near the Charles River and a mile from the center of Cambridge. A year later, construction was finished on a separate studio building, a third of a mile north of Allston's house; it was large enough to accommodate paintings of tremendous size, but *Belshazzar* remained rolled up for eight more years. The house and the studio were the scenes of successive visits by artists, writers, educators, and the simply curious to the sage of Cambridgeport. Thomas Sully, who had first met Allston in Boston in July 1821, visited the studio in June 1831, soon after its completion, and commented that the walls, painted in Spanish brown, allowed Allston's colors to

reveal all their brilliance. The following year, his friend of the old days in Rome and London, Washington Irving, appeared and found Allston "much retired from the world." His Charleston artist friend of his youth, Charles Fraser, visited him about 1832 also. Allston was greatly delighted with the young artist-naturalist John James Audubon, who arrived in Boston in April 1833 with an introduction from Thomas Sully. In 1835 Asher B. Durand visited Allston in the company of the great New York collector Luman Reed. Allston looked upon Durand's engraving after John Vanderlyn's *Ariadne* with much approval, but he put off acceding to Reed's request for a painting because of prior commitments. The following year Reed was dead, and New York art patronage was keenly affected.[97]

The most enthusiastic visitor of all was the English historian and writer Anna Jameson, who visited late in 1837 and who was so magnetized by Allston's conceptions that she made a point of visiting all the houses in Boston containing his works and went on to spread the reputation across Europe of "one of the finest *painters in the world.*" Her initial contact with Allston came in response to a poem he wrote and sent to her after reading her *Diary of an Ennuyée*, of 1826.[98] Margaret Fuller visited Allston in 1839, at the time of the Harding Gallery exhibition. In July 1841 the miniaturist Cornelius Ver Bryck, along with Daniel Huntington, spent an evening with Allston, who was "as usual, full of delightful talk," according to Ver Bryck's letter to Thomas Cole. A possible subject for speculation is the influence Allston might have exerted upon Huntington and the development of the latter's conception of *Mercy's Dream* of the following year, perhaps the most popularly successful American painting of the decade.

In 1842 Allston, though sick and feeble, attended a great banquet held in Boston in honor of Charles Dickens; the great author subsequently visited Allston's studio on February 4, prior to his departure. Later that year, in London, Dickens inscribed a copy of his *American Notes* to Allston and gave it to Henry Wadsworth Longfellow to deliver to the artist.

During these years in Cambridgeport Allston continued in his role of local doyen of art as well as guide and mentor to a number of young artists. The first painter known to have studied with him on his return to America was Joshua H. Hayward, who later told Richard Dana that he became a pupil in 1818 but subsequently gave up that professional pursuit. Allston is often said to have refused to accept pupils. In 1829 he recommended his friend Chester Harding, Boston's leading portraitist (who later painted a sympathetic likeness of Allston; see fig. 48), to the young South Carolinean James De Veaux, who, however, studied drawing in Philadelphia under John Rubens Smith and painting with Henry Inman. But Allston did give instruction to his nephew George Whiting Flagg, who arrived in Boston around July 1831 and remained until 1833. Flagg's subsequent excursion into historical painting in the manner of Paul Delaroche, made under the patronage of Luman Reed, is a fascinating, little-known aspect of American grand-manner art. Likewise, George's brothers, Henry and Jared (Allston's future biographer), received instruction from the master. Both Sophia Peabody and Sarah Clarke appear to have had lessons or encouragement from Allston; Ralph Waldo Emerson, who admired Miss Clarke's landscape painting, referred to her as Allston's only pupil, but this seems not to have been quite the case.

Fig. 48. CHESTER HARDING, American, 1792-1866
Washington Allston, ca. 1835-1840
Oil on canvas
Providence Athenaeum

In the fall of 1834 the young Henry Kirke Brown came to Boston to study with Chester Harding. Brown was then struggling to become a painter, several years before turning to sculpture, in which field he later made his reputation. Harding brought a work of young Brown's to Allston's attention, and as a result of the latter's encouragement, Brown continued his artistic pursuits; it was also because of Allston's advice that he had the confidence to turn to sculpture. He traveled first to Pittsfield to study anatomy and then proceeded to Cincinnati in late 1836, where he began to model in clay.

Likewise, Allston from the first exerted his influence in support of the sculptor Horatio Greenough, recommending him to Gulian Verplanck in Congress, as early as 1828. John Cogdell engaged in what amounted to a correspondence course in sculpture with Allston, writing to him from Charleston and sending works to him. Allston returned criticism and advised Cogdell on a proper European course of study.

Well known in the history of landscape painting is Allston's letter to his friend Henry Pickering, of November 23, 1827, offering advice to the young Thomas Cole on a traveling itinerary and on landscape painters to study when in Europe—Claude, Rosa, and Turner. Allston and Cole met in the spring or summer of the following year. Allston's old friend and brother-in-law to be, Edmund T. Dana, may have sought Allston's guidance too for his one known work, *Coast Scene* of 1827 (fig. 49), exhibited at the Athenaeum the following year; the painting was done very much in Allston's manner. The young landscape painter George Loring Brown is sometimes referred to as a pupil of Allston's, and while this may overstate the case, Allston did render Brown assistance and support.

Toward the end of his life, Allston acquired new friends among the younger artists of Boston. Albert G. Hoit was one of these. Allston counseled Richard Morell Staigg, who was brought up in Newport and followed in Malbone's footsteps as a miniaturist; Staigg painted an attractive miniature of Allston (no. 105). In 1841 Allston sent advice to his old friend and patron in Philadelphia James McMurtrie, whose son was pursuing an artistic career. About the same time, the poet-painter Thomas Buchanan Read was encouraged by Allston to follow an artistic career; Read later said that he received from the master some valuable hints in the use of color. Allston watched with interest and approval the move away from the law and toward art of William Wetmore Story, the young son of his friend Judge Story. He encouraged Charles Sumner in his support of Thomas Crawford, and while Allston never met Hiram Powers, he voiced the opinion to Cogdell in 1843 that, if Powers's much-discussed *Eve* were as fine as his bust of Colonel Baldwin, Powers would have no equal among his contemporaries. And, as is known, he attempted to aid his former pupil Morse in obtaining a Congressional commission and was successful in helping his former colleague Vanderlyn to secure the Washington portrait commission for the House of Representatives in 1832.

Allston took pride during these years in the honors that accrued to him. He was immensely gratified by his associate membership in the British Royal Academy, and, as already noted, was distressed when John Murray, the English publisher of Irving's *Knickerbocker History* failed in 1824 to indicate "A.R.A." with Allston's name in the reproduction of an engraving after his illustrative designs. He was

Fig. 49. EDMUND T. DANA, American, 1779-1859
Coast Scene, 1827
Oil on canvas
Victor Spark

pleased, too, when his good friend Gulian Verplanck, the New York politician and Knickerbocker figure, dedicated his *Essays on the Nature and Uses of the Various Evidences of Revealed Religion* to Allston in 1824 and equally so when Rufus Griswold paid him the same compliment in 1842 in the case of his *Poets and Poetry of America,* which included several verses by Allston. He considered it a signal honor when Count Athanasius Raczynski sent him a copy of his momentous three-volume *Histoire de l'art moderne en Allemagne,* published in Paris in 1841. Indeed, Allston had good reason to be pleased: Raczynski not only presented him with a generous gift; he also referred to him in his book, in the section dealing with modern art outside Germany, as the first painter in America. Raczynski had well documented Allston's career, from sources that included reminiscences of Baron Rumohr of the early Roman years, Dunlap's biographical treatment, the catalogue of the 1839 Harding Gallery exhibition, and recent information sent to him by George Ticknor from Boston.

Allston's significance for contemporary American artists may be found in the endorsement they sought from him for their publications. These included John Rubens Smith's *A Key to the Art of Drawing the Human Figure* of 1831, and George Harvey's *Atmospheric Landscapes of North America,* only the first part of which, *Harvey's Scenes of the Primitive Forest of America at the Four Seasons of the Year,* saw publication, in 1841.

Allston's fame was ever growing in America, particularly among the patrons and cognoscenti of Boston. George Ticknor's estimation of the artist noted in his *Journals* in Rome in 1837 probably reflected the opinion of many. "Cammuccini [sic] here and Benvenuti in Florence reign supreme," he wrote, "but there is not a man in Europe who can paint a picture like Allston."

The finest and most poetic impression of Allston in his later years in Cambridge is given by James Russell Lowell in his *Fireside Travels,* of 1864 describing the artist on his way into Boston:

> The stranger who took the 'Hourly' at Old Cambridge, if he were a physiognomist and student of character, might perhaps have had his curiosity excited by a person who mounted the coach at the Port. So refined was his noble appearance, so fastidiously neat his apparel—but with a neatness that seemed less the result of care and plan, than a something as proper to the man as whiteness to the lily— that you would have at once classed him with those individuals, rarer than great captains and almost as rare as great poets, whom Nature sends into the world to fill the arduous office of Gentleman. . . . A *nimbus* of hair, fine as an infant's, and early white, showing refinement of organization and the predominance of the spiritual over the physical, undulated and floated about a face that seemed like pale flame, and over which the flitting shades of expression chased each other, fugitive and gleaming as waves upon a field of rye. It was a countenance that, without any beauty of feature, was very beautiful. I have said that it looked like pale flame, and can find no other words for the impression it gave. Here was a man all soul, whose body seemed a lamp of finest clay, whose service was to feed with magic oils, rare and fragrant, that wavering fire which hovered over it. You, who are an adept in such matters, would have detected in the eyes that artist-look which seems to see pictures ever in the air, and which, if it fall on you,

Fig. 50. ALONZO CHAPPEL, American, 1828-1887
Washington Allston
Engraving

make you feel as if all the world were a gallery, and yourself the rather indifferent Portrait of a Gentleman hung therein. As the stranger brushes by you in alighting, you detect a single incongruity—a smell of tobacco-smoke. You ask his name, and the answer is, Mr. Allston.

By the 1830s Washington Allston was answering the call for a recognized American genius in the area of cultural expression. Although Allston's aesthetic doctrine was totally oriented toward Europe and the old masters—and, indeed, it was this factor that led to its supplantation by a nativist and naturalist aesthetic, ironically also supported by European theory, that of John Ruskin—he was acknowledged as the answer to European charges of American cultural inferiority. He was the graphic response to such questions as those posed by Sidney Smith in the *Edinburgh Review* in January 1820: "In the four quarters of the globe, who reads an American book? or goes to an American play? or looks at an American picture or statue?" But Coleridge had already responded to that question, saying of Allston, "he is the first genius produced by the western world."

With the temporary cessation of his painting on *Belshazzar,* Allston resumed work on his more immediately remunerative smaller pictures. Almost all of these were now painted in a mood of gentle reverie. This mood probably characterized his now lost *Mother and Child*, which was acquired by the Boston Athenaeum in 1829. This work is known from an engraving by Seth Cheney, which appeared in the gift book *The Token* in 1837. There is also an unfinished variant of the picture, similar to the engraving but with sufficient differences to make it uncertain whether Allston had in mind a second rendering of the subject. The *Mother and Child* was not exhibited at the annual exhibition of the Athenaeum until 1830, a year after its purchase, but a miniature copy of it by Hugh Bridport was shown there in 1828. The painting was exchanged by the Athenaeum for an old master picture, Peter Boel's *Fruit and Flower Piece,* owned by the English connoisseur and collector John Watkins Brett in 1837. Brett's collection of old masters had been successfully shown by the Athenaeum in 1833, an event that infuriated the artists of Boston, including Allston, who felt that the policy of exhibiting European old masters was detrimental to the interests of the contemporary painter. And, in fact, this antagonism led Allston to withdraw from exhibiting at the Athenaeum; few of his pictures, apart from several that continued to be owned by that organization, appeared on its walls again until after his death. It also led to the formation of a rival series of exhibitions held at Chester Harding's Gallery. The first of these opened in May 1834. Allston was not represented on that occasion, but Harding's Gallery was the location of the major showing of forty-seven of the artist's paintings in 1839, arranged by his nephew, the painter George Flagg. The catalogue of this much-reviewed show lists forty-five works, but several critics deplored the absence particularly of *The Spanish Girl,* and this painting, together with a comic piece, was added later. The exhibition was held to display the greatness and the variety of Allston's achievement, although it was also hoped it would raise a considerable sum to help relieve the artist's financial distress; he himself wrote to his mother that, after clearing expenses, the show was estimated to net him about $1,500.

It was at Harding's Gallery that the newly formed Boston Artists' Association

held its first exhibition in 1842. Allston, who was president of the association, was represented in the show by his *Beatrice* of 1819. The following year he was represented by his sketch of *Polyphemus;* Allston died the same year, 1843, and was succeeded by his friend Henry Sargent, formerly vice-president of the association. A memorial exhibition of a small group of Allston's pictures was held that year. In 1845 the Artists' Association joined the Athenaeum, and the next several exhibitions held there were called the "United Exhibition of the Boston Athenaeum and the Boston Artists' Association."

Once in his new and spacious studio in 1831, Allston returned to what was for him increased and truly productive activity, although, as mentioned, *Belshazzar* still remained unrolled. The best known of all his images of poetic women, *A Spanish Girl in Reverie* (no. 63), was produced that year. The girl sits upon a slight landscape ridge and looks wistfully off to the left; behind her is a placid lake and farther in the distance rise steep mountains. Her costume is "period" rather than contemporary, but the period is exceedingly generalized. She sits upright, and the diagonal of her outline repeats and harmonizes with the mountain elevations of the middle and far distance. Allston, of course, had never been in Spain; and the landscape inspiration may, in fact, be Alpine. She is a *Spanish* girl because Allston tells us so; the poem that describes her situation in greater detail, informing the reader that this fair Inez dreams of her lover Isidore away in the wars, appeared in the *North American Review* for October 1831. The two conceptions are interdependent, although in the manner of the times, the reviewer elaborated a whole scenario based upon the poem and built around the painting.

In the same year, Allston painted and exhibited *A Roman Lady Reading* (fig. 51). The image here is half-length, seen close up in an indoor setting. Allston seems to have alternated two forms of what was essentially the same conception of mood-inducing, poetic imagery. His Roman lady is a fuller, more mature figure than the Spanish girl. The soft light and translucency of form mitigate the severity of the frontal and symmetrical image, as does the inclination of the subject's head, bent in rapt attention to the small volume she holds in her hands. Her costume, like that of the Spanish girl, seems historical, and a variant title, which informs the viewer that the subject is reading a volume of Tasso, suggests a more specific Renaissance allusion. The image combines the largeness of Michelangelo with the technique of Titian, and of all Allston's later paintings, *A Roman Lady Reading* most recalls that sixteenth-century master who fused those two influences, Sebastiano del Piombo.

Still a third poetic image of 1831 is Allston's little-known *Tuscan Girl* (fig. 52). Like the Spanish girl, she is seated on a bank out of doors, leaning on a pitcher she has taken to fill at a forest spring, but her thoughts are concentrated upon a "moth come twinkling by." The poem that complements the painting identifies her as the peasant girl Ursulina. Again like that relating to the *Spanish Girl,* the poem was published in the October 1831 *North American Review,* and it appeared again in *The Charleston Book* of 1845. The foreign, relatively exotic appearance of these three figures painted in the same year must constitute a reflection of Allston's cosmopolitan experience and a reinforcement of a general mood of romantic yearning; what they specifically and purposely lack is American associations. They may be viewed as memory images, perhaps, but only in the most general sense a middle-

Fig. 51. *A Roman Lady Reading,* ca. 1831
Oil on canvas, 30 x 25 in. (76.2 x 63.5 cm.)
Richardson 136
The Newark Museum, Newark, New Jersey

Fig 52. *A Tuscan Girl,* 1831
Oil on millboard, 17½ x 14½ in. (44.5 x 36.8 cm.). Richardson 137
Robert Vose

aged man's youthful dreams. They are certainly not reflections of Martha, the artist's new but fifty-year-old second wife, as *The Valentine* and possibly several of his other early figural works were reflections of his first wife, Ann. The *Tucan Girl* was acquired by David Sears, who, ten years earlier, had commissioned the artist's more dramatic image, *Miriam* (fig. 47).

It is possible that the unfinished *Una in a Wood* (fig. 53) dates from about this time also. The pose of the seated figure is quite close to that of the *Spanish Girl,* while the density of the wooded setting corresponds more closely to that of the *Tuscan Girl.* Allston's only known picture of the following year, *Lorenzo and Jessica* (no. 64), is likewise a small work, similar in size to the *Tuscan Girl.* Allston continued throughout his career to paint works derived from or suggested by Shakespeare; this is one of the most poetic of them, taken from Act 5 of *The Merchant of Venice,* the play that had inspired his *Casket Scene* of 1807. The prevailing mood of this painting, in which a young woman and her male companion recline in reverie in a moonlit landscape, is particularly close to that of the romantic images of Caspar David Friedrich of not many years earlier. Because the work has a literary derivation, Allston has been somewhat more specific in the depiction of the Renaissance costumes, and the "period" atmosphere is reinforced by the Italianate villa behind the figures, a double facade mirroring the two-figure composition; the picture was perceptively referred to in its time as "Giorgionesque." Emerson noted that Sophia Peabody painted a copy of this work and later commented that "there is moonlight but no moon."

The following year Allston painted his now unlocated *Young Troubadour,* a dreamy figure playing his guitar beside a fountain and singing to his fair Isabel. Again, the artist wrote a poem relating to the picture, from which some suggestion of its appearance may be gleaned. There is also, however, a work that may be similar in content and mood, more a drawing than a painting, in umber on linen. Since the study is a large one, Allston may well have planned to continue working directly on the canvas; as it stands, the work is a very complete conception. The figure plays a guitar while reclining on an embankment that overlooks a gentle stream in a wooded setting. The most curious aspect of the picture is the oriental costume worn by the figure. The work, in fact, is sometimes referred to as *A Girl in Persian Costume* (no. 65), although, when the study was engraved by John and Seth Cheney for publication in *Outlines and Sketches,* which appeared in 1850, it was entitled *Girl in Male Costume.* Given the general androgynous nature of a good many of Allston's youthful figures, the peculiar suggestion of a female troubadour may perhaps be discarded safely, but the oriental, perhaps specifically Persian, identification would be unusual for American art at this period and even for Allston, although it would constitute a still further display of romantic exoticism.[99] By the end of February 1833, Allston's *Young Troubadour* was in the possession of the artist's patron Sarah Gibbs, at "Oakland," her house in Newport, Rhode Island, but two years later it was owned by John Bryant, Jr., and exhibited by him at the Boston Athenaeum.

Music and musical instruments, introduced to reinforce a mood of idyllic reverie and perhaps also to assume the role of a pictorial life force, albeit a gentle and tranquil one, are increasingly significant in Allston's later paintings. Such accessories

Fig. 53. *Una in a Wood*
Oil on canvas, 30¾ x 26 in. (78 x 66 cm.)
The Lowe Art Museum, University of
Miami, Florida

are found earlier in his work, of course, in pictures such as *David Playing before Saul* and the later *Miriam*, as well as in several of his juvenilia, but there they are an integral part of the biblical stories. In the paintings of the shepherd boys and troubadours and, above all, in *The Evening Hymn* of 1835 (no. 66), the pictorialization of music and the activity of music-making are vital to the establishment of mood. These are musical pictures.

The Evening Hymn is one of Allston's most beautiful works in the series of dreamy women. From Oliver Wendell Holmes to Henry Wadsworth Longfellow Dana, Jr., writers have recognized a profound spiritual, even specifically religious, aura in the picture. A recent study has shown that Allston's painting relates to the traditional theme of melancholy in both its graphic and literary resemblances, perhaps depending upon Miltonic imagery from *Il Penseroso*.[100] By placing the figure in a black garment and setting the time as evening, before the ensuing gloom of night, Allston has overlaid the painting with this mood of gentle melancholy. But no specific story is suggested, and, strangely, no poem exists that relates to the image. The temple-front structure behind and classical ruins also suggest a specific reference, one in which Dana saw the emergence of Christianity in the young woman's vesper hymn, rising out of the ruins of antiquity.

The lute player appears earlier in Allston's art; a male figure playing that instrument can be found in *Italian Landscape* (no. 62), exhibited at the Boston Athenaeum in 1830. A lute-playing troubadour is also prominent in several highly interesting but unfinished figure compositions by Allston; one of these, *Lover Playing a Lute* (no. 70), depicts a standing musician serenading a seated young woman amidst a setting of vine-covered ruined arches and a colonnade surrounding a sparkling fountain. In the Renaissance costumes, the combination of ruins and music, the expression of poetic reverie of the young woman, and the soft shadows about the face of the attendant minstrel, this work closely resembles *The Evening Hymn* of 1835, and it may also relate to the missing *Young Troubadour* of this period. Somewhat similar to this work is another unfinished composition, depicting a *Family Group* (fig. 54), which, in fact, is almost a pastiche of previously considered Allston paintings. The young father in Renaissance costume resembles the young troubadour; the mother and child bear a likeness to the unfinished half-length figures already discussed. The large storage jar with a cloth over it is a compositional accessory that appears in Allston's *Jeremiah*. The hard, wiry outlines and drawing of the facial features are akin to those in the figure in "Persian" costume. Since the figures in *Family Group* and those in the *Lover Playing a Lute* are primarily only dead-colored (lacking the glazes that would eventually have been applied), the pictures offer a distorted view of Allston's intentions, but they are fascinating documents of his methodology.

In addition to *The Evening Hymn*, Allston also painted in 1835 a large, half-length female figure entitled *Rosalie* (no. 67). According to Allston's nephew and pupil George Flagg, the head of *Rosalie* was painted in only two or three hours. She is more youthful than the *Roman Lady* (fig. 51) but is a similarly full figure. In one hand she holds a book, and her other hand touches the chain at the neck of her costume. Her deeply shadowed eyes are averted. Allston's poem "Rosalie," which appeared in the *Boston Book* for 1837, informs us that she is listening to music at

Fig. 54. *Family Group*, ca. 1835
Oil on canvas, 37¾ x 31½ in. (95.9 x 80 cm.)
Richardson 191
Boston University

evening time—that "dreamy hour of day." Similar in form and format, *Rosalie* and the 1819 *Beatrice* were often compared, with reference not only to the more restrained sentiment of the earlier work but also, in William Ware's study of Allston, to the nationality of the two women. Ware concluded that Beatrice was English and Rosalie Italian, on the basis of Beatrice's greater calmness.

There are several unfinished heads of women in profile that resemble, in their dreamy melancholia, Allston's *Rosalie* and some of the other images of this period and probably date from this time. One of these heads, especially, which was shown in a number of exhibitions at the Boston Athenaeum during the 1850s is a quietly moving work, with the severity of the profile image mitigated by the gentle downward incline of the head and a sweetly sad expression. In 1840 Margaret Fuller quoted two sonnets that, according to H. W. L. Dana, Jr., were both written by Samuel Ward about Allston's painting *The Bride*. Dana relates the picture to Allston's poem "The Betrothed," which concerns a woman called "sweet Esther." *The Bride* was unfortunately destroyed in the Boston fire of 1862.

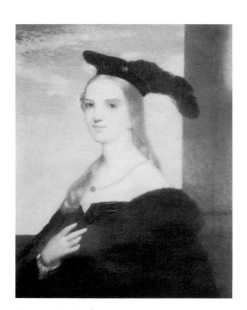

Fig. 55. *Amy Robsart*, 1840
Oil on canvas, 30¾ x 25¾ in. (78.1 x 65.4 cm.)
Richardson 152
Phoenix Art Museum, Phoenix, Arizona, Gift of
Mr. and Mrs. Walter James

John Lowell of Boston originally commissioned a figure painting by Allston, *Amy Robsart* (fig. 55), but the inevitable delays ensued, and Lowell himself died in India while traveling around the world. He had previously hired the Swiss artist Charles Gleyre, later the teacher of Whistler and many of the French impressionists, as a traveling artist-companion, and one might speculate on the stories Lowell told Gleyre, during their travels in North Africa, of the artist-genius of Boston. The commission was continued by Lowell's cousin, John Amory Lowell. *Amy Robsart* was the last of Allston's figure pictures; Charles Sumner wrote about it to Horatio Greenough in September 1840: "Allston . . . has recently painted a beautiful woman, Amy Robsart." Wife of Lord Robert Dudley, Earl of Leicester, Amy Robsart died in 1560 apparently at the hands of her husband (although his guilt has never been proved), who sought the position of consort to Elizabeth I. She is the tragic heroine of Walter Scott's novel *Kenilworth* of 1821, which was probably the source of Allston's depiction. The best-known representation of the story by an English artist was by Richard Parkes Bonington in about 1827, but Allston could not have known it. No hint of the tragic drama is presented by Allston, however; rather, the subject is presented as a half-length figure, inspired by Allston's remembrance of a golden-haired image by Titian. Silhouetted against the bright blue sky, she has long golden tresses and pale skin and is dressed in a dark garment with a rich fur collar. In deference to the historical and literary source, Allston has made the costume more specific here; the plumed hat worn by Amy Robsart is very similar to that worn by Lorenzo in Allston's painting of 1832 (no. 64).

The series of images of romantic women and youths are among the most beautiful and unique of Washington Allston's paintings. Derived in part from the earlier imagery of Titian, they are nevertheless a romantic creation of Allston's own time, owing little to his contemporaries, however, and establishing few immediate progeny. They were the works upon which much of the admiring critical reaction centered after the 1839 retrospective and during the last years of his life. They perhaps most clearly justified the critical belief that beauty was Allston's domain.

ON ALLSTON'S RETURN FROM ENGLAND, he also resumed his interest in landscape painting, which had stayed pretty much in abeyance since his Italian years because of his preoccupation in London with major historical canvases. Most of Allston's later landscapes that have been located are relatively small works, unlike his earlier pictures such as the 1805 *Diana* (no. 11) or the most ambitious "pure" landscape done in England, the *Italian Landscape* (no. 31) of 1814; undoubtedly, they correspond to the small paintings he was able to produce to escape from debt, much to the detriment of *Belshazzar*. How many of these small landscapes Allston produced is not known; currently, about half a dozen have been located. But the large selection of Allston's works shown at the Boston Athenaeum in 1850—a selection exhibited as a memorial tribute at the same time as the publication of *Outlines and Sketches*—included a particularly lavish group of landscapes, many of which were probably done during these last twenty-five years. Specific identification and dating are hampered also by the general tendency to label such works, whether in early exhibitions or contemporary ownership, simply as "landscape," although often a secure exhibition record can at least define a time limit for a work.

Margaret Fuller preferred Allston's landscapes above all the other works exhibited in 1839, and the later landscapes, particularly, continued to receive critical esteem after the artist's death, even when the early religious paintings were disparaged as weak and foreign to the American experience and the later figure paintings were condemned as sentimental.

In Allston's 1821 letter to Collins he speaks of the second picture painted after his return to America as a "moonlight"; this is the *Moonlit Landscape* (no. 54) of 1819 and is the best known of the later landscapes. It is a beautiful and evocative work, in which the full moon illuminates a placid river scene. Several sailboats occupy the river bank; behind a bridge in the middle distance, an Italianate town can be dimly seen. A small figure walks near the boats, while in the foreground a family group communicates with a figure on horseback. The woman of the group, with upraised arm and cloak, is similar in profile to figures in a number of Allston's earliest works, such as *Landscape with Banditti* (fig. 5), and she parallels in miniature the figure of Daniel in *Belshazzar*. Yet, the specific meaning of the meeting and of the painting remains intentionally elusive.

The picture is well documented in the correspondence between Allston and the Salem poet Henry Pickering. These letters, which were among the first that Allston wrote after his return to America, suggest that Pickering was anxious to own a work by the artist. In a letter of December 29, 1818, Allston defined his attitudes toward landscape painting: "It may be well for me to notice here that I objected not to landscapes, (of which I am very fond) but to all *classical and allegorical* subjects, and to all subjects where either the figures or the landscapes are not decidedly subordinate." Allston went on to explain the prices he placed upon his pictures: "If the pictures are to be figures, with subordinate landscape back-ground, size 3½ feet by 2½, the price will be five hundred dollars; if landscape, with wholly subordinate figures, size from 3 by two to 4½ by 3 feet, also five hundred. Should you wish landscapes, I think 4½ by 3 feet, not too large for our modern rooms. A landscape of half the size would not require less time in the execution."

By August 10, 1819, Pickering had acquired a painting, but for three hundred

106
JOSEPH AMES, American, 1816-1872
Washington Allston, ca. 1840
Oil on canvas, 30 x 25 in. (76.2 x 63.5 cm.)
Private Collection

dollars. The letter in which Allston acknowledged receipt of this payment is tantalizing for it does not state specifically which painting Pickering had acquired; it reads, in part, as follows: "It is with perfect sincerity that I assure you I cannot join in the censure which your modesty is disposed to bestow on your own judgment. I did not consider your choice as determined by a comparison between the 'Florimel' and the 'Moonlight,' which are so wholly distinct in character as in fact to preclude it. I was both aware of, and highly gratified by your approbation of the Florimel. As works of art I confess I should myself be at a loss to decide which of the two professes the most technical skill, so that the preference given either must arise from the nature of the subject. They both gave me equal pleasure in the painting, but the Florimel being the largest and having nearly double to work in it, I ought to consider the more important of the two."

Pickering certainly admired the *Moonlit Landscape* for he published three poems as paeans to it. In 1822 his "Reflections on Viewing the Beautiful Moonlight Picture by the Same Artist" appeared in his *Ruins of Paestum and Other Compositions in Verse,* which followed his tribute to Allston's *Jeremiah.* The book of poetry, in fact, is something of a panegyric to Allston; the "Moonlight Picture" poem ends with the lines "Raphael, the secret high was thine—'tis thine, O Allston, now!"

In addition to specific poems lauding the *Jeremiah* and the *Moonlit Landscape,* Pickering included a sonnet "To Washington Allston" and mentioned his name along with those of West, Copley, Stuart, Trumbull, Vanderlyn, Sully, Leslie, and Newton in "American Painters." But the most laudatory and complete of all the poems is "Painting," which is basically a summation of Allston's major achievements in religious art. It reads as follows:

O lovely Power, whose magic touch can raise
To renovated life the glorious dead,
Or catch the graces ere forever fled
Of living beauty—who shall sing thy praise!

For when thou bidd'st, the dungeon's gloom in blaze
Is sudden wrapt, and thence the Prisoner led;
Or low in murky cave, the bones his bed,
The Man revives, reserv'd for happier days.

Look, where the Prophet sits, and Zion weeps!
See Him whom ravens fed—celestial scene!
And lo! among the hosts of heaven, where sleeps
The chosen Youth, and *dreams* that he has *seen.*

There, Uriel shines; and here, yet dimly shown,
Belshazzar trembles on his ivory throne.

In 1828 Pickering's "Moonlight, an Italian Scene" accompanied the engraving of Allston's *Moonlit Landscape* by George B. Ellis in the gift book *The Atlantic Souvenir.* The third, and most elaborate, of Pickering's poems written about this painting appeared in his *Poems by an American,* published in Boston in 1830. Here, more than in the previous works, the poet creates a fanciful, dramatic scenario of imaginative happenings within the moonlight setting, but he begins faithfully

enough with a description of the Italianate nocturnal scene. And here also, in a footnote to the title, he acknowledged that the work was painted for him by Allston.

In his poems Pickering interprets Allston's painting as a eulogistic memory image of Italy but offers no specific narrative conclusion. None of Allston's own poems appear to relate to this work. It has been suggested, quite convincingly, that there is a general autobiographical reference in the painting, Allston's recognition of the return home from two sojourns abroad and his commemoration of the reunion with his homeland. Allston described to Dunlap his arrival in Boston harbor, "on a clear evening in October. . . . The moon looked down on us like a living thing, as if to bid us welcome." In addition, the painting has been related to Allston's continued interest in and dependence upon the landscapes and seascapes of Turner, and parallels have been established between this work and the moonlight pictures of Joseph Wright of Derby and Caspar David Friedrich.[101] Contemporary critics as well as later ones viewed the picture favorably, although their interpretations of it ran the gamut from "complete poetic reverie" to "true, naturalistic representation of moonlight effects."

In any case, in this landscape, the first that Allston painted after his return to America, may be found the same gentle lyricism that characterizes his contemporaneous figure pieces. This soft, poetic strain is to be seen again in his *Landscape, Time after Sunset* (no. 55), which was perhaps the third picture he painted after his return. In his 1821 letter to Collins, he referred to it as representing a sunset. It was owned in Boston by the Codman family, who exhibited it in the first Boston Athenaeum show in 1827; according to family tradition, it was acquired about 1820. *Moonlit Landscape* had been completed by the middle of 1819, and this small sunset picture was probably completed shortly afterwards.

It is significant that Allston was rather specific concerning the time of day represented in these two works. The pictures, of course, are not scientific studies of natural phenomena—far from it. Rather, Allston has chosen two periods notable for romantic evocation, when forms are indistinctly glimpsed; and he has chosen to convey a mood of harmony, in which man is at one with nature. In the sunset scene, cattle wade contentedly in a calm, meandering stream, while a figure on a white horse crosses in the middle distance. All forms and all color are absorbed in the golden sunset light—a Claudian evocation—with only the touch of red in the figure's doublet offering a spot of brighter color. If time is significant here, place is not, although there is the suggestion of an Italian hill town in the distance, far behind the equestrian figure. Allston's settings are landscapes of the mind, constructed from memory diffused through imagination—memory of his experiences with places and with works of art.

This is equally true of the most richly colored of all the known later landscapes, *Landscape, Evening (Classical Landscape)* (no. 61) dated 1821, one of several paintings to which Allston proudly affixed the initials designating his Royal Academy association. Again, it is a sunset scene; here the sky glows richly, and the light filters through the feathery but dense forest foliage in the foreground, casting a flickering pattern on the young traveler with pack and dog reclining contemplatively in an open area. He appears to have traversed the serpentine path that leads back toward the buildings, which glow in a purple haze on a hill rising at the head of a plain.

Like Allston's contemporaneous shepherd boys, the still, solitary figure is in a reverie, a delightful reverie in the Claudian mode, in which the artist invites the spectator to join.

In 1821, as already mentioned, Allston temporarily abandoned the painting of these small landscapes in order to concentrate upon *Belshazzar*. Warren Dutton, who acquired *Landscape, Evening,* was one of the Boston subscribers who held and distributed the $10,000 fund to aid Allston in his completion of the great work. Dutton also acquired Allston's *Evening Hymn*, painted in 1835. The next recorded landscape by Allston, *Italian Landscape* (no. 62), was owned by one of the chief subscribers to that fund, Samuel Eliot, who exhibited his acquisition at the Boston Athenaeum in 1830. The more sharply drawn figures and greater definitiveness of form might suggest a somewhat earlier date for this landscape, but, if it had been painted earlier, it is likely that it would have been exhibited at the Athenaeum in one of the previous shows.

Among Allston's later paintings, *Italian Landscape* is the work that most clearly evokes nostalgia for Italy. The idyllicism and idealism implicit in its pictorial statement were fully recognized by James Freeman Clark in the poem he wrote after viewing the picture in the Harding Gallery exhibition of 1839; this poem, "Allston's Italian Landscape," was published in the *Dial* in October of the following year. Clark's interpretation of the scene as vision rather than reality is expressed in the following lines:

> This tranquil land which no rude shapes deform,
> From all harsh contrasts free;
> This grace, this peace, this calm unchanging life
> Belong not to our world of sin and strife.

And Allston must have read Clark's recognition of divine inspiration expressed in the following lines with pleasure and approval:

> O, happy artist! whose God-guided hand
> This second Eden planned.

In the painting a young lute player sits lost in his own song beneath an Italian pine, while two young women next to him are transported by his song (the face of one of them prefiguring that of Jessica in the 1832 *Lorenzo and Jessica* (no. 64), and a peasant woman stops on the winding path to listen to his music. At the right lie several pieces of classical architectural ruin, and in the middle distance sits a fortified structure upon a hill; beyond a wide plain rises a distant mountain, reminiscent of those that appear in Allston's earlier Italian landscapes of 1805 and 1814.

Allston's only known vertical landscape, this work lends itself to particular comparison with one of the most famous landscapes of Claude, which Allston almost certainly knew: *Landscape with Hagar and the Angel*. This had been one of the prize pictures in the great collection formed by Sir George Beaumont, Allston's English patron, and had just recently, in 1828, entered the National Gallery in London. (Although Beaumont had included it in his gift to the nation in 1823, he would not part with it until he died in 1827.) Allston's painting is his most Claudian, in the gentle luminosity and, especially, in the careful planar recession moving from

right to left and back again in succeeding parallel planes of light and dark. The placement of Allston's figures relates to that in the Claude as do the gently swaying, overhanging tree and the bridge in the middle distance. There is, however, an even closer source for Allston's composition, which he must have seen at the Royal Academy exhibition of 1815: Turner's *Crossing the Brook,* one of that artist's most Italianate landscapes and itself very close to the *Hagar* of Claude. Although Turner has anglicized the components of the Claudian landscape, parallels between all the forms can be found in his and in Allston's works.

When Allston returned to the creation of smaller pictures in his new studio in Cambridgeport in 1831, his attention was primarily occupied with figural works. His next recorded and located landscape is *Landscape, American Scenery: Time, Afternoon, with a Southwest Haze* (fig. 56), painted for Edmund Dwight and mentioned as completed in a letter to Dr. Walter Channing of July 2, 1835. Dwight was one of Allston's major patrons, owning in addition to this work an early Italian landscape of 1810 and the 1831 figural piece *A Roman Lady Reading* (fig. 51). This is Allston's only located painting of American scenery, but there can be found in it no concern with exploiting or extolling the beauties of distinctly American nature. The landscape forms are completely generalized, and the golden light seeps through a Claude-like hazy atmosphere, softening forms that are already shadowy in the darkened foreground. A single, near-dead tree is silhouetted against the golden light, a reflection of that motif so common in the work of Thomas Cole but found in Allston's work only here and in his *Elijah;* and this landscape lacks the Rosa-inspired dramatic suggestion of terror and destruction so relished by Cole. A solitary traveler on horseback leaves a path at the left and crosses a stream somewhat wider than the similar configuration in the evening landscape of sixteen years earlier. This landscape, in fact, is more general and more evanescent than the earlier pictures. Rather than bearing any relationship to the developing landscape of Thomas Cole and the earlier phase of the Hudson River School or even to the New England work of his colleague and associate Alvan Fisher, this late landscape, in its looser, dreamlike quality, looks forward to the ethereal merging of man into nature that characterizes the late work of George Inness, half a century later. Ednah Cheney later recalled the presence of Allston's painting gallery of landscapes and quoted a pupil of Allston's that "it was the only gentleman in the company."[102]

Allston's late landscapes were much admired in his own time. They have a glowing warmth that is quite distinct from the classical coolness of the early Italian landscapes. Yet, they too are purely emanations of the mind; they offer no reflection of the real and reveal no attempt at literal transcription. This quality was observed by one of Allston's admirers, Ednah Cheney, in her 1880 history of art: "It is still Nature as the revelation of Spirit, that he recognizes, and his landscapes are as poetic, and as far from all servile imitation of outward material forms as his heads of saints or angels." And perhaps the best description of them was given, fifteen years earlier, by Mrs. Cheney's good friend and Allston's pupil, Sarah Clarke, who found them "more musical than pictorial" and likened them to odes, anthems, and symphonies.[103]

Landscape, American Scenery is the last known completed landscape by Allston; an *Italian Landscape,* owned by the Reverend Dr. Charles Lowell and shown at the

Fig. 56. *Landscape, American Scenery: Time, Afternoon, with a Southwest Haze,* 1835
Oil on canvas, 18½ x 24¾ in. (47 x 62.9 cm.)
Richardson 143
Museum of Fine Arts, Boston, Bequest of Edmund Dwight

Boston Athenaeum several times in the 1850s, is reported to have been destroyed by fire in Schenectady in 1912. But one of Allston's several unfinished scenes deserves comment, the *Ship in a Squall* (fig. 57), which was viewed by Anna Jameson when she visited Allston's studio in 1837; it sufficiently impressed Stephen Perkins for it to be chosen for reproduction in *Outlines and Sketches* of 1850, which was prepared under his supervision.

The *Ship in a Squall* consists of an outline in white chalk upon a reddish-brown ground on canvas. Something of the eeriness of the picture as it now appears depends upon the unfinished nature of the work. The ship is a ghostly presence, a dreamlike *Flying Dutchman* precisely because it *is* only an outline sketch, transparent and hollow, yet brightly outlined in white against a dark background, and almost absorbed in the powerful natural setting. Compared to the early *Thunderstorm at Sea*, of 1804, this work appears to rely much less upon formula and to involve the viewer more directly in the drama. The horizon has been greatly lowered so that a vast plane, or dome, of sky appears. The ship seems to sit almost upon the horizon, and yet a second, far smaller vessel appears faintly even farther back, stressing the infinitude of space. While the horizontal band of sea is not nearly as broad as in the earlier, completed work, its powerful swelling still suggests ferocious power. One can only speculate whether Allston would have retained the compelling force and haunting vision had he completed this sea painting.

Fig. 57. *Ship in a Squall*, before 1837
Chalk on canvas, 48⅛ x 60 in. (122.1 x 152.5
cm.). Richardson 147
Fogg Art Museum, Harvard University, The
Washington Allston Trust

THE MOST MYSTIFYING ASPECT of Allston's long involvement with his great *Belshazzar* was his unwillingness to resume work upon it after he had installed himself, in 1831, in a studio large enough to accommodate the 16-foot canvas. Increasingly, as we have seen, he appears to have postponed finishing the work until he was totally out of debt, and, as he himself acknowledged, his subscribers never complained.

Ten years earlier, Allston had used *Belshazzar* as an excuse to put off fulfilling his Boston hospital commission. Now it intervened between Allston and a commission for a painting for the rotunda of the United States Capitol. Allston's name was put forward as early as July 1828, when James Hamilton of South Carolina offered a resolution in the House of Representatives that Allston should be asked to provide a painting of the Battle of New Orleans for the Capitol; in Hamilton's speech he referred to Allston as "restoring the Augustan Age of Painting." But for the moment, nothing more came of this suggestion.[104] However, Congress actually approached Allston twice. First, in 1830, Gulian Verplanck tried to induce Allston to paint a large, 12-by-18-foot picture for $15,000, but the requirement of a subject taken from American history was interpreted by Allston as a military battle subject, and he declined. He offered to provide a religious work, citing the Three Maries at the Tomb of Christ, but Verplanck repeated the condition of an American subject and offered the example of the landing of the Pilgrim Fathers. This Allston also refused out of deference to the Boston painter Henry Sargent, who had already depicted this subject, and out of unwillingness to compete with Sargent in recording the same event. An agreement was almost reached on the depiction of the first interview of Columbus with Ferdinand and Isabella, a subject that foreshadows the Columbian imagery upon which Emanuel Leutze made his reputation as a historical painter a decade later. This theme appealed to Allston since it was drawn from the history written by his close friend Washington Irving, but the project was dropped by Congress at that time. Characteristically, Allston at the same time urged Congress to consider commissions for Vanderlyn, Morse, and Sully also. When negotiations were resumed in 1836, Allston wrote to Leonard Jarvis in Congress, his close friend of his Harvard years, that he could not consider such a commission, since he was about to resume work on *Belshazzar's Feast*. By this time, however, the picture had taken on both mythic and hallucinatory proportions in Allston's mind. He told Jarvis that he had never ceased working on the picture except when pressed by debts; yet it had remained rolled up for many years. And although he told Jarvis at this time that he was about to begin work on it, it was still rolled up when Anna Jameson visited him at the end of the following year. By then, at least, she reported him exceedingly sensitive on the subject, "almost verging on insanity."

It is idle to speculate on what form Allston's work for the Capitol might have taken and what success he might have had. Congress, in 1836, had hoped to have two works by Allston, and one each by other artists, this at the prompting of John Quincy Adams, who had strong doubts concerning the ability of any American painters except Allston to successfully undertake historical paintings. Allston himself had promoted the talents of his one-time pupil Samuel F. B. Morse, whose heart was set upon obtaining such a commission, believing it to be the only successful culmination of his artistic pursuits. Adams, however, appears to have been implacably set against Morse. When the *New-York Mirror* published the information that All-

107
EDWARD AUGUSTUS BRACKETT, American, 1818-1908
Washington Allston, 1843-44
Marble, height 26 in. (66 cm.)
Worcester Art Museum, Worcester, Massachusetts, Gift of the Family of Edward Augustus Brackett

ston had refused to paint the two requested works, it was assumed that he would definitely accept a single commission. But Allston immediately denied this, putting forth Morse's qualifications. After the initial awards were made to John Gadsby Chapman, Robert Weir, John Vanderlyn, and Henry Inman, Inman refused the commission, and Morse was championed again. Adams insisted to Inman that he should not decline, however, and at length Inman consented, but his commission was never carried out. Morse's failure to obtain the commission effectively brought to an end the career of Allston's most significant pupil. About the time of the Congressional negotiations in 1833, Allston likewise refused a commission presented to him by Edward Everett, from an association in Charleston, for a painting of the American Minister to Mexico unfurling the flag, despite the urgings of the association chairman, Allston's old friend and patron Colonel William Drayton.[105] Allston's reasons for refusal were his commitment to *Belshazzar* and the military nature of the subject. The commission subsequently went to Allston's old friend from his early Charleston and London years, the resident historical painter in Charleston, John Blake White. The Charleston press reported the matter late in 1834 and during the following year. Although White was, in any event, the logical alternative recipient of the commission, it is possible that Allston, out of regard for his native town and a friend among its resident artists, urged the association to consider him.[106]

Allston's disinclination to resume work on *Belshazzar* may well have resulted from his ever increasing distance from the inspiration of his earlier years, when *Belshazzar* had first been conceived, nurtured by tradition and examples of the old masters and the presence in Britain of active historical painters such as Fuseli and his own master, Benjamin West. By 1831 ten years had elapsed without his having completed a major dramatic canvas. Yet, that year he resumed work on a painting of this nature, *Spalatro's Vision of the Bloody Hand*, taken from Ann Radcliffe's Gothic novel of mystery and terror *The Italian* of 1797. The picture was commissioned and acquired by the South Carolina collector Hugh Swinton Ball, who had first read the novel and discussed it with Allston. The work was first exhibited publicly in a Scollay Square residence in Boston and at the National Academy in 1832 before being sent to South Carolina, where it was shown in Charleston in the same year. Hugh Swinton Ball was killed in the explosion of the *Pulaski* off the coast of North Carolina in 1838. The picture was willed to his brother and continued to represent Allston in a number of exhibitions in South Carolina until it was acquired by Ball's nephew, Elias N. Ball, at auction in 1859 for $3011, Elias Ball outbidding South Carolina's major art patron of the period, Robert Francis Withers Allston, whose father was the painter's half-brother. Elias Ball exhibited the picture once more in Charleston, at the Carolina Art Association in 1860. The painting subsequently passed from Elias Ball to Taylor Johnston of New York in 1866; Johnston exhibited it at the Seventh Annual Artists' Fund Society in New York in 1866 and at the Brooklyn Art Association in 1872. An engraving of it by Lindon served as the frontispiece for Clara Clement's *Handbook of Legendary and Mythological Art* of 1871. The *Aldine* listed it in the John Taylor Johnston sale in New York in 1876; it may have burned in a fire in the home of H. R. Bishop on the Hudson, before 1882.[107]

Spalatro's Vision is known today only in the engraving (fig. 58). It depicted the

Fig. 58. *Spalatro's Vision of the Bloody Hand,* 1831
Engraving after painting. Richardson 134

monk, Schedoni, and the assassin, Spalatro, in a dark corridor on their way to murder Elena. Spalatro was horrified by the apparition of a beckoning, bloody hand. He appeared as if frozen with supernatural fear, while the priest stood erect and haughty, holding high a lamp, which critics considered one of the finest depictions of fire ever created. Sweetser, who stated that Allston felt it to be one of his best works, commended the intense realization of the power of conscience. Allston's old friend Charles Fraser, writing in the Southern publication *The Magnolia*, in September 1842, praised particularly the magic effect of the flickering light of the lamp. In this work Allston has returned to his preoccupation with the effects of the supernatural, the creation of a "miracle," though now on a small scale; the picture was only 18 by 30 inches in size. The dank prisonlike gloom of the dark corridors and the successive passageways seen through arched openings also hark back to the settings of his *Angel Releasing St. Peter* and *Jeremiah*. Perhaps Allston was attempting to recapture the mood and recover the motivation that had prompted those works before proceeding with *Belshazzar*.

Allston does not appear to have pursued the dramatic potential of *Spalatro*, but there remain a series of studies and other references to further works of an ambitious nature that suggest intriguingly that the motivation for *Belshazzar* had not actually subsided. These relate to multifigured compositions of a scope vaster even than his *Dead Man Restored* but never actually realized in a completed canvas. Precedent for such compositions exists only in the early *Jason*, *Belshazzar*, and the design for *The Stoning of St. Stephen*, which Allston had considered for the Boston hospital commission, and which is compositionally quite similar to *Belshazzar*. The *St. Stephen* is known today in the reproduction of the design that appears in Flagg's biography.

There is an oil study of a single active and contorted figure that may be for *The Angel Pouring out the Vial of Wrath over Jerusalem* (fig. 59), which, according to Richard Henry Dana, was an idea that came to Allston while laboring under a severe attack of sickness in 1829; the work was later obliterated and recommenced in July 1840. The scene, from the Book of Revelation, depicted the angel of wrath floating in the air, holding a drawn sword in one hand and, from the vial in the other, pouring forth the golden wrath. Allston also modeled a figure for this work, a continuation of his earlier practice at sculpture. *Heliodorus Driven from the Temple* (no. 69) is more completely known through the large chalk outline study on primed canvas that was engraved in *Outline and Sketches*. It naturally derives from the great fresco of this subject by Raphael in the Vatican, but it also peculiarly prefigures Delacroix's mural in St. Sulpice in Paris, as both Allston and Delacroix, unlike Raphael, block the architectural passage with the dramatic figure of the heavenly rider. Both these works involved tremendous activity and movement, unlike anything known in Allston's completed pictures.

In September 1833, William Dunlap recorded in his *Diary* that he had learned from Morse that Allston was engaged upon his *Gabriel Setting the Watch at the Gates of Paradise*, taken from Milton's *Paradise Lost*. Reported as of small size, the work appears to have been abandoned or destroyed; it was a multifigure composition, judging from the six outline studies for it that appeared in engraving in *Outlines and Sketches*, where the name *Michael* is substituted for *Gabriel* in the title.

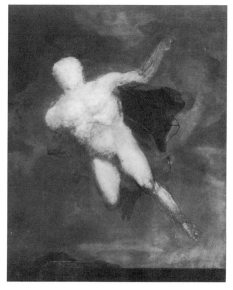

Fig. 59. *The Angel Pouring out the Vial of Wrath over Jerusalem*, ca. 1840
Chalk study on canvas, 36⅜ x 29½ in. (91.9 x 74.9 cm.). Richardson 184
Boston University, Gift of the Allston Trust

A quieter, more solemn mood is conveyed by the majestic figure of *The Sibyl* (identified by H. W. L. Dana as the Cumaean sibyl; fig. 60) in contemplative pose and holding a stylus. Also known through the engraving in *Outlines and Sketches*, the work was chalk outline on canvas, measuring 7 feet high; it would thus appear to have been conceived as a companion to the 1817 *Uriel*.

The dates of all of these conceptions and incomplete or destroyed works are not known, but they indicate that Allston had not completely abandoned the dramatic inspiration offered by such sources as Milton and the Bible in his later American years. Yet, he was not able to bring them to completion. The only painting of the 1830s where we can view Allston's later involvement with dramatic tragedy is his *Death of King John* (no. 68), and even that is incomplete.

The Death of King John was recorded by that indefatigable chronicler Anna Jameson, who saw the painting in Allston's studio at the end of 1837 and noted that he was working on it at the time. But the picture remained unfinished. As with many of Allston's other unfinished works, it has been "dead colored" (that is, the flat areas of pure pigment have been laid in), but, for the most part, the subsequent glazes have not yet been added. It becomes obvious that this stage of creation was a stopping point for Allston. The concept germinated, the idea of forms and composition took hold, the compositional sketches were created, earlier drawings were consulted, the initial outline in chalk and paint laid onto a primed canvas, and the flat areas of color applied. The final stage would be the application of the glazes. Allston's inability to carry this last stage through in so many works may be a combination of the extraordinary difficulty involved and the realization that, once the glazes were successfully applied, the work would be finished. It may have been a combination of pride and humility that caused this reluctance: pride in his anticipated achievement that would result in his parting with the work, humility in his aesthetic association with the old masters, whose techniques he was emulating.

Allston's painting of *The Death of King John* shows a dramatic scene from Act 5 of Shakespeare's drama *King John*. The King is dying of poisoning in the orchard in Swinstead Abbey, while his son and successor, Prince Richard, looks on. The figures are compactly arranged before the Gothic setting, and Allston has taken pains to ensure historical accuracy in the architecture and in the armor of Richard. The contrast between the contorted agony of King John and the varying reactions of the other principals surrounding him is effective, although the intensity is somewhat dissipated by the prominence given to the standing figure of Richard in the foreground, which shares the primary attention with that of the king.

This painting is significant because it is the most telling link between Allston's great dramatic canvases done in England and the final work on *Belshazzar*, although it must be recalled that the latter painting was begun many years earlier. The figure of King John, in particular, suggests a relationship to the *Dead Man* in its dramatic pose and partial nudity, although the pose might well relate equally to Allston's ultimate sources in the cartoons of Raphael and the Elgin marbles. Yet, the dramatic facial expression of the king is not unlike that of Belshazzar, and, fortuitously, the intense, clutching hands of John are extremely similar to those of Belshazzar—even to the extent that one of the hands is unfinished; in both cases the hands serve as an outward manifestation of fear and pain. The figure of King John

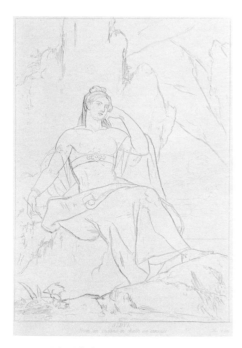

Fig. 60. *The Sibyl*
Chalk on canvas, 83½ x 59½ in. (212.1 x 151.1 cm.). Richardson 154
The Lowe Art Museum, University of Miami, Florida, Gift of the Allston Trust

probably bears a resemblance, too, to that of Allston's Heliodorus. The "chorus" of onlookers in *King John* also parallels that in the *Dead Man Restored,* both in the pictorial role they serve and in the variety of reactions they express; Allston himself had written about the role of these figures in the earlier work. Perhaps most significant, however, is the kneeling, grieving figure of a mourning woman at the king's side, touching, and very tenderly painted, perhaps all the more affecting because her face is so completely shielded. It should be noted, too, that this figure is Allston's invention. In Shakespeare's play *King John* dies in the company of Prince Richard, the Earl of Salisbury, and Lord Bigot, but no women are present. In Allston's painting the grieving woman parallels the kneeling Jewish woman to the right of Daniel in *Belshazzar's Feast,* and the latter, in turn, was Allston's principal figural addition to his final conception of the masterwork. She and her companions are absent from the artist's original studies for the painting. The young woman in *Belshazzar,* which was to be the most admired single figure in the great painting, is the figure there that reflects the "later" Allston, that embodies the mood of gentle, poetic reverie. In *King John* it is as though Allston were "trying out" such a figure as a contrast to the horrifying drama of the principals in a work of moderate size before adding a similar one to his magnum opus.

Although Shakespearean subjects increasingly abound in American painting of the early and middle nineteenth century, *King John* was an extremely unusual source, and the death of the king appears unique in American iconographic involvement. Allston would have been familiar, however, with the famous Shakespeare Gallery of John Boydell, formed in the late eighteenth century, or at least with the engravings produced after the paintings commissioned for it. This included several scenes from *King John,* the primary one by that major follower of Sir Joshua Reynolds, James Northcote, taken from Act 4 of the play. But very likely the ultimate pictorial source for Allston was another painting done for Boydell's Gallery, the *Death of Cardinal Beaufort* (see fig. 61), one of the relatively few historical works and perhaps the most famous by Reynolds himself. This scene, taken from *Henry VI, Part 2,* and Reynolds's conception, itself derived from Poussin's great *Death of Germanicus,* depicts the cardinal in the final throes of agony on his deathbed; it was written about many times subsequent to its depiction. Allston would have known the original painting quite well also, for it was owned by the Earl of Egremont at Petworth (where hung his own *Jacob's Dream*), which he visited toward the end of his English years.

Allston's lifelong interest in and derivation from Shakespeare, then, did not diminish even in his last years, but it did assume another direction in one or two of his late works, a surprising and intriguing development. This was his creation of two "fairy pictures," *Fairies on the Seashore, Disappearing at Sunrise* (fig. 62), and *Titania's Court* (fig. 63). Both were viewed by Mrs. Jameson at the end of 1837, although, when she later referred to them in her writings, she confused them as one composition; however, she referred correctly to the title of the former and to the source of the latter, Shakespeare's *A Midsummer Night's Dream.* Both works were unfinished and were engraved for *Outlines and Sketches. Fairies on the Seashore* is no longer extant. *Titania's Court,* consisting only of a painted outline on canvas, is much larger and more ambitious than the other picture. Allston seems to have been proud of the work and to have shown it and spoken of it often.

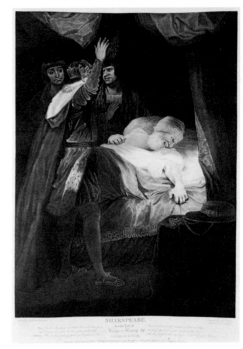

Fig. 61. CAROLINE WATSON, British, 1760-1814
Death of Cardinal Beaufort, 1792
Engraving after a painting by Sir Joshua Reynolds. Published by Boydell of the Shakespeare Gallery
Museum of Fine Arts, Boston

Fig. 62. *Fairies on the Seashore, Disappearing at Sunrise,* before 1837
Engraving in *Outlines and Sketches,* 1850
Richardson 146

Fig. 63. *Titania's Court*, 1837
Outline in oil on canvas, 48⅝ x 72¾ in. (122.7
x 184.8 cm.). Richardson 145
Vassar College, Poughkeepsie, New York, Gift
of the Allston Trust

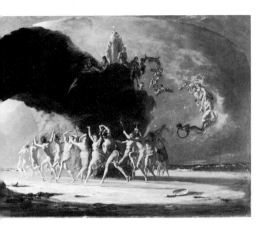

Fig. 64. RICHARD DADD, British, 1819-1887
Come unto These Yellow Sands
Oil on canvas
Private Collection

Both conceptions involve a great deal of movement, light and airy as befitting their subject. The emphasis upon beauty and grace, on the representation of ideal and idyllic figures in an outdoor setting, would seem to derive ultimately from Raphael's *Parnassus* in the Vatican, although *Titania's Court* is closer to another work with which Allston would have become familiar in his early years in Rome, Domenichino's *Hunt of Diana*. In Allston's unfinished work, the basic theme is the expression of joyous emotion; although the subject is derived from Shakespeare, Titania herself literally takes a "back seat" in the composition. But Allston's pictures have more immediate precedent in some of the paintings that constitute the beginning of a lively interest in fairy subjects in English art. This theme gained popularity in the 1840s and is today especially associated with the paintings of the brilliant but tragically mad Richard Dadd: *Titania Sleeping, Puck,* and *Come unto These Yellow Sands* (fig. 64), all about 1841-42.[108] The dancing fairy circle in Dadd's *Titania* is quite similar to Allston's, while his *Come unto These Yellow Sands* appears to be an expanded version of Allston's *Fairies on the Seashore*. In fact, it raises the question as to the possible literary source of Allston's picture. Mrs. Jameson's confusion of this work with *Titania's Court* may throw light on part of the truth, for Allston's *Fairies* is very likely an illustration of Titania's lines from Shakespeare's *A Midsummer Night's Dream*:

Or in the beached margent of the sea
To dance our ringlets to the whistling wind.

155

However, Allston's conception and the extant outline engraving may, like Dadd's painting, equally represent a pictorialization of Ariel's song from Act 1 of *The Tempest:*

> Come unto these yellow sands,
> And then take hands. . . .

The parallels between Allston's and Dadd's works are surprising, for neither artist could have been familiar with the other's pictures. Dadd's fairy paintings and drawings are later than Allston's, but Allston's remained in his studio or were destroyed, and the engravings after them that appeared in *Outlines and Sketches* date from almost a decade after Dadd's paintings were created and exhibited. Rather, these works would seem to derive from a common fascination with the theme of fairies and realms of the subconscious and from the increasingly inward-turning life of both artists, painters of the inner mind rather than outward experience.

But earlier paintings of fairy subjects also played a role in both artists' conceptions. While the paintings and engravings related to *King John* in the Boydell Gallery are not well known, those depicting scenes from *A Midsummer Night's Dream* are among the most famous. One is Reynolds's *Puck,* which was the basis of Dadd's painting of that theme, but perhaps the best known are several by Henry Fuseli, who was greatly admired by Allston in his early years in England. These include several depictions of Titania and her fairy following, although it is significant that Allston in his *Titania's Court* eliminated the grotesque and purposely discordant figure of the ass-headed Bottom. More immediate sources still were the fairy pictures created by Francis Danby, the Irish-born artist. Danby had worked in Bristol and may have been influenced by Allston before moving to London, where he painted in the manner of Allston's friend John Martin. Danby's watercolor *Scene from A Midsummer Night's Dream,* of 1832, is a more specific illustration of the Shakespearean tale and could not have been known to Allston. But his *Fairies on the Seashore* of about the same date was engraved for the *Literary Souvenir* of 1833 and was easily available to both Allston and Dadd. Dadd may have drawn upon Danby's work for the rocky setting of his *Come unto These Yellow Sands.* Although Allston's title is identical to Danby's, there are closer similarities between his *Titania's Court* and Danby's work.[109]

Jared Flagg recalled seeing *Titania's Court* about 1836 and hearing Allston's elaborate description of the work. He quoted Richard Henry Dana, Jr., concerning the Duchess of Sutherland, who commissioned her brother, Lord Morpeth, Earl of Carlisle, who was visiting Boston in the winter of 1841, to attempt to acquire another painting by Allston; his *Uriel* was already in her collection. Viscount Morpeth had recently left the position of chief secretary for Ireland and was making a tour of the United States. He was a friend of Allston's close friend Charles Sumner, who introduced Morpeth to the artist. Lord Morpeth examined the study for *Titania's Court* and agreed upon a price of £5,000, or $25,000, a then unheard-of price for an American painting. But Allston agreed to the commission only on condition that the duchess wait until *Belshazzar* was completed, for by then his work on the latter painting was again underway. As Flagg wrote, "this was an indefinite postponement." In late 1843, after Allston's death, Lord Morpeth communicated

with Sumner about the possibility of acquiring either the *Titania* or the *Heliodorus* from the estate, but Sumner informed him that there were strong sentiments concerning the removal of the *Titania* from Boston, and nothing more came of the negotiations. *Diana in the Chase* (no. 11), which had been owned by Isaac Davis, was then available, according to Sumner, who, however, contrasted the cold, hard clarity of this early landscape with Allston's later, more glowing landscapes, which, he said, would then have been tremendously valuable and sought after. Lord Morpeth later gave a lecture to the Yorkshire Union of Mechanic Institutes on his travels in America in which he eulogized Allston: "There was the painter, Allston, a man of real genius, who suffices to prove that the domain of the fine arts, though certainly not hitherto the most congenial to the American soil, may be successfully brought, to use their current phrase, into annexation with it."[110]

Allston's fairy pictures are curious reflections and anticipations of artistic trends in England. There was little continuation of this theme in American art, although isolated examples can be found in the work of several members of the next generation, painters such as Lilly Martin Spencer and William Beard. Perhaps the finest fairy picture completed by an American artist is the beautiful fantasy *Christmas Bells*, of about 1864, by John Ferguson Weir. The work was presented to the Century Association in New York when Weir became a member there; several replicas of it exist. A more immediate reflection of Allston's *Titania* can be seen in the frontispiece to Gulian Verplanck's 1844-1847 edition of Shakespeare's plays, designed by Robert Weir, John Weir's father. There Titania's fairy court dances hand-in-hand in a manner similar to Allston's conception. Weir later owned a copy of *Outlines and Sketches*, in which Allston's grand design was engraved, but he would also have been shown the original study when he visited Allston's studio immediately after the artist's death.

Although Allston remained in Cambridgeport, traveling little and rarely seeing members of his family except on their visits to Boston, he remained extremely close to his mother and siblings. The death of his mother, Rachel Flagg, at the end of 1839 left him distraught, and he was further burdened by a controversy and lawsuit instituted by his nephew Henry Flagg and his brother-in-law, Thomas Wigfall of Charleston, husband of his half-sister, Eliza Flagg. Previously, on the death of his step-father, Henry Collins Flagg, Allston had inherited a black slave named Diana and had immediately sent her papers of manumission. Now, the slaves inherited from Rachel Flagg were about to be divided into five portions for Allston, his brother and sister, and the descendants of Rachel and Henry Flagg. Allston freely renounced his claim to his inheritance and attempted to secure similar documents from William and Mary, so that the black families would not have to be separated. The concern expressed in Allston's letters over the fate of the slaves is quite moving. The affection between the children of Rachel and William Allston is also attested to eloquently by Mary's renunciation of her inheritance from her mother so that it could be divided between her less well-off brothers. In turn, Washington Allston directed Rachel's executors to give over the entire inheritance to William. Mary's death, two years after their mother's, affected Allston profoundly.

IN DECEMBER 1838 Allston wrote to Chester Harding that he expected to resume work on *Belshazzar* the following spring. Finally, for reasons unknown, Allston was able to rouse himself to the task; as he wrote to Cogdell a year later, in December 1839, "The 'King of Babylon' is at last liberated from his imprisonment, and is now holding court in my painting room." Yet, fearful of extended publicity, he would not let his friends see the picture. Not even his brother-in-law and closest friend, Richard Dana, or the workmen who unrolled the picture were allowed to view it. In 1840 Charles Sumner reported in a letter to Horatio Greenough that *Belshazzar* was, indeed, unveiled, but that it was always covered with a curtain to act as a breakwater to the curiosity of visitors. Again, as twenty years before, Allston repeated in his letters to Cogdell and McMurtrie of 1841 and 1842 that he was constantly at work on the painting, but he refused to say more or to propose a date for completion. Nevertheless, speculation about the picture continued, and there was even a suggestion that now the modern "prophet" of New England, Daniel Webster, was a model or analogue for the Daniel of the Bible.

Among Allston's last letters was one to the widow of William Ellery Channing, dated July 4, 1843, regretting his inability to finish her late husband's portrait, begun over thirty years earlier, until he had completed the *Belshazzar;* Channing had died the previous autumn. Allston also mentioned in the letter that two years of illness had held up his work. A few days prior to this, he had told Cogdell that while working on the picture, he was experiencing pains, and on June 19 he had asked his doctor, George Shattuck, to visit him in Cambridgeport, as he had been suffering from pain in his left side. Then, on the evening of July 9, Allston came into his house from his painting room, about seven o'clock in the evening, to enjoy a visit from his wife's family. The artist was exhausted from working on the great picture, in which he had been concentrating on the soothsayers to the right of the figure of Daniel. His painting necessitated constantly ascending and descending a ladder so that he could judge the effectiveness of his work, and this effort was wearying to him. Shortly thereafter, his wife left the room in which Allston was resting; when she returned, he was dead. His last act of painting had been on *Belshazzar's Feast.*

Three days after Allston's death, a group that included his brother-in-law, Richard Henry Dana, and Dana's son, Richard, Jr. (author of *Two Years before the Mast,* of 1840), Edmund Dana and his son, and John Greenough, the painter, entered Allston's painting room. They pulled back the curtain, and what they saw both excited and dismayed them. It seemed that Allston's early changes in perspective had never been completed or had never been satisfactory, because he was still involved with them twenty years later. Chalk lines indicated changes in the architecture and the figures. The queen was unfinished above the waist. Daniel was almost complete except for the right hand. This hand had once hung passively, but Stuart had advised Allston to show a more forceful prophet, with the hand clenched. As soon as Allston began to follow Stuart's advice, he realized that his original conception of the figure was preferable; it was still unfinished in 1843. The left arm was of undue length, and the neck too long. The Chaldeans and soothsayers were in the process of being raised. The heads of the soothsayers were only begun in their new proportions, and there was fresh paint on the head of the soothsayer nearest Daniel. But the real cause of anguish was the figure of Belshazzar himself, once

Fig. 65. DAVID C. JOHNSTON, American, 1797-1865
Washington Allston in His Studio, ca. 1840
Oil on millboard, 10½ x 9 in. (26.6 x 22.8 cm.)
Bowdoin College Museum of Art, Brunswick, Maine

finished but now pumiced down and covered with a solid coat of paint. A few areas were still visible, including the left foot of the original and the right hand of the newer conception, which needed glazing. As Greenough correctly noted, the elimination of this figure was a double loss; it left not only a missing "key" element but also a blankness that cast a pall over the entire painting. "The *Belshazzar's Feast* is a melancholy ruin," Charles Sumner wrote to Lord Morpeth later in 1843, noting that part of the picture was early, part late. Richard Henry Dana, referring both to the missing figure of the king and the relationship of the picture to Allston's life, commented, "That is his shroud."

It undoubtedly occurred to those in charge of Allston's estate to have the picture completed by another hand, but with a respect rare in the nineteenth century—and even in our own—the picture was not tampered with.

Warren Dutton, one of the intermediary agents involved in the tripartite agreement originally subsidizing the painting, and Franklin Dexter were in charge for the subscribers, and they followed a sensitive course of action to salvage what they could. First the picture was sponged down with water. Then, with John Greenough's assistance, an attempt was made to remove the edges of the overpaint, but Greenough feared that the solvents were hurting the glazes on the original figure of Belshazzar beneath. At this point, Samuel F. B. Morse was invited to examine the work with Dexter, and he agreed that the original Belshazzar had been covered over, not out of Allston's dissatisfaction, but because other changes had made it necessary that the figure be raised. Morse was asked to put the picture into condition, but finally the task was given to Darius Chase (ca. 1808-after 1859), a little-known Boston painter and restorer active there in the 1840s, who later worked in Philadelphia and Charleston. Chase succeeded in removing the overlay of dead color, unveiling the king. Dana, writing to Leonard Jarvis in Congress, on January 12, 1844, spoke of the figure as the "coming up of [the] sun," saying that Belshazzar's reappearance successfully threw back the architecture, adding light to a dark foreground and bringing the figures of the queen and Daniel into bold relief. The only losses that occurred, due to varnishing, were the chalk outlines indicating changes in the king's foot, Daniel's left heel, and an indication that a pillar in the upper left would have been shown in its entirety, covering over part of the great candlestick. Dana insisted, however, that no paintbrush was to touch the picture. Allston's own paintbrush, still wet with paint used on the soothsayer's face, was given to Morse as a memorial, and he, in turn, presented it to the National Academy of Design.

Darius Chase may not have survived the annals of American art, but to him we owe the present appearance of *Belshazzar's Feast* (fig. 45). As it is, the painting is an amalgam of Allston's earlier conception and changes made before his death. These changes can be seen by comparing the unfinished canvas with two earlier oil studies. Both Allston's alterations and the incompleteness of the figures are evident in the large picture, and it is obvious that Belshazzar himself, as revealed by Chase's removal of the dead coloring, has already been raised and enlarged. The Fogg study (no. 42), as mentioned, would seem to be the earlier of the two, for in the Boston study (no. 43) the two attendant youths in the lower left of his work have been replaced to give greater prominence to the Jewish ceremonial vessels,

sacrilegiously used by Belshazzar's court. In the Boston picture, as in the large canvas, the seven-branch candlestick above Belshazzar's throne is more prominent than in the Fogg study. Alterations and changes occur throughout the large picture, but the most significant addition—one much admired and commented upon by contemporaries—was the group of lovely young Jewish women between and behind Daniel and the soothsayers, poetically rendered in the spirit of some of Allston's late studies of single figures.

The large canvas was seen widely after Allston's death. Artists such as Robert Weir and John Cheney, the engraver, were invited both for their own satisfaction and for their advice. On completion of the restoration, in 1844, the subscriber-owners exhibited the picture in Boston. The American art world expected the work to travel at least to New York and Philadelphia. But the owners, though anxious for it to be seen in Boston, were not interested in profit and, to the great disappointment of many, were unwilling to let it travel.

The picture was first shown in a rented hall, the Corinthian Gallery, in 1844, but from the following year onward it was exhibited almost annually at the Boston Athenaeum. Despite its condition, the public was extremely enthusiastic. Typical of the prevailing sentiments is a letter of May 28, 1844, from E. P. Whipple to Anna Cora Mowatt, inviting Miss Mowatt to visit Boston if only to enjoy the supernatural light and mystical beauty of the great picture. Laudatory and detailed articles were written analyzing each figure's role in the sacred drama. The queen—whom one critic emphasized was Nitocris, wife of Merodach and thus the *mother* of Belshazzar, who was in turn the grandson of Nebuchadnezzar—was called beautiful and intelligent, with her head based on that of Napoleon! Her slaves were thought to be Arabic or Near Eastern. Each soothsayer was individually characterized. Much was made of the fainting princess at the table in the middle distance and of the distraught figures of the "grandees of the empire." But the highest praise was reserved for the group of Jewish women, which "alone would have immortalized the painter." Allston's niece, Charlotte Dana, is said to have posed for the much-admired kneeling Jewess. Charles Sumner thought the picture combined the drawing of Raphael and the coloring of Titian, and another critic referred to Allston as "the American Apelles."

Although the great painting was not intended to travel, it did so, "by proxy." A little-known Boston painter, Thomas Truman Spear (1803-ca. 1882), developed a sketch of it made in 1846 into a large version, which he planned to take to the South. This venture was opposed by Chester Harding and other artists, particularly since Spear's painting was shown with the designation "Great Picture by Washington Allston," followed by the word "copy" in exceedingly small letters. As time went on, the confusion became more pronounced; in Chicago in 1869 this copy was actually believed to be Allston's original. Prior to the copy of *Belshazzar*, Spear had exhibited at the Athenaeum a copy of Allston's *Beatrice, from Recollection*.

As we have seen, on its first public presentation, viewers were often rapturous about the merits of the great canvas. Charles Edward Lester, describing it as "a great fragment," went on to say that collective "power and style are, however, clearly evident. To the Artist it will ever be an object of veneration, for it bears the last touches of the great pencil." Even as late as 1864, James Jackson Jarves spoke

of *Belshazzar's Feast* as "the greatest, best composed, and most difficult painting yet attempted by an American artist."

But even before Allston's death, a less overwrought and more perceptive analysis had appeared. Margaret Fuller had written of the artist as an "altar without a fire," adding, "Cambridgeport has rotted the man's soul. He cannot finish his *Belshazzar's Feast*." And she had shrewdly noted in the *Dial* in July 1840, on the occasion of the Allston exhibition in Boston, "the Beautiful is Mr. Allston's Domain."

Even Allston's closest friend and admirer, Richard Henry Dana, in reviewing not Allston's art, but his poetry, reflected, "Though we have not allowed to Mr. Allston a mastery over the more intense passions, yet he seems filled with the milder feelings, and to have nothing pass the imagination untouched by them." And he wrote elsewhere: "Nor does Mr. Allston, like Byron, stir the fiery passions within you, or carry you down to the dark and mysterious depths of the soul, moving you to and fro in their wild and fearful workings. He is not majestic and epic."

Allston's earliest biographer, William Ware, referred in 1852 to *Belshazzar* as a class of subject for which Allston's genius was not suited—the large picture with a multitude of figures. He felt that Allston had overstepped the line between sentiment and caricature and criticized the lack of grandeur in the architecture, although he praised—as did almost all other commentators—the picture's "Venetian" color.

Later critics were even more censorious. In 1880 Samuel Benjamin wrote that "in his desire to give intellectual and moral value and permanent dignity to his productions, and in his aversion to sensationalism in art, [Allston] treated his subjects with a deliberate severity which takes away from them all the feeling of spontaneity which is so delightful and important in works of the imagination."

Arthur Dexter, in his section of the great *Memorial History of Boston* of 1883, decried Allston's lack of the needed vigor and resolution to see his picture through to the end, and William Howe Downes, in 1888, claimed that even if the work had been finished, it would have been a failure. He found Daniel theatrical and repulsive, Belshazzar shapeless and disjointed, and he discovered merit only in the figures of the queen and the kneeling Jewess.

Over the years, historians have attempted to ascribe Allston's failure to finish *Belshazzar* to a single cause. More probably there were a number of interrelated causes. Gilbert Stuart was correct when he told William Ellery Channing that with Allston "the work of this month or year was felt to be imperfect the next, and must be done over and over again, or greatly altered, and therefore could never come to an end." Certainly, too, Anna Jameson's summation of Allston's condition seems to be true: she discerned a lack of inward or outward stimulus to exertion, concluding that he was living neither a healthy nor happy artistic life.

The changes of themes from the early, powerful *Uriel* (no. 41) to a companion piece as sensitive and as poetic as *Titania's Court* (fig. 63) is significant. Ralph Waldo Emerson may have put his finger on the core of the problem when he observed in 1839 that Allston's genius seemed feminine, not masculine. After Allston's death he characterized the artist as a "boulder of the European ledge; a spur of those Apennines on which Titian, Raphael, Paul Veronese and Michael Angelo sat, cropping out here in this remote America and unlike anything around it, and not reaching its natural elevation. What a just piece of history it is that he should have

left this great picture of *Belshazzar* in two proportions! The times are out of joint, and so is his masterpiece."

The times may not have been "out of joint," but they had changed. Allston's spirit, as revealed in *Belshazzar*, had been nurtured by a European tradition of social revolution and major wars. Thirty years later a more tranquil spirit had emerged, particularly in an America witnessing great political and territorial growth and conceiving of itself as a new Eden. The spirit of confrontation embodied in *Belshazzar's Feast* had given way to one of reconciliation, as in Daniel Huntington's *Mercy's Dream* of 1841, significantly drawn from Bunyan's *Pilgrim's Progress*. The wrathful God of the Old Testament had little place in a new land on which the Deity seemed to be bestowing his blessing.

In concluding this discussion of *Belshazzar*, it might be appropriate to offer three further summations on Allston and his great work by three significant writers of the nineteenth century. Nathaniel Hawthorne, in his story "The Artist of the Beautiful" from his *Mosses from an Old Manse* (1846), characterized his hero, Owen Warland, in the following manner:

> The painter—as Allston did—leaves half his conception on the canvas to sadden us with its imperfect beauty, and goes to picture forth the whole, if it be no irreverence to say so, in the hues of heaven. . . . This so frequent abortion of man's dearest projects must be taken as proof that the deeds of the earth, however etherealized by piety or genius, are without value, except as exercises and manifestations of the spirit.

In 1885 William Wetmore Story wrote to James Russell Lowell of Allston's last years:

> Allston starved spiritually in Cambridgeport—he fed upon himself. There was nothing congenial without & he introverted all his powers & drained his memory dry. His work grew thinner & vaguer every day & in his old age he ruined his great picture. I know no more melancholy sight than he was—so rich and beautiful a nature, in whose veins the South ran warm, which was born to have grown to such height & to have spread abroad such fragrancy, stunted on the scant soil & withered by the cold winds of that fearful Cambridgeport. I look at his studio whenever I pass with a heartpang.

And much later, Henry James, in his biography of William Wetmore Story (1903), commented thus on the above allusion to Allston:

> Irrepressible memory plays up again at this touch, not of the beautiful colourist and composer himself, withering in the cruel air, but of the indistinct yet irresistible inference that his great strange canvas, so interrupted but so impressive, at the old Boston Athenaeum, used, at a particular restless season, to force one to draw. The unfinished, the merely adumbrated parts of this huge *Daniel before Belshazzar* would certainly have boded sufficient ill had it not been for the beauty of these other portions which shone out like passages of melody, of musical inspiration, in some troubled symphony or sonata; and the lesson of the whole picture, even for a critic in the groping stage, seemed to be that it was the mask of some impenetrable inward strain.

Fig. 66. *The Student*
Oil on canvas, 34 x 31½ in. (86.3 x 80 cm.)
Richardson 171
Boston Athenaeum

Allston's reputation was kept alive by the exhibition of his art, primarily, of course in Boston, the city with which he had been so closely associated. In addition to the annual showing of *Belshazzar's Feast,* at the Boston Athenaeum, other paintings and studies were exhibited, sometimes lent by private owners, sometimes by Martha Dana Allston, his widow; the principal unfinished works were all exhibited by her there in 1847. In 1850 what was tantamount to a memorial show was created out of the loan of forty-nine of Allston's paintings to the annual exhibition that year, held in a single gallery in the Athenaeum's new building on Beacon Street. Only one was a previously unfamiliar work, *Interior of a Church,* lent by Joseph Burnett of Boston. Burnett showed the painting again in 1854 in Westminster Hall in Providence; it is now unlocated. Allston's work continued to be shown at the Athenaeum throughout the fifties, sixties, and early seventies. In addition, seven of his paintings were borrowed from private owners and shown in the Boston Sanitary Fair of 1863, and four pictures were exhibited at the galleries of the Boston Art Club in the Massachusetts Centennial Art Exhibition. The Boston Athenaeum also continued to add to their initial acquisitions of Allston's work, which comprised two of the heads of Polish Jews and the *Mother and Child.* Although they disposed of the last, they purchased his unusual and atypical *The Student* (fig. 66), in 1855, and two other works—an early landscape and the *Casket Scene* (no. 18)—were given to them soon afterwards. In 1870 Allston's *Elijah in the Desert* (no. 49) became the first gift to the newly formed Museum of Fine Arts in Boston. In the summer of 1881, in recognition of the illustrious artists of Boston's past, the museum held an exhibition of almost a hundred paintings and drawings by Allston, following one devoted to Gilbert Stuart. Thomas Gold Appleton acknowledged in the introduction to the catalogue of the Allston show that the artist "belonged to another time and a different way of thinking. . . . He almost closed the period when the great influences of Italy were felt."

Allston's death came as a shock and tragedy to all who knew, admired, and loved him. The young sculptor Edward Augustus Brackett, whom Allston had aided and encouraged when Brackett arrived in Boston two years earlier, immediately took a death mask of Allston. He was commissioned to do this by the Dana family, for in 1841 Brackett had modeled a bust of Richard Henry Dana, a work that Allston greatly admired and about which he commented that, with the exception of one head by Hiram Powers, he had never seen anything modern or antique that pleased him as well. Allston's nephew Robert Francis Withers Allston, of South Carolina, had established a relationship with his uncle and had visited him in 1838. In September 1843 he returned to Boston and saw and admired *Belshazzar's Feast,* finding the head of the soothsayer upon which Allston had last worked the most marvelous thing he "ever beheld on Canvass." He visited Brackett's studio and saw the plaster bust that Brackett had made from Allston's death mask, and he ordered a marble copy of it, preferring it to the earlier sculptured portrait by Shobal Clevenger of 1839. A cast of the latter had been sent by Allston to his mother in December of that year, shortly before her death.

The bust by Clevenger (see no. 104) was taken immediately following Allston's recovery from a severe attack of neuralgia, probably in February 1839, and Elizabeth Peabody, while admiring Clevenger's accuracy, reported that this bust looked

"infinitely more as if he were dead than the real corpse did." A painting of Allston by his nephew George Flagg (fig. 67), done at the same time as Clevenger's sculpture, represents less starkly the effect of Allston's illness. Ironically, R. F. W. Allston and many others preferred Brackett's bust (see no. 107) done after death to Clevenger's, because Brackett's was more refined and poetic, revealing the "beautiful countenance of death," without the heavy modeling and strong indication of age and illness.[111] Brackett had refined his conception, creating a more harmonious and gentle image, and although Clevenger's is the more powerful, Brackett's bust better expresses the concept of the poetic genius and American "old master." And Brackett's bust also affected contemporary viewers profoundly because it was based upon a death mask. Like Allston, Brackett was both artist and poet, and he wrote the following poem in connection with his sculpture, "Lines Suggested on Finishing a Bust of Allston," published in his 1845 *Twilight Hours:*

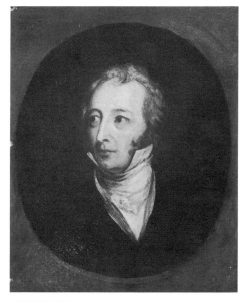

Fig. 67. GEORGE W. FLAGG, American, 1816-1897
Washington Allston, 1839
Oil on millboard, 7¾ x 6¾ in. (19.8 x 17.2 cm.)
Courtesy Kennedy Galleries, New York

> Upwards unto the living light,
> Intensely thou dost gaze,
> As if thy very soul should seek,
> In that far distant maze,
> Communion with those heavenly forms,
> That, lifting to the sight
> Their golden wings and snowy robes
> Float in a sea of light . . .
> How strangely have the swift hours flown,
> As o'er the shapeless pile
> I poured the strength of my full soul,
> Lost to all else the while.
> When fell the last faint stroke which told
> That thou and I must part,
> That all of life that I could give
> Was thine, how throbbed my heart! . . .
> Thou who was kind and good and great,
> Thy task on earth is done
> Of those that walked in beauty's light
> Thou wast the chosen one.

In the 1850s Thomas Ball brought back to Boston from Italy a statuette of Allston, seated in his robes and with contemplative gaze. Allston had given the young artist much encouragement and earned his almost filial reverence; in Ball's early years his ambitions were toward painting rather than sculpture. His statuette, now unlocated, was sufficiently admired in Boston in 1863, at the time of the Sanitary Fair exhibition, that it was proposed to reproduce the work in a permanent material as a memorial to the deceased master.[112]

Allston's funeral was held on the evening of July 10, 1843, with a sermon delivered at the Allston home by the Reverend John Adams Albro at 7:30. Allston's body was borne in a torchlight procession, the flames carried by students from his Alma Mater, Harvard University, slowly to the Cambridge Burying Ground, and to the Dana family vault where the artist was to be buried. His interment occurred

about 8:30, with church services read by Dr. Vinton of St. Paul's Church, Boston, when the darkening clouds opened up and, according to Jared Flagg, moonlight streamed down. Colleagues and friends such as Henry Dexter, and the Danas, Walter Channing, Lemuel Shaw, Joseph Story, and Charles Sumner were among the impressive group assembled for the final farewell to the great artist. Later, Sumner attempted to raise $2,000 for a fitting memorial to Allston in Mt. Auburn Cemetery, but the artist's widow was opposed to it. A week after Allston's death, the Reverend Albro delivered a sermon, "The Blessedness of those Who Die in the Lord," in the Church of the Shepard Society, Cambridge, a sermon later published and dedicated to Martha Allston. John Braham composed a mournful dirge on "The Burial of Allston," with words by Hannah F. Gould. Poetic tributes also abounded, not the least of which were sonnets written by William Wetmore Story.

Allston's many unfinished works, his drawings and sketches and *Belshazzar's Feast,* continued to be held by his widow, although, in fact, the artist had drawn heavily upon the funds invested in the Allston Trust, the trustees of which technically held ownership of the last-named work. In 1854 she deposited them at the Boston Athenaeum; at her death, in 1862, care of the collection passed to her nephew, Richard Henry Dana II, and her niece, Charlotte Dana. The latter arranged for the collection, together with works inherited by the Dana family, to be deposited with the Museum of Fine Arts in Boston in 1876. After that institution was established and for many years subsequently some of Allston's paintings hung in its rooms and corridors. Meanwhile, the funds remaining in the Allston Trust accrued, and Richard Henry Dana III was able, in 1908, to acquire Allston's *Uriel* from England; he also added the artist's *Rebecca at the Well,* the early portrait of Coleridge, and the early self-portrait. Finally, in 1956, the collection in the hands of the Allston Trust was dispersed to eight public collections.

Tributes to Allston and plans to perpetuate his memory abounded in the years after his death. In New York, in 1847, the American Art-Union issued a medal designed and modeled by Peter Paul Duggan, the dies engraved by Charles Cushing Wright. Fifty copies in silver and two hundred and fifty in bronze were distributed, and a further unspecified bronze edition was distributed in later years. Another plan to perpetuate Allston's memory and enshrine his genius was devised by Stephen Perkins and Franklin Dexter: the publication of the engravings and lithographs of the finest of Allston's drawings and sketches found in his studio after his death; these were published by Perkins under the title *Outlines and Sketches* in 1850. The task was entrusted to two of the finest engravers in Boston, the brothers Seth and John Cheney, who had known and admired Allston and had received encouragement from him. They were engaged on the project during 1848 and 1849, faithfully reproducing the works, even repeating some idiosyncratic double-outline treatment found in some of the drawings. These engravings presented to the American public works otherwise unknown for the most part: Allston's *Uriel* and individual figures from his *Jacob's Dream* (the latter still in a British private collection), and compositions he had left unfinished or had destroyed, preserving only the preliminary outlines. Not surprisingly, perhaps, the German Nazarene painter Peter von Cornelius praised *Outlines and Sketches* highly. Yet, the sale of the very beautiful volume was disappointing, and the plates themselves were destroyed in

the great Boston fire of 1872. In 1850 also appeared Allston's *Lectures on Art and Poems,* edited by Richard Henry Dana, Jr., which included a statement of Allston's aesthetic and philosophy. Allston had intended the lectures as a series of public discourses, but he did not live to complete or deliver them.

The question of Allston's influence upon the development of American painting after his death is one that has often been ignored or dismissed, despite frequent acknowledgment of his premier position in American culture in his own time and the encouragement he appears to have given to all who sought his advice. Art historians have perceived, in part quite correctly, that at the time of Allston's death, the American aesthetic was shifting radically from a European derivation, both old master and contemporary, to a nativist emphasis; from idealism to realism; and from an elitist belief in the superiority of the special genius to a democratic thesis that art was for and of the masses. For all the veneration offered to Allston, it was not he but William Sidney Mount who would have been acknowledged the most significant painter of the 1840s by many American patrons, critics, and writers of the time.

Yet, the tremendous growth of historical and literary painting in America in the 1840s and 1850s was undoubtedly influenced by Allston, not only by his personal example but also by his artistic achievement. Since the late nineteenth century, however, art historians and public and private collectors, too, have tended to consign the works of this period to at least temporary oblivion and even to ignore their creation and existence. The historical and literary art of these middle decades took a direction more consonant with the ideals of the new generation, more populist and nationalist. (Emanuel Leutze's *Washington Crossing the Delaware* of 1851 was a painting expressing these new ideals that received the highest recognition by critics and historians, but many other works of this kind were created.) Yet, even as democratic an organization as the American Art-Union in New York actually still honored the belief in the superiority of historical art as a nation's greatest cultural achievement, as attested by the prices they were willing to pay for paintings and the engravings they distributed to their entire membership. Although Allston played a seminal role in establishing the validity of historical painting in America, its full development began only about the time of his death.

The influence of Allston's later investigation of the theme of figure painting, divorced from anecdote and even for the most part from incident, is more difficult to assess since the development of this theme was more tentative at this time. In any event, it can be considered only one of several factors involved in the pictorial investigation of this hitherto ignored area of thematic exploration in America. Certainly, the opportunity to use depictions of figures as graphic embellishments in the extremely popular annuals, or gift books, which were valued for their aesthetic appeal, was an incentive to produce such paintings, and, indeed, engravings after them were often made for this purpose. And European figure paintings, of which American artists (including the Anglo-Americans Leslie and Newton) were becoming increasingly aware, must have provided further inspiration. Finally, the genteel and refined nature of such imagery coincided with and reflected the growing (real or imaginary) cultural refinement in the new nation.

The artists who followed Allston in the production of occasional figure paintings here were often portrait specialists and thus conversant with the painting of the figure; often, in fact, these figure paintings were based upon quite specific portrait images. In New York Charles Cromwell Ingham produced a number of much-praised figure paintings, particularly *The White Plume,* exhibited in 1828, *Black Plume,* and *Flower Girl* of 1846. His contemporary and near-namesake Henry Inman painted his "fancy piece" *Lady with a Mask,* around 1841, and Daniel Huntington (student of Henry Inman and Samuel Morse) based his *White Plume* upon the image of Inman's daughter, Mary; it was exhibited at the Pennsylvania Academy in 1847 but was probably painted six years earlier.

Robert Weir's *Rebecca* of 1835 and *Bianca* of 1836 are more directly inspired by literature—by works of Sir Walter Scott and Washington Irving, respectively—but these small, full-length images of lovely ladies stand independently and are closer in conception and even in stylistic manner to figural images by Allston such as the *Spanish Girl* (no. 63). The ideal figural pieces of Philadelphia's premier portraitist, Thomas Sully, are usually ignored in discussions of his art, but he painted over six hundred of these. Many were copies of European figure paintings, but others were original works. It is significant that Sully's interest in painting ideal images of the female figure began in earnest when Allston's works of this kind were being championed by writers reviewing his Harding Gallery exhibition of 1839. That year Sully painted his *Gipsy Girl;* in 1840 he produced his best-known figure painting, *The Spanish Mantilla.* Later images include his 1846 *Contemplation, The Student* of 1848, *Brunette* of 1850, and the *Chip Girl* and *Lady and Fan,* both of 1856. The possibilities and the appeal of such figural "fancy pieces" carried to the thriving midwestern city of St. Louis, where George Caleb Bingham painted *The Dull Story* in 1843-44, a (literally!) dreamy image of fair loveliness.

More specifically, however, Allston's influence was immediately felt among the younger artists in New England, another aspect that later art historians have tended to ignore. One might, in fact, propose a regional distinction in American art at mid-century, with Boston assuming and continuing an elitist, aristocratic role and upholding the principles of Allston. This may, in fact, account for the relatively late and apathetic appeal of the more democratic Art-Union movement there, in contrast to its strength in New York City as well as in Philadelphia, Cincinnati, and even Newark, New Jersey!

Allston's art appealed to the cultivated; it was an art that presupposed classical learning, familiarity with the Bible, and literature. One of the strongest supporters of his ideals was his friend and patron Franklin Dexter, who wrote in the *North American Review* of the growing influence of John Ruskin in the 1840s as a threat to the development of American art. Oliver Wendell Holmes was also a champion of Allston who condemned democratic, nativist standards in that same magazine in 1840. Henry Greenough (the writer brother of Allston's friends and colleagues Horatio and John Greenough), in his roman à clef of 1858, *Ernest Carroll,* wrote that in the opinion of American partisans of Reynolds's doctrines, John Ruskin was a "sophistical lawyer." James Jackson Jarves acknowledged in 1863 that he had previously considered Allston's reputation to be based upon local friendship or Boston partisanship, but that he had come to realize the vitality of his idealism, and

that to him alone of American painters could one apply "the term *genius,* as it is spoken of the chief of the old masters."[113]

For the younger painters of the mid-nineteenth century, it was Allston's color that provided inspiration. William Ware wrote in 1852 of Allston's "grand, distinguishing" characteristic: "that which, at once, raises him, not only above our own artists, but I am equally clear, above all others, certainly of the present day, is *Color*. He was great in many ways, but greatest there." And a generation later, Samuel Benjamin distinguished the Boston school as the finest one for color.

Color, for Allston and his followers, however, was distinct from painterliness. He upheld the traditions of Reynolds in insisting upon proper finish, which disguised the artistic means, rather than the romantic method of Delacroix, in which painterly brushwork was united with rich colorism. From a technical point of view, this is one of the difficulties of accepting Allston as a romantic artist. Asher B. Durand, in his "Letters on Landscape Painting," in 1855, described, with approval, Allston's position:

> All the best artists have shown that the greatest achievement in the producing of fine color, is the concealment of pigments, and not the parade of them; and we may say the same of execution. The less apparent the means and manner of the artist, the more directly will his work appeal to the understanding and the feelings. I shall never forget the reply of Allston to some friends who were praising a very young student in Art for great cleverness, especially in the *freedom* of his execution. 'Ah,' said he, 'that is what we are trying all our lives to get rid of.' With that he opened a closet, and brought out a study of a head that he had painted from life, when a young man, at one sitting, and placed it beside a finished work on his easel, at which we had been looking: 'There,' said he, 'that is freely painted.' No other comment was required; in the one, paint and the brush attracted attention, in the other, neither was visible, nothing but the glow of light and color which told its truth to Nature—and thus it is with the works of all the greatest colorists.

Among the young artists to come under Allston's influence was that other American painter to gain the appellation of "the American Titian," William Page. Although Page criticized Allston for his imperfect knowledge of color in his articles "The Art of the Use of Color in Imitation of Painting" of 1845, he still concluded: "it will be apparent that he more nearly approached that which I have endeavored to set forth, than most of the other painters about."

Both Thomas Ball and Henry Kirke Brown, as mentioned, came under Allston's influence during their early years before they turned to sculpture. Ball acknowledged in 1884 that in the late 1840s in Boston, he and his fellow art students "were strongly after Allston's color." He thought that the effect of George Fuller's admiration for Allston at the time could be traced in all his works; and Joseph Ames was another who was "striving after Allston's methods." And Ball concluded, "Let me here remark that we shall never have another Joe Ames or George Fuller till some of our young artists learn to appreciate Allston as highly as they did." The following advice was sent by Henry Kirke Brown to Fuller from Rome in 1844: "Study Allston's pictures wherever you find them, for his best are nowhere surpassed."[114]

Benjamin Champney, too, in Boston, in his *Sixty Years' Memories of Art and Artists*, recalled the admiration of Ball, Fuller, and Ames for Allston's works when they were first beginning, and in his view, too, no modern colorist had shown more "feeling for harmonious color than Allston." Champney expressed his regret that Allston did not live to complete his *Belshazzar's Feast;* "but even in its unfinished state," he wrote, "some parts of it are almost equal to Titian in beauty of color."

It is not surprising, therefore, that the esteem for Allston penetrated to younger artists in Boston who had never known the great man. This was touchingly acknowledged in the formation of the Allston Club there in 1866, a short-lived but significant organization under the leadership of William Morris Hunt, who was considered to be Allston's successor as the doyen of art in Boston. Boston was actually not the first city to make such acknowledgment; the Allston Association was founded in Baltimore in 1859, having as its purpose the "reproduction of the aims and acts of the great artist whose name it bears." Clarence Cook, in his obituary of Hunt written for the *New York Tribune*, September 9, 1879, coupled Hunt with Allston: "the name of each" he wrote, "will long be dear to those who cherish with some jealousy the slow beginnings of our culture; for everything that remains to us from the hand of either of these masters shows the artist—deeply in love with his art; not thinking of it as a means to an end, but joying in it as in life itself; and with the unconsciousness of nature with her stars and clouds, holding up to us in this work-a-day world of care and cumber the bright ideal of a time when the things of the intellect and the soul shall have fairer play."

In a number of Hunt's more intimate figural works, the relationship to Allston is touchingly apparent. Hunt's *The Lost Profile* (fig. 68), of about 1856, bears a startling similarity in method and sentiment to the "original" component of Allston's *The Sisters.* In 1879 Hunt's biographer and pupil Helen M. Knowlton published her *Hints for Pupils in Drawing and Painting,* in which she described in detail Allston's methods of painting. The young John La Farge also acknowledged the admiration for Allston that had been passed on to him by Hunt. In July 1869 he wrote to the collector and dealer Samuel Avery from Newport, advising him to see as many works by Allston in Boston as he possibly could. "There are a couple owned by the Elliotts which are lovely," he informed Avery, "one a landscape another a female head and then the Lorenzo and Jessica owned by the Jacksons—Both the families have moved from their former residences. . . . Perhaps the Lorenzo and Jessica may be at the Athenaeum this year. I heard that it was to be sent there. Another Allston, 'The Valentine' I saw at Mr. Ticknor's—it is less valuable."[115] Allston was certainly not forgotten by his New England artistic progeny.

Immediately after Allston's death, his brother-in-law, Richard Henry Dana, planned a biography in tribute to Allston, a work upon which he labored for many years, but which, unhappily, he never completed. Jared Flagg's biography of 1892 was a final attempt to bring forth that volume, although Dana's grandson, Henry Wadsworth Longfellow Dana, Jr., was still working with the original Dana material well into the twentieth century. Nevertheless, the elder Dana performed an extremely useful service by entering into correspondence with all who knew Allston, gathering from them their recollections of the artist. From the many tributes he culled much useful biographical and artistic information. Yet the sentiments of the

Fig. 68. WILLIAM MORRIS HUNT, American, 1824-1879
Lost Profile, ca. 1856
Oil on panel
Private Collection

often remarkable individuals who so loved and admired Washington Allston may finally be the most compelling reason for our own continued interest in the man and his art, for if they found such value in his company, such beauty in his paintings, and such inspiration in his thoughts, cannot we, a later generation, still profitably share in that inspiration? And would we not be the less were we deprived of or blind to the beauty of his art? Perhaps the significance of Washington Allston for his age—and for ours also—was best summed up by Horatio Greenough in a letter to Dana written from Austria in September 1844: "Alston [sic] is the head the chief—the Adam of American Idealists. He is the first of that noble Spartan band— sure to fall because the hosts of the Persians are overwhelming, but sure to carry with them to the ground whereon they fall not only the sense but the proof of having acted the noblest part that God grants to a man, that of sacrificing body to mind—expediency to right—fact to truth—now to hereafter."[116]

NOTES

1. William A. Coffin, "The Columbian Exposition, III," *Nation,* August 17, 1893, p. 116.

2. Jared B. Flagg, *The Life and Letters of Washington Allston* (New York, 1892; reprint ed., New York, 1969), is still indispensable for a study of Allston. The Allston bibliography, in terms of books, monographs, articles, exhibition catalogue essays and references, unpublished dissertations, and incidental but still significant references, is enormous, and we have attempted but certainly not achieved comprehensiveness in the bibliography included with this catalogue. Frequent references will be made to William Ware, *Lectures on the Work and Genius of Washington Allston* (Boston, 1852); Moses Foster Sweetser, *Allston* (Boston, 1879); and Edgar P. Richardson, *Washington Allston: A Study of the Romantic Artist in America* (Chicago, 1948). One of the important sources of manuscript material on Allston's life and career is the collection of Dana papers at the Massachusetts Historical Society. This collection includes the memorial letters of reminiscence and tribute accumulated by the elder Richard Henry Dana, the biographical reminiscences written by Allston's Harvard schoolmate and longtime friend, Leonard Jarvis, and Dana's own biographical notes. The files of Henry Wadsworth Longfellow Dana, deposited at the Longfellow National Historic Site, in Cambridge, Massachusetts, constitute the other major source of material relating to Allston: Dana's research notes, a photographic archive, and a large portion of Allston's library. Much of the remainder of the library is deposited at Houghton Library, Harvard University. Other Allston correspondence frequently consulted and referred to in this essay is deposited at the Boston Public Library, Houghton Library, the New-York Historical Society, the Historical Society of Pennsylvania, among the Vanderlyn papers at the Senate House State Historic Site in Kingston, New York, and among the Morse papers at the Library of Congress. The bibliography included in this volume was compiled by Chad Mandeles and is a tribute to his diligence and perceptivity.

3. Mariana Van Rensselaer, "Washington Allston," *Magazine of Art* 12 (April 1889), 145-150.

4. Emily Farnham, *Charles Demuth: Behind a Laughing Mask* (Norman, Oklahoma, 1970), pp. 22, 23.

5. James Branch Cabell, "The Way of Ecben," in *The Witch-Woman: A Trilogy about Her* (New York, 1948), p. 107.

6. The most complete discussion of the Allston genealogy is found in Joseph A. Groves, *The Alstons and Allstons of North and South Carolina* (Atlanta, 1901). See also Henry Wadsworth Longfellow Dana, "Allston at Harvard 1796-1800," Cambridge Historical Society, *Publications 29, Proceedings for the Year 1943*.

7. On Samuel King see William B. Stevens, "Samuel King of Newport," *Antiques* 96 (November 1969), 729-733; Vals Osborne, "The Influence of Copley on Pre-Revolutionary New England Portraiture: A Reconsideration of the Artists of the Period," Master's thesis, Hunter College, 1978.

8. William Dunlap, *A History of the Rise and Progress of the Arts of Design in the United States* (1834; reprint ed., New York, 1965), vol. 2, p. 28. On Malbone and his relationship to Allston, see Ruel P. Tolman, *The Life and Works of Edward Greene Malbone, 1777-1807* (New York, 1958).

9. One of the most interesting treatments of Allston's early years can be found in Anna L. Snelling, "The Artists of America: Washington Allston," *Photographic Art-Journal*, May 1851, pp. 295-299.

10. See *Catalogue of Paintings, Marbles and Casts in the Collection of R. W. Gibbes, M.D.* (Columbia, S. C., n.d.); Rodger Stroup, "Up-County Patrons: Wade Hampton II and His Family," *Art in the Lives of South Carolinians: Nineteenth-Century Chapters,* Book I (Charleston, 1978), with references to the Gibbes collection; this volume and its companion provide extensive references to the continuing antebellum South Carolinian interest in and patronage of the state's most illustrious native artist.

11. On John Johnston see the two-part article by Frederick W. Coburn, "The Johnstons of Boston," *Art in America* 21 (December 1932), 27-36; ibid. (October 1933), 132-138. For pastel painting, see Theodore Bolton, *Early American Portrait Draughtsmen in Crayons* (New York, 1923).

12. The manuscripts of Allston's youthful compositions written while at Harvard can be found in the archives at the Pusey Library, Harvard University.

13. *Apollo* 105 (May 1977), 56, advertisement.

14. Wouvermans's paintings, for instance, were frequently exhibited at the Boston Athenaeum, beginning with its earliest art show of 1827; see Mabel Munson Swan, *The Athenaeum Gallery 1827-1873* (Boston, 1940). The cumulative index of the Athenaeum's art exhibitions will be published shortly, and information on the appearance of paintings of specific subjects and by specific artists, foreign and American, will be of much easier access. I would like to express extreme gratitude to William Gavin of the Athenaeum for making available the pertinent information on Allston's exhibition record at the Athenaeum. H. Nichols B. Clarke, who is currently preparing a dissertation for the University of Delaware on Dutch paintings in America, has also been most generous in sharing his information and bringing pertinent material to my attention.

15. See Marcia R. Pointon, *Milton and English Art* (Toronto, 1970). Dr. Pointon's study, which is extremely brilliant and perceptive, omits discussion of Allston, although one of his major works, *Uriel*, was Milton-derived and painted in England. Dr. Pointon has been most generous in sharing considerations of Allston and British history painting of the early nineteenth century.

16. The literature on West's life and career is enormous and is still increasing. Most pertinent to this discussion and to West's relationship to Allston are Jerry Don Meyer, "The Religious Paintings of Benjamin West: A Study in Late Eighteenth and Early Nineteenth Century Mural Sentiment," Ph.D. dissertation, New York University, 1973; John Dillenberger, *Benjamin West: The Context of His Life's Work with Particular Attention to Paintings with Religious Subject Matter* (San Antonio, 1977).

17. Paul R. Weidner, ed. "The Journal of John Blake White," *South Carolina Historical and Genealogical Magazine* 42-43 (1941-42). These memoirs appeared in six consecutive issues of this publication.

18. The Vanderhorst family papers, which are deposited in the Bristol City Archives, in the Council House, include correspondence by and concerning Allston.

19. See Roger Anthony Welchans, "The Art Theories of Washington Allston and William Morris Hunt," Ph.D. dissertation, Case Western Reserve University, 1970. In a long and quite complete Appendix, Welchans deals with Allston's two periods of residence in England and the paintings done there and attributed to his English years. In 1974 I received a grant from the Paul Mellon Centre for Studies in British Art (London) Limited for the study of Allston's English career. At the time I was not aware of Dr. Welchans's work, since its pertinence was not readily apparent from the title. Subsequently, I located a certain amount of additional material and two of Allston's hitherto lost paintings, the copy after Titian's *Adoration of the Magi* and the portrait of *Dr. John King*, but this material only amplified Dr. Welchans's findings. I would like to express my appreciation at this time to Christopher White, Ellis Waterhouse, and Jules Prown of the Mellon Centres for their aid and encouragement.

20. *The North Carolina Portrait Index, 1700-1860*, compiled for the National Society of the Colonial Dames of America in the State of North Carolina (Chapel Hill, 1963), p. 219.

21. See Young Men's Association, Troy, *Catalogue of the Loan Exhibition, Being One Hundred and Forty Ancient and Modern Oil Paintings, Loaned by the Hon. Thomas B. Carroll for the Benefit of the Association* (Troy, N.Y., 1878): "Addenda #141. Washington Allston. *John Kemble.* (After Sir Thos. Lawrence)."

22. See Vanderlyn's letter concerning Allston and their friendship published in the Charleston, South Carolina, *Courier*, July 15, 1855. The Senate House State Historic Site in Kingston, New York, has an extensive collection of Vanderlyn correspondence with much material from and about Allston. I am extremely grateful to James A. Ryan and Mallory Newman of the Senate House for their cooperation and to Mary Jo Viola for her initial study of the Vanderlyn manuscript material relating to Allston references.

23. See Henry Greenough, "Washington Allston as a Painter. Unpublished Reminiscences of Henry Greenough," *Scribner's Magazine* 11 (February 1892). Greenough wrote a *roman à clef* on artist life in Italy entitled *Ernest Carroll* (Boston, 1858), which included Allston only thinly disguised.

24. For the analysis of Turner's paintings and the relationship of Allston's art to that of Turner, here and in later years, I am extremely indebted to the studies by and discussions with Marcia Wallace, who is currently preparing a doctoral dissertation on the influence of Turner upon American landscape painting. Ms. Wallace has prepared a study of Allston's indebtedness to Turner. Her master's thesis, prepared for Hunter College, is summarized in "J. M. W. Turner's Circular, Octagonal, and Square Paintings, 1840-1846," *Arts Magazine* 53 (April 1979), 107-117. A still earlier term paper, "Turner's Sources in English Painting," deals directly with the development that led to the aesthetic upon which Allston based his *Rising of a Thunderstorm at Sea*.

25. Washington Irving's important essay on Allston is in the New York Public Library, Manuscripts Division.

26. Richard C. McCormick, *St. Paul's to St. Sophia, or Sketchings in Europe* (Boston, 1860), p. 260.

27. Louise Hunt Averill, "John Vanderlyn, American Painter," Ph.D. dissertation, Yale University, 1949, remains the basic study of Vanderlyn to date. It documents Vanderlyn's progress through Italy (pp. 66-67), quoting from Robert Gosman's unpublished manuscript "Biographical Sketch of John Vanderlyn, Artist," two manuscript versions of which are deposited with the New-York Historical Society.

28. Kathleen Coburn, "Notes on Washington Allston from the Unpublished Notebooks of S. T. Coleridge," *Gazette des Beaux-Arts* 25 (April 1944), 249-252.

29. Averill, "John Vanderlyn," p. 68 and footnote.

30. Much of the material in this essay relating to Allston's Roman years has been previously published in my article "Washington Allston and the German Romantic Classicists in Rome," *Art Quarterly* 32 (summer 1969), 166-196.

31. A new and definitive study of Wallis is currently being undertaken by Colin J. Bailey; see his "The English Poussin—An Introduction to the Life and Work of George Augustus Wallis," Walker Art Gallery, Liverpool, *Annual Report and Bulletin* 6 (1975-76), 35-54.

32. Benjamin Rowland, Jr., "Diana in the Chase by Washington Allston," Fogg Art Museum, *Annual Report*, 1955-56, pp. 48-49, 61.

33. Flagg, *Life and Letters of Allston*, p. 64.

34. See Albert Boime, *The Academy and French Painting in the Nineteenth Century* (London, 1971), for a thorough study of the academic methodology and the distinctions between the different kinds of preparatory drawings and studies.

35. A letter written to Vanderlyn by Allston from Leghorn, April 23, 1808, just prior to his departure from Italy, mentions Vanderlyn's "observations on the famous picture, which made such a noise, in report, at Rome"; this may well refer to Camuccini's *Death of Caesar*, now in the Museo Capodimonte, Naples. Allston's letter is in the New-York Historical Society.

36. This painting has been quite definitively analyzed by Henry H. Hawley, "Allston's Falstaff Enlisting his Ragged Regiment," *Wadsworth Atheneum Bulletin*, ser. 3, no. 3 (winter 1957), 13-16.

37. Archives of American Art.

38. See letter to Vanderlyn, cited in note 35. There is some confusion over the length of time the works were left in Leghorn. Allston referred to them as remaining in storage for seven years, but as he left Italy in 1808 and a number of the pictures he painted and stored there were on view in Bristol in 1814, there is some inconsistency. The "Veroneses" of Allston and Vanderlyn must have been shipped to London in the first half of 1814 or earlier.

39. See Walter K. Watkins, "The New England Museum and the Home of Art in Boston," The Bostonian Society, *Publications*, 2nd ser., 2 (1917), 103-130.

40. Elizabeth Palmer Peabody, *Reminiscences of Reverend William Ellery Channing, D.D.* (Boston, 1880).

41. Quoted in Flagg, *Life and Letters of Allston*, p. 327.

42. Barbara Novak, *American Painting of the Nineteenth Century: Realism, Idealism, and the American Experience* (New York, 1969), pp. 44-60, especially pp. 54-55.

43. James Jackson Jarves, *The Art-Idea* (1864; reprint ed., Cambridge, Mass., 1960), p. 174.

44. *Common-Place Book of Romantic Tales Consisting of Original and Select Pieces by the Most Eminent Authors* (New York, 1831), p. 237, "The Valentine. By the Author of Hobomok."

45. Allston to William Collins, April 16, 1819, published in William Wilkie Collins, *Memoirs of the Life of William Collins, Esq., R.A.* (London, 1848), vol. 1, p. 142.

46. "Letter of July 23, 1810 from Anna Cabot Lowell to Mrs. Anne Grant, of Leggan, Scotland," Massachusetts Historical Society, *Proceedings* ser. 2. 18 (May 1904), 314-315.

47. Meyer, "Religious Paintings of West," pp. 264-274.

48. Anna Wells Rutledge, "Dunlap Notes," *Art in America* 39 (February 1951), 43.

49. John Albee, *Henry Dexter, Sculptor: A Memorial* (Cambridge, Mass., 1898), pp. 57-59.

50. *Catalogue of W. Allston's Pictures, Exhibited at Merchant Tailors' Hall, Broad Street, Bristol, July 25th, 1814* (Bristol, 1814), pp. 2-3; *Exhibition at the Pennsylvania Academy of the Fine Arts, Mr. C. R. Leslie's Picture of the Murder of Rutland . . . and also of Mr. Allston's Celebrated Pictures, of the Dead Man Restored to Life, By Touching the Bones of the Prophet Elisha; and Donna Mencia In the Robbers Cave—From Gil Blas . . .*, October 1816 (Philadelphia, 1816), p. 3.

51. In her recent article "Washington Allston's *Dead Man Revived*," *Art Bulletin* 61 (March 1979), 78-79, Elizabeth Johns presents a complete and incisive history of the picture. Dr. Johns deals brilliantly with the beginnings of the British Institution and its role (including its limitations) in the patronage of history painting, discussing Allston's relationship to the organization and some of its principal directors. However, on certain points her opinion differs from mine: she estimates Allston's success as more qualified and considers Coleridge's emotional outbursts in defense of Allston and against West and others more reasonable than I do. She concludes that Allston's disappointment in regard to the *Dead Man Revived* (the title used by Richardson for this work) was the major factor in Allston's choice to return to America, where the picture had been acquired. Certainly, this would have contributed to his decision, but I feel that a good many other factors were involved.

52. *Collected Letters of Samuel Taylor Coleridge*, ed. Earl Leslie Griggs (Oxford, 1956-1971), vol. 3, p. 508; references to Coleridge's relationship with Allston and his comments and opinions concerning Allston's career vis-à-vis British patronage are found in the letters collected here.

53. According to a letter written to Mary Wordsworth of May 7, 1812. See *The Letters of William and Dorothy Wordsworth*, ed. Ernest de Selincourt (Oxford, 1937), vol. 2, p. 473; Martha H. Shackford, *Wordsworth's Interest in Painters and Pictures* (Wellesley, Mass., 1945), p. 33. I am grateful to Beth Darlington of the English Department of Vassar College, who has been studying the Wordsworth correspondence at the Wordsworth Library in Grasmere, England.

54. Flagg, *Life and Letters of Allston*, pp. 163, 165, 170, 268, 359-360; Allston was particularly rapturous concerning Haydon's painting in a letter to Thomas Sully of April 11, 1833. Allston's critical concern with Haydon's picture stemmed from its exhibition in America after it had been acquired by Cephas Childs and Henry Inman in September 1831. The work is now in St. Mary's Seminary in West Norwood, Ohio. Perhaps partly as a result of Allston's enthusiasm, Haydon was much heralded in this country. His painting was received as a masterwork by an artist who was recognized by some as the major British historical painter of his age. See Haydon's *Autobiography and Journals*, ed. Malcolm Elwin (London, 1950); Clarke Olney, *Benjamin Robert Haydon, Historical Painter* (Athens, 1952).

55. The careers of Allston and Morse in Bristol are best studied through Morse's *Letters and Journals*, ed. Edward Lind Morse (Boston. 1914). This period in their lives is further documented and interpreted by Samuel Irenaeus Prime, *Life of Samuel F. B. Morse, LL.D.* (New York, 1875). Paul Staiti has prepared a doctoral dissertation on Morse for the University of Pennsylvania and has been extremely helpful and generous in supplying information with regard to the relationship of the two artists.

56. A very thorough study of the artistic situation in Bristol is discussed in the catalogue City Art Gallery, Bristol, *The Bristol School of Artists* (1973). Francis Greenacre, who wrote the essays, has been most helpful in discussing the work of the Bristol artists and Allston's place in that milieu. Also of significance here is Eric Adams, *Francis Danby: Varieties of Poetic Landscape* (New Haven and London, 1973), chaps. 1 and 2, on Danby's years in Bristol. See in addition Trevor Fawcett, *The Rise of English Provincial Art* (Oxford, 1974).

57. D. E. Williams, *The Life and Correspondence of Sir Thomas Lawrence, Kt.* (London, 1831), vol. 2, p. 6

58. Letter from Allston in the Vanderhorst files in the City of Bristol Archives. Richard Henry Dana refers in his notes to a portrait of a lady painted in Bristol, "who was dressed out in the richest colours and bedecked [?] with jewels. He used to tell me how he revelled in Jewellry and velvets at that sitting." Dana, manuscript notes for a life of Allston, Massachusetts Historical Society.

59. "A Painter on Painting," *Harper's New Monthly Magazine*, February 1878, p. 460.

60. See Roger A. Welchans, "Washington Allston Portrait of Samuel Williams," *Bulletin of the Cleveland Museum of Art* 60 (January 1973), 4-8.

61. Reprinted in Coleridge's *Biographia Literaria*, ed. with his *Aesthetical Essays* by John Shawcross (Oxford, 1907).

62. Ticknor's comments can be found in his journal among the Ticknor papers, Dartmouth College Library, entry dated May 31, 1815, pp. 60-61; see also George Ticknor, *Life, Letters and Journals of George Ticknor*, 2 vols. (Boston, 1876). I am extremely grateful to Kenneth C. Cramer, archivist of the Dartmouth College Library, for his assistance here.

63. William Thomas Whitley, *Art in England, 1800-1820* (Cambridge, 1928), p. 255.

64. On Beaumont see the exhibition catalogue Leicester Museum and Art Gallery, *Sir George Beaumont of Coleorton, Leicestershire* (1973); *Memorials of Coleorton,* ed. William Knight, 2 vols. (Boston, 1887).

65. Patricia M. Burnham prepared an excellent study of this painting for "Selected Topics in American Art: Washington Allston," seminar conducted by the Museum of Fine Arts, Boston, and the Graduate Center of the City University of New York, 1978. I am indebted to her research for much of the material presented here.

66. *Lectures on Art and Poems* (1850; republished, Gainesville, Fla., 1967), pp. 61ff.

67. Beaumont to Wordsworth, April 17, 1816, typescript of letter at Longfellow House, Cambridge, Mass. Beaumont's more adulatory comments to Allston are in Flagg, *Life and Letters of Allston*, p. 92.

68. So indicated in the catalogue *American Paintings in the Museum of Fine Arts, Boston* (1969), where the "Art Treasures Exhibition" is dated incorrectly as 1856. In the catalogue of the "Art Treasures Exhibition," the Allston is not listed. Not infrequently, though, works of art were added to such shows after the printing of the official catalogue, and the Beaumont descendants might well have urged the exhibition of the painting if they were hoping to sell it on an international market.

69. I am extremely indebted to Robin Hamlyn for information on Charles Robert Leslie and Leslie's relationship to and comments upon Allston. Mr. Hamlyn is preparing a doctoral dissertation on Leslie for the University of Birmingham, England.

70. Julia Ward Howe, *Reminiscences, 1819-1899* (Boston, 1899), pp. 429-430.

71. Pierre M. Irving, *The Life and Letters of Washington Irving* (New York, 1862-1864), vol. 1, pp. 360-362, 405-406.

72. Ben Harris McClary, ed., *Washington Irving and the House of Murray* (Knoxville, 1969), pp. xxv, xxix-xxxi, 14.

73. Anna Brownell Jameson, "Washington Allston," *Athenaeum* (London), January 6, 1844, pp. 15-16; January 13, 1844, pp. 39-41.

74. Leslie to his sister, London, May 12, 1812, in Charles Robert Leslie, *Autobiographical Recollections* (Boston, 1860), p. 177.

75. Coleridge to Allston, June 29, 1817, Houghton Library, Harvard University; Ralph Waldo Emerson, *English Traits* (Boston, 1856), pp. 19-20; *The Journals and Miscellaneous Notebooks of Ralph Waldo Emerson,* ed. Alfred R. Ferguson (Cambridge, Mass., 1964), vol. 4, p. 411; Michael Kennedy Joseph, "Charles Aders," *Auckland Universtiy College Bulletin,* no. 43, English ser. no. 6, 1953, p. 5; James Fenimore Cooper, *Gleanings in Europe* (New York, 1930), vol. 2, pp. 332-333. Allston's copy of Veronese's *The Adoration of the Magi,* lost for many years, was rediscovered in London by David Bindman.

76. William G. Constable, *Art Collecting in the United States of America* (London and New York, 1964), p. 15. I am grateful to H. Nicholas B. Clarke for this reference.

77. I have not been able to determine the author of this poem; the derivation of Allston's painting is mentioned in the *Morning Herald* (London), February 2, 1818, and the *Examiner* (London), February 9, 1818.

78. This relationship was noted by Patricia Burnham, to whom I am much indebted for her many insights concerning Allston's religious imagery.

79. Keats's reaction to *Uriel* is mentioned in all the collections of his letters, including those edited by H. Buxton Forman (London, 1895), p. 91; Sidney Colvin (London, 1925), p. 76; Maurice Buxton Forman (London, 1952), p. 105; and Hyder Edward Rollins (Cambridge, 1958), vol. 1, p. 236. See also Ian Jack, *Keats and the Mirror of Art* (Oxford, 1967), p. 92.

80. For a discussion of the concept of the historical and poetic landscape in the early nineteenth century, see Kathleen Dukeley Nicholson, "J. M. W. Turner's Images of Antiquity, Classical Narrative, and Classical Landscape," Ph.D. dissertation, The University of Pennsylvania, 1977, especially chap. 3.

81. *Letters and Journals of James Fenimore Cooper,* ed. James F. Beard (Cambridge, Mass., 1960-1964), vol. 2, p. 397.

82. For the complete history of *Belshazzar's Feast,* see my two-part article "Allston's 'Belshazzar's Feast,' " *Art in America* 61 (1973), March-April, pp. 59-66, and May-June, pp. 58-65. The discussion of the painting in this essay is a shortened and slightly amended version of that article and appears here by permission of Art in America, Inc.

83. The bibliography concerning John Martin is substantial; the most recent and most complete treatment is by William Feaver, *The Art of John Martin* (Oxford, 1975), which deals quite extensively with Martin's relationship to

Allston, particularly, of course, in regard to their respective paintings of *Belshazzar's Feast,* pp. 49-51.

84. Johns, in her excellent article "Washington Allston's *Dead Man Revived,*" overstates the issue of the paucity of Allston's British patronage. It is true that the number of known English patrons is limited, but this is, in part at least, the insurmountable problem of the historical painter, working for months or even years on a single large canvas and thus creating an extremely limited oeuvre; the journals and biographies of Haydon offer ample proof of this and of the artist's recognition of the matter. Johns further distorts the facts somewhat, to strengthen her point, by suggesting that most of Allston's patrons in England were American. One could even argue whether Samuel Williams should be considered "American," given the length of his expatriation, but it is incorrect to refer to either Harmon Visger or Elias Vanderhorst as Americans; although both of them had American relatives, there is no indication that Vanderhorst ever set foot upon American soil, and Visger had been in England since before the turn of the century. Johns also states that Vanderhorst purchased only one picture from Allston's Bristol exhibition and then commissioned another landscape. In fact, he purchased three pictures from the show, and the landscape, the *Italian Landscape* of 1814, was one of Allston's most impressive works in that category.

85. The letters from Allston to Leslie and Collins written aboard the *Galen* are in the collection of the Massachusetts Historical Society.

86. I am grateful to Robin Mackworth-Young, the librarian at Windsor Castle, for providing me with photocopies of the entries relating to Allston in the typescript of the complete Farington Diary.

87. Allston's expression of his love for England is quoted by William Dunlap in his *Diary* and appears again in Elizabeth Palmer Peabody, "Allston the Painter," *American Monthly Magazine* 7 (May 1836), 441; a copy of the letter to Collins, dated April 16, 1819, is in the Dana Collection, Massachusetts Historical Society.

88. See Edward Everett's editorial on the engraving and the article by Nathaniel Langdon Frothingham on the painting *Saul and the Witch of Endor* in the *Bulletin of the New England Art Union,* no. 1 (1852), pp. 3-5.

89. Fuller's enthusiasm for Allston's art is discussed more fully later in this essay; it is documented in Josiah B. Millet, *George Fuller: His Life and Works* (Boston, 1886).

90. In a graduate course at the City University of New York, spring 1974, Bruce Weber prepared a paper on the "Similarities between Washington Allston and Horatio Greenough," which documents the extensive relationship be-

tween the two artists. Nathalia Wright also deals with this relationship in *Horatio Greenough, The First American Sculptor* (Philadelphia, 1963). Allston figures strongly in Greenough's correspondence; see the *Letters of Horatio Greenough, American Sculptor,* ed. Nathalia Wright (Madison, 1972), which complements *Letters of Horatio Greenough to His Brother, Henry Greenough,* ed. Frances Greenough (Boston, 1887).

91. See George Gibbs, *The Gibbs Family of Rhode Island and Some Related Families* (New York, 1933); Elizabeth Palmer Peabody, *Reminiscences of Reverend William Ellery Channing, D.D.* (Boston, 1880), pp. 332-333.

92. Allston's relationship with Stuart is most fully described by Mabel Munson Swan, *The Athenaeum Gallery 1827-1873: The Boston Athenaeum as an Early Patron of Art* (Boston, 1940), especially chap. 4, "The Stuart Benefit Exhibition," pp. 62ff.

93. See "Percival's Poem," *North American Review* 22 (April 1826).

94. Harding's Gallery, Boston, *Exhibition of Pictures, Painted by Washington Allston,* April 1-July 10, 1839. Among the most significant critical notices are the following: Margaret Fuller, "A Record of Impressions, Produced by the Exhibition of Mr. Allston's Pictures in the Summer of 1839," *Dial* 1 (July 1840), 73-84; Oliver Wendell Holmes, "Exhibition of Pictures Painted by Washington Allston at Harding's Gallery, School Street," *North American Review* 50 (April 1840), 358-381; J. Huntington, "The Allston Exhibition: A Letter to an American Traveling Abroad," *Knickerbocker* 14 (August 1839), 163-174; Elizabeth Palmer Peabody, "Exhibition of Allston's Paintings in Boston in 1839," in *Last Evening with Allston, and Other Papers* (Boston, 1886); William D. Ticknor, *Remarks on Allston's Paintings* (Boston, 1839).

95. This especially significant letter, detailing Allston's first several years back in Boston, is dated May 18, 1821, and is in the collection of the New-York Historical Society.

96. The John Quincy Adams papers are in the Massachusetts Historical Society; I am extremely grateful to Robin Hamlyn for bringing the Allston references contained therein to my attention. Adams spent a good deal of time with Allston and Leslie at this time, visiting Allston's studio and dining with him.

97. The most complete study of Allston's Cambridgeport years, with emphasis upon his house and studio, the numerous visitors, and Allston's later works, especially, the images of "dreamy women," can be found in Henry Wadsworth Longfellow Dana, "Allston in Cambridgeport," Cambridge Historical Society, *Publications* 29, *Proceedings for the Year 1943,* pp. 34-67. For the Durand-Reed refer-

ences, I am indebted to Dr. Wayne Craven, who is currently working on Asher B. Durand, and who kindly sent me the pertinent references from the Durand papers on deposit at the New York Public Library.

98. Once Anna Jameson had met Allston, she continued to write about him, not only in the above-mentioned memorial article in the *Athenaeum* and in a number of separate essays but also in her private letters to her mother and to her friend Ottilie von Goethe. See her *Memoirs and Essays Illustrative of Art, Literature and Social Morals* (London, 1846), and *Letters of Anna Jameson to Ottilie von Goethe,* ed. George Henry Needler (London, New York, and Toronto, 1939).

99. See Richardson, *Washington Allston,* p. 214, no. 157; Evan H. Turner, "Three Paintings by Washington Allston," *Wadsworth Atheneum Bulletin,* 2nd ser., no. 61 (January 1956), p. 1.

100. The paper prepared by Chad Mandels on *The Evening Hymn* for "Selected Topics in American Art: Washington Allston," seminar conducted by the Museum of Fine Arts, Boston, and the Graduate Center of the City University of New York, 1978, must constitute the definitive study of this picture. The results of his investigation of the relation of the painting to the theme of melancholy were presented at the Frick Symposium in New York, April 20, 1979, and will appear in *Arts Magazine* early in 1980.

101. Marcia Wallace, in connection with her study of the relationship of American landscape painting to the art of J. M. W. Turner, has examined this painting in depth. Many of my conclusions presented here are derived from conversations with Ms. Wallace and from her paper prepared for "Selected Topics in American Art: Washington Allston," seminar conducted by the Museum of Fine Arts, Boston, and the Graduate Center of the City University of New York, 1978. The results of her study will be incorporated into her doctoral dissertation for City University of New York. Ms. Wallace is pursuing the Washington Allston-Henry Pickering connection, which, judging from the correspondence preserved at the Massachusetts Historical Society and from Pickering's published poems, appears extremely strong.

102. Ednah Dow Cheney, *Gleanings in the Fields of Art* (Boston, 1881), p. 293. Ednah Cheney's estimate of Allston is a moving and touching one, yet quite sensitive to Allston's limitations as they were recognized almost forty years after the artist's death. She was the wife and sister-in-law of Seth and John Cheney, respectively, the two artists who prepared the prints for *Outlines and Sketches,* published in 1850, and she was therefore extremely knowledgeable concerning Boston art in general and Allston in particular. Her volumes on each of the Cheney brothers are important studies containing much valuable first-hand information on the artistic milieu in which Allston lived.

103. Sarah Clarke, "Our First Great Painter, and His Works," *Atlantic Monthly* 15 (February 1865). Sarah Clarke's tribute to Allston here is probably the most significant study of the artist to appear between William Ware's monograph, published in 1852, and the group of writings by Sweetser, Cheney, Van Rensselaer, and others that appeared at the time of the Allston exhibition in the new Museum of Fine Arts in Boston, in 1881.

104. See Charles Warren, "Why the Battle of New Orleans Was Not Painted," in his *Odd Byways in American History* (Cambridge, Mass., 1941), pp. 177-191.

105. Allston's extensive correspondence with Gulian Verplanck and Leonard Jarvis is to be found in the Dana papers at the Massachusetts Historical Society and the Verplanck papers at the New-York Historical Society; the congressional debates are recorded in the Journal of the House of Representatives and the Register of Debates. John Quincy Adams's opinions of the potentials of American artists can be found in his *Memoirs,* ed. Charles Francis Adams (Philadelphia, 1876). The Morse papers in the Library of Congress document Morse's efforts to obtain the commission and Allston's commiserations with his former pupil when these efforts proved unsuccessful. I am indebted to Paul Staiti for his assistance with the Morse material. Lillian B. Miller well documents and summarizes the attempt to enlist Allston in decorating the Capitol in her extremely important study *Patrons and Patriotism* (Chicago and London, 1966). See also the Jarvis correspondence published by George Davis Chase in the *New England Quarterly,* December 1943, and "Some Unpublished Correspondence of Washington Allston," *Scribner's Magazine* 1 (January 1892), 76-83. The Charleston commission is described in the Edward Everett papers at the Massachusetts Historical Society, Allston to Everett, May 1, 1883; Everett to Edward Dana, August 30, 1843; Everett to Charles Sumner, September 5, 1846.

106. See "On the Intellectual and Moral Relations of the Fine Arts," *Southern Literary Journal,* n.s. 1 (August 1837), 488-489; Anna Wells Rutledge, *Artists in the Life of Charleston, Transactions of the American Philosophical Society,* n.s., vol. 39, pt. 2 (Philadelphia, 1949), pp. 136, 143, citing references in the local newspapers, the *Courier, Mercury,* and *Southern Patriot.*

107. The history of *Spalatro* can be found in part in Robert Stockton, "R. F. W. Allston: Planter Patron," in *Art in the Lives of South Carolinians: Nineteenth-Century Chapters,* Book I, ed. David Moltke-Hansen (Charleston, 1978), pp. RSa-2-3.

108. The interest in Dadd has grown in recent years, and the literature on him is fairly extensive. For his fairy pictures, see the exhibition catalogue The Tate Gallery, London, *The Late Richard Dadd, 1817-1886,* with an essay by Patricia Aldredge (London, 1974). On the fairy pictures in general, see Christopher Neve, "But Are They Happy in Fairyland?" *Country Life,* December 23, 1971, pp. 1768-1770.

109. Eric Adams, *Francis Danby,* cat. nos. 131, 169.

110. George William Frederick Howard, 7th Earl of Carlisle, *Travels in America; The Poetry of Pope.* Two Lectures Delivered to the Leeds Mechanics' Institution and Literary Society, December 5th and 6th, 1850 (New York, 1851), p. 12.

111. Robert Stockton, "R. F. W. Allston," pp. RSa-3-4.

112. "W," "Boston," *Round Table,* December 26, 1863, p. 28.

113. James Jackson Jarves, "Art and Artists of America," *Christian Examiner* 75 (July 1863), 116-118.

114. Josiah Millet, ed., *George Fuller, His Life and Works* (Boston, 1886), pp. 18, 72-73. Allston's influence on Fuller was early recognized by William Howe Downes, "Boston Painters and Paintings II," *Atlantic Monthly* 62 (August 1888), 261.

115. *Brooklyn Museum Quarterly* 2 (April-October 1915), 283.

116. Flagg, *Life and Letters of Allston,* publishes this letter, pp. 380-382, as by an unknown American artist, but Nathalia Wright, *Letters of Horatio Greenough, American Sculptor* (Madison, 1972), correctly ascribes the letter to Greenough, pp. 348-350. The letter was written from Freiwaldau in Austrian Silesia, where, in 1844, Greenough and his wife had begun annual visits for hydrotherapy treatment under Vincent Priessnitz.

Checklist
of the
Paintings

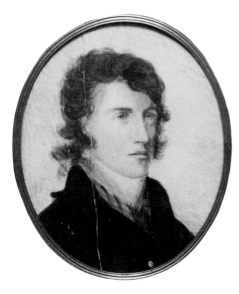

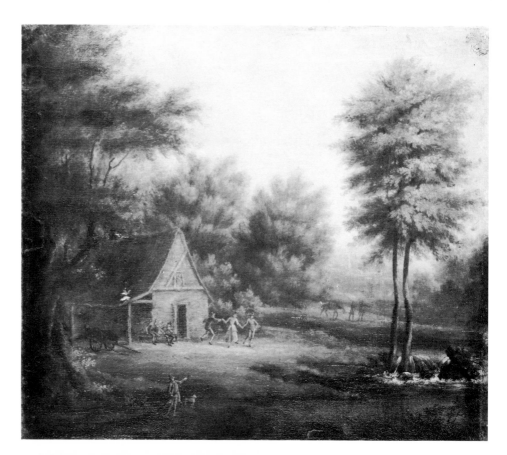

1
John Harris, 1796
Watercolor on ivory, 2¾ x 2½ in. (7 x
6.4 cm.)
Richardson 4
Museum of Fine Arts, Boston

2
Landscape with Rustic Festival, 1798
Oil on canvas, 11½ x 13⁷⁄₁₆ in. (29.2 x
34 cm.)
Richardson 10
Private Collection

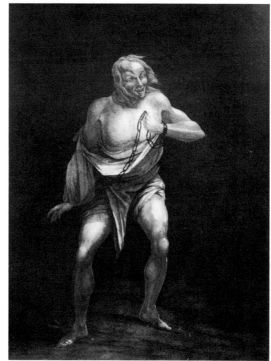

3
Tragic Figure in Chains, 1800
Oil on panel, 12⅜ x 9½ in. (31.4 x
24.1 cm.)
Richardson 18
Addison Gallery of American Art, Phillips
Academy, Andover, Massachusetts

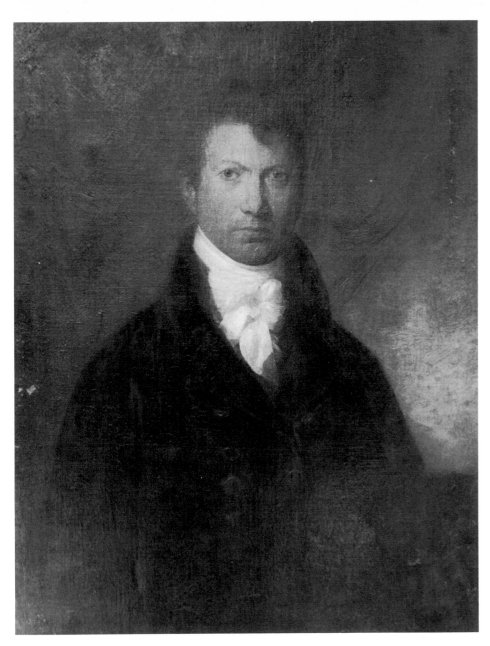

4
Matthias Spalding, 1801
Oil on canvas, 30 x 25 in. (76.2 x 63.5 cm.)
Private Collection

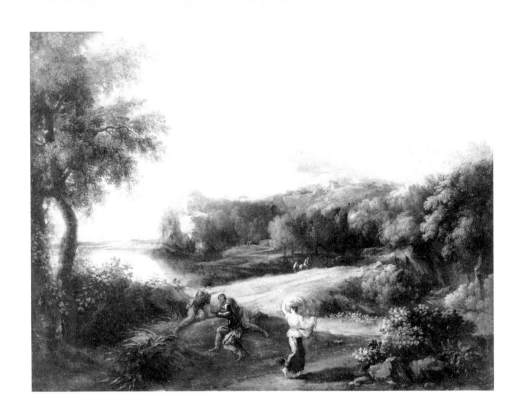

5
Romantic Landscape, ca. 1803
Oil on canvas, 33 x 42 in. (83.8 x 106.7 cm.)
Richardson 32
Anonymous Loan

6
Cupid, 1804, after Rubens
Oil on canvas, 38 x 30¾ in. (96.5 x
78.1 cm.)
Richardson 35
Vassar College Art Gallery, Poughkeepsie,
New York, Gift of the Allston Trust

7
Rising of a Thunderstorm at Sea, 1804
(see color plate, p. 34)

177

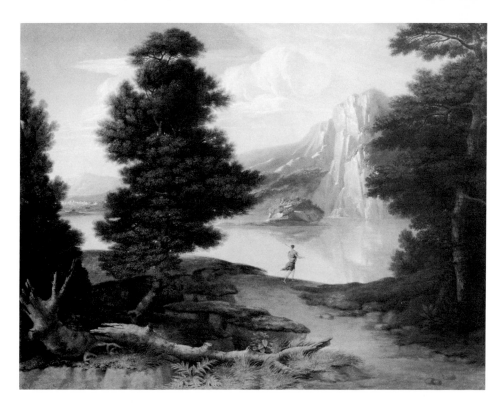

8
Landscape with a Lake, 1804
Oil on canvas, 38 x 51¼ in. (96.5 x
130.2 cm.)
Richardson 36
Museum of Fine Arts, Boston, M. and M.
Karolik Collection

9
David Playing before Saul, ca. 1805
Oil on canvas, 15⅛ x 18⅛ in. (38.5 x
46 cm.)
Richardson 43
Carolina Art Association, Gibbes Art
Gallery, Charleston, South Carolina

10
Moses and the Serpent, ca. 1805
Oil on canvas, 15⅛ x 18⅛ in. (38.5 x
46 cm.)
Richardson 44
Carolina Art Association, Gibbes Art
Gallery, Charleston, South Carolina

11
Diana and Her Nymphs in the Chase, 1805
(see color plate, p. 36)

12
Italian Landscape, ca. 1805
(see color plate, p. 37)

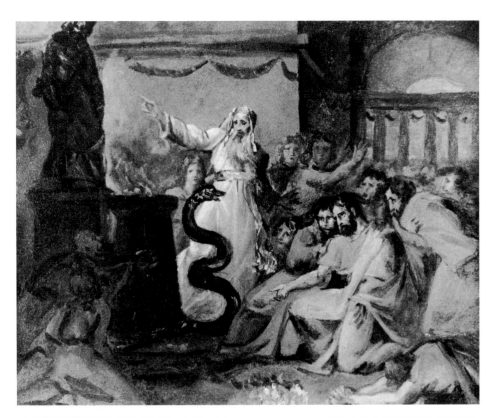

14
Morning in Italy, ca. 1805-1808
Oil on canvas, 17¼ x 21 in. (43.8 x 53.3 cm.)
Richardson 93 (?)
Shelburne Museum, Shelburne, Vermont

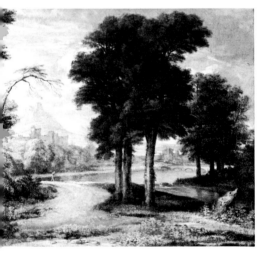

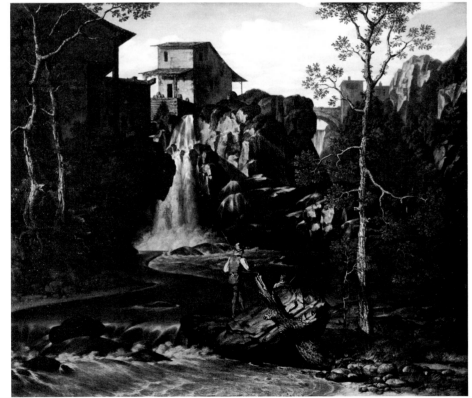

13
Italian Landscape, ca. 1805
Oil on canvas, 26 x 30½ in. (66 x 77.5 cm.)
Richardson 59 (?)
The Baltimore Museum of Art, Gift of Mrs.
William Bliss

15
Self-Portrait, 1805
(see color plate, p. 40)

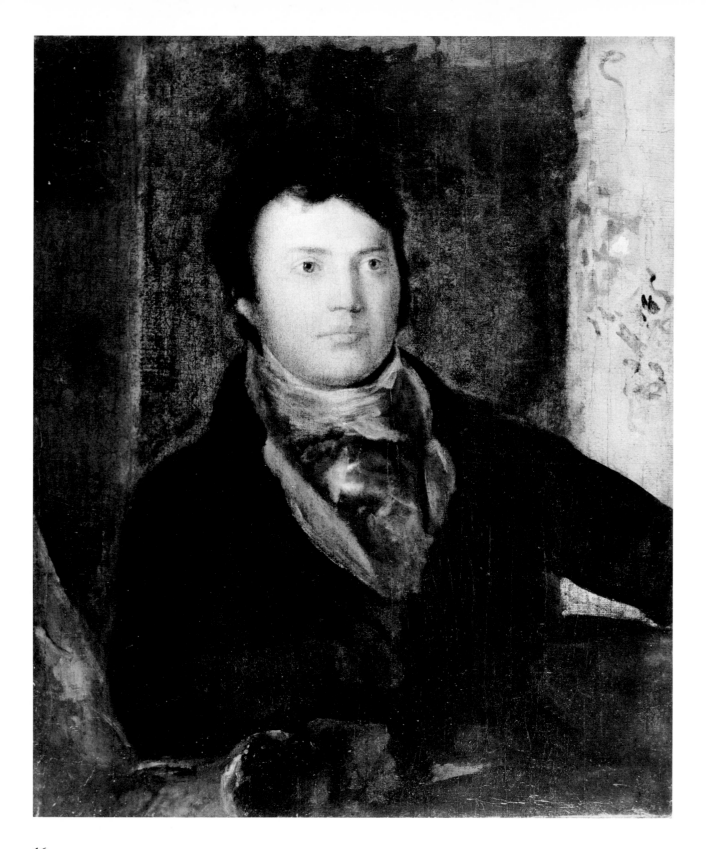

16
Portrait of Samuel Taylor Coleridge, 1806
Oil on canvas, 29½ x 24⅝ in. (74.9 x 62.5 cm.)
Richardson 40
Fogg Art Museum, Harvard University, The Washington Allston Trust

17
Jason Returning to Demand His Father's Kingdom, ca. 1807-08
Black crayon on paper mounted on canvas, 34¾ x 44 in. (88.3 x 111.8 cm.)
Richardson 85
Fogg Art Museum, Harvard University, The Washington Allston Trust

18
Casket Scene from "The Merchant of Venice," 1807
Oil on canvas, 19¾ x 24 in. (50.3 x 61 cm.)
Richardson 47
Library of the Boston Athenaeum

19
Francis Dana Channing, 1808-09
(see color plate, p. 41)

20
William Ellery Channing, 1811
Oil on canvas, 31 x 27½ in. (78.7 x 69.8 cm.)
Richardson 65
Museum of Fine Arts, Boston, Gift of William Francis Channing

21
Ann Channing Allston, 1809-1811
Oil on canvas, 17½ x 15¾ in.
(44.5 x 40 cm.)
Richardson 64
Henry Channing Rivers

22
The Valentine, 1809-1811
(see color plate, p. 44)

23
Coast Scene on the Mediterranean, 1811
Oil on canvas, 34 x 40 in. (86.4 x 101.6 cm.)
Richardson 61
Columbia Museums of Art and Science,
Columbia, South Carolina

24
The Poor Author and the Rich Bookseller, 1811
Oil on canvas, 31 x 28 in. (78.7 x 71.7 cm.)
Richardson 62
Museum of Fine Arts, Boston, Bequest of Charles Sprague Sargent

25
*The Dead Man Restored to Life by Touching
the Bones of the Prophet Elisha*, 1811-1814
(shown in Philadelphia only)
(see color plate, p. 48)

26
Dido and Anna, 1813-1815
(see color plate, p. 45)

27
Study for the Head of St. Peter in Prison,
1814-1815
Oil on millboard, 26 x 23½ in.
(66 x 59.7 cm.)
Richardson 72
Eleanor A. Bliss

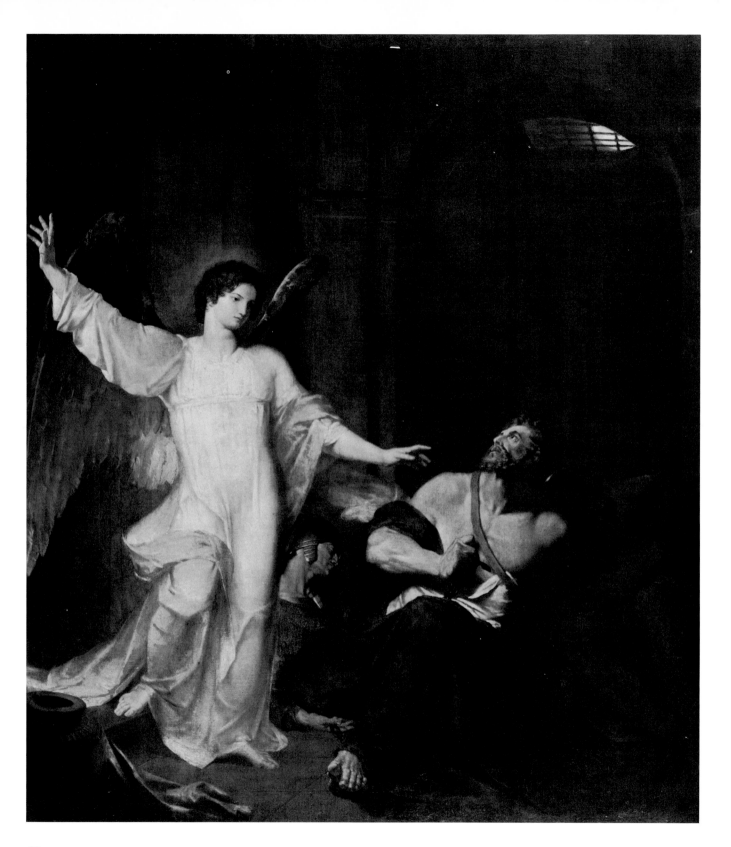

28
The Angel Releasing St. Peter from Prison, 1814-1816
Oil on canvas, 124½ x 108½ in. (316.2 x 275.6 cm.)
Richardson 70
Museum of Fine Arts, Boston, Gift of Robert William Hooper
(shown in Boston only)

29
Christ Healing the Sick, 1813
Oil on millboard, 28¾ x 40⁵⁄₁₆ in.
(73 x 102.3 cm.)
Richardson 75
Worcester Art Museum, Worcester,
Massachusetts

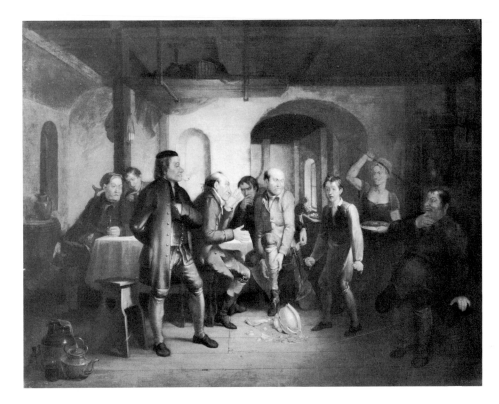

30
A Scene in an Eating House, 1813
Oil on canvas, 27⅞ x 36 in. (70.8 x 91.4 cm.)
Richardson 77
Layton Art Collection, Milwaukee Art
Center

31
Italian Landscape, 1814
(see color plate, p. 66)

32
Samuel Taylor Coleridge, 1814
(see color plate, p. 70)

33
Dr. John King of Clifton, 1814
Oil on canvas, 44½ x 34 in. (113 x 86.4 cm.)
Richardson 83
The Fine Arts Museums of San Francisco, Gift of Mr. and Mrs. John D. Rockefeller 3rd

34
Benjamin West
1814, the head; 1837, the background and drapery
Oil on canvas, 30⅜ x 25¼ in. (77.3 x 64 cm.)
Richardson 82
Library of the Boston Athenaeum

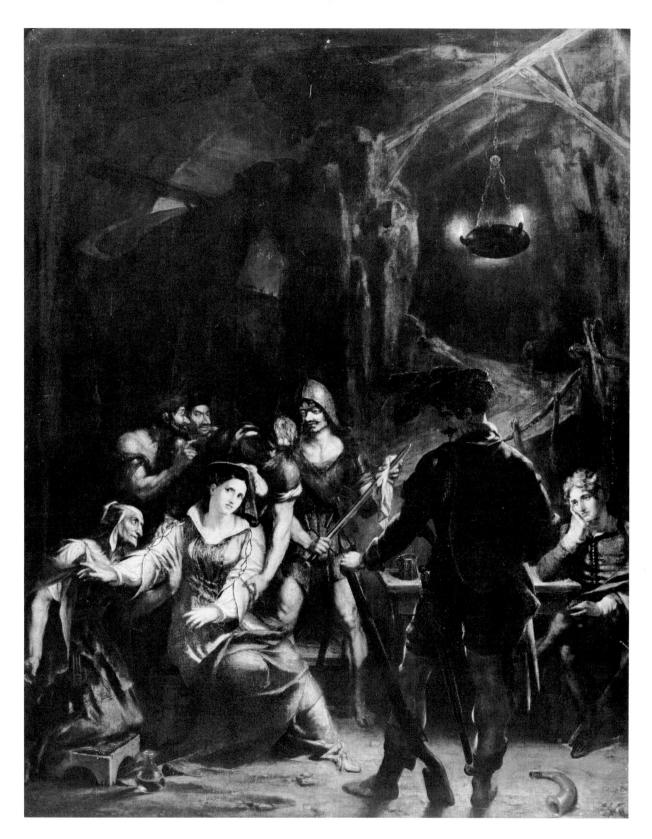

35
Donna Mencia in the Robbers' Cavern, 1815
Oil on canvas, 56 x 43½ in. (142.3 x 110.5 cm.)
Richardson 90
Museum of Fine Arts, Boston, M. and M. Karolik Collection

36
Rebecca at the Well, 1816
(see color plate, p. 74)

37
The Sisters, ca. 1816-17
(see color plate, p. 75)

38
Contemplation, ca. 1817-18
Oil on canvas, 26 x 27¾ in. (66 x 70.5 cm.)
Richardson 113A
Lord Egremont, Petworth House, Sussex,
England

40
Marriage at Cana, 1817, after Veronese
Oil on paper glued to linen, 21¼ x 27½ in.
(54 x 69.9 cm.)
Richardson 103
Mugar Memorial Library, Boston University

39
Jacob's Dream, 1817
Oil on canvas, 62 x 94 in.
(157.5 x 238.8 cm.)
Richardson 105
The National Trust, England

41
Uriel in the Sun, 1817
(see color plate, p. 78)

42
Study for "Belshazzar's Feast" ("first
study"), 1817
Oil on millboard, 25 x 34 in.
(63.5 x 86.4 cm.)
Richardson 101 (recto)
Fogg Art Museum, Harvard University, The
Washington Allston Trust

43
Study for "Belshazzar's Feast" ("color
study"), 1817
Oil on millboard, 25½ x 34¼ in.
(64.8 x 87 cm.)
Richardson 102
Museum of Fine Arts, Boston, Bequest of
Ruth Charlotte Dana

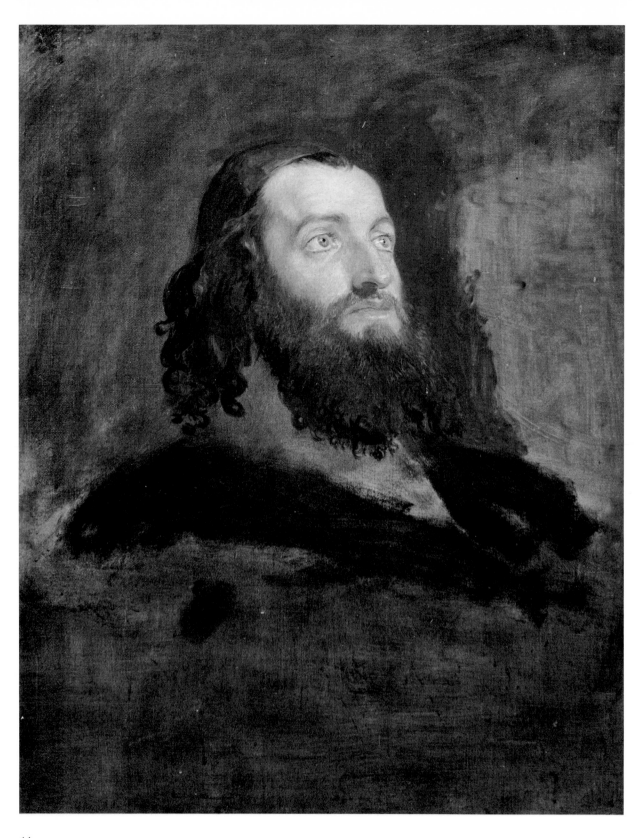

44
Head of a Jew, 1817
Oil on canvas, 30¼ x 25¼ in. (76.8 x 64.1 cm.)
Richardson 96
Museum of Fine Arts, Boston, Gift of Henry Copley Greene

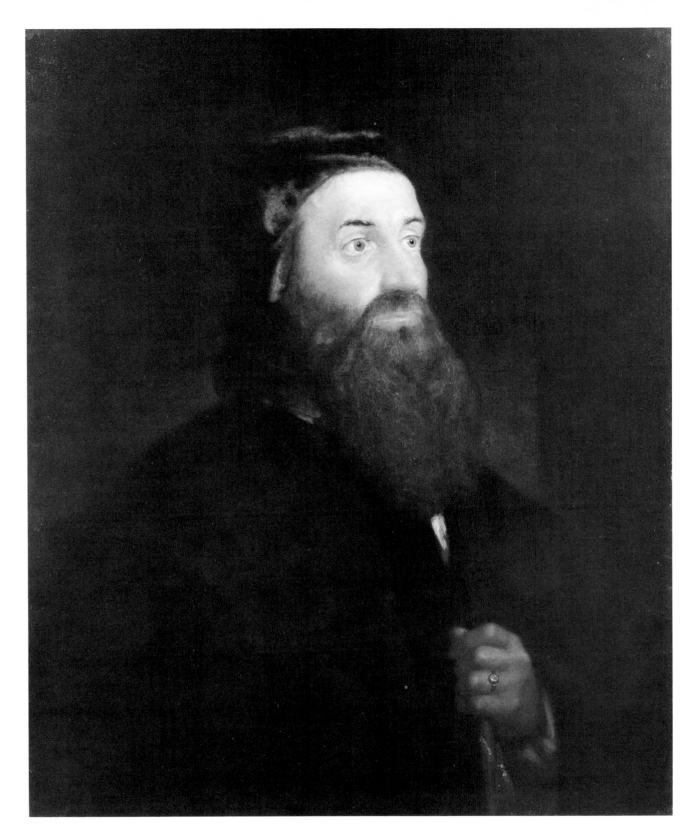

45
Head of a Jew, 1817
Oil on canvas, 30 x 25 in. (76.2 x 63.5 cm.)
Richardson 95
Hirschl and Alder Galleries, New York

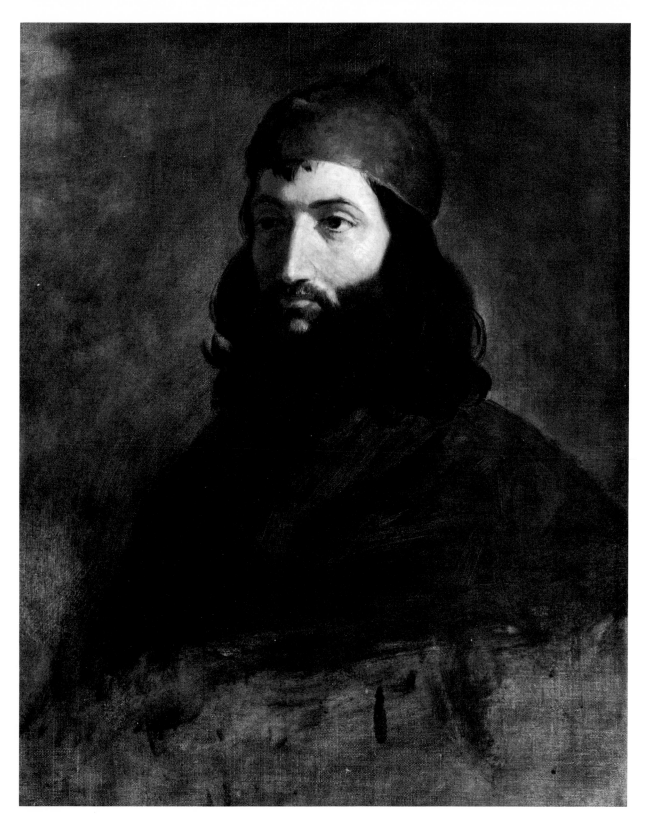

46
Sketch of a Polish Jew, 1817
Oil on canvas, 30¼ x 25¼ in. (76.8 x 64.1 cm.)
Richardson 97
Corcoran Gallery of Art, Washington, D.C.

47
Isaac of York, 1817
(see color plate, p. 79)

48
Samuel Williams, ca. 1817
(see color plate, p. 71)

49
Elijah in the Desert, 1817-18
(see color plate, p. 67)

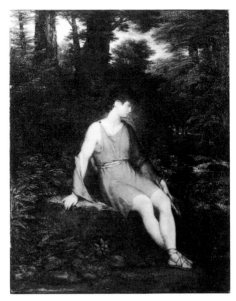

50
Italian Shepherd Boy, 1819
Oil on canvas, 21 x 17 in. (33.3 x 43.2 cm.)
Richardson 121
The Detroit Institute of Arts, Gift of D. M.
Ferry, Jr.

51
Italian Shepherd Boy, ca. 1819
Oil on canvas, 47½ x 34⅛ in. (120.7 x
86.7 cm.)
Richardson 128
The Brooklyn Museum, The Dick S.
Ramsay Fund

52
The Flight of Florimell, 1819
(see color plate, p. 116)

53
Beatrice, ca. 1816-1819
(see color plate, p. 117)

54
Moonlit Landscape (Moonlight), 1819
(see color plate, p. 113)

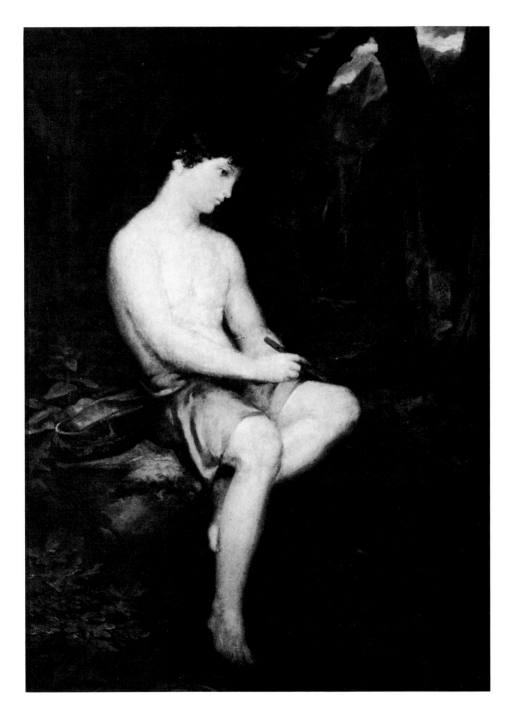

55
Landscape, Time after Sunset, ca. 1819
Oil on canvas, 18 x 25½ in. (45.7 x
64.8 cm.)
Richardson 118
Corcoran Gallery of Art, Washington, D.C.

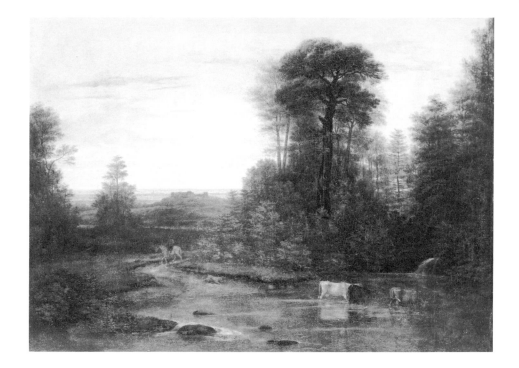

58
*Jeremiah Dictating His Prophecy of the
Destruction of Jerusalem to Baruch the
Scribe,* 1820
(see color plate, p. 120)

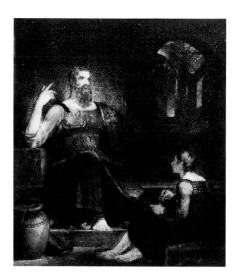

57
*Jeremiah Dictating His Prophecy of the
Destruction of Jerusalem to Baruch the
Scribe* (study), ca. 1820
Oil on millboard, 18⅜ x 16 in. (46.7 x
40.6 cm.)
Richardson 123
Yale University Art Gallery, Director's
Purchase

59
*Study of a Foot for "Saul and the Witch of
Endor,"* ca. 1820
Oil on millboard, 16 x 23¾ in. (40.6 x
60.3 cm.)
Richardson 193
The Lowe Art Museum, University of
Miami, Florida

56
Study of the Head of Jeremiah, 1819
Oil on wood, 22⅜ x 19¾ in. (56.8 x
50.2 cm.)
Richardson 124
The Sisterhood of St. Mary and Hirschl &
Adler Galleries, New York

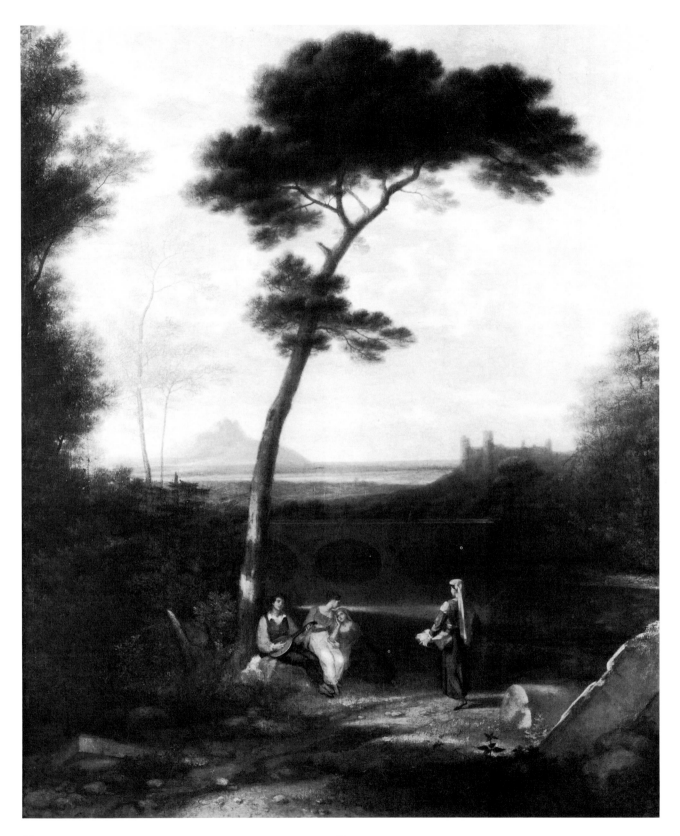

60
Saul and the Witch of Endor, ca. 1820
(see color plate, p. 121)

61
Landscape, Evening (Classical Landscape), 1821
(see color plate, p. 124)

62
Italian Landscape, ca. 1828-1830
Oil on canvas, 30¼ x 25¼ in. (76.8 x 64.1 cm.)
Richardson 133
The Detroit Institute of Arts, Founders Society Purchase, D. M. Ferry, Jr., Fund

63
The Spanish Girl in Reverie, 1831
(see color plate, p. 125)

64
Lorenzo and Jessica, 1832
Oil on millboard, 15 x 18 in. (38.1 x
45.7 cm.)
Richardson 138
Elizabeth von Wentzel

65
Girl in Persian Costume (A Troubadour), ca. 1832
Oil on linen, 35 x 27¼ in. (88.9 x 69.2 cm.)
Richardson 157
Wadsworth Atheneum, Hartford, Gift from the
existing Trustee of the Allston Trust

66
Evening Hymn, 1835
(see color plate, p. 128)

67
Rosalie, 1835
Oil on canvas, 38½ x 28⅝ in. (97.8 x 72.7 cm.)
Richardson 144
Society for the Preservation of New England Antiquities, Boston

68
The Death of King John, 1837
Oil on millboard, 28 x 37¾ in. (71.1 x
95.9 cm.)
Richardson 149
Wadsworth Atheneum, Hartford,
Connecticut, Gift from the existing Trustee
of the Allston Trust

69
Heliodorus Driven from the Temple,
ca. 1830s
Chalk on canvas, 44¾ x 56¾ in. (113.7 x
144.1 cm.)
Richardson 156
The Lowe Art Museum, University of
Miami, Florida

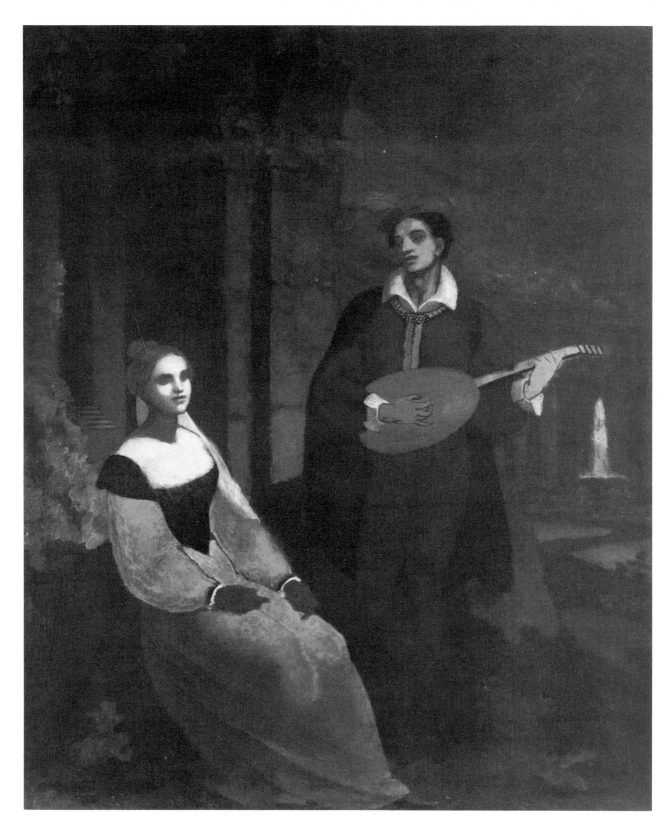

70
Lover Playing a Lute, ca. 1830s
Oil on canvas, 30⅜ x 25 in. (77.2 x 63.5 cm.)
Richardson 185
Mugar Memorial Library, Boston University

MENSURATION

less will be the probability of error.

Exam.

Given the side AB = 59.6 rods, & the
angle BAC = 71° & ABC = 19°. required AC.

As radius 90° = 10
Is to the sine of B = 19 = 9.5126419
So is the distance AB 59.6 = 1.7752442
To AC 19.4 = 1.2878881

Problem. IV.

To find the height of an inaccessible object.

Rule. Take two stations which shall be upon the same
plane with the object to be measured. At each station
take the angles which the horizontal line makes with
the visual rays at the vertex of the object & measure
the stationary distance. Example

71
*Mensuration: Drawing to Illustrate a
Geometry Problem (IV),* ca. 1796–1800
Brown ink on cream paper, 9 7/16 x 7 5/16 in. (23.8 x 18.1 cm.)
Fogg Art Museum, Harvard University, The Washington Allston Trust

The Drawings
of
Washington Allston

By Theodore E. Stebbins, Jr.

A YEAR BEFORE HIS DEATH Washington Allston lamented, in a letter to a friend, "Perhaps no artist has been more careless than myself of his sketches, the greater part having been lost, destroyed, given away, or otherwise disposed of years ago. I have often of late regretted that I took not better care of them."[1] About three hundred of Allston's drawings survive,[2] and even without the artist's corroboration, one would guess from their random nature that these represent only a fraction of his graphic oeuvre. There is a handful of juvenile works, and another representing Allston's early years of academic study in London and Rome. However, most of the drawings are preparatory studies of varying kinds for paintings, ranging from quickly conceived compositional ideas and sketchbook sheets to highly worked figurative studies of groups, individual heads, even hands, legs, and ears. The drawings date from the earliest college years to the end of his career, they make use of almost every possible drawing medium—including charcoal, colored chalks, pen, pencil, and watercolor—and stylistically they are varied and complex.

Even with the limited evidence of the surviving work, one comes inevitably to see Allston as the most complete draftsman of his time: his drawings have a wider range and show greater competence than those of any American before him, and they stand up to the work of all but a few of his contemporaries internationally. He followed exactly the prescriptions of Sir Joshua Reynolds: "When they [the most eminent painters of the past] conceived a subject they first made a variety of sketches; then a finished drawing of the whole; after that a more correct drawing of every separate part,—head, hands, feet, and pieces of drapery."[3]

Apparently Allston drew from early childhood; "I remember," he wrote, "that I used to draw before I left Carolina, at six years of age." In Newport, as a boy, he drew more methodically, copying prints and the like; titles included *The Siege of Toulon* (watercolor), *The Storming of Count Roderick's Castle* (pen and ink), and "three drawings of log huts and blockhouses." By the time Allston reached Harvard College in 1796, he was already a practiced draftsman and watercolorist. The earliest works known today are three finished watercolors entitled *The Buck's Progress* (figs. 69-71), each signed and dated November 10, 1796, which were first published by Henry Wadsworth Longfellow Dana in 1948[4] but have since disappeared from sight. These are caricatures in the general manner of Hogarth, with both title and subject making obvious reference to Hogarth's *The Rake's Progress,* the series of eight paintings that became widely known through his engravings of 1735. Number 1 in Allston's series, *The Introduction of a Country Lad to a Club of Town Bucks* (fig. 69) shows the country lad being drawn by one member into a room where the other "bucks" are drinking at a table. Here, in the most carefully executed of the series, the artist has taken great pains with the drawing and spatial perspective

Fig. 69. *The Buck's Progress: The Introduction of a Country Lad to a Club of Town Bucks,* 1796
Watercolor on paper, dated November 10, 1796, 9½ x 11⅝ in. (24.1 x 29.5 cm.). Richardson 1
Location unknown

of the room itself, of the slab table and country-Chippendale chairs, and especially with the depiction of the eight figures around the table. Each of their faces is distinguished from the others in attitude and physiognomy as the artist concentrates on each individual's reaction to the newcomer. The central figure rises from his chair in a courtly way, raising his glass, while the fop beside him leans back drunkenly, his long dark curls askew. The faces are increasingly caricatured and oafish as one proceeds around the table counter-clockwise, to the two slouching inebriates in the foreground.

This watercolor foretells many of Allston's lifelong concerns: it is, in fact, a study of a group of figures within a complex perspective system, and though successful in many ways, it fails to relate the three main groups in terms of scale, the foreground figures, for example, appearing much smaller than the standing ones behind them. Here one recalls Allston's eternal difficulties with perspective, particularly, of course, in the painting of *Belshazzar's Feast* (see fig. 45, above); it was one of the most devastating moments of his life when Stuart pointed out to him in 1820 that the architectural perspective of the great work was unconvincing, thus bringing about his never-ending efforts to correct and to complete the painting. In addition, this early watercolor has as its real subject the reactions of people to an *event*, albeit a less dramatic event than Daniel's prophecy or the revival of the dead man (see no. 25). Nonetheless, here there is an orchestration of individual reactions with concomitant facial and bodily expressions that characterized Allston's mature work and suggests that by this time he had already read LeBrun, Hogarth, and Burke. Finally, one sees in this drawing an obviously autobiographical statement (Allston as country boy from the South, entering that very year the sophisticated urban world of Harvard College and of Boston society—the "Club of Town Bucks"), precursor to the subtler personal and psychic component that can be found in drawings and paintings throughout his career.

The second in Allston's series was called *A Beau in His Dressing Room* (fig. 70). The young man is seated and pours himself a drink while being waited upon by a tailor, a shoemaker, and two barbers. He has evidently now adopted the values of his new companions. As his dress improves so his debauchery grows, as evidenced by the empty bottle and glasses on the floor. Allston's final work in the series (fig. 71) shows the newly attired lad and his cronies involved in a midnight brawl with the town watchmen, drawing a Hogarthian moral (seduction by the Town Bucks leads to ill behavior and possible arrest) and suggesting something also of the artist's own carefree lifestyle while at Harvard.

Direct comparisons with Hogarth can be made for each of Allston's watercolors. The first, *The Introduction of a Country Lad,* is closest to Hogarth's large illustration of 1725/26 for Samuel Butler's *Hudibras* entitled *The Committee,* where the Puritans seated at a square table look up in various attitudes of anger and dismay. The second, *A Beau in His Dressing Room,* alone of Allston's set, refers directly to one of Hogarth's *Rake's Progress* engravings, in this case to Plate 1, *The Young Heir Takes Possession of the Miser's Effects* (fig. 72), which shows him being measured by a tailor; and Allston's work may also have been partly inspired by a print from Hogarth's *Marriage-à-la-Mode* entitled *The Countess's Levee,* wherein the countess's hair is being dressed. It is more difficult to link the third of Allston's

Fig. 70. *The Buck's Progress: A Beau in His Dressing Room,* 1796
Watercolor on paper, dated November 10, 1796, 9½ x 11⅝ in. (24.1 x 29.5 cm.). Richardson 2
Location unknown

Fig. 71. *The Buck's Progress: A Midnight Fray,* 1796
Watercolor on paper, dated November 10, 1796, 9½ x 11⅝ in. (24.1 x 29.5 cm.). Richardson 3
Location unknown

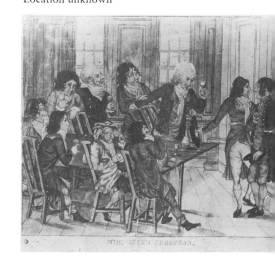

watercolors, *A Midnight Fray,* to a direct source, but in the weapons and postures it relates to several of Hogarth's small illustrations for *Hudibras,* including *Hudibras Encountering Talgol and Magnano.* The important point here is that, although Allston learned a great deal from the work of a master, as he would many times again, he was no copyist, and each of his watercolors became an original and wholly personal conception.

There exist no American parallels to these juvenile efforts of Allston. Although Hogarth had American admirers and imitators who were active by the 1760s, as one sees, for example, in Paul Revere's print *A View of the Year 1765,* their work was almost exclusively politically inspired. An edition of John Trumbull's mock epic *M'Fingal,* illustrated by Elkanah Tisdall, appeared in 1795, marking the beginning of nonpolitical humorous illustration in this country.[5] In comparison, Allston's watercolors were more sophisticated and more closely related to the English tradition of Hogarth and Rowlandson; and in retrospect, their production is simply astonishing.

Allston sketched frequently during his college years, filling his letters with cartoons and caricatures, drawing friends, teachers, and illustrious figures. Only a few sheets survive from what must have been many, but they are enough to suggest the artist's graphic touch and his keen wit. Allston's classmates were frequent subjects, and on one occasion he composed a rather finished sheet now at the Huntington Library (fig. 73), containing thirty-four heads and three fuller figures, each numbered for identification (his class included forty-seven men at graduation). Surely his inspiration again was Hogarth, particularly in the satiric prints such as *Characters and Caricatures* of 1743.

Flagg noted Allston's proclivity to draw: "When resting after the composition of a sentence, his pen would often be employed in sketching a head or figure upon the same paper." And he remarked "even his mathematical manuscripts . . . have the

Fig. 72. WILLIAM HOGARTH, English, 1697-1764
The Rake's Progress: Plate 1, *The Young Heir
Takes Possession of the Miser's Effects,* 1735
Engraving, dated June 25, 1735, 12⅝ x 15¼ in.
(31.2 x 38.6 cm.)
Museum of Fine Arts, Boston

Fig. 73. *Caricature Heads,* ca. 1798-99
Pencil touched with ink, 11 x 17 in. (28 x
43.2 cm.)
Huntington Library and Art Gallery, San
Marino, California

marks of his pencil, which he sometimes suffered to run riot in caricature."[6] What the author undoubtedly had in mind here were the pen and ink drawings Allston made in his mathematics notebook: four of these survive, each giving a graphic illustration of a geometry problem. Allston carefully entitled each one "MENSURATION" and stated the particular problem. Problem VI, for example, was "To find the height of an accessible object from a rising ground" (see fig. 74). Problem IV was "To find the height [crossed out—he meant "distance"] of an inaccessible object" (no. 71). Giving the mathematical rule, he established an example and solved it accurately. However, his greatest pains were taken in depicting the inaccessible object, here a keg of "double French proof" seen across the river with a man dancing upon it, and labeled "A political argument supported on spirited grounds!" A notebook from the same class, prepared by Allston's classmate Joshua Bates, survives in the Harvard Library and offers an interesting comparison, for Bates worked with equal care (and greater mathematical abilities) and also made a drawing to illustrate the problem. However, his is simple and schematic and depicts the measurement of a tree (the inaccessible object), again seen across a river. Allston's style in the "Mensuration" drawings still recalls Hogarth's in a general way, but in its careful hatching, lack of exaggeration and overall effectiveness, it compares most closely with the prints of the later English caricaturist James Gillray (1757-1815).

During his freshman year, Allston lived with Professor Benjamin Waterhouse, and the young artist was employed in making a number of "Illustrations for Dr. Waterhouse's Essays"; these were "used to make clear certain points in the doctor's treatises and letters which he was sending to various scientists abroad."[7] He also began to experiment with pastel, making portraits of members of the Waterhouse family and other friends; he gained little facility with this very difficult medium and apparently never took it up again.[8] His humor and graphic talents were combined in producing an ongoing series of watercolor sketches on the window panes of his rented room during the following years, and he continued to experiment with wash and watercolor in more serious ways as well, as recorded in the sophisticated landscape composition at the Gibbes Art Gallery, Charleston (no. 72).

Another kind of illustration is seen in the three small ink and wash drawings that Allston made at about this time. In one of these oval compositions, the artist has depicted a hunter with a long rifle in a wooded landscape, with a two-rail fence and a rather large (English or French) mansion in the distance. Another shows a frail wooden footbridge over a stream, with young trees at each side. The third (no. 73), most carefully executed, illustrates an old man dressed in a flowing robe and holding a staff, dozing against a rock; a barren landscape stretches into the distance, while minutely drawn tree branches and leaves reach out over his head. The second of these vignettes bears an inscription in another hand: "7th stanza of verses in Spring/Corydon and Phillida/Allston July 10, 1799/, Harvard"; and the third bears a poem on the verso that has been crossed out. Thus, they are doubtless poetic illustrations, and done so painstakingly that Allston surely meant them for a publisher. They must date either from the end of Allston's third year at college, if the inscription is correct, or within the following year or two. One inevitably thinks of these drawings in recalling Flagg's statement that the artist, on arriving in Lon-

Fig. 74. *Mensuration, Problem VI,* ca. 1797-1799 Ink on paper, 9⁵⁄₁₆ x 7⅜ in. (23.2 x 18.3 cm.) Fogg Art Museum, Harvard University, The Washington Allston Trust

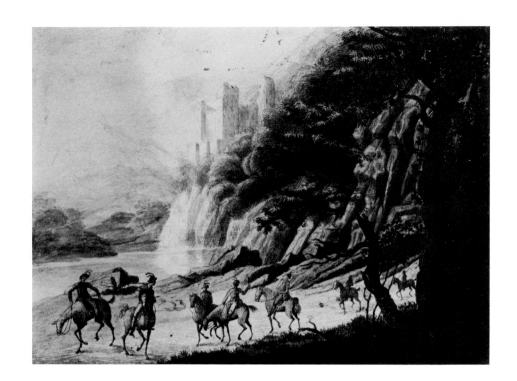

72
Landscape with Horsemen, ca. 1799
Sepia wash drawing, 6¾ x 6¾ in. (17.2 x 17.2 cm.)
Carolina Art Association, Gibbes Art Gallery, Charleston, South Carolina

73
Old Man Resting against a Rock,
ca. 1799-1800
Black ink and wash on paper, oval composition, 4¾ x 7⁵⁄₁₆ in. (12.4 x 10.8 cm.)
Fogg Art Museum, Harvard University, The Washington Allston Trust

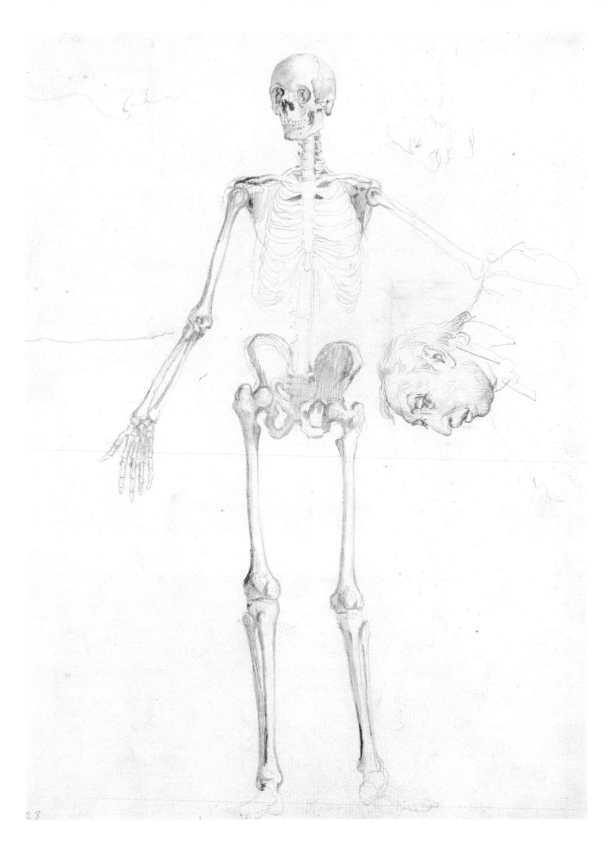

74
Skeleton with Caricatures, ca. 1801
Graphite on paper, 12 x 9⅛ in. (30.5 x 23.2 cm.)
Verso: perspective drawings and a caricatured head
Fogg Art Museum, Harvard University, The Washington Allston Trust

Fig. 75. *Son, from the Antique Statue Laocoön,* ca. 1801
Black and white chalk on gray paper, 10 3/16 x 13 3/16 in. (25.9 x 33.5 cm.)
Fogg Art Museum, Harvard University, The Washington Allston Trust

Fig. 76. Circle of BERTEL THORVALDSEN, Rome
Study of a Female Nude, ca. 1799-1819
Black chalk, heightened with white, on cream paper
Thorvaldsens Museum, Copenhagen

don, "was anxious to ascertain whether by his work he could make a living [there]. Accordingly he showed some of his water-color sketches to a publisher." Allston had assiduously been preparing himself to work as an illustrator, in case his higher ambitions should fail.

Shortly after arriving in London, Allston applied for entrance to the school of the Royal Academy, the official arbiter of English taste, and was accepted in September 1801. The keeper of the Academy was Joseph Wilton, and painting (the subject studied by most of the students, although architecture, engineering, and sculpture were also included in the curriculum) was taught by Henry Fuseli, who succeeded Wilton as keeper in 1804. It is interesting that to qualify for the school, a student had to submit a figure drawing *and* an outline of an anatomical figure or skeleton with lists and references to the muscles.[9] This rule helps to explain the nature of a pencil drawing of Allston's, *Skeleton with Caricatures* (no. 74), which must be a preliminary study for a now-lost qualifying drawing; the study must therefore date from the summer of 1801. This is the first mature drawing by Allston, the first example of his use of the medium in a fluent and graceful manner. The man's head in the center is expressive and far more ably modeled than the Harvard caricatures, while in the skeleton one sees the artist testing out the pencil, reworking the skull and shoulder bones, and rubbing in rich darks on the legs. There are few other drawings that can be firmly dated to the first London trip, although Allston must have drawn a good deal during this period and must certainly have made many figure and other drawings at the Royal Academy in the process of receiving his first formal training. He may have quickly grown dissatisfied with these early efforts and discarded them, for even Allston's early biographer, Sweetser, suggests that "The young student began his labors by drawing from plaster casts . . . [but] the academic precision learned in London was cold and meaningless to his mind."[10] This may overstate the case, as Allston clearly learned a great deal there, but it does help to explain the lack of surviving drawings from this period. The only one known today that would illustrate Sweetser's comment is the competent but dry study in chalks on brownish gray paper, now irregularly torn, of the crouching boy at the feet of the *Laocoön* (fig. 75).

Allston's landscape paintings in general refer far more to earlier European pictures than to nature, and the relative paucity of *plein air* studies and sketches is thus not surprising. His earliest known landscape drawings date from about 1804, when he made his journey from Paris to Rome via the Alps, and there is little evidence that he felt it necessary to sketch or work outdoors before this time. One possible exception may be the watercolor landscape that spreads across the verso of one page and the recto of the next in Allston's early "Smith Warner & Co." sketchbook now at the Massachusetts Historical Society (see no. 75). Here Allston quickly and ably washed in the greens of the trees and fields, leaving uncolored a pencil outline of distant mountains beyond. This was his last venture into watercolor, following *The Buck's Progress* and other early works. Given Allston's obvious knowledge of Thomas Girtin's style, as carried on by such English contemporaries as John Varley (1778-1842) and John Sell Cotman (1782-1842), and the fact that Varley, Constable, and a host of other landscapists were studying at the Royal Academy at exactly this time, one might have expected the American to delve further into English

75
Trees in a Landscape, ca. 1801-1804
Watercolor on paper, 5⅛ x 14½ in. (13 x 36.8 cm.)
Massachusetts Historical Society, Boston

watercolor style. However, in landscape Allston knew what he was looking for, and that was a far cry from the naturalistic landscape tradition.

For at least a short period, nonetheless, Allston did make observed landscape studies in pencil, building a vocabulary of trees, ferns, mountains, and clouds, which he used in *Landscape with a Lake* (no. 8) of 1804, *Diana in the Chase* (no. 11) of 1805, and a number of subsequent landscape compositions. One of these he inscribed "Mont Pilat" (no. 76). Working only in pencil, he rubbed in the foreground, then used great care to record the fields and wooded hills in the middle ground and finally the topography of the great Alpine peak itself, wreathed in clouds.[11] This is a confident drawing, with its fine, rhythmic movement, ranging from broad strokes at the bottom and the calligraphic V- and M-shaped lines through the middle, to the horizontal lines, varying in density, that describe the mountain top. As scholars, beginning with Richardson, have pointed out, the drawing was evidently used in composing the *Diana* for the peak there resembles it in reverse. On the verso of *Mont Pilat* is a pencil sketch of Mont Blanc.

Another drawing from the same sketchbook (now broken up) is *Ferns and Leaves* (no. 77). It was presumably also sketched in the Alps, and surely was made in 1804, as it was used in the foreground of the painting created late that year, *Landscape with a Lake*. A detailed study, it is closer in style to the objective realism of Constable than to Gainsborough's more generalized manner. And indeed, the same thing can be said of the half-dozen or so surviving drawings of trees that were made about this time and probably during the same journey. Each one studies a single tree, carefully working through foliage, branches, and trunk with short, horizontal strokes, and usually some suggestions of grasses or rocks at its base. They

are very much like the single tall trees that appear in the painted landscapes of 1804-05, although none of the sketches can be linked precisely to a painting.

Allston was here referring to nature for the detailed elements of his landscapes, as Reynolds and so many others had advised. It is interesting, however, that there is little in his work of the romantic artist's ardent love of the real. Even the best of these drawings (see no. 78) have none of the wondrous, living quality that one finds in the tree studies of his contemporaries Caspar David Friedrich or John Constable, or in the later work of Thomas Cole in America, although they have many *formal* similarities. Allston's touch is confident enough, but the drawings remain cold; they lack any sense of real light or space and give no indication that the artist felt comfortable in nature. Allston, in other words, studied the mountain, the ferns, and the trees for their shape and form, using the romantics' method but lacking true romantic inspiration. His style was very much his own, though clearly English in inspiration; it is somewhat akin to Cotman's manner but relates more closely to the earlier

76
Mount Pilat, Switzerland, 1804
Pencil on paper, 8⅝ x 11¼ in. (21.9 x 28.6 cm.), inscribed bottom center: "Mont Pilat"
Verso: pencil sketch of mountains, inscribed "Mont Blanc"
Fogg Art Museum, Harvard University, The Washington Allston Trust

211

77
Fern and Leaves, ca. 1804
Pencil on paper, 8⅝ x 11⅜ in. (21.9 x 28.9 cm.)
Fogg Art Museum, Harvard University, The Washington Allston Trust

78
Tree, ca. 1804
Pencil on paper, 8⅜ x 8⅝ in. (21.3 x 21.9 cm.), inscribed: "R of WA," with two columns of figures
Fogg Art Museum, Harvard University, The Washington Allston Trust

work of Richard Wilson (1713?-1782), the English master of classical, Italianate landscapes. Allston's trees especially, as in *Pine Tree* (Fogg Art Museum, 8.1955.252), are close in conception to Wilson's, with their detailed trunks and summary, decorative treatment of the leaves. They are even more like the work of Wilson's students such as Johnson Carr or William Hodges, and they may actually be closest of all to prints after Wilson's landscapes.[12]

One quite unique drawing was made at this time: this is the *Watermill Set among Rocks and a Stream* (no. 79), closely related to the drawings of trees in size, paper, and style. It shares with them also a quality of artificiality, a lack of involvement with nature, as discussed above. Yet, it was probably drawn directly from nature, and it was used without alteration for the fine painting *Italian Landscape,* in the Baltimore Museum of Art (no. 13), which may well date from a few years after the drawing. The forms in both painting and drawing are flattened, and both somehow seem mannered and unobserved. Again, drawings made out of doors take on something of the look of engravings, betraying the original source of Allston's drawing style.

Allston painted and drew landscapes for most of his career, but only in this brief period, about 1804-05, did he do detailed, outdoor studies from nature. Just three Allston sketchbooks survive: the one from Smith Warner & Co., about 1800-1805, mentioned above; the "blue sketchbook," about 1812-1818; and the one from "J. Gage Bookseller, Highgate," about 1830 (all at the Massachusetts Historical Society). The artist used a few sheets in each, and only the "blue sketchbook" contains a number of landscape sketches, among which are a compositional sketch for a classical landscape, faint topographical sketches (one of sky and clouds with color notes, again foretelling a Hudson River School practice), and one of ocean waves. More interesting are some of the loose, small sketches on letters, envelopes, and the like, which are in the Allston Trust Collection at the Fogg Art Museum. These include a study, possibly from nature, of Roman ruins by a river, seen by moonlight (8.1955.110), which in simplified form became the well-known *Moonlit Landscape (Moonlight)* (no. 54), as well as the original thumbnail sketch (8.1955.27) and a detailed drawing of the boat (fig. 79) for *Ship in a Squall* (see fig. 57, above). These sketches are useful in illuminating the artist's conceptual processes, and they indicate as well the decreasing interest that *plein air* landscape studies held for him after the Roman sojourn.

On occasion Allston made a very different kind of landscape drawing: the pencil and ink classical landscape study as seen in *Italian Landscape* (Fogg Art Museum, 8.1955.94) or *Pool in the Forest* (no. 99). There is no question of observing nature here; rather, these are compositional studies, drawn from memory and based on long experience with art and nature. Allston's manner here is quick and calligraphic, with long sweeping strokes defining trees and water in a generalized way. Stylistically, they recall Benjamin West, who sometimes made drawings of this kind, as did a good many of Allston's contemporaries—and again they look back to Wilson in his classicizing mode of the mid-1750s.[13] *Pool in the Forest,* with its interest in the flat pattern of trees seen in sunlight and shadow, shows similarities to Allston's late landscapes such as *Landscape, American Scenery: Time, Afternoon, with a Southwest Haze* (fig. 56, above) and thus probably dates from the 1830s. If

79
Watermill Set among Rocks and a Stream, ca. 1804-1806
Pencil on paper, 9⅛ x 9¾ in. (23.2 x 24.8 cm.)
Fogg Art Museum, Harvard University, The Washington Allston Trust

80
Standing Full-Length Female Nude, ca. 1804-1806
Black chalk with white highlights and graphite on light brown paper,
21⅛ x 16⁷⁄₁₆ in. (53.7 x 41.6 cm.), cut on both sides at top
Fogg Art Museum, Harvard University, The Washington Allston Trust

this is accurate, we find the odd phenomenon of Allston's landscape drawings having become more and more classical, now showing no interest at all in the real world, at the very time when the Hudson River School was beginning to flourish around him, and when his own landscape paintings were increasingly concerned with observing natural effects of light and atmosphere.

Allston's favorite medium for drawing became black and white chalks on blue, gray, or tan paper, and a great many of his best drawings throughout his career were done in this medium. It is quite likely that he learned to draw with these materials in England, for they were frequently employed by West and Copley, among others, but there is no evidence that he actually did so. In fact, the earliest known Allston drawings in chalks are a group of academic studies of young women and boys (see nos. 80-83), which have been assigned by almost all recent historians to Allston's years in Rome.

Perhaps the two earliest of these drawings are studies of a young female nude with very short, cropped hair. In one (no. 80), she is seen from the side, standing, with her left arm held out languidly, while the second drawing (no. 81) is the top half of what must have been a full-length composition, showing the model with her arms folded across her breasts and her left elbow resting on a tall block. The

81
Upper Body, Female Nude, ca. 1804-1806
Black chalk and white highlights on light brown paper,
10⅝ x 17⅞ in. (27 x 44.8 cm.)
Fogg Art Museum, Harvard University, The Washington Allston Trust

82
Young Female Nude, ca. 1804-1808
Black chalk and white highlights on blue-purple paper,
20¹³⁄₁₆ x 16⅛ in. (53 x 41 cm.)
Fogg Art Museum, Harvard University, The Washington Allston Trust

lower half of the drawing has never appeared, and as the whole would have been one of the most direct and sensual of Allston's studies—even the fragment is immensely appealing—it would be interesting to know whether the artist himself tore it, or if it were "edited" on grounds of propriety during the nineteenth century. In any case, the drawings have many qualities: they are highly sensuous, limply expressive, carefully observed and executed. At the same time, there are both obvious faults and weaker areas that betray the hand of the student-artist: for example, the outline of the torso in both is worked and reworked on the right side while oversimplified into a too regular curve on the left. In the standing figure, Allston had considerable difficulty with the right leg and the perspective of the right foot, as well as with the line of the left shin. In that drawing also, great attention is paid to the fingers and toes; these details are literally drawn and are imperfectly integrated with the whole. And the medium itself is rather tentatively handled in both works; the touch is minute, even niggling, and the chalks are moved with small, thin strokes that are almost imperceptible and look like the work of an artist who was used to drawing in pencil.

Could they have been drawn in London or Paris, or were they made shortly after Allston's arrival in Rome? London seems unlikely, although there were regular classes in life drawing at the Royal Academy. British academic drawings of the period (like nineteenth-century academic drawings of all nationalities) have been studied very little to date, but enough is known for us to conclude that Allston's simply do not have the "look" of British drawings of this era. There *is* a single English drawing of the previous generation that offers a fascinating comparison, William Blake's *Study of a Nude Male Model* (British Museum), about 1778, with its similar use of black chalk and the relaxed pose from the side, with an arm outstretched. Blake's model, however, looks directly out at the viewer, his expression dominating the work. Moreover, this example is apparently far more precise than Blake's other figure drawings, and as an isolated object seems most unlikely to have served as the basis of Allston's style.[14] More important, the implications of Blake's drawing were not taken up by the academy teachers or students of Allston's time. Fuseli's figure drawings were likely to be in pen and wash with long flowing lines; the history painters William Hilton and Richard Westall used a similar style, with more halting hands. Closest to Allston of his English contemporaries was Benjamin Haydon, who arrived in London in 1804, and who left behind many life studies of male and female nudes, often using chalks on tan or white paper. Yet Haydon's work wholly lacks Allston's sensuousness; his style is linear, the chalk being used as earlier draftsmen used the pencil, to create a variety of hatched strokes that produced a very different effect from the smooth, gently lit figures of the American.

Similarly, it would be difficult to conceive of Allston's works as stemming from his visit to Paris, for in many ways they are less French than English. The typical French life drawing of the period depicts frontal nudity and emphasizes the muscles flexed and the limbs in action or about to move. The figures have bodily strength, physical weight and substance, and they are often depicted under strong light. These qualities are apparent even in the work of Pierre Paul Prud'hon, whose charcoal drawings such as *La Source* (Clark Art Institute, Williamstown) are most comparable to Allston's. However, in Prud'hon's work one is always aware of the

83
Young Boy Seated on a Stone Block, ca. 1804-1808
Black chalk and white highlights on blue-gray paper,
20¾ x 16⅛ in. (52.7 x 41 cm.)
Watermark: "Conte"
Fogg Art Museum, Harvard University, The Washington Allston Trust

medium, particularly the linear white chalk lines, which suggest light falling on the nude figure and give it substance, while Allston never used the chalks in such a direct, decorative way.

Allston's nudes are strangely androgynous; they are sexual yet unreachable, with averted eyes. The form and shape of the body rather than its structure or musculature concerned the artist. Sweetser reported that Vanderlyn and Allston were together in Rome in 1805 and that "they cast in their lots with an association of youths from Germany, Sweden, and Denmark who assembled frequently to draw from the living model."[15] And, indeed, it is in German and other northern European drawings of the time that one finds the closest parallels to Allston's life studies. One thinks of the similarity of mood between Allston's *Self-Portrait* (no. 15), created in Rome in 1805, and the *Self-Portrait with Brown Collar,* 1802, by Phillip Otto Runge (1777-1810), the great German romantic artist. In addition, Runge's technique with black chalk on paper is close to Allston's. The former's drawing *Sleeping Nude* of 1800 (Berlin) shows his smooth style and his interest in the body's contour; it depicts the cube that appears in many of Allston's academic studies, and it also includes a pillow and soft mattress or blanket on which the figure lies. Props used in this way are seldom found in French or English studies, and they recall Allston's very literal depiction of a sheet and mattress in the *Study of a Seated Female Nude* (Fogg Art Museum, 8.1955.71).

There is a closer parallel between Allston's work and drawings made during exactly the same years by members of Bertel Thorvaldsen's circle in Rome.[16] The Danish artists were using red and black chalks, again depicting the smooth flesh of languid, unmuscular models. Indeed, one can speculate that after Allston's initial Roman training (as seen in nos. 80 and 81), he actually worked with the Danish artists for a time. His model for *Young Female Nude* (no. 82) appears as a seated figure in one of the Thorvaldsen drawings (fig. 76), as does the teen-aged boy from another Allston drawing (Fogg Art Museum, 8.1955.3).

Interestingly, Allston's drawings seem to prefigure the work of early German Nazarenes in Rome during the following decade. Thus, Franz Pforr's innocent yet evocative pencil studies of prepubescent boys from about 1810 and similar contemporary drawings by Johann Overbeck (the latter now discarding the rough, muscular style he had practiced in Vienna in 1808) were influenced either by Allston, or, as has been suggested, by such artists as Luigi Sabatelli (who studied at the French Academy in Rome from 1789 to 1794) and his followers there in the subsequent decade.[17]

One of the most superb of these early drawings is *Young Boy Seated on a Stone Block* (no. 83). Here a well-formed boy of ten or eleven sits on a carefully drawn stone base in a relaxed, graceful pose, looking down pensively. Using another sheet of blue-gray paper, watermarked "CONTE," of the same size, Allston has further refined the style of the *Young Female Nude,* using short, horizontal strokes to define the block, then rubbing black and white chalks together to form the gentle contours of the boy's body. The light and shadow are somewhat stronger than in the other, presumably earlier, academic studies; the youth is lit from the top, with dark shadows to the right of his legs. He is an ideal manifestation of youth at ease, thoughtful and almost angelic, and as such he foretells the female figures found in

Contemplation (no. 38), *Beatrice* (no. 53), and other later pictures. Clearly, Allston must have valued these drawings. One of a slightly older boy (Fogg Art Museum, 8.1955.3) was used for the painting of the *Italian Shepherd Boy* (no. 50) of about 1819, now in Detroit, while the drawing exhibited here became the basis of a closely related painting also called *Italian Shepherd Boy* (no. 51), now in Brooklyn, which presumably dates from about the same period, some ten to fourteen years after the drawing. In the painting the boy has lost his classical purity and innocence; his now bulky body is treated more generally, while his face has aged by a few years, and as Pan he sits in a wild landscape setting.

Allston must have conceived the academic studies much as he had the landscape sketches that preceded them. Both kinds of drawing were crucial in his training, as he taught himself how to see, how to record faces, bodies, gestures, skies, and tree trunks—all the elements of a painting—and then how to create his own forms on canvas. Painting for him was an extension of drawing, and the final drawings were made directly on the canvas. Later in life he advised younger artists, "with regard to preparatory studies, I should warmly recommend your devoting a portion of every day to drawing."[18] By the term "preparatory study" he seems to have meant almost any kind of drawing at all. Thus, his own conceptual process included the use of various kinds of studies. Later, when he looked back through his drawings, he would simply use whatever forms seemed suitable, as he did in the case of the *Young Boy,* while at the same time making any new studies of figure, composition, perspective, or color that were necessary.

One of the academic drawings, *Standing Young Man, Seen from the Rear* (Fogg Art Museum, 8.1955.4) shows the model leaning on a square pedestal to his right, with his left forearm raised. It is an accomplished, easy drawing, very close stylistically to number 83, and thus datable to the latter part of Allston's stay in Rome. This is confirmed by the fact that the same figure appears on the far right of the monochrome oil study for *Jason Returning to Demand his Father's Kingdom* of about 1807-08 (no. 17). The drawing is so close to the other nude studies and seems so purely "academic" (in the sense that it was made during the learning process in an academy or group, using a professional model) that we can assume it was made as an exercise and then used very shortly afterwards when Allston saw in his painting the need for a male figure seen from the rear. However, also relating to Jason is a second drawing, *Three Men in Conversation* (no. 84), which is more problematic in terms of conception. It was used with little change (except for the addition of togas over the shoulders) for a group in the right middle ground of *Jason.* The technique, though still painstaking, is more summary than in the "pure" figure studies, the legs and feet being omitted, and the costumes broadly sketched. Allston here was dealing with psychology, with the look each man is exchanging with the others, with the tension between them. Although he may well have had professional models posing for him as he drew, one senses that he did so with the *Jason* already firmly in mind and that this extraordinary, energized drawing is thus "preparatory" in the traditional sense.

Another very beautiful drawing, also somewhat problematic with regard to its date and purpose, is the *Right Hand, from a Cast* (no. 85.) Subtly modeled and carefully shaded in black and white chalks rubbed together to create a convincing

84
Three Men in Conversation, ca. 1807-08
Black chalk and white highlights on blue-gray paper,
16¼ x 12¹/₁₆ in. (41.3 x 30.5 cm.)
Fogg Art Museum, Harvard University, The Washington Allston Trust

surface, this work shares the languorous feminine quality found in the Roman drawings. It has been considered a study for *The Dead Man Restored to Life by Touching the Bones of the Prophet Elisha* (no. 25), thus dating from 1811-1814, on the basis that it rather closely resembles the right hand of the soldier in armor in the upper left of the painting,[19] but the technique, style, and paper all suggest that it is one of the Roman drawings. It is clearly a study from a plaster cast (as seen in the cut-off wrist and the depiction of shadow on the surface on which it rests) and it seems unlikely that Allston would have drawn from casts after his final student years. The relationship to *The Dead Man* is conjectural; it is conceivable that the artist used the drawing, or was inspired by its memory, in making the painting, although the hand in the picture is seen more from below, with the thumb showing,

85
Right Hand, from a Cast, ca. 1812
Black chalk with white highlights on blue-gray paper, 8⅜ x 10 in. (21.3 x 25.4 cm.)
Verso: male anatomical study
Fogg Art Museum, Harvard University,
The Washington Allston Trust

and it is vigorous and muscular—a hand expressing a strong man's wonder and fright—rather than mannered, elongated, and delicate like the hand in the drawing.

For a major painting such as *The Dead Man,* Allston must have made a great many studies of all kinds. Based on the surviving oeuvre and what can be deduced about his practices, one would expect him to have made initial compositional studies (perhaps in pen), then sketches of various individual figures and their poses (in pencil), and detailed chalk studies of many or all of the major figures' heads and hands, and perhaps their feet, clothing, and other details, along with at least one final oil study of the entire composition. For this picture there exist a number of minor studies and possibly related works, such as the *Right Hand,* but there survives only one important drawing that was surely executed with the painting in mind: *Six Drapery Studies* (no. 86), one of the most confident of Allston's drapery studies. The two smallest sketches on the sheet depict a right arm and a left arm, both clothed, which can be directly identified with the bearded old man in the upper left corner of the painting and the younger man with head turned and arm outstretched on the opposite side. However, the four larger drapery studies are more difficult to identify with a particular painting. Two appear to be alternative studies for the dead man's clothing, while one relates to the raised right leg of the angel in *The Angel Releasing St. Peter from Prison,* 1813-1816, on which Allston was working at the same time. Drapery was a special interest of Allston's; he paid great attention to the way cloth falls across the lap and legs of a seated or reclining figure, and in a drawing like this he followed the practice of Renaissance draftsmen, working to make his renderings of costume more subtle and more convincing.

Drawings from all periods of Allston's career are known in sufficient number to give us a sense of the consistency in his approach to making sketches and more finished studies in chalk and in oil for the history paintings, although nothing like a complete set of drawings for a single work survives. In connection with *The Angel Releasing St. Peter,* for example, there are at the Museum of Fine Arts an early conception of the theme, of small size, in pencil (fig. 77), and a number of similar quick sketches for the figure of St. Peter, each one trying out a pose, expression, or figurative type; each was rejected and therefore not carried forward into more detailed studies. For this painting, the larger chalk drawings that one would expect—of the drapery around St. Peter's legs, for example, of his face, of his clenched right hand and the angel's left hand, of the architectural setting—must have been among the many works discarded or destroyed. There are several oil sketches for the painting (as there must have been for many of Allston's pictures): one depicts the angel (fig. 31), another, on the verso of the "color study" of *Belshazzar,* depicts St. Peter along with other detailed sketches (fig. 34), and a third shows the whole composition (fig. 30), though with a rather more feminine angel than appears in the finished painting. Copley made some fine full-sized oil sketches of military figures in preparation for his history paintings, and Trumbull had done the same in miniature, but Allston was the first American to make such extensive and varied use of that medium. One additional work helps to explain the angel's appearance in the oil sketch: a tiny drawing in the "blue sketchbook," clearly a life study of Ann Channing (no. 87), whom Allston had married in 1809. Here one feels both a quality of realism, of the artist working from nature, and a high sense of idealization, of the

Fig. 77. *Study for "The Angel Releasing St. Peter,"* ca. 1813-14
Pencil on paper, 6½ x 6¼ (16.5 x 16 cm.)
Museum of Fine Arts, Boston

86
Six Drapery Studies, ca. 1811-1813
Black chalk and white highlights on greenish faded paper,
20¼ x 16¾ in. (51.4 x 42.5 cm.) (sight)
Fogg Art Museum, Harvard University, The Washington Allston Trust

87
Life Study of Ann Channing, ca. 1812-1815
Pencil on paper, 5¼ x 8¼ in. (13.3 x 21 cm.)
Massachusetts Historical Society, Boston

88
Ann Channing Allston, ca. 1812-1815
Black chalk and white highlights on blue-gray paper, 6⅛ x 5¼ in. (15.6 x 13.3 cm.)
(sight 4¾ x 3½ in. [12.1 x 8.9 cm.])
Fogg Art Museum, Harvard University,
The Washington Allston Trust

95
Half-Length Study of a Young Woman, ca. 1821
Black chalk with white highlights and pencil on blue-gray paper,
8⅞ x 6⅛ in. (22.5 x 15.6 cm.)
Fogg Art Museum, Harvard University, The Washington Allston Trust

artist working over his lines, rubbing the face to give a slightly blurred and dreamy —indeed, angelic—appearance. Surely, they are Ann Channing's features that appear on the face of the angel in the preliminary oil sketch (fig. 30), again in *Rebecca at the Well* (no. 36) of 1816, and in mature perfection in *Beatrice* (no. 53) of 1819. There is no doubt that she became for the artist the personification of female form. He paid homage during her lifetime, using her as model, and memorialized her in the years following her death in 1815. Another fine small drawing (no. 88) shows her in profile, even more idealized yet presumably drawn from life; there is no painting that makes use of this pose. Allston must have drawn Ann on many occasions, in many ways; and if her face represented the ideal for him, so did the rest of her form. For example, one sketch of her ear is known (no. 89); and there are several paintings, notably *Beatrice*, for which this study might well have been used. And given his interest in the nude and his feeling for his wife, it would be hard to imagine Allston *not* making life studies of her, but, unfortunately, none are known

89
Study of an Ear, ca. 1812-1815
Black chalk and white highlights on blue-gray paper, 4⅝ x 3⅞ in. (11.7 x 9.8 cm.)
Fogg Art Museum, Harvard University,
The Washington Allston Trust

90
Portrait Study: Profile of a Man,
ca. 1811-1818
Black chalk and white highlights on blue-gray paper, 6¹⁵⁄₁₆ x 4⅝ in. (17.5 x 11.7 cm.)
Fogg Art Museum, Harvard University,
The Washington Allston Trust

to survive; any intimate drawings of this kind would probably have been destroyed by the artist after his wife's death.

Allston apparently made few portrait studies of any kind, aside from these ideal heads of his wife. Of the handful that survive the *Profile of a Man* (no. 90) is most deftly executed. The subject is a gentleman with a heavy coat and white cravat (quickly indicated in black and white chalks); his face is softly modeled, with expressive eyes and an open, alert expression. One would guess that Allston simply made this drawing of a patron, or perhaps one of his writer-friends, either during the years in Rome or later in England, with no intention of using it later in a painting. The artist's touch is seen here at its best; the quick yet convincing manner stands in contrast to the more literal, precise handling of the *Half-Length Study of a Young Woman* (no. 95). The subject of this study is probably Miriam Sears, wife of David Sears, who commissioned Allston's painting *Miriam* (fig. 47) in 1821. It is likely that Allston used the portrait sketch as the basis for the painting, indeed, that he made it for that purpose. More formal than *Profile of a Man,* it is also more carefully worked and reworked, with white chalk used to cover corrections, as in the comb in the woman's hair.

As one would expect, there exist more drawings for *Belshazzar* than for any other project, Allston having devoted himself to it sporadically for over twenty years, and they provide important clues about his technique and his methods with regard to history painting. As William Gerdts points out above, in "The Paintings of Washington Allston," the two major oil sketches, the "first study" (no. 42) and the "color study" (no. 43) were both probably done by May 1817. These represented an essentially finished conception, and they were themselves based on numerous drawings, including pen or pencil sketches of the initial idea; small pencil sketches of the major figures, some with emphasis on pose and gesture, others on facial expression and costume; larger chalk studies of more extensive areas of drapery and particularly significant hands, legs, and other individual features; and ink drawings of special problems of perspective or architectural setting. A number of drawings of these types survive. The artist's concern with Daniel's figure is apparent from the start; there is a small pencil sketch of his raised left hand, another early study of him kneeling, and others of the standing figure. One sheet called *Four Male Heads* (Fogg Art Museum, 8.1955.188) is a fine pencil study in varying expressions of horror, astonishment, and wonder. And also from this early stage is the *Perspective Drawing of Abacus and Columns* (no. 92), in which the artist was studying the placement of the columns in the background of the great painting. This is precisely and carefully drawn, in pencil and brown ink, with a textbook passage on the vexing question of perspective copied onto the same sheet. Also interesting is a later sketch to the lower right, in chalk, of a column in the simpler block form it would assume during the twenties, showing how Allston would reuse and sometimes rework his drawings years after they had been made.

A good example of Allston's sketch technique in pencil is the *Study for the King in Belshazzar's Feast* (no. 93). The head is clear and expressive, with emphasis on the neck muscles and rounded shoulders, while the remainder of the figure is suggested with a nervous, wavering pencil line. The position of the figure and the facial expression were the artist's concern here, and drapery, hands, and other details

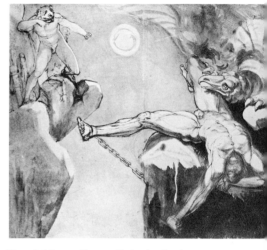

Fig. 78. HENRY FUSELI, Swiss (active in England), 1741-1825
Prometheus Rescued by Hercules
Wash on paper
British Museum, London

91
Danger, ca. 1811-1818
Ink on paper, 9⅝ x 7¹¹⁄₁₆ in. (24.4 x 20.1 cm.), inscribed, lower left: "W. Allston" and below:
> "Danger, whose form of giant mould
> What mortal eye dare, fix'd, behold:
> Who stalks his round and hideous Form,
> Howling amidst the midnight storm,
> Or throws him on the ridgy steep
> Of some hanging rock to sleep!"
> > Collins

The Walters Art Gallery, Baltimore, Maryland

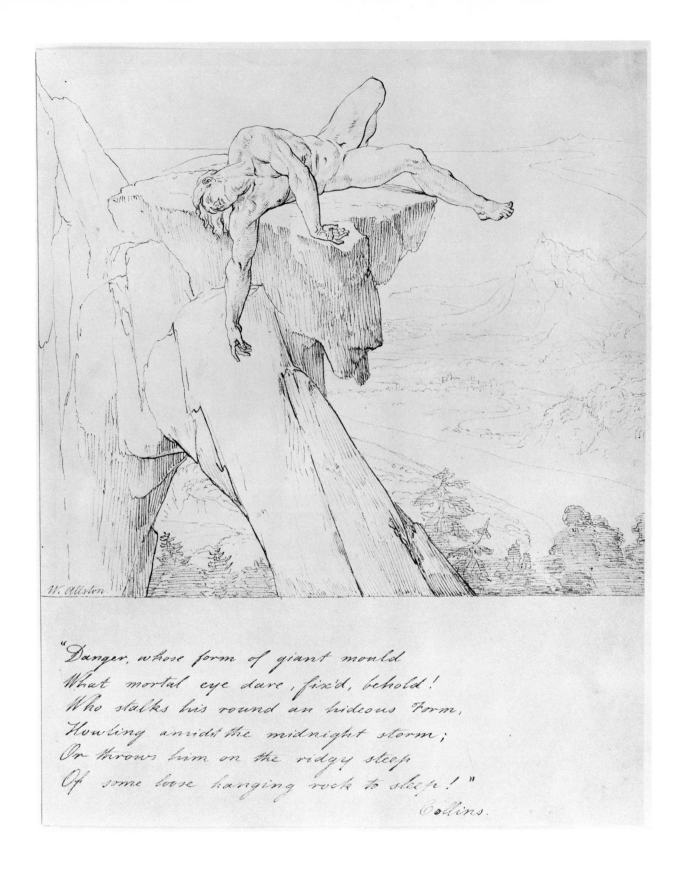

W. Allston

"Danger, whose form of giant mould
What mortal eye dare, fix'd, behold!
Who stalks his round an hideous Form,
Howling amidst the midnight storm;
Or throws him on the ridgy steep
Of some loose hanging rock to sleep!"

Collins.

231

Take the center line of the tile *parallel*
to find the extent of the circle in large ball
drop a perpendicular from said line
two thirds from the outer end of the line.
— same at the other end.
To find the square for the circle.
divide the depth of the ball
into two equal parts — then draw
a line from the ~~dividing~~
point ~~taken middle~~ to the
of distance through
the dividing point
(viz middle of the depth)
~~a then where it~~
a parallell line through
the ~~box~~ mid depth ~~which~~
and where they intersect
the perpendiculars
draw ~~it~~ lines to the
point of sight, the
upper part of which
being intersected by
the line abovementioned
from the point of
distance will give the
upper angles of the
square.

Truer

92
Perspective Drawing of Abacus and Columns, ca. 1817
Pencil, ink, pen, and red chalk on paper, 9⅛ x 7½ in. (23.2 x 19.1 cm.)
Fogg Art Museum, Harvard University, The Washington Allston Trust

93
Study for the King in Belshazzar's Feast, ca. 1817
Pencil on paper, 9¹⁵⁄₁₆ x 7¹³⁄₁₆ in. (25.1 x 20 cm.),
inscribed bottom: "Sketch for Belshazzar (?) R.H.D. Jr."
Fogg Art Museum, Harvard University, The Washington Allston Trust

were of no interest as he made the drawing. The style is one Allston would use as he thought visually, and the small size and quick pencil strokes also typify his preliminary sketches. Yet this is not a normal preliminary drawing, for it surely postdates the oil sketches. Having decided on a changed composition during the twenties, Allston had to rethink the major figures; hence this drawing has all the characteristics of an early sketch. Here the king leans back in horror, his neck straining, somewhat as he would appear in the large unfinished painting (see fig. 45, above).

It is difficult, perhaps impossible, to know whether Allston's habit was to make the large-scale drawings of hands, legs, and drapery before or after the final oil sketch of the composition; there is no reason to assume he was completely consistent, and he probably did both, depending on the particular painting and its needs.

94
Two Groups of Angels from "Jacob's Dream," ca. 1817
Brown ink on tracing paper turned brown, 17⅞ x 23⅝ in. (45.4 x 60 cm.)
Fogg Art Museum, Harvard University, The Washington Allston Trust

In the case of *Belshazzar*, the well-known chalk drawings of hands postdate the oil sketches. *Belshazzar's Left Hand* (no. 96) also reflects the new conception of the king's figure; here studied in detail, the left hand rests on and clutches the thigh. Every detail and especially every part of the body was important for Allston, but none more so than the hand, which could reflect all the tension or the calm, the fright or the nobility of a face, indeed, of a human character. Allston was a lifelong student of dramatic gesture and expression; he followed the eighteenth-century practices of Hogarth and Reynolds, who themselves had looked to the treatises of Charles Le Brun, Johann Kaspar Lavater, and Gérard le Lairesse.[20] For Allston, each facial expression in *Belshazzar* had to relate to those nearby, while being individualized; and each had to express a variant of one of the basic emotions of wonderment and fear that characterized the painting itself. *Belshazzar*, like many of

96
Belshazzar's Left Hand, ca. 1821-1828
Black chalk and white highlights on blue-gray paper, 9⅜ x 12½ in. (23.8 x 31.8 cm.)
Verso: drapery studies
Fogg Art Museum, Harvard University, The Washington Allston Trust

Allston's paintings, was designed as a study in emotions, as seen most easily in the face and posture and in gestures, especially those of the hands, that reinforced, echoed, and occasionally modified those emotions. Drawing was a crucial means to the setting up of such a complex system, for only through the most careful preparations could the final composition be successful; it needed to tell its story and give life to specific emotions, while at the same time being drawn, colored, and composed in a convincing and effective way. Basic for the romantic painter, as for Allston, was "the fascination with psychological responses, the emotions and the emotional."[21] Lavater in his *Essays on Physiognomy*, in the chapter discussing the "Harmony Between Moral and Physical Beauty," quoted Wolf: "We know that nothing passes in the soul without producing a perceptible change in the body."[22] Mastery of gesture and expression was crucial for Allston's effort to describe and affect the human soul, which was to seek truth itself.

These drawings make clear not only that Allston struggled with the perspective problems pointed out by Stuart but also that the conception of the scene itself changed as he worked during the 1820s. In the "color study" in oil (no. 43), the figure of Daniel marks the center of the picture, both emotionally and compositionally. He looks to the left at the king and queen, and his large left hand gestures powerfully toward the prophecy, providing a balance for his head and a focal point for the right side of the picture. The king and queen shrink back, with frightened faces; like Daniel, each has one hand (the king's right, the queen's left) carefully painted, silhouetted against a dark background, which echoes emotion expressed in the face and reinforces both the message and the compositional rhythm of the painting. When Allston greatly strengthened the king, as seen in the emphasis of his head and neck and his *left* hand, an already delicate balance was thrown off. The queen had to be made more powerful; the soothsayers to the far right became more dramatic to balance the king and queen, while Daniel also had to be strengthened. In the process, something was lost, and the painting became more and more difficult for the artist.

Allston made many drawings for Belshazzar during this period, studying the king's upper body, the queen's right hand, Daniel's clenched right hand, groups of figures, drapery, and architecture. In the figure studies, often in chalk on colored paper, the artist's style is not very different from the Roman drawings of nearly two decades earlier. *Belshazzar's Left Hand* (no. 96), is especially firmly drawn; the varied hatched and parallel strokes of the black chalk are wider and more vigorous, with a new sense of energy in the execution, but otherwise the early academic technique is continued.

For the other major history paintings only scattered drawings exist. *Christ Healing the Sick* of 1813, is known through the umber outline drawing at the Fogg Art Museum. No large-scale chalk studies are known, and since no full-sized version of the painting was ever begun, it is probable that Allston never reached the point of needing to make such studies. This is further evidence that the chalk drawings of hands, drapery, and the like were made after the composition was firmly established and just before or even during the time that the final painting was being outlined on the canvas. On the other hand, for the major finished painting of *Uriel* (no. 41) of 1817, there are only minor pencil studies, probably early conceptual

97
Bust of a Man with Frightened Staring Eyes (Spalatro), ca. 1830
Pencil on paper, 4¹³⁄₁₆ x 4¼ in. (12.4 x 10.8 cm.)
Fogg Art Museum, Harvard University, The Washington Allston Trust

98
Hand Holding a Lamp, ca. 1830
Pencil on paper, 4⅝ x 3¾ in. (11.7 x 9.3 cm.)
Fogg Art Museum, Harvard University, The Washington Allston Trust

sketches. For the related painting, *Jeremiah Dictating His Prophecy* (no. 57) of 1820, there are several drawings, including an intriguing pencil sketch of a seated male nude, a prototype for the figure of the scribe Baruch, and several studies of Jeremiah's drapery and shoulders. The last are executed in chalk, about 5 by 5 in. We are reminded that Allston often drew in this small scale, using pencil for quicker studies of pose, outline, or figure and chalk for the careful depiction of details—an arm or a fold of drapery—and the study of form, light, and volume. Allston made many studies of single figures and many representing groups of two or three figures in the history paintings. However, there are no compositional drawings for these pictures; for the overall conception he relied on oil sketches on millboard, such as those for *Belshazzar* (nos. 42 and 43) and *Jeremiah* (no. 57). This represented a considerable variation from traditional practice. A great many of West's drawings, for example, are devoted to these problems of composition and grouping. Allston seems to have thought in terms of an *individual's* psychological reactions and re-

lationships to other individuals, not in terms of the overall pictorial scene, and this signals one of his major weaknesses as an artist.

Allston sketched from nature throughout his career. Besides the few sketchbooks there survive a miscellany of loose sheets where he used pen or pencil to observe figures and occasional landscape elements. One sheet has two fine pencil sketches of a camel, which was used in the background of *Rebecca at the Well* (no. 36) of 1816. These have the look of sketches based on observation, as the artist confirms in a letter, where he comments that the camel had been "drawn from a living one now at Exeter."[23] A great many sketches of this type must have been discarded.

Allston continued to draw well on occasion throughout his troubled years in Boston and Cambridgeport. He looked to earlier inspiration and technique for the fine late history picture *Spalatro's Vision of the Bloody Hand,* which we know only through a print (see fig. 58, above). There survive five studies of the priest Schedoni's hands, as well as chalk drawings of Spalatro's right leg and left leg. There are also five small studies of Spalatro's head and shoulders, a tiny one in chalk, perhaps the first, and four increasingly effective pencil drawings. This is the only surviving set of drawings of a single figure, where one sees the artist working out a human emotion on paper through a series of subtle changes. The final sketch (no. 97), less than 4½ by 5 in., is an archetypal study in "the passions of the soul." Lavater quoted the Swiss physician Albrecht von Haller: "It is the will of God . . . that the afflictions of the mind should express themselves by the voice, the gestures, but especially by the countenance."[24] Allston had worked since his *Buck's Progress* to depict the gestures and countenance of the frightened and astonished. Here Allston has closely followed Charles Le Brun's design for *Horror* in the furrowed brow, eyebrows, sunken cheeks, and bulging eyes with sharply drawn round pupils. Yet, he has not followed Le Brun literally, for here the mouth is closed, with lowered corners and bottom lip extended, all elements from Le Brun's depiction of *Scorn.*[25] As William Gerdts points out above, Spalatro was equally horrified and conscience-stricken; Allston has demonstrated both his knowledge of classical passions and his originality of conception in this depiction of Spalatro's agonies.

Another area of the same painting, the priest holding an oil lamp, was studied with similar care and similarly remarkable results. Allston loosely sketched the forearm, hand, and lamp in one preliminary drawing (Fogg Art Museum, 8.1955.133), defining his idea. He must have worked it out in other drawings, now lost, and then drawn it finally with great confidence and grace (no. 98). Again, it is a very small pencil drawing, but in its grace of form and subtlety of execution it departs from Allston's usual sketches. In its high finish, its lack of sketchiness, it resembles the drawing of *Danger* (no. 91), and, indeed, it differs so much from Allston's other sketches that one wonders whether he foresaw some added purpose for it, such as an engraving or other form of reproduction.

The drawing of *Danger* was surely intended for reproduction; it is an illustration for a poem by William Collins (1721-1759), the eighteenth-century English poet who bore the same name as Allston's painter friend. Included in Collins's *Odes on Several Descriptive and Allegoric Subjects* of 1748 is his "Ode to Fear," which describes a giant who personifies danger. Allston illustrates the lines that describe

his "hideous form" thrown on a "loose hanging rock to sleep." Although Collins's imagery is frightening and sublime, Allston's giant seems youthful and relaxed, and the drawing is refined and classical in effect. It is quite unusual in Allston's graphic oeuvre in that it is a complete and finished, signed composition. Executed in a painstaking, linear fashion in pen and ink, it bears a resemblance to William Rimmer's work in Boston several decades later. It is also closely related to a drawing by Allston of *Prometheus* (Museum of Fine Arts, Boston), which shows a similar giant chained to a rock; both compositions may have been inspired by Henry Fuseli's *Prometheus Rescued by Hercules* (fig. 78). The images are similar, although Fuseli's rapid wash technique and horrific mood find no echoes in Allston's work. Allston's drawing also suggests Samuel F. B. Morse's *Dying Hercules* of 1813 now at Yale University, and it should be noted that Morse wrote to Allston in 1839 that he had just then made a careful tracing of his "beautiful design of Danger."[26]

In 1850 Allston's drawings were memorialized in a volume entitled *Outlines and Sketches by Washington Allston*. The publisher was Seth W. Cheney (1810-1856), a Boston engraver and portrait draftsman, who was well-trained and much-traveled (he had made at least four trips to Europe) and an admirer of Allston's work. Cheney wrote a short introduction to the volume: "The Outlines and Sketches contained in this Volume, are a part of those found in Mr. Allston's Studio, in Cambridge, Massachusetts, after his death in July 1843. . . . They consist in great part of compositions, hastily sketched in chalk, and never carried further; among them, however, are a few outlines in umber, on canvas, which, although more carefully done, should not be considered as finished Outlines, since they were intended merely as a ground work on which to paint."[27]

Cheney's comments cannot be understood without considering the terminology of his period; to our ears it might sound as if Allston's "Outlines and Sketches . . . hastily sketched in chalk" were academic drawings of the kind discussed above. However, this is not the case, for Cheney was referring in the main to unfinished *paintings,* which had been left in the studio, and which were reproduced either in part or as a whole. Cheney's motivation must have been to provide a permanent record of the most important of Allston's unfinished canvases as well as some of the major finished pictures that were in England and thus unknown to the American public. In the latter category was a line engraving after *Uriel* (no. 41), then owned by the Duke of Sutherland, and a series of four engravings (each described in the text as a "fac-simile of a Pen and Ink drawing on Tracing paper made by Mr. Allston from his Original Painting"), depicting groups of figures from *Jacob's Dream* (no. 39), then, as now, at Petworth. One print was based on the drawing *Two Groups of Angels, from Jacob's Dream* (no. 94), a life-sized drawing of two areas of the picture that Allston left in England in 1818. Late in his life Allston wrote to McMurtrie that among his drawings were "some few that I wish to preserve as memoranda of former works,"[28] and surely *Two Groups of Angels* is one of these. It is interesting that it was also reproduced by Flagg in 1892, when the very thin tracing paper had already suffered from severe wrinkling and other damage.

There are a number of related tracings and outline drawings in the large group deposited by the Allston Trust at the Fogg Art Museum, and they exhibit enough

99

Pool in the Forest, ca. 1830-1835
Brown ink on paper, 4⅞ x 7⅞ in. (12.4 x 20 cm.)
Fogg Art Museum, Harvard University, The Washington Allston Trust

variation in quality and touch so that one must be wary of attributing all to Allston himself. For example, there is an apparent "tracing" of the angels to the upper right of *Jacob's Dream,* with the figures reversed: if this is by Allston, it would have to be a tracing of the verso of a tracing.

Many of Cheney's other prints reproduce unfinished pictures, which he presumably thought were unexhibitable and therefore likely to remain unknown to Allston's public. There are complete reproductions of Allston's full-sized outlines on canvas of *The Sibyl, Heliodorus, Fairies on the Sea Shore, Titania's Court,* and *Girl in a Male Costume* also called *Girl in a Persian Costume* (no. 65), which is annotated "From a sketch in umber on canvas." There are also six details from the now-lost *Michael,* which Allston had originally called *Gabriel Setting the Waters at the Gates of Paradise.* The book also has a print of one finished picture, *Dido and Anna* (no. 26), two lithographic reproductions (*The Prodigal Son* and *Prometheus*), four now unknown pencil sketches, and, finally, the best-known of Allston's full-scale sketches for unpainted pictures, *Ship in a Squall* (fig. 57), which probably dates from the 1830s. For this composition, as for other unfinished compositions,

Fig. 79. *Study for "Ship in a Squall,"* ca. 1830s
Pencil on paper, 4⅞ x 5³⁄₁₆ in. (12.4 x 13.7 cm.)
Fogg Art Museum, Harvard University, The Washington Allston Trust

240

there exist several preliminary sketches; at the Fogg there are two tiny compositional studies and a fine, detailed pencil study of the main sailing ship itself (fig. 79), and there are also sketchbook studies of waves and clouds that relate to it. As Allston made clear, for every painting he would outline the composition on primed canvas, using chalk; normally, once this was completely satisfactory, he would wipe out the chalk and replace it with a final outline in raw umber before laying in the initial areas of color. *Ship in a Squall* is perhaps the most beautifully drawn of these late "outlines," for it not only gives evidence of Allston's technique but also stands on its own as a fresh and original romantic conception.

100
Flying Figures, ca. 1830-1837
Brown ink on tracing paper, 7³⁄₁₆ x 9⁵⁄₁₆ in. (18.4 x 23.8 cm.)
Verso: two flying figures, in pencil
Fogg Art Museum, Harvard University, The Washington Allston Trust

As one would expect, Allston did fewer drawings for the late projects than for the earlier ones, both because he was losing energy, and because so many of these works never advanced beyond the outline stage, and thus never required detailed studies. Nonetheless, the drawings of the thirties can be fine ones; and surprisingly, Allston frequently reverts to a quick pen-and-ink style that recalls West's manner. *Flying Figures* (no. 100) is a study for *Fairies on the Seashore, Disappearing at Sunrise,* a work now known only through Cheney's engraving. Its quick, short pen-strokes and its format are close to those in West's drawings of the first decade of the century, such as *Achilles Weaving the Armor Brought by Thetis* (Morgan Library, New York). Allston again studies small groups of figures for a larger composition, rather than the whole scene, as he had in so many earlier drawings. In this and in many other ways he differed from his mentor. West's Italianate style, so close to Guercino and other baroque masters, with its emphasis on flowing, decorative line, was very much a product of the eighteenth century. Allston's drawings, sensitive, gently modeled, introspective yet observant, are products of the nineteenth-century romantic mind, and as a group are unique in American art.

NOTES

1. Jared B. Flagg, *The Life and Letters of Washington Allston* (New York, 1892; reprint ed. New York, 1969), p. 25.

2. The drawings are part of the Washington Allston Trust at the Fogg Art Museum, Harvard University. Kenyon C. Bolton has catalogued them in his useful Ph.D. dissertation "The Drawings of Washington Allston," Harvard University, 1974.

3. Bolton, "Drawings of Allston," vol. 1, p. 19.

4. Henry Wadsworth Longfellow Dana, *Allston in Cambridge* (Chicago, 1948).

5. John Trumbull, *M'Fingal,* illus. Elkanah Tisdall. (New York, 1795).

6. Flagg, *Life and Letters of Allston,* p. 25.

7. Dana, *Allston in Cambridge,* p. 17.

8. See William H. Gerdts, "The Paintings of Washington Allston," p. 16, above.

9. H. C. Morgan, "A History of the Organization and Growth of the Royal Academy Schools from the Beginning of the Academy to 1836, with Special Reference to Academic Teaching and Conditions of Study," Ph.D. dissertation, University of Leeds, 1964, p. 24.

10. Moses F. Sweetser, *Allston* (Boston, 1879), p. 33.

11. According to Flagg, *Life and Letters of Allston,* p. 194, the painter wrote about "studying Mount Pilot, in Switzerland." Richardson believed this to be Mt. Pilatus, in central Switzerland; however, there is a Mt. Pilat a few miles south of St. Etienne in France, which might have been Allston's subject.

12. Brinsley Ford, *The Drawings of Richard Wilson* (London, 1951).

13. Ibid., pp. 29-31.

14. See Diana Strazdes, "Allston's Life Studies: Stylistic Sources," paper prepared for "Selected Topics in American Art: Washington Allston," seminar conducted by the Museum of Fine Arts, Boston, and the Graduate Center of the City University of New York, 1978.

15. Sweetser, *Allston,* p. 40.

16. Pointed out by Diana Strazdes, "Allston's Life Studies."

17. Ibid.

18. Flagg, *Life and Letters of Allston,* p. 197.

19. Bolton, "Drawings of Allston," p. 29.

20. A. Smart, "Dramatic Expression in the Age of Hogarth and Reynolds," *Apollo,* n.s. 82 (August 1965), 90-97.

21. Frederick J. Cummings and Allen Staley, *Romantic Art in Britain: Paintings and Drawings, 1760-1860.* Catalogue of an exhibition ... at the Detroit Institute of Arts and the Philadelphia Museum of Art (Philadelphia, 1968), p. 21.

22. John Casper Lavater, *Essays on Physiognomy Calculated to Extend the Knowledge and the Love of Mankind,* trans. Henry Hunter, D.D. (London, 1789), vol. 1, p. 49.

23. Letter from Allston to Van Schaick, London, November 13, 1816, Houghton Library, Harvard University.

24. Lavater, *Essays on Physiognomy,* p. 51.

25. Engravings after Le Brun's drawings, which were made to illustrate the "expression of the passions," were published by Sébastien Leclerc, *Les Caractères des passions gravées sur les dessins de l'illustre M. le Brun* (Paris, 1696).

26. Bolton, "Drawings of Allston," quoting R. H. Dana's notes at the Massachusetts Historical Society.

27. Seth W. Cheney, in *Outlines and Sketches by Washington Allston* (Boston, 1850), p. 1.

28. Flagg, *Life and Letters of Allston,* p. 318.

Selected Bibliography

Included in the following list are references of major importance in the study of Allston's art. A complete bibliography of the life and work of the artist has been compiled during the preparation of this catalogue and may be consulted at the Museum of Fine Arts, Boston, or at the Graduate Program in Art History, City University of New York.

"A is for Allston." *Art Journal* 34 (winter 1974-75) 146.

ADAMS, CHARLES FRANCIS. "Allston and His Unfinished Picture. Passages from the Journals of R. H. Dana." *Atlantic Monthly* 64 (November 1889) 637-642.

ALBEE, JOHN. *Henry Dexter, Sculptor: A Memorial.* Cambridge, Mass., Privately printed by J. Wilson & Son, 1898.

ALBRO, JOHN ADAMS. *The Blessedness of Those Who Die in the Lord. A Sermon Occasioned by the Death of Washington Allston, Delivered in the Church of the Shepard Society, Cambridge, July 16, 1843.* Boston: C. C. Little and J. Brown, 1843.

The Album. . . . New York: F. & R. Lockwood, 1824.

ALLSTON, ELIZABETH DEAS. *The Allstons and Alstons of Waccamaw.* Charleston, S. C.: Privately printed, 1936.

ALLSTON, ROBERT F. W. *The South Carolina Rice Plantation as Revealed in the Papers of Robert F. W. Allston.* Edited by James Harold Easterby. Chicago: University of Chicago Press, 1945.

ALLSTON, SUSAN LOUNDES. *Brookgreen Waccamaw in the Carolina Low Country.* Charleston, S. C.: Nelson's Southern Printing & Publishing Co., 1956.

ALLSTON, WASHINGTON. "America to Great Britain." *Bellman*, February 23, 1918, p. 215.

ALLSTON, WASHINGTON. "Color Book." Manuscript notes, with notes on his conversation by another hand. Dana Papers, Massachusetts Historical Society, Boston.

ALLSTON, WASHINGTON. Correspondence (especially Allston to Vanderlyn from Leghorn, April 23, 1808). New-York Historical Society, New York.

ALLSTON, WASHINGTON. *Lectures on Art and Poems.* Edited by Richard Henry Dana, Jr. New York: Baker and Scribner, 1850.

ALLSTON, WASHINGTON. *Lectures on Art and Poems, 1850; and Monaldi, 1841.* Introduction by Nathalia Wright. Gainsville, Fla.: Scholars' Facsimiles & Reprints, 1967.

ALLSTON, WASHINGTON. "Letter 'To the Editor of the North American Review.'" *North American Review* 51 (October 1840), 518-520.

ALLSTON, WASHINGTON. *Monaldi: A Tale.* London: Edward Moxon, 1842.

ALLSTON, WASHINGTON. *Outlines and Sketches, by Washington Allston.* Engraved by J. & S. W. Cheney. Boston: S. H. Perkins, 1850.

ALLSTON, WASHINGTON. Papers. Dana Collection, Massachusetts Historical Society, Boston.

ALLSTON, WASHINGTON. *The Sylphs of the Seasons, with Other Poems.* Boston: Cummings and Hilliard, 1813.

"Allston in Detroit." *Art Digest*, June 1, 1947, p. 12.

"Allston's Lectures on Art." *Literary World*, July 6, 1850, pp. 13-14.

"Allston's Monaldi." *Crayon* 3 (August 1856), 255-256.

"Allston's Poems and Lectures on Art." *North American Review* 71 (July 1850), 149-168.

"Allston's Poems and Lectures on Art." *Sartain's Union Magazine of Literature and Art* 6 (June 1850), 434.

"Allston's Retrospective Exhibition." *New York Daily Tribune*, July 11, 1881, p. 5.

"Allston's St. Peter in Prison." *Crayon*, March 28, 1855, p. 194.

"American Genius as Expressed in Art." *Round Table*, December 26, 1863, pp. 21-22.

"Analysis of Mr. Allston's Picture." *Telescope* (Columbia, S. C.), May 14, 1816.

"Art and Artists in America." *American Whig Review* 2 (December 1845), 658-663.

"Art at the South." *Cosmopolitan Art Journal* 4 (September 1860), 132.

Artist-Biographies; Fra Angelico, Murillo, Allston. Vol. 5. Edited by Moses F. Sweetser. Boston: Ticknor, 1877-78.

"The Artist Speaks: Part One, Colonial Challenge and Federal Response 1700-1825." *Art in America* 53 (August-September 1965), 24-37.

"The Artists of America." *Crayon* 7 (February 1860), 44-51.

"The Athenaeum Exhibition of Painting and Sculpture." *Dial* 1 (October 1840), 260-264.

"The Athenaeum Gallery and the Allston Collection." *American Art-Union Bulletin*, October 1850, pp. 109-112.

AVERILL, LOUISE HUNT. "John Vanderlyn, American Painter." Ph.D. dissertation, Yale University, 1949.

B. "The Sylphs of the Season, with Other Poems, by Washington Allston." *Analectic Magazine* 6 (August 1815), 151-158.

BAILEY, COLIN J. "The English Poussin"—An Introduction to the Life and Work of George Augustus Wallis." Walker Art Gallery, Liverpool, *Annual Report* 6 (1975-76), 35-54.

BAKER, CHARLES HENRY COLLINS. *Catalogue of the Petworth Collection of Pictures in the Possession of Lord Leconfield.* London: The Medici Society, 1920.

BARTLETT, MABEL. "Washington Allston as Critic." Ph.D. dissertation, Boston University, 1960.

BASSHAM, BEN LLOYD. "The Anglo-Americans: American Painters in England and at Home, 1800-1820." Ph.D. dissertation, University of Wisconsin, 1972.

BAUDISSIN, KLAUS VON. *George August Wallis, Maler aus Schottland, 1768-1847.* Heidelberg: C. Winter, 1924.

BAYLEY, FRANK W. *Little Known Early American Portrait Painters* (No. 3: Samuel King). Boston: Copley Society, 19—?

BENZ, JOHN CHRISTOPHER. "Washington Allston, American Artist-Philosopher." *Folio* (English Department, Indiana University) 19 (February 1954), 105-114.

"A Biographical Sketch of the Life of Washington Allston." *Bulletin of the New England Art Union*, no. 1 (1852), 5-6.

BLAIR, HAROLD ROBERT. "The American Titian: A Study of Washington Allston and His Age. Ph.D. dissertation, University of Illinois at Urbana-Champaign, 1974.

BOLTON, KENYON C. "The Drawings of Washington Allston." Ph.D. dissertation, Harvard University, 1974.

"Boston." *Round Table,* December 26, 1863, p. 28.

Boston University School of Fine and Applied Arts. *Boston Painters, 1720-1940.* Catalogue essay by William B. Stevens. Boston, 1968.

BREESKIN, ADELYN D. "Summer Harvest." *Baltimore Museum of Art News* 16 (October-November 1952), 6-9.

"British Institution." *Morning Post* (London), February 8, 1814.

C.G.E.B. "Washington Allston: A Study of the Romantic Artist in America: by Edgar P. Richardson. Review." *Connoisseur* 127 (March 1951), 64.

CABOT, ANNA. "Letters of Miss Anna Cabot." Edited by Josiah P. Quincy. Massachusetts Historical Society, *Proceedings,* ser. 2, 18 (May 1904), 302-317.

CAREY, WILLIAM. *The National Obstacle to the National Public Style Considered: Observations on the Probable Decline or Extinction of British Historical Painting, from the effects of the Church Exclusion of Paintings. . . .* London: Hawlett & Brimmer, 1825.

CARY, ELIZABETH LUTHER. "Four American Painters Represented in the Metropolitan Museum." *International Studio* 35 (September 1908), xci-xcvi.

Catalogue of Paintings, Marbles and Casts in the Collection of R. W. Gibbes, M.D. Columbia, S. C., n.d.

A Catalogue of Pictures, Drawings and Sketches in Oil and Watercolors, the Property of the Late C. R. Leslie, Esq., R.A. London, 1860.

"Catalogue of the Sixteenth Exhibition of Paintings at the Boston Athaneum." *Pioneer* 1 (January 1843), 15.

CHAMPNEY, BENJAMIN. *Sixty Years' Memories of Art and Artists.* Woburn, Mass: Wallace and Andrews, 1900.

CHANNING, WALTER. "Reminiscences." *Christian Register,* August 5, 1843, p. 105.

CHANNING, WILLIAM ELLERY. *Memoir of William Ellery Channing with Extracts from His Correspondence and Manuscripts.* Edited by William H. Channing. 3 vols. London: John Chapman, 1848.

CHANNING, WILLIAM ELLERY. "Remarks on National Literature." *Christian Examiner* 7, n.s. 2 (January 1830), 269-295.

CHASE, GEORGE DAVIS. "Some Washington Allston Correspondence." *New England Quarterly* 16 (December 1943), 628-634.

CHENEY [EDNAH DOW]. "Allston as a Writer. By a Lover of Art." *Commonwealth* (Boston), February 10, 1866, p. 1.

CHENEY, EDNAH DOW. *Gleanings in the Fields of Art.* Boston: Lee and Shepard, 1881.

CHENEY, EDNAH DOW. *Memoir of John Cheney, Engraver.* Boston: Lee and Shepard, 1889.

CHENEY, EDNAH DOW. *Memoir of Seth W. Cheney, Artist.* Boston: Lee and Shepard, 1881.

CHENEY, EDNAH DOW. *Reminiscences of Ednah Dow Cheney.* Boston: Lee and Shepard, 1902.

City Art Gallery, Bristol, England. *The Bristol School of Artists.* Catalogue essay by Francis Greenacre. Bristol, 1973.

CLARKE, SARAH. "Our First Great Painter, and His Works." *Atlantic Monthly* 15 (February 1865), 129-140.

CLEMENT, CLARA ERSKINE. "Early Religious Painting in America." *New England Magazine* 11 (December 1894), 387-402.

COBURN, KATHLEEN. "Notes on Washington Allston from the Unpublished Notebooks of S. T. Coleridge." *Gazette des Beaux-Arts* 25, ser. 6 (1944), 249-252.

COFFIN, WILLIAM A. "The Columbian Exposition—III." *Nation,* August 17, 1893, pp. 114-116.

COLE, THOMAS. Papers (especially letters: Luman Reed to Thomas Cole, May 26, 1835; Reed to Cole, June 16, 1835; Cornelius Ver Bryck to Cole, July 21, 1841). New York State Library, Albany.

COLERIDGE, JOHN DUKE. "Wordsworth and Allston." *Athenaeum* (London), July 7, 1894, pp. 33-34.

COLERIDGE, SAMUEL TAYLOR. *Animae Poetae, from the Unpublished Notebooks of Samuel Taylor Coleridge.* Edited by Ernest Hartley Coleridge. 2 vols. London: W. Heinemann, 1895.

COLERIDGE, SAMUEL TAYLOR. *Collected Letters of Samuel Taylor Coleridge.* Edited by Earl Leslie Griggs. 6 vols. Oxford: Clarendon Press, 1956-71.

COLERIDGE, SAMUEL TAYLOR. *The Notebooks of Samuel Taylor Coleridge.* Edited by Kathleen Coburn. 2 vols. in 4. New York: Pantheon Books, 1955-61.

COLERIDGE, SAMUEL TAYLOR. *The Table Talk and Omniana of Samuel Taylor Coleridge.* London: H. Milford, Oxford University Press, 1917.

COLERIDGE, SAMUEL TAYLOR. *Unpublished Letters of Samuel Taylor Coleridge.* Edited by Earl Leslie Griggs. 2 vols. London: Constable, 1932.

The Collection of Portraits of American Celebrities and Other Paintings Belonging to The Brook. Catalogue compiled by Diego Suarez. Together with a History of The Brook, by Thomas B. Clark, completed by Philip D. Holden. New York, 1962.

COLLINS, WILLIAM WILKIE. *Memoirs of the Life of William Collins, with Selections from His Journals and Correspondence.* 2 vols. London: Longman, Brown, Green and Longmans, 1848.

"Common Sense in Art." *Crayon,* February 7, 1855, p. 81.

CONSTABLE, WILLIAM GEORGE. *Art Collecting in the United States of America; An Outline of a History.* London: Nelson, 1964.

CONWAY, WILLIAM MARTIN. "Life and Letters of Washington Allston, by Jared B. Flagg." *Academy,* April 15, 1893, pp. 330-331.

"Copley, Stuart, and Allston." *Old and New* 4 (December 1871), 735-738.

COX, KENYON. "The Life and Letters of Washington Allston. By Jared B. Flagg." *Nation,* January 12, 1893, pp. 32-34.

CRAVEN, WAYNE. "The Grand Manner in Early Nineteenth Century American Painting: Borrowings from Antiquity, the Renaissance, and the Baroque." *American Art Journal* 11 (April 1979), 5-43.

Crayon 7 (June 1860), 178.

CUNNINGHAM, ALLAN. *The Lives of the Most Eminent British Painters and Sculptors.* 3 vols. New York: Harper & Brothers, 1840.

DAME, LAWRENCE. "Boston Museum Evaluates Washington Allston." *Art Digest* 21, no. 19 (1947), 13, 30.

DANA, HENRY WADSWORTH LONGFELLOW. "Allston at Harvard 1796-1800; Allston in Cambridgeport 1830-1843," Cambridge Historical Society, *Publications* 29, *Proceedings for the Year 1943,* pp. 13-67.

DANA, HENRY WADSWORTH LONGFELLOW. "Allston in Italy." Unpublished notes on Allston. Longfellow National Historic Site, Cambridge, Mass.

DANA, HENRY WADSWORTH LONGFELLOW. "Exhibition of Twenty Paintings by Allston, with a Biography on the Program." Boston Symphony Orchestra, *Concert Bulletin,* April 28, 1946.

DANA, HENRY WADSWORTH LONGFELLOW. Manuscript notes, letters, receipts, lists. Dana Collection, Longfellow National Historic Site, Cambridge, Mass.

DANA, RICHARD HENRY. "Allston and His Unfinished Picture. Passages from the Journals of R. H. Dana." *Atlantic Monthly* 64 (November 1889), 637-642.

DANA, RICHARD HENRY. Manuscript notes for a life of Washington Allston. Dana Papers, Massachusetts Historical Society, Boston.

DANA, RICHARD HENRY. "The Sylphs of the Seasons, with Other Poems by Washington Allston." *North American Review* 5 (September 1817), 365-389.

DAVIDSON, RUTH BRADBURY. "Paintings by Allston." *Antiques* 7 (March 1957), 274.

DEARBORN, A. H. S. "Allston's Feast of Belshazzar." *Knickerbocker* 24 (September 1844), 205-217.

The Detroit Institute of Arts. *Washington Allston, 1779-1843: A Loan Exhibition of Paintings, Drawings and Memorabilia*. Catalogue essay by Edgar P. Richardson, Detroit, 1947.

The Detroit Institute of Arts. *Travelers in Arcadia: American Artists in Italy 1830-1875*. Introduction by Edgar P. Richardson and Otto Wittmann, Jr. Toledo: Toledo Museum of Art, 1951.

DEXTER, A. "The Fine Arts in Boston." In *The Memorial History of Boston, Including Suffolk County, Massachusetts 1630-1880*. Edited by Justin Winsor. Boston: J. R. Osgood, 1880-81.

DEXTER, FRANKLIN. "Exhibition of Pictures at the Athenaeum Gallery: Remarks upon the Athenaeum Gallery of Paintings for 1831." *North American Review* 33 (October 1831), 506-515.

DEXTER, FRANKLIN. "Modern Painters." *North American Review* 66 (January 1848), 110-145.

DILLENBERGER, JOHN. *Benjamin West: The Context of His Life's Work with Particular Attention to Paintings with Religious Subject Matter*. San Antonio: Trinity University Press, 1977.

DOEHN, RUDOLF. "Der Maler-Dichter Washington Allston." *Unsere Zeit* 1 (1881), 616-625.

"Domestic Art Gossip." *Crayon* 6 (December 1859), 379-381.

DOWNES, WILLIAM HOWE. "Boston Painters and Paintings II. Allston and his Contemporaries." *Atlantic Monthly* 62 (August 1888), 258-266.

DRAKE, SAMUEL ADAMS. *Old Landmarks and Historic Personages of Boston*. Boston: James R. Osgood, 1873.

DUNLAP, WILLIAM. *Diary of William Dunlap 1776-1839: The Memoirs of a Dramatist, Theatrical Manager, Painter, Critic, Novelist, and Historian*. New York: Benjamin Blom, 1930.

DUNLAP, WILLIAM. *A History of the Rise and Progress of the Arts of Design in the United States*. New ed. Edited, with additions by Frank W. Bayley and Charles E. Goodspeed. 3 vol. Boston: C. E. Goodspeed, 1918.

DURAND, ASHER B. "Letters on Landscape Painting, No. 7." *Crayon*, May 2, 1855, pp. 273-275.

DURAND, ASHER B. Papers (especially letters) A. B. Durand to J. W. Casilear, June 1835; Casilear to Durand, June 17, 1835; Alvan Fisher to Durand, October 16, 1828: I. P. Davis to Durand, June 12, 1836; E. T. Dana to Durand, July 9, 1844. New York Public Library, New York.

ELLIOTT, MAUD HOWE. "Some Recollections of Newport Artists." *Bulletin of the Newport Historical Society*, no. 35 (January 1921), pp. 1-32.

ELMES, JAMES. *Annals of the Fine Arts*, 1816, 1818, 1819. Vols. 1, 3, 4. London: Sherwood, Neely, and Jones, 1817, 1819, 1820.

EMERSON, RALPH WALDO. *Journals of Ralph Waldo Emerson, 1820-1872*. Edited by Edward Waldo Emerson and Waldo Emerson Forbes. 10 vols. Boston: Houghton Mifflin, 1909-1914.

EMERSON, RALPH WALDO. *The Letters of Ralph Waldo Emerson*. Edited by Ralph L. Rusk. 6 vols. New York: Columbia University Press, 1939.

EVERETT, EDWARD. *Bulletin of the New England Art Union*, no. 1 (1852), p. 3.

"Exhibition of Pictures at the Athenaeum Gallery." *North American Review* 31 (October 1830), 309-337.

"Exhibition of Pictures at the Boston Athenaeum." *North American Review* 25 (July 1827), 227-230.

"Exhibition of Pictures by Old Masters: No. 1, Jacob's Dream. By Barocci." *Bristol Mirror*, October 6, 1838.

FARINGTON, JOSEPH. *The Farington Diary*. Edited by James Greig. 8 vols. London: Hutchinson, 1922-1928.

FARNHAM, EMILY. *Charles Demuth: Behind a Laughing Mask*. Norman: University of Oklahoma Press, 1971.

FELTON, CORNELIUS CONWAY. "Allston's 'Poems and Lectures on Art.' " *North American Review* 71 (July 1850), 149-168.

FELTON, CORNELIUS CONWAY. "Raczynski's Modern Art in Germany." *North American Review* 57 (October 1843), 373-399.

FELTON, CORNELIUS CONWAY. "Monaldi: A Tale." *North American Review*. 54 (April 1842), 397-419.

FIEBIGER, OTTO. Zwei römische Briefe des Malers Franz Riepenhausen aus dem Jahre 1805." *Deutsche Rundschau* 176 (July-September 1918), 211-227.

"Fine Art." *New Monthly Magazine and Universal Register* 11 (June 1819), 450-456.

"Fine Arts, British Institution." *Examiner* (London), February 13, 1814.

"Fine Arts, British Institution." *Examiner* (London), February 11, 1816.

"Fine Arts, British Institution." *Examiner* (London), February 9, 1818.

FISHER, ALVAN. Letter to Durand, Boston, June 7, 1828. Durand Correspondence. Archives of American Art, Detroit.

FLAGG, JARED B. *The Life and Letters of Washington Allston*. 1892. Reprint. New York: Kennedy Galleries, DeCapo Press, 1969.

FLEXNER, JAMES THOMAS. "The American School in London." *Metropolitan Museum of Art Bulletin* 7 (October 1948), 64-72.

FLEXNER, JAMES THOMAS. *The Light of Distant Skies, 1760-1835*. Boston: Houghton Mifflin, 1947.

"Foreign Literature and Science." *Analectic Magazine* 6 (July 1815), 173.

"A Forgotten A.R.A. *Saturday Review*, April 1, 1893, pp. 354-355.

"The Frontier Fallacy." *Baltimore Museum of Art News* 21 (June 1958), 2-11.

FROTHINGHAM, NATHANIEL LANGDON. "Mr. Allston's Paintings of Saul and the Witch of Endor." *Bulletin of the New England Art Union* no. 1 (1852), pp. 3-5.

FULLER, MARGARET. *Art, Literature and the Drama*. Edited by Arthur B. Fuller. New York: Tribune Assoc., 1869.

FULLER, MARGARET. "A Record of Impressions Produced by the Exhibition of Mr. Allston's Pictures in the Summer of 1839." *Dial* 1 (July 1840), 73-84.

FULLER, MARGARET. *The Writings of Margaret Fuller*. Selected and edited by Mason Wade. New York: Viking Press, 1941.

FUSELI, HENRI. "Lectures at the Royal Academy." *Blackwood's Magazine* 54 (December 1843), 691-708.

GARDNER, ALBERT TEN EYCK. "Memorials of an American Romantic." *Metropolitan Museum of Art Bulletin* 3 (October 1944), 54-59.

"A Genteel Custom." *Time*, June 3, 1957, pp. 74-75.

GERDTS, WILLIAM H. "Allston's Belshazzar's Feast." *Art in America* 61 (March-April 1973), 59-66.

GERDTS, WILLIAM H. "Belshazzar's Feast II: 'That is his shroud.' " *Art in America* 61 (May-June 1973), 58-65.

GERDTS, WILLIAM H. "Washington Allston and the German Romantic Classicists in Rome." *Art Quarterly* 32 (summer 1969) 166-196.

GERRY, SAMUEL L. "The Old Masters of Boston." *New England Magazine* 3 (February 1891), 683-695.

GORDON, JEAN. *"The Fine Arts in Boston 1815 to 1879."* Ph.D. dissertation, The University of Wisconsin, 1965.

GOULD, HANNAH F. *The Burial of Allston: Dirge Written & Respectfully Inscribed to Mrs. Allston by Miss Hannah F. Gould. Composed by John Braham.* Boston: Oliver Ditson, 1846.

GREENOUGH, HENRY. *Ernest Carroll; Or Life in Italy, A Novel . . .* Boston: Ticknor and Fields, 1858.

GREENOUGH, HENRY. "Washington Allston as a Painter. Unpublished Reminiscences of Henry Greenough." *Scribner's Magazine* 11 (February 1892), 220-221.

GREENOUGH, HORATIO. *Letters of Horatio Greenough to His Brother, Henry Greenough. With Biographical Sketches, and Some Contemporary Criticism.* Boston: Ticknor, 1887.

GROVES, JOSEPH A. *The Alstons and Allstons of North and South Carolina.* Atlanta: Franklin Printing and Publishing Co., 1901.

GUATTANI, GUISEPPE ANTONIO. *Memorie enciclopediche sulle antichità e belle arti di Roma* Vol. I. Rome: Pel Salmoni, 1806.

HALE, S. J. "Monaldi." *Christian Examiner* 31, 3rd ser. 13 (January 1842), 374-381.

HALL, GORDON LANGLEY. "Long-lost Allston Painting Discovered." *News and Courier* (Charleston, S. C.) October 6, 1963, p. 3C.

HARDING, CHESTER. *Sketch by His Own Hand.* Edited by M. E. White. New ed. with annotations by W. P. G. Harding. New York: Houghton, 1929.

Harding's Gallery, Boston. *Exhibition of Pictures, Painted by Washington Allston.* Boston: J. H. Eastburn, 1839.

HARRIS, NEIL. *Artist in American Society: The Formative Years, 1790-1860.* New York: George Braziller, 1966.

HAVELL, ROBERT, JR. "American Landscapes: The Romantic Spirit, Washington Allston (1779-1831)." In "The World Around, the World Within: Important Eighteenth and Nineteenth Century Paintings." *Kennedy Quarterly* 4 (April 1964), 112-176.

HAWLEY, HENRY H. "Allston's Falstaff Enlisting His Ragged Regiment." *Wadsworth Atheneaum Bulletin,* ser. 3, no. 3 (winter 1957), pp. 13-16.

HAZLITT, WILLIAM. "British Institution." *Morning Chronicle* (London), February 5, 1814. In *The Complete Works of William Hazlitt.* Vol. 18. London: J. M. Dent and Sons, 1930-1934.

HICKS, GRANVILLE. "A Glance at Channing's Friendships." *Christian Register* (Boston), September 5, 1929, pp. 723-724; September 12, 1929, pp. 741-742.

HOBERG, PERRY F. "Washington Allston: Biography of an Aesthetic Experience." Master's thesis, University of Delaware, 1965.

HOFLAND, THOMAS R. "The Fine Arts in America." *Knickerbocker* 14, (July 1839), 39-52.

HOLMES, OLIVER WENDELL. "Exhibition of Pictures Painted by Washington Allston at Harding's Gallery, School Street." *North American Review* 50 (April 1840), 358-381.

HOWARD, GEORGE WILLIAM FREDERICK, 7th Earl of Carlisle. *Travels in America. The Poetry of Pope. Two Lectures Delivered to the Leeds Mechanics Institution.* New York: G. P. Putnam, 1851.

HOWE, JULIA WARD. *Reminiscences, 1819-1899,* Boston: Houghton Mifflin, 1899.

HUNT, WILLIAM PARSONS. "Belshazzar's Feast." *Christian Examiner* 37, 4th ser. 2 (July 1844).

HUNTER, DOREEN. "America's First Romantics: Richard Henry Dana, Sr., and Washington Allston." *New England Quarterly* 45 (March 1972), 3-30.

HUNTINGTON, J. "The Allston Exhibition: A Letter to an American Traveling Abroad." *Knickerbocker* 14 (August 1839), 163-174.

IRVING, WASHINGTON. "Biographical Sketch of Washington Allston, with three letters from Irving to E. A. Duyckinck, 1854-55, portraits and other engravings." Manuscripts division, New York Public Library, New York.

IRWIN, DAVID. *English Neoclassical Art: Studies in Inspiration and Taste.* Greenwich, Conn.: New York Graphic Society, 1966.

"Italian Sunset, 'Extract from Allston.' " *Crayon* 3 (August 1856), 247.

JACK, IAN. *Keats and the Mirror of Art.* Oxford: Clarendon Press, 1967.

"Jacob's Ladder, W. Alston." *Examiner* (London), May 24, 1819.

JAMESON, ANNA BROWNELL. *Companion to the Most Celebrated Private Galleries of Art in London.* London: Saunders and Otley, 1844.

JAMESON, ANNA BROWNELL. *Letters of Anna Jameson to Ottilie von Goethe.* Edited by George Henry Needler. London: Oxford University Press, 1939.

JAMESON, ANNA BROWNELL. "Washington Allston." *Athenaeum* (London), January 6, 1844, pp. 15-16: January 13, 1844, pp. 39-41.

JARVES, JAMES JACKSON. *The Art-Idea: Part Second of Confessions of an Inquirer.* New York: Hurd and Houghton, 1864.

JARVIS, LEONARD. Manuscript notes on Washington Allston. Dana Papers. Massachusetts Historical Society, Boston.

Jewett Art Center, Wellesley College. *4 Boston Masters: Copley, Allston, Prendergast, Bloom.* Wellesley, Mass. 1959.

"John Neagle, the Artist." *Lippincott's Magazine* 1 (May 1868), 477-491.

JOHNS, ELIZABETH. "Washington Allston: Method, Imagination, and Reality." *Winterthur Portfolio,* no. 12 (1977), pp. 1-18.

JOHNS, ELIZABETH. "Washington Allston's *Dead Man Revived.*" *Art Bulletin* 61 (March 1979), 78-99.

JOHNS, ELIZABETH. "Washington Allston's Library." *American Art Journal* 7 (November 1975), 32-41.

JOHNS, ELIZABETH. "Washington Allston's Theory of the Imagination." Ph.D. dissertation, Emory University, 1974.

JOSEPH, MICHAEL KENNEDY, "Charles Aders." *Auckland University College Bulletin,* no. 43, English ser. no. 6, 1953.

KELLNER, SYDNEY. "The Beginnings of Landscape Painting in America." *Art in America* 26 (October 1938), 158-169.

KENNEY, ALICE P., and WORKMAN, LESLIE J. "Ruins, Romance, and Reality: Medievalism in Anglo-American Imagination and Taste, 1750-1840. *Winterthur Portfolio* 10 (1975), 131-164.

KINGSBURY, MARTHA. "The Native Landscapes of Washington Allston." Unpublished paper, Harvard University, 1966.

KINGSBURY, MARTHA. "Washington Allston: Composition of Late Works, and Implications for His Development." Photocopy of typescript, Archives of Fogg Art Museum, Harvard University.

KNAPP, SAMUEL LORENZO. *Sketches of Public Characters, Drawn from the Living and the Dead, with Notices of Other Matters.* New York: E. Bliss, 1830.

KNOWLTON, HELEN M. *Hints for Pupils in Drawing and Painting.* Boston: Houghton, Osgood, 1879.

KOEHLER, SYLVESTER ROSA. *Catalogue of the Engraved and Lithographed Works of John Cheney and Seth Wells Cheney.* Boston: Lee and Shepard, 1891.

LARKIN, OLIVER W. *Samuel F. B. Morse and American Democratic Art.* Edited by Oscar Handlin. Boston: Little, Brown, 1954.

LEAVITT, THOMAS W. "Disposition of the Washington Allston Trust." *Art Quarterly* 19, no. 4 (1956), 415-417.

LEAVITT, THOMAS W. "Permanent Loan From the Washington Allston Trust." Fogg Art Museum, Harvard University, *Annual Report,* 1954-55, pp. 14-15.

LEAVITT, THOMAS W. "Washington Allston at Harvard." *Harvard Alumni Bulletin,* April 21, 1956, pp. 550-553.

LEAVITT, THOMAS W. "Washington Allston's Studio." *Art in America* 44 (fall 1956), 12-14.

LEBRUN, MARIE LOUISE ELISABETH. *Souvenirs of Madame Vigée-Lebrun.* New York: R. Worthington, 1880.

"Lectures on Art and Poems, by Washington Allston." *Graham's American Monthly Magazine* 36 (June 1850), 415.

"Lectures on Art and Poems, by Washington Allston." *Literary World,* April 20, 1850, pp. 398-400.

"Lectures on Art and Poems, by Washington Allston." *New Englander* 8, n.s. 2 (August 1850), 445-452.

LEE, HANNAH FARNHAM. "Washington Allston." *Howitt's Journal,* December 18, 1847, pp. 395-396.

LESLIE, CHARLES R. *Autobiographical Recollections. With a Prefatory Essay on Leslie as an Artist and Selections from His Correspondence.* Edited by Tom Taylor. Boston: Ticknor and Fields, 1860.

"Leslie's Personal Notes." *Cosmopolitan Art Journal* 4 (September 1860), 122-124.

LESTER, CHARLES EDWARD. *The Artists of America: A Series of Biographical Sketches of American Artists.* New York: Baker & Scribner, 1846.

"Life and Letters of Washington Allston, by Jared B. Flagg." *Art Critic* 1 (1893), 19.

Lines Read at the Centennial Celebration of the Hasty Pudding Club of Harvard College, 1795-1895. Boston: Little, Brown, 1896.

LONGFELLOW, HENRY WADSWORTH. "Poems by Washington Allston." *Signal,* January 7, 1843.

The Lowe Art Museum, University of Miami. *The Paintings of Washington Allston.* Catalogue essays by Kenyon C. Bolton III and Elizabeth Johns. Coral Gables, 1975.

LOWELL, JAMES RUSSELL. *Cambridge Thirty Years Ago, 1854: A Memoir Addressed to the Edelmann Storg in Rome.* Boston: Houghton Mifflin, 1910.

LOWELL, JAMES RUSSELL. *Fireside Travels.* Boston: Ticknor and Fields, 1864.

MABEE, CARLETON. *The American Leonardo: A Life of Samuel F. B. Morse.* New York: Alfred A. Knopf, 1943.

The Magnolia (Charleston, S. C.) 1 (September 1842), 171-172; (December 1842), 388.

MANDELES, CHAD. "Washington Allston's *The Evening Hymn.*" *Arts Magazine* (in press).

MATHER, FRANK JEWETT, JR. "Edgar P. Richardson, 'Washington Allston: A Study of the Romantic Artist in America.'" *College Art Journal* 8 (spring 1949), 231-232.

Merchant Tailors' Hall, Bristol, England. *Catalogue of W. Allston's Pictures Exhibited at Merchant Tailors' Hall.* Bristol, 1814.

MEYER, ANNIE NATHAN. "A Portrait of Coleridge by Washington Allston." *Critic* 48 (February 1906), 138-141.

MEYER, JERRY DON. "The Religious Paintings of Benjamin West: A Study in Late Eighteenth and Early Nineteenth Century Moral Sentiment." Ph.D. dissertation, New York University, 1973.

"Michael Angelo, 'Extract from Allston's Monaldi.'" *Crayon* 3 (August 1856), 256.

MILLER, LILLIAN. *Patrons and Patriotism: The Encouragement of the Fine Arts in the United States, 1790-1860.* Chicago: University of Chicago Press, 1966.

"Monaldi." *New York Review* 10 (January 1842), 211-216.

"Monaldi." *Southern Literary Messenger* 8 (April 1842), 286-289.

"Monaldi: A Tale." *Boston Quarterly Review* 5 (January 1842), 119-121.

MORGAN, CHARLES H., and TOOLE, MARGARET C. "Saul and the Witch of Endor, Painting in Amherst College." *Art in America* 38 (December 1950), 275-277.

MORGAN, JOHN HILL. "Nathaniel Jocelyn's Record of the Palettes of Gilbert Stuart and of Washington Allston." New York Historical Society, *Quarterly Bulletin* 23 (October 1939), 131-134.

MORSE, SAMUEL F. B. Papers. Library of Congress, Washington, D. C.

MORSE, SAMUEL F. B. *Samuel F. B. Morse: His Letters and Journals.* Edited by Edward Lind Morse. Boston: Houghton Mifflin, 1914.

"Mr. Allston's Exhibition of Paintings." *Bristol Gazette,* August 4, 1814, p. 3.

"Mr. Allston's Pictures." *Bristol Mercury,* August 29, 1814.

"Mr. Coleridge by Washington Allston." *Antiques* 55 (January 1949), 63-64.

Museum and Art Gallery, Leicester, England. *Sir George Beaumont and His Circle.* Leicester, 1953.

Museum and Art Gallery, Leicester England. *Sir George Beaumont of Coleorton, Leicestershire.* Exhibition catalogue. Leicester, 1973.

Museum of Fine Arts, Boston. *Exhibition of the Works of Washington Allston.* Introduction by T. G. Appleton. Boston, 1881.

NEAL, JOHN. "American Painters and Paintings." *Yankee and Boston Literary Gazette.* N.s. 1 (July 1829), 46-51.

NEAL, JOHN. "Landscape and Portrait Painting." *Yankee and Boston Literary Gazette.* N.s. 3 (September 1829), 113-121.

NEAL, JOHN. *Observations on American Art: Selections from the Writings of John Neal (1793-1876).* Edited, with notes by Harold Edward Dickson. State College, Pennsylvania: Penn State College, 1943.

"Notes of the Month: The Allston by Gilbert Stuart." *International Studio* 92 (January 1929), 60.

NOVAK, BARBARA. *American Painting of the Nineteenth Century: Realism, Idealism, and the American Experience.* New York: Praeger, 1969.

"On Landscape Painters." *New York-Mirror,* July 18, 1840, pp. 29-30; July 25, 1840, p. 38.

"On the Intellectual and Moral Relations of the Fine Arts." *Southern Literary Journal,* n.s. 1 (August 1837), 481-492.

OPIE, JOHN. *Lectures on Painting, Delivered at the Royal Academy of Arts.* London: Longman, Hurst, Rees and Orme, 1809.

"Our Artists.—No. XI. Allston." *Godey's Lady's Book* 35 (October 1847), 180-182.

"Outlines and Sketches, by Washington Allston; Allston's Lectures on Art and Poems." *Knickerbocker* 35 (June 1850), 537-538.

PAGE, WILLIAM. "The Art and the Use of Color in Imitation in Painting. No. 6, Reynolds, Alston, Stuart." *Broadway Journal,* March 22, 1845, pp. 201-202.

"A Painter on Painting." *Harper's New Monthly Magazine* 56 (February 1878), 458-461.

PEABODY, ELIZABETH PALMER. "Allston the Painter." *American Monthly Magazine* 7, n.s. 1 (May 1836), 435-446.

PEABODY, ELIZABETH PALMER. "Last Evening with Allston." *Emerson's Magazine and Putnam's Monthly* 5 (October 1857), 497-503.

PEABODY, ELIZABETH PALMER. *Last Evening with Allston, and Other Papers.* Boston: D. Lothrop, 1886.

PEABODY, ELIZABETH PALMER. *Reminiscences of Reverend William Ellery Channing, D.D.* Boston: Roberts Brothers, 1880.

PEASE, THOMAS W. "Allston's Lectures. Lectures on Art and Poems, by Washington Allston." *New Englander* 8, n.s. 2 (August 1850), 445-452.

PECK, GEORGE W. "Allston's Lectures on Art." American Art-Union, *Bulletin,* June 1850, pp. 38-41.

PECK, GEORGE W. "Lectures on Art and Poems." *American Whig Review* 12, n.s. 6 (July 1850), 17-32.

PECK, GEORGE W. "Monaldi." *American Whig Review* 7, n.s. 1 (April 1848), 341-357.

The Peerless Geraldine, a Favorite Recitative and Air. As Sung by Mr. G. C. Germon. At the Boston Museum in the Fairy Romance of the Paint King, Dramatized from Washington Allston's Poem by Charles H. Saunders, the Music Composed by Thomas Comer, Boston: George P. Reed, 1845.

Pennsylvania Academy of the Fine Arts. *Exhibition at the Pennsylvania Academy of the Fine Arts of Mr. Allston's Picture "Of the Dead Man Restored to Life by Touching the Bones of the Prophet Elisha" together with Many Valuable Paintings.* Philadelphia, 1816.

Pennsylvania Academy of the Fine Arts. *Exhibition of C. R. Leslie's Picture of the Murder of Rutland . . . and also of Mr. Allston's Celebrated Pictures of the Dead Man Restored to Life, by Touching the Bones of the Prophet Elisha; and Donna Mencia in the Robber's Cave from Gil Blas; . . .* Philadelphia, 1816.

"Percival's Poem." *North American Review* 22 (April 1826), 317-333.

PERKINS, ROBERT F., JR., and GAVIN, WILLIAM J., III. *Boston Athenaeum Art Exhibition Index 1827-1874.* Boston, 1980. (Distributed by M.I.T. Press.)

PICKERING, HENRY. *The Ruins of Paestum, and Other Compositions in Verse.* Salem: Cushing and Appleton, 1822.

PLATNER, ERNEST, et al. *Beschreibung der Stadt Rom.* Vol. 1. Stuttgart, 1829.

Poetic Illustrations of the Athenaeum Gallery of Paintings. Preface by William George Crosby. Boston: True and Greene, 1827.

PRESTON, MARGARET J. "Art in the South." *Southern Review* 25 (July 1879), 394-408.

PRIME, SAMUEL IRENAEUS. *Life of Samuel F. B. Morse, LL.D.* New York: D. Appleton, 1875.

PROWN, JULES D. "The Sisters by Washington Allston." Fogg Art Museum, Harvard University, *Annual Report,* 1956-57, pp. 45-48.

RACZYNSKI, ATANAZY. *Histoire de l'art moderne en Allemagne.* 3 vols. Paris: Chez J. Renouard, 1836-1841.

RAGAN, DAVID PAUL. "Washington Allston's Aesthetics and the Creative Imagination." In *Art in the Lives of South Carolinians: Nineteenth-Century Chapters. Book I.* Charleston: Carolina Art Association, 1978.

"Raphael, 'Extract from Monaldi.'" *Crayon* 3 (October 1856), 297.

REED, JUDITH K. "Art Books. 'Washington Allston' by Edgar P. Richardson." *Art Digest,* October 15, 1949, p. 26.

RICHARDSON, EDGAR P. "Allston and the Development of Romantic Color." *Art Quarterly* 7 (winter 1944), 33-57.

RICHARDSON, EDGAR P. "Allston: History of a Reputation." *Art News* 46 (August 1947), 12-15, 37-38.

RICHARDSON, EDGAR P. "The America of Washington Allston." *Magazine of Art* 40 (October 1947), 218-223.

RICHARDSON, EDGAR P. "The Flight of Florimell by Washington Allston." *Bulletin of the Detroit Institute of Arts* 24, no. 1 (1944-45), 1-5.

RICHARDSON, EDGAR P. "Three Late Pictures." *Bulletin of the Detroit Institute of Arts* 24, no. 1 (1944), 1-5.

RICHARDSON, EDGAR P. *Washington Allston: A Study of the Romantic Artist in America.* Chicago: University of Chicago Press, 1948.

ROBINSON, HENRY CRABB. *Diary, Reminiscences and Correspondence.* Selected and edited by Thomas Sadler. 2 vols. Boston: J. R. Osgood, 1871.

ROWLAND, BENJAMIN, JR. "Diana in the Chase by Washington Allston." Fogg Art Museum, Harvard University, *Annual Report,* 1955-56, pp. 48-49, 61.

ROWLAND, BENJAMIN, JR. "Edgar Preston Richardson, 'Washington Allston: A Study of the Romantic Artist in America. Review.'" *Art Bulletin* (September 1949), 238-242.

ROWLAND, BENJAMIN, JR. "Popular Romanticism: Art and the Gift Books." *Art Quarterly* 20 (winter 1957), 364-381.

RUTLEDGE, ANNA WELLS. *Artists in the Life of Charleston. Transactions of the American Philosophical Society,* n.s. vol. 39, pt. 2 (Philadelphia, 1949).

RUTLEDGE, ANNA WELLS. "Dunlap Notes." *Art in America* 39 (February 1951), 38-48.

RUTLEDGE, ANNA WELLS. "Salute to Washington Allston." *Antiques* 44 (July 1943), 24.

SHACKFORD, MARTHA HALE. *Wordsworth's Interest in Painters and Pictures.* Wellesley, Mass.: The Wellesley Press, 1945.

SHERRILL, SARAH B. "Washington Allston." *Antiques* 107 (March 1975), 388.

SIMMS, WILLIAM GILMORE. "The Writings of Washington Allston." *Southern Quarterly Review* 4 (October 1843), 363-414.

SNELLING, MRS. ANNA L. "The Artists of America: Washington Allston." *Photographic Art-Journal,* May 1851, pp. 295-299.

SOBY, JAMES THRALL. "Washington Allston, Eclectic." *Saturday Review of Literature,* August 23, 1947, pp. 28-29.

"Some Unpublished Correspondence of Washington Allston." *Scribner's Magazine* (January 1892), 68-83.

SORIA, REGINA. "Washington Allston's Lectures on Art: The First American Art Treatise." *Journal of Aesthetics and Art Criticism* 18 (March 1960), 329-344.

SPEAR, THOMAS T. *Description of the Grand Historical Picture of Belshazzar's Feast, Painted by Washington Allston and Now Exhibiting at the Corinthian Gallery.* Boston: Eastburn's Press, 1844.

SPEAR, THOMAS T. *Description of the Grand Historical Picture of Belshazzar's Feast, Painted on Another Canvas of the Same Size, and Finished with a View to Carry Out the Conceptions of the Author.* Boston: Eastburn's Press, 1846.

SPOONER, SHEARJASHUB. *Anecdotes of Painters, Engravers, Sculptors, and Architects, and Curiosities of Art.* 3 vols. in 1. New York: A. W. Lovering, 1880.

STILLMAN, WILLIAM JAMES. "Sketchings." *Crayon,* March 7, 1855, p. 155; March 14, 1855, p. 171.

STOCKTON, ROBERT. "R. F. W. Allston: Planter Patron." In *Art in the Lives of South Carolinians: Nineteenth-Century Chapters, Book I.* Charleston: Carolina Art Association, 1978.

STORY, JOSEPH. *Life and Letters of Joseph Story.* Edited by William Wetmore Story. Boston: Charles C. Little and James Brown, 1851.

SUMNER, CHARLES. *Boston Book.* Boston, 1850.

SUMNER, CHARLES. *The Scholar, the Jurist, the Artist, the Philanthropist. An Address before the Phi Beta Kappa Society of Harvard University.* Boston: W. D. Ticknor, 1846.

SWAN, MABEL MUNSON. *The Athenaeum Gallery, 1827-1873: The Boston Athenaeum as an Early Patron of Art.* Boston: Athenaeum, 1940.

SWEETSER, MOSES FOSTER. *Allston.* Boston: Houghton, Osgood, 1879.

TICKNOR, WILLIAM D. *Remarks on Allston's Paintings.* Boston: W. D. Ticknor, 1839.

Ticknor papers. Dartmouth College Library, Hanover, New Hampshire.

TOLMAN, RUEL PARDEE. *The Life and Works of Edward Greene Malbone 1777-1807.* New York: New York Historical Society, 1958.

TURNER, EVAN H. "Three Paintings by Allston." *Wadsworth Atheneum Bulletin,* ser. 2, no. 61 (January 1956), p. 1.

"Unfinished Feast." *Time,* July 28, 1947, pp. 48-50.

University Art Museum, University of California, Berkeley. *The Hand and the Spirit: Religious Art in America 1700-1900.* Catalogue essay by Joshua C. Taylor, catalogue by Jane Dillenberger. Berkeley, 1972.

University of Michigan Museum of Art. *Art and the Excited Spirit in the Romantic Period.* Catalogue essay by Daniel Huntington. Ann Arbor, 1972.

"Uriel in the Sun, by Washington Allston (1779-1843)." *Museum of Fine Arts (Boston), Bulletin* 6 (October 1908), 42-43.

VAN RENSSELAER, MARIANA G. "Washington Allston, A.R.A." *Magazine of Art* (London) 12 (April 1889), 145-150.

Vanderhorst papers. City of Bristol Archives, Bristol, England.

VANDERLYN, JOHN. "Tribute to the Memory of Washington Allston by a Brother Artist." *Charleston Courier* (South Carolina), July 15, 1844.

VARICK, VERNON. "Washington Allston, Painter and Poet." *Hobbies* 43 (December 1938), 31-32.

VERPLANCK, GULIAN C. Papers. New York Historical Society, New York.

WALKER, WILLIAM EDWARD. "Washington Allston, South Carolina Painter." *South Carolina Magazine* 16 (August 1952), 12-14.

Walker Art Gallery, Liverpool, England. *American Artists in Europe 1800-1900.* Catalogue by Edward Samuel Morris. Liverpool, 1977.

WARE, WILLIAM. *Lectures on the Work and Genius of Washington Allston.* Boston: Phillips, Sampson, 1852.

WARREN, CHARLES. "Why the Battle of New Orleans Was Not Painted." In his *Odd Byways in American History.* Cambridge, Mass.: Harvard University Press, 1942.

"Washington Allston." *Atlantic Monthly* 71 (May 1893), 698-701.

"Washington Allston." *Crayon,* October 31, 1855, pp. 276-277.

"Washington Allston." *Democratic Review* 13 (October 1843), 431-434.

"Washington Allston. The Life and Letters of Washington Allston. By Jared B. Flagg. Review." *Nation,* January 12, 1893, pp. 32-34.

"Washington's Allston's Pictures." *Bristol Gazette.* July 28, 1814.

"Washington Allston's Pictures." *Felix Farley's Bristol Journal,* August 27, 1814.

Washington Irving and the House of Murray: Geoffrey Crayon Charms the British, 1817-1856. Edited by Ben Harris McClary. Knoxville: University of Tennessee Press, 1969.

WELCHANS, ROGER ANTHONY. "The Art Theories of Washington Allston and William Morris Hunt." Ph.D. dissertation, Case Western Reserve University, 1970.

WELCHANS, ROGER A. "Washington Allston Portrait of Samuel Williams." *Bulletin of the Cleveland Museum of Art* 60 (January 1973), 4-8.

WELSH, JOHN R. "An Anglo-American Friendship: Allston and Coleridge." *Journal of American Studies* 5 (April 1971), 84-91.

WELSH, JOHN R. "Washington Allston, Cosmopolite and Early Romantic." *Georgia Review* 21 (winter 1967), 491-502.

WELSH, JOHN R. "Washington Allston: Expatriate South Carolinian." *South Carolina Historical Magazine* 67 (April 1966), 84-98.

WHITE, JOHN BLAKE. "The Journal of John Blake White." Edited by Paul R. Weidner. *South Carolina Historical and Genealogical Magazine* 42 (April 1941), 55-71; (July 1941), 99-117; (October 1941), 169-186; 43 (April 1942), 103-117; (July 1942), 161-174.

WHITE, ROBERT L. "Washington Allston: Banditti in Arcadia." *American Quarterly* 13 (fall 1961), 387-401.

WINSTON, GEORGE P. "Washington Allston and the Objective Correlative." *Journal of Aesthetics and Art Criticism* 18 (March 1960), 329-344.

WRIGHT, CUTHBERT. "The Feast of Belshazzar." *New England Quarterly* 10 (December 1937), 620-634.

WRIGHT, I. B. "Catalogue of the Sixteenth Edition of Paintings at the Boston Athenaeum." *Pioneer* 1 (1843), 12-16.

WRIGHT, NATHALIA. *Horatio Greenough, the First American Sculptor.* Philadelphia: University of Pennsylvania Press, 1963.

"The Writings of Washington Allston." *Southern Quarterly Review* 4 (October 1843), 363-414.

Index